Photographic
Possibilities

Photographic Possibilities

The Expressive Use of Ideas, Materials, and Processes

Robert Hirsch

Focal Press
Boston London

Front Cover
James M. Butkus. "Untitled 25," 1985. Type C print. 18" x 14".

Back Cover
Jane Alden Stevens. "The Open Door," 1985. Cyanotype print.
19-1/2" x 9-1/2".

Focal Press is an imprint of Butterworth–Heinemann.

Library of Congress Cataloging-in-Publication Data
Hirsch, Robert.
 Photographic possibilities: the expressive use of ideas,
 materials, & processes / Robert Hirsch.
 p. cm.
 Includes bibliographical references.
ISBN 0-240-80047-8
1. Photography. I. Title.
TR145.H54 1990
771–dc20 90-30200
 CIP

British Library Cataloguing in Publication Data
Hirsch, Robert
Photographic possibilities: the expressive use of ideas, materials, and processes.
1. Photography
I. Title
770

ISBN 0-240-80047-8

Butterworth-Heinemann
313 Washington Street
Newton, MA 02158-1626

10 9 8 7 6 5 4

Printed in the United States of America

To Robert Frank and his book *The Americans* for awakening my mind through my eyes to the possibilities of photography.

If a photographer wants to be an artist,
his thoughts cannot be developed overnight at the corner drugstore.
 —Robert Frank

Contents

Preface

In any act, the primary intention of him who acts is to reveal his own image.
—Dante

This book is designed for the person who has rudimentary knowledge of photographic history and has successfully mastered the basic technical processes of black-and-white photography: film developing, printmaking, and image presentation. It is for the individual who has acquired a keen interest in photography and desires to learn a variety of processes as a means of reaching new visual goals.

The book presents different ways of working with photography in a concise, straightforward manner. I selected the subjects covered based on my experience in teaching photography. These areas constantly provoke interest and questions from people in my classes.

The book begins with a discussion of the importance of the thinking mind in creating an expressive image. A basic thinking model is provided as a guide that may be used to analyze the material in this book. The book follows the sequence of traditional working methods used in the making of silver-based photographs. It begins with different types of film and their processing methods and proceeds with a variety of printmaking options. Next, unusual cameras and specialized equipment are discussed. A look at nonsilver and hand-altered processes and techniques follows. Finally, the last chapter looks to the future of photography and computers.

Electronic imaging is the fastest-growing, and one of the least understood, areas in photography. It has the potential to revolutionize the aesthetic, ethical, and technical working methods used since the beginning of photography. I felt that it was necessary to address these issues, but I did not think that I had the expertise to do so. I selected Terry Gips of the University of Maryland at College Park to write Chapter 14. Terry wrote a number of drafts, which I edited. After she completed the final draft, I rewrote some of the material to make it stylistically compatible with the rest of the book, but the information is all Terry's. If it were not for her, this chapter would not exist. I am also indebted to Terry Gips for all the fine work she did supplying the images and line art for this chapter. Thanks to David Cohen and Mark Gryparis, students at the University of Maryland at College Park, for their assistance with the line art.

The primary focus of this book is on black-and-white processes. Conventional silver-based color materials have been intentionally omitted, but they can be used in place of black-and-white materials in many instances.

Knowledge of materials is necessary if one is to achieve the satisfaction that can come with the ability to create. Technique is not offered merely for the sake of technique. Importance is placed on having something concrete to express with each application of the methods discussed. The photographs that accompany the text demonstrate how thinking artists can apply different approaches with insight and aesthetic concern. The happiness of an artist

hinges on the ability to create. Knowledge of materials is needed to achieve fine craftsmanship, which goes hand in hand with the creation of meaningful photographs.

My basic philosophy is to open different paths for readers to travel so they can successfully solve their visual quests. This book is a point of departure and should not be taken as the final authority on photography.

The text provides some brief historical background for some of the major processes covered. Terms that may be unfamiliar are defined on their first appearance. Additional sources of information and supplies are provided at the end of each major section.

Discovering possibilities means being able to recall a childlike curiosity about the world. In the process of becoming adults, we often forget how to learn. As children, we will consider almost anything. As we get older, this in-born process often gets corrupted into fear and worry. By reclaiming our childhood curiosity, we can embark on a continuous process of discovery.

A note of caution: Many of the techniques covered in this book require the use of a wide variety of chemicals. All chemicals pose a possible threat to your health and to the environment. By using common sense and following some standard working procedures, health and environmental problems can be avoided. Read Chapter 3 on health and safety before attempting any of the processes described.

The art package has been put together with the intent of providing the reader with visually stimulating images that illustrate techniques discussed in the book. I have purposely steered away from the traditional photographic textbook illustrations that show what equipment looks like or how to agitate film. I believe the readers of this book are already familiar with the basics. Instead, I stress the contemporary concerns of photographers across North America that I have found during the course of viewing thousands of images for this project. I have tried to present works that have not been used widely in other photographic texts.

I would like to acknowledge the help I have received from the following people: Karen Speerstra, editor at Focal Press, for her continued confidence and support; Susie Shulman, developmental editor at Focal Press, for her suggestions in organizing the first draft; Sharon Falter, developmental editor at Focal Press, for her recommendations in trimming the final draft down to size; Terry Gips, for the pleasure and the knowledge I gained while working with her on the computer chapter; Barbara Wooten, for patience and comments during her thorough reading of the early drafts; Joe Walsh and Ken Pirtle, my colleagues in the photography department at Amarillo College, Amarillo, Texas, for their expert criticism and support; Dr. Keith Kesler, for his challenges as the "target reader"; Nancy Klingsick of the Lynn Library of Amarillo College, for research assistance; and Harriet Martin, for offering advice and for living through the process of creating this manuscript.

I also wish to thank all the photographers who let me consider their work for this project. I am sorry that I could not use all the excellent contributions due to budget constraints. I especially want to thank Matthew Postal of the Laurence Miller Gallery in New York; Marie Spiller of the Jayne H. Baum Gallery in New York; Janet Russek of Scheinbaum & Russek in Sante Fe; Terry Etherton of Etherton/Stern Gallery in Tucson; Ben Breard of Afterimage Gallery in Dallas; Dina Palin of The Witkin Gallery in New York; Pamela M. Lee of Metro Pictures in New York; and Anne R. Pasternak of the Stux Gallery in New York.

Finally, I want to pay tribute to all my teachers and students and to past authors who have provided me with the knowledge that I hope to continue to convey.

Readers are invited to send me their comments and suggestions. The learning process is cyclical, with good students instructing and surpassing their teachers. I hope this book encourages readers to make photographs and to enjoy themselves in the process.

Robert Hirsch
Canyon, Texas

Thinking with Photography

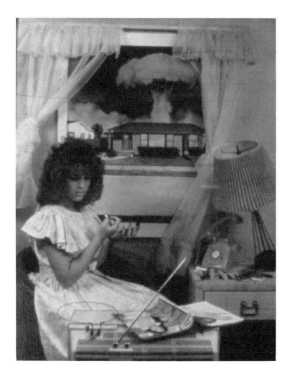

Figure 1.1 Nagatani and Tracey combine their individual skills and strengths as artists in different media to translate scenes of biting social satire from their imaginations to physical reality.

© Patrick Nagatani and Andree Tracey. "Sioux City, Iowa," 1988. From Radioactive Inactives Portraits. Chromogenic color print. 20 × 16". Courtesy of Jayne H. Baum Gallery, New York, Original in color.

Discovering the Process of Personal Creation

We have all heard so much about the creative use of photographic methods that the word *creative* has lost much of its original meaning. There are countless ways of defining the process of creation. Creation comes about through thinking. Thinking involves the creative interaction between the photographer and the subject. Definition is important because it takes you into the thinking process. It lets you acknowledge and take responsibility for a problem.

A problem is a situation for consideration. It is a question for open discussion and should not be a cause of anxiety. Defining the true nature of a problem paves the way for understanding, which can lead to the successful resolution of the problem. To obtain the maximum benefit from this book, it is necessary to begin thinking about how photography can be used to arrive at your specific destination. This can occur when the mind and heart combine in taking an idea from the imagination and finding the most suitable technical means of bringing it into existence.

A Derivative Process

Photography is a derivative process. We can usually trace a photograph back to its technical origin. The final image depends on the properties of the specific materials involved in the creation. Photography does not imitate nature, as it is often said to do, but it manifests personal realities. Photography can provide us with the means to create, invent, and originate ideas from our imaginations. Various processes allow us to bring our thoughts into the physical world. By gaining an understanding of a wide range of photographic processes and the interaction between them and our minds, we put ourselves in a better position to be able to control the final results of this collaboration.

Learning to control a process is the first step a photographer must master to transform an abstract idea into a concrete physical reality. To facilitate the transformation from mind to medium, the photographer needs to discover how to direct energy effectively through the technical means at hand. This text introduces a variety of these photographic methods, gives examples of how other photographers have applied them, provides basic working procedures, and encourages the reader to make future inquiries. Once a person obtains a basic understanding of a process, control over it can begin.

Points of Embarkation

Before embarking on a photographic project, ask yourself the questions in the following sections.

Interest Am I really interested in this project? Am I willing to spend energy, time, and money on it? Am I willing to make an internal pact with myself to see the idea through to completion?

Selection Am I familiar with this subject? Narrow down your choices and be specific about what you are going to include. Once you have begun, do not be afraid to change or expand the project according to the situation.

Audience Will other people be interested in this subject? Can I engage and retain the audience's attention without violating my personal integrity or that of the subject?

Visualization Does the subject lend itself to a strong visual interpretation? Subjects and themes that portray action or strong emotions are generally easier to visualize than intellectual concepts. Think of films you appreciate. Their message and story are generally delivered primarily through the use of images, with dialogue used only sparingly.

Accessibility Is this a practical project? Can I photograph at times that are accessible to the subject and me?

Research How can I learn everything there is to know about the subject? Look at the work of other photographers who have covered similar areas. What did they do right and wrong? What would you do differently? Discuss the subject with people directly involved. See what they are thinking and feeling. Read what others have discovered. Write out your thoughts to help expand and clarify your understanding of the project. Think about all these different ideas and approaches and how they tie in together. Use these bits of information to generate ideas of your own that can be visually expressed.

Thinking within a System

The following section offers a base model for a process of thinking (creative interaction between the photographer and the subject) with photography. Try using it as a starting point. Feel free to expand it or contract it. Analyze it. Criticize it. Throw it away and replace it with your own model. The important thing is to start thinking and uncover what works best for you in conveying your ideas with photographs.

Most people tend to perform better if they begin with a point of departure and a specific destination. The use of a system or thinking model can be very helpful in instigating, clarifying, and speeding up the creative process. A system can reveal errors and inconsistencies and can help to substantiate the accuracy of a working method. Look for a system that expands your thought process and opens new vistas and working premises to solve problems. A successful problem solver must become a fearless questioner.

A system may be used as a tool of the experimental. Work with a model that encourages experiments that can take you outside the system. Systems that function well inspire confidence, but they can never tell you exactly what to do. A true thinking model acts as only a guide. It should provide a channel for the free flow of creative energies without diverting their strength by demanding rigid adherence to arbitrary procedures.

If the truth is going to be discovered, there must be freedom to ask uninhibited questions. Remember that experimental work disrupts assumptions and conventions of traditional modes of working. Ideas about originality, subject matter, print quality, process, and treatment should all come into question during the creative process. An ideal thinking model is one that entitles you to uninhibited questioning.

Although systems provide the reassurance of starting out on a known road, you must remember that there are many routes to most destinations. For this reason, using the same system model in every situation can be dangerous. If there is too much grid work, the problem solver can get confused

Figure 1.2 Serrano disrupts assumptions and conventions and uses his work to startle and alarm. This awakening may force viewers to confront issues they would rather not encounter. In an effort to suppress such work, conservative members of the U.S. Congress have voted to cut off federal funding to institutions showing "obscene" art.

© Andre Serrano. "Piss Discus," 1988. Cibachrome. 60 x 40". Courtesy of Stux Gallery, New York. Original in color.

or lost or can develop a mind-set that provides solutions without studying the problem. If everything is spelled out exactly, creativity ceases, boredom sets in, and a set of programmed responses results. There is nothing creative about regurgitating preconditioned responses to a situation. Unfortunately, the seeming coherence of a known system is not a guarantee of truth. The proper purpose of a thinking model is to open the possibilities of new visions and provide a means of capturing what has been seen.

A Thinking Model

This thinking model is offered, despite the warning, as a structural device to help you contemplate the approaches put forth in this book. Try this model on for size, make alterations, and come up with a consistent method on which to base your explorations (see Table 1.1).

Phase 1: Thinking Time

This is when you experience the first conscious awareness that you have an idea. Where did this idea come from? Sometimes you can trace it back to an external stimulus, such as talking with friends, watching a film, reading a book, or observing a situation. Other times it may come from within. It may be produced by anxiety or pleasure based on your past experiences and knowledge. It may be brought about through conscious thought directed at a particular subject. Or it may strike without warning, seemingly out of nowhere. It can be of an intellectual or emotional nature. It can arrive while you are driving to work or in the middle of the night in the form of a dream.

Holding on to Ideas What should you do when an idea first makes itself known? Do not lose it. Many ideas emerge only to be lost in the routine of everyday life. An idea can be the spark that will ignite the act of creation. It does no good to think of great ideas if you cannot hold on to them. If you ignore it, the spark will die out. Whenever possible, act on an idea immediately by recording it. If it is a thought, write it down. If it is a visual image, get the camera and start making exposures. If you do not have a camera, make a thumbnail sketch. This is not the time to be concerned about creating a masterpiece. Start recording what has piqued your interest; worry about analyzing it later. The important thing is to break inertia and generate raw source material.

Many of the processes offered in this text enable the photographer to have continued interaction with these initial situations over a period of time. This provides an opportunity for you to rethink your initial response and build the concept of extended time into the image.

Table 1.1 A Thinking Model Summary

Step	Summary
1. Thinking time	Discovering and holding on to key ideas. Using a source notebook for idea generation.
2. Searching for form	A self-declaration of accepting the situation and the challenge to give the idea concrete form by visualizing all the possibilities.
3. Picking an approach	Selecting the equipment, materials, methods, and techniques that provide the best avenue for visual development of the idea.
4. Putting it together	Photographically pulling all your knowledge and resources together into a concrete form of an image.
5. Appraisal	Reviewing all that has been done by formulating questions that reflect your concerns, expectations, needs, and wants. Discovering what did and did not work and why.

Keep a Source Notebook There are times when you cannot act on your idea immediately. In these situations, record it in a notebook. Keep the notebook handy and take the time to transfer all your notes on scrap paper into it so your ideas will be preserved in one place. The notebook should include your own written ideas; other visual and written material from books, magazines, and newspapers; and sketches, snapshots, work prints, and any other items that stimulate your thought processes.

The notebook also can help you define and develop ideas. Do not worry about following up on every idea. The notebook will help you sort out your ideas and decide which are important. It can act as a compass pointing out the direction in which you want to travel. The notebook can serve the future by providing you with a personal history of ideas to which you can refer back. As your needs and interests change, an idea that did not seem worth pursuing last year may provide the direction you are currently seeking.

Getting Ideas Here are a few suggestions for getting ideas that have helped other photographers:

- Stick to what you know. Photograph something with which you are already familiar.
- Discover something new. Photograph something with which you are unfamiliar but that you would like to explore.
- Look at photographs, paintings, and drawings. When one makes an impression, try to figure out what it is that either appeals to you or disturbs you. Incorporate these concepts as active ingredients into your way of seeing and working.
- Study the development of the photographic medium. It is difficult to understand the present or the future with no knowledge of the past. Look for concepts, ideas, and processes that appeal to your personal needs and artistic direction. They can provide a springboard for your experiments.
- Collect materials that you may use in making future photographs.

Look for ways to generate new ideas. Do not live off borrowed materials. Create your own resources that begin a cycle of self-renewal. (See Color Plate I.)

Phase 2: Searching for Form

In the search for concrete representations of an idea, both the problem and the challenge need to be acknowledged. The problem is how to present the idea visually in a form that communicates your thoughts and feelings to the intended audience. The challenge is to create visual impact and feel satisfied with the outcome. This is the growth stage of the idea. You have acknowledged the problem and taken responsibility for its resolution. Now make a declaration of faith to uncover all the possibilities.

This is the time to consider all your previous experiences and knowledge. Attempt to visualize the idea in as many different forms as possible and then analyze the strong and weak points of each visualization. Imagine how the choice of camera format, lens, point of view, quality of light, film-developer combinations, and paper and its processing procedures will affect the final outcome of the visualization. Let these internal pictures run inside the projection room of your brain. Do not limit any of your visualizations but look for elements that will provide continuity and unity to your vision.

The power to visualize is important because it lets you consider several different approaches without making a concrete representation. Practice using the "possibility scale" concept, which states that there are no impossibilities, only different levels of possibility. If you can think of it, there is a way to make it happen.

Figure 1.3 Sherman established herself as the only subject in the "Film Still Series." The work points out that photographic truth is a myth and that media-generated imagery is as staged as her own. Through self-portraiture, it is possible to be actor, director, and producer, living out your personal fantasies and fears. Sherman uses it to unmask sexual stereotypes and to question her own identity.

© Cindy Sherman. "Untitled Film Still," 1979. Gelatin silver print. 10 x 8". Courtesy of Metro Pictures, New York.

Opening Up Your Mind and Heart You can do a number of things to stimulate the problem-solving process. Try breaking your normal routine and working habits. Turn off the bombardment of external stimuli and listen to what is happening inside yourself. Sit down and chart out your ideas on a big piece of paper. Get beyond surface scanning and start "seeing" before making any final decisions. The act of perception provides the visual awareness that can reveal the true problem and not just its symptoms.

Avoiding Fear Avoid the roadblock of fear. Fear kills more ideas than anything else. Do not worry about being right. This is a learning situation, and mistakes are part of the process. We often learn more from our failures than from our successes. This is the time to let ideas evolve, to alter them, or to throw them away and begin anew. Question everything and consider all the options to discover what you want to say and how you want to express it. Once you know this, it is easier to go about the business of making your images.

Asking "What If" Questions Keep asking "what if" questions. What if I use this type of light? What if I use this kind of film? What if I use this developer formula? What if I use this brand of paper? What if I tone the image? Consider all the possibilities and keep wondering about everything.

Phase 3: Picking an Approach

Picking an approach means you have considered the strengths and limitations of all the possibilities. This is the time to narrow down the choices and decide which will best suit the visual development of your ideas and feelings. The key to a successful approach is being able to select the equipment, materials, methods, and techniques that will enable you to speak in the strong-est visual terms. Give thought to both previsualization (before the exposure is made) and postvisualization (after the exposure has been made) methods. Mastering the techniques will not guarantee artistic results, but it will provide a means to overcome the limitations inherent in the mechanics of photography. Do not fall in love with one idea or approach. Stay loose and keep alternatives available.

Phase 4: Putting It Together

This is when you muster all your resources and put them into photographic action. You are no longer thinking or talking about photography; you are actually involved in making images. Try out the visualizations you have generated and selected. Enjoy the process; it can be as rewarding as the final manifestation of the idea.

A possible working scenario first involves the pre-exposure considerations of subject, quality of light, angle of view, camera format, type of film, and exposure determination. Next consider what types of developer and film are best suited for what you have photographed. Ask yourself, "Am I going to get the results I want from the printing of a straight negative, or should I consider altering the negative by means such as retouching or hand-alteration?" Once the final look of the negative has been determined, decide which paper proc-essing materials and methods you will use. These decisions include type of paper developer, paper grade and surface, use of archival or nonarchival methods, and type of toner, if any.

Examine the completed print. Does it look like, and say what you had in mind? If not, postdarkroom work is the next step. This may include retouching the print or even painting, drawing, collaging, or reshooting the results. When the image is satisfying, it is time to think about presentation. Will the

image be stronger individually or in a group? Should it be mounted, matted, floated, framed, or shown in book format? Keep asking yourself questions to help you maintain an open mind. Shoot that extra exposure. Make one more print. Cut one more matte. Do not get discouraged, for this is a time of discovery, growing, and learning.

Phase 5: Appraisal

This is the stage at which you review all that you have done. Appraisal can be carried out during any stage of the process—after the initial exposure, film processing, or printmaking—or when the work is completed and/or presented. Formulate questions that reflect your concerns, expectations, needs, and wants. Get specific and give detailed answers. Consider these questions: Am I satisfied with the outcome? Why or why not? Did I accomplish what I set out to do? Have I deviated from my original approach? What methods did I use to accomplish my goals? If I were to do this again, what would I do differently? Locate, define, and discuss sources of satisfaction and dissatisfaction. Have someone else look at the work and listen to what they have to say. Now ask the big questions: Does this image meet my goals? Is the final work aesthetically, spiritually, and technically satisfying? If the answers are yes, note the things you did that were helpful and try applying them to future efforts. If the answers are no, it is time to start the process over and reshoot. Learn from both your successes and failures. Do not get scared away. Keep on working and making images.

How do you know when you have created a good image? Experience will help you to form your own methods of judgment based on personal experiences and input from additional sources. Some points to consider include the following: Were you able to define your internal thoughts? Did you find and master a technique that allows you to present the final photograph with the desired feeling and power? Have you gained insight and understanding into the true nature of the challenge? Has this experience been translated through the medium to the intended audience? When the image fits the problem and the problem solver, a successful resolution has been achieved.

Strong work carries the mark of centered individual thought that results from a well-formed interior process of thinking (Table 1.1). To become a good photographer, you must incorporate these attitudes into your photographic life. Look for that joyful moment in the process of photography that defies words when there is nothing else, just you and the subject. If we could

Figure 1.4 Strong work is the result of a well–formulated process of interior thinking. Good pictures come into being when a photographer uses the mind and heart to express something that would not otherwise be possible.

© Lee Friedlander. "Kentucky," 1977. Gelatin silver print. 11 x 14". Courtesy of Laurence Miller Gallery, New York.

express everything we wanted with written symbols, there would be no need for any of the visual arts. When used in conjunction with the mind and the heart, the processes of photography allow us to express things that would not otherwise be possible. When this blending occurs, good photographs come into being.

Roles Photography Can Play

The equipment, materials, and processes covered in this text take you away from the widely accepted notion that the sole purpose of photography is to recreate outer reality. Most of the material is designed to let you discover the many possibilities within the medium of photography. This information can help you to bring into existence that which never was. It starts to supply answers to the question "Why not?" It raises the question "How can I get past merely recording the reflections of the surface?" This type of thinking disrupts the assumptions and conventions that many people still possess. If the work is unfamiliar, it can make some people uncomfortable because there are no prescribed guidelines on which they can base their responses. Be prepared for possible challenges when presenting work that is unconventional.

You can meet a challenge and use it to your advantage if you have done your thinking, are making images you care about, and have learned to control the technique so that it blends in and becomes a vital part of the visual statement. If the situation permits, take on the role of teacher and explain the information required to handle the problem in a particular way. It is likely you will learn more about the subject by trying to teach someone about something you understand and believe in. Nobody learns more about the subject than a well-prepared teacher. It is also possible that the explanation will help the listener to see something new and unlock some doors of perception.

Additional Information

Davis, Philip J., and David Park, eds. *No Way, The Nature of the Impossible.* New York: W.H. Freeman, 1987.

Koberg, Don, and Jim Bagnall. *The Universal Traveler.* Los Altos, Calif.: William Kaufman, 1976.

Samuels, Mike, and Nancy Samuels. *Seeing with the Mind's Eye.* New York: Random House, 1987.

von Oech, Roger. *A Whack on the Side of the Head.* New York: Warner Books, 1983.

———. *Kick in the Seat of the Pants.* New York: Harper and Row, 1986.

Ideas Affecting Photographic Printmaking

Since Louis-Jacques-Mandé Daguerre made public his daguerreotype process in 1839, people have been busy altering and discovering new materials and methods to use the photographic medium as a means to present their way of seeing. People wanted and got a mechanical method for transferring what was seen in nature into a recognizable two-dimensional form. Within a short period of time, photographs were being confused with and substituted for reality. Photography proved so able at this task of reality substitution that many people came to think that this was the sole purpose of photography. The photographer was supposed to act as a neutral observer, an operator of a piece of machinery, while the camera performed and did the work of recording.

There are no neutral photographs. Any depiction has an inherent bias. Photography has two distinct kinds of bias. The first bias comes from the people who create and manufacture the commonly used photographic systems, which include the cameras, lenses, films, papers, chemicals, and darkroom equipment used to produce an image physically. These people set up the physical boundaries and the general framework within which the photographer must operate. The second bias comes from the prejudices of the photographer who uses these systems to create specific images. Every photograph reveals the photographer's viewpoints and is a combination of

Figure 2.1 Painters such as LeClear took advantage of photography's ability to deliver an immediate, two-dimensional substitute for reality. Both full-length portraits in this painting were posthumous, executed from a daguerreotype. It is believed that the artist included himself as the photographer, seen at right from the rear, bending over a collodion wet-plate camera.

© Thomas LeClear. "Interior with Portraits," circa 1865. Oil on canvas. 26 1/4 x 40 1/2". Courtesy of Hirschl & Adler Galleries, New York. Original in color.

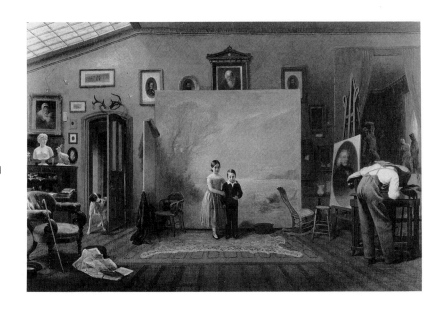

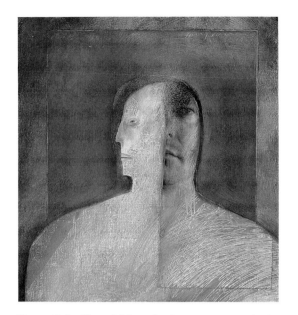

Figure 2.2 The addition of color to meet aesthetic requirements is one of photography's oldest modifications. Here Roberts cut the photograph and attached it to a gessoed canvas. After allowing it to dry, she painted it with oils.

© Holly Roberts. "Man Listening to Himself," 1988. Oil on gelatin silver print on canvas. 20 x 18 1/2". Courtesy of Jayne H. Baum Gallery, New York. Original in color.

the subject, the photographer, and the process. For the photographer to uncover what is important and how it should be presented, he or she must leave the biases of "proper" and "ought to" in the wastebasket.

Early Printmaking Modifications

In the beginning, the practitioners of photography had no qualms about modifying any process to meet their aesthetic and technical requirements. Painters of miniatures set to work immediately on daguerreotypes to meet the demand to reproduce color. This set the precedent of applying color by hand to any process. Calotypes were waxed to make them more transparent and thus easier and quicker to print. Photographers such as Charles Nègre also used pencil work on calotype negatives to alter tonal relationships, increase separation of a figure from the background, accent highlights, add details or objects not included in the original exposure, and remove any unwanted items. Methods that could alter the photographic reality were widely practiced and accepted at this time.

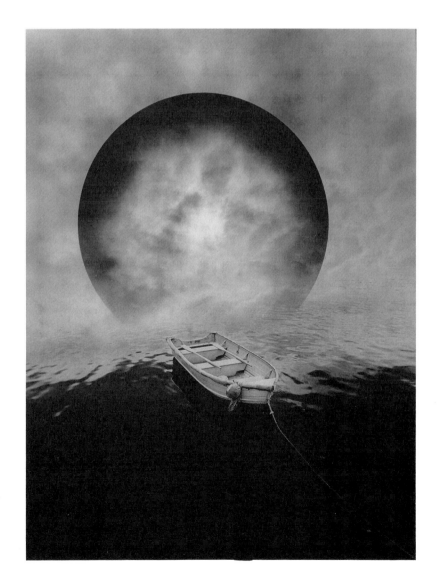

Figure 2.3 In the 1960s, Uelsmann revived the process of combination printing. With magician-like craftsmanship, he creates surreal juxtapositions that the viewer knows cannot reflect reality. Yet these pictures remain believable because of the general belief in the truth of the photographic image.

© Jerry N. Uelsmann. "Untitled," 1982. Gelatin silver print. 16 x 20". Courtesy of the Witkin Gallery, New York.

Combination Printing

The collodion, or wet-plate, process that became the major photographic process in the 1850s possessed a low sensitivity to light, which made group portrait making difficult. It was oversensitive to the blue end of the spectrum, making it impossible to capture naturalistic landscapes. If the exposure for the group was correct, the sky would be overexposed. Combination printing began as a technique to overcome this inherent technical problem. Separate exposures were made and, through the use of masking, printed on a single piece of paper. This technique burst on the scene with the unveiling of Oscar Gustave Rejlander's "Two Ways of Life" (1857), an image made from 32 negatives. Through the photographs and writing of Henry Peach Robinson, combination printing became the method of choice for serious photographers of artistic intent.

Beginnings of Straight Photography

Major objections to these methods of working were raised by Peter Henry Emerson's *Naturalistic Photography*, published in 1889. It launched a frontal attack on the combination printing concepts of picture making. Emerson called for more simplified working procedures and a visual approach of "se-

Figure 2.4 Dawson's work comes out of the ideas put forth in Peter Henry Emerson's *Naturalistic Photography*. Photographers such as Alfred Stieglitz and Paul Strand later expanded these ideas into straight, sharp-focus, nonmanipulative photography. In straight photography, the work is created (previsualized) at the time of exposure rather than through various postvisualization techniques.

© Robert Dawson. "Flooded Salt Air Pavilion, Great Salt Lake, Utah," 1985. From the Water in the West Project. Gelatin silver print. 16 x 20".

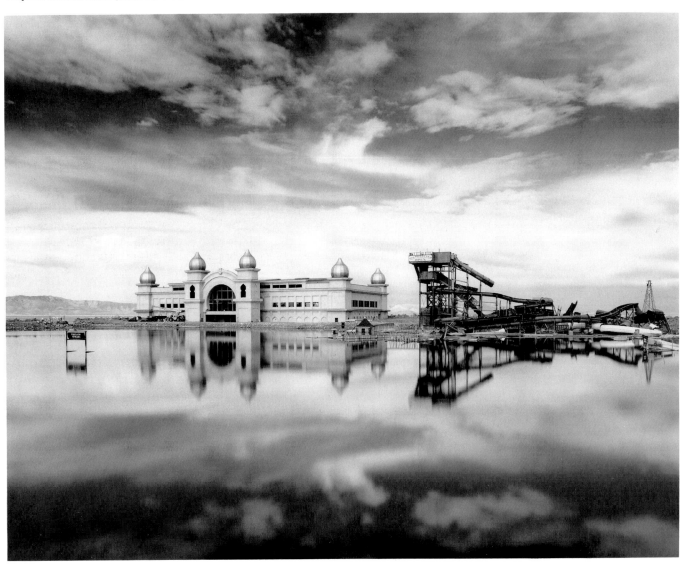

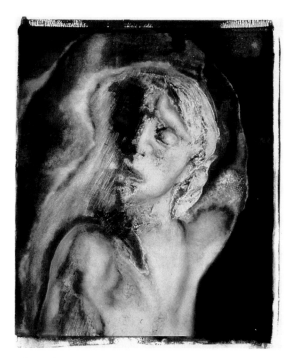

Figure 2.5 Reuter's Polacolor transfers with applied color stem from the Pictorialist tradition of stressing the atmospheric and formal effects of the image over the subject itself. The emphasis of such work is on the construction of meaning, as opposed to the finding of meaning that occurs naturally in the world.

© John Reuter. "Spirits of Pere La Chaise," 1988. Polacolor transfer with pastel and dry pigment graphite. 20 x 24". Courtesy of Jayne H. Baum Gallery, New York. Original in color.

lective naturalistic focusing." This was supposed to let the photograph represent the world in a manner that would more closely replicate human vision, in which everything is not seen clearly and sharply.

Emerson thought it was the photographer's job to discover the camera's own rules. He saw photography as a blending of art and science. He stated that through one's selection of framing, lighting, and selective focusing, good images could be made. Emerson emphasized photographing subjects in their natural surroundings without any of the artificial manipulations of the combination printers. He came under heavy attack for these ideas and recanted with *The Death of Naturalistic Photography* in 1890, but the seeds of straight photography had been sown.

The Pictorialists

The 1890s were the heyday of many manipulative methods, such as gum printing. This type of printing was favored by the Pictorialists and championed through the work and writing of Alfred Maskell and Robert Demachy. The Pictorialists stressed the atmospheric and formal effects of the image over that of the subject matter. Composition and tonal values were of paramount concern. Soft-focus lenses were used to emphasize surface representation rather than detail. These expressive printmakers favored elaborate processes in their attempts to make photography a legitimate visual art form. The Pictorialists' attitudes and procedures have dominated much commercial portrait and illustrative work throughout the twentieth century, with an emphasis on constructing beauty as opposed to finding it in nature.

The Photo-Secessionists

In the United States, the Pictorialists were followed by the Photo-Secessionists, under the leadership of Alfred Stieglitz. In their quest to have photography recognized as an art form, the group, which included Joseph Keiley, Gertrude Käsebier, Frank Eugene, Edward Steichen, Alvin Coburn, and Clarence White, expended tremendous amounts of energy experimenting with a wide variety of printmaking methods.

This movement's ideals culminated in the 1910 Photo-Secession retrospective show at the Albright Gallery in Buffalo, New York. By this time, a number of the group's members, including Stieglitz, had already abandoned the ideas and working concepts of the manipulated image. Influenced by avant-garde artists, such as Picasso, whom he showed for the first time in the United States at his 291 Gallery, Stieglitz began to formulate a straight photographic aesthetic.

The Pictorialists did not update their working concepts and faded as an art movement by the mid-1920s. At this time, photographers such as Paul Strand were incorporating the concepts of abstraction directly into the idea of straight, sharp-focus, nonmanipulative photography. Emphasis switched to creating the image in the camera at the moment of exposure and maintaining a much narrower range of what was considered acceptable in printmaking.

Recent Approaches in Printmaking

Straight Photography and Previsualization

Edward Weston's work from about 1930 on represents the idea of straight photography through the use of previsualization. By previsualization, Weston meant that he knew what the final print would look like before releasing the camera shutter. The idea of previsualization would bring serious printmaking full circle, back to the straightforward approach of the 1850s, when work was contact printed onto glossy albumen paper. Weston simplified the photographer's working approach by generally using natural light and a view camera with its lens at a small aperture. This produced a large-format nega-

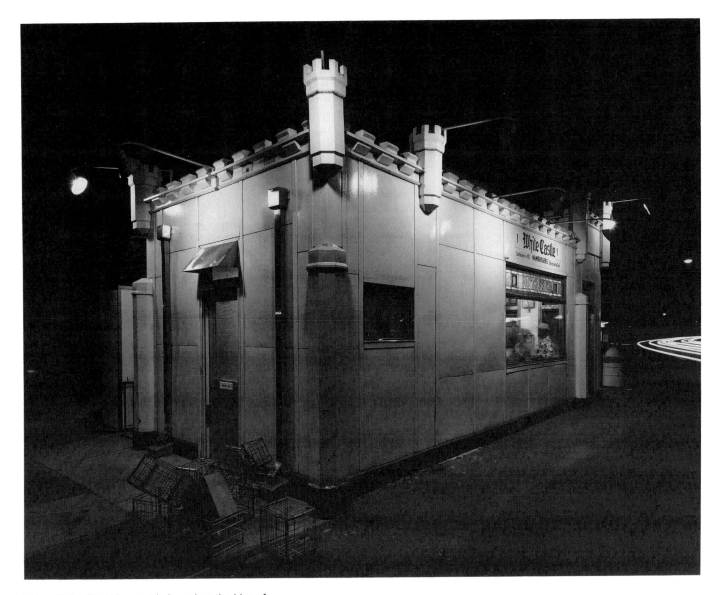

Figure 2.6 Tice's imagery is based on the idea of previsualization, knowing what the final print will look like before the camera's shutter is released. He used a wide-angle lens on his 8 x 10" Deardorff camera to give the diner more angularity. The 30-second exposure was sufficient to provide shadow detail in the milk crates piled up at the back of the diner. The photographer anticipated the pattern of lights produced by the cars rounding the curve of the highway, and made it an important compositional element.

© George Tice. "White Castle, Route #1, Rahway, New Jersey," 1973. Gelatin silver print. 8 x 10". Courtesy of the Witkin Gallery, New York.

tive that was contact printed (no enlarging) with a bare light bulb. Detail was at a premium. The object was to create an exact translation of the original subject in black-and-white on glossy, commercially prepared paper. Weston thought that eliminating all that he considered unnecessary would enable him to get at the truth.

Group F/64 In 1932, a band of California-based photographers that included Edward Weston, Ansel Adams, Imogen Cunningham, and Willard Van Dyke founded Group F/64, which incorporated these working methods into their image making. Their primary goal was to make images in the mode of intense realism. The name of the group reflects the fact that the members favored a small lens aperture, which enabled them to achieve images with maximum detail, sharpness, and depth of field.

The Zone System The ideas from Group F/64 were refined and expanded by Ansel Adams in his zone system method. The zone system is a scientifically based technique for controlling exposure, development, and printing to

Figure 2.7 The work of the Starn Twins is based on the concept of postvisualization. This idea allows the artist to interact with the image during any part of the creation process. In making this image, the paper was treated in sepia toner that was mixed with fixer. The ortho film (making up the appropriated portrait) was toned with Berg blue toner. The entire picture was formed by combining cut and torn pieces of film and paper with tape. The work pays homage to art history while creating an icon that refers back to the Starn Twins' own mirror-image existence.

© The Starn Twins (Doug Starn and Mike Starn). "Double Rembrandt with Steps," 1987–88. Gelatin silver prints with silver-based film and mixed media. 108 x 108". Courtesy of Stux Gallery, New York. Original in color.

give an incisive translation of detail, scale, texture, and tone in the final image. Adam's accomplishments have set the standards for pristine wilderness landscape photography for the past fifty years. Through his work, teaching, and writing, Adams came to dominate serious photographic printmaking. He was so popular and successful that the zone system sent the other forms of printmaking into exile.

Postvisualization

The mid-1960s sparked a renewal of many photographic printmaking processes. This was a time of experimentation in many aspects of society. A rising interest in countercultural ideas sent many photographers back in photographic history to rediscover alternative techniques and encouraged new directions in image making. A revival of historical methods began with the use of combination printing, and this spread to nonsilver approaches such as cyanotypes and gum printing. The concept of postvisualization, in which the photographer could continue to interact with the image at any stage of the process, was reintroduced into the repertoire of acceptable practices.

These ideas found a large following in institutions of higher learning because interest in the study of photography was expanding and being taken more seriously. Many of the people who studied photography during this era are now teachers who have continued to support the idea of preserving all options that allow the printmaker to be expressive, flexible, and individualistic. In addition, electronic imaging has begun to revolutionize all the working methods that previous generations of photographers have used in the creation of images.

Figure 2.8 Computers have begun to open new paths of exploration in image making. Such work can leave the viewer with a sense of wonderment at how the image was made. Burson's composite human is made up of a Caucasian, Negroid, and Oriental.

© Nancy Burson. "Mankind," 1983–85. Gelatin silver print. 7 3/4 x 7 1/2". Courtesy of Jayne H. Baum Gallery, New York.

Having a Sense of History

Some people have no sense of the history of photography and no interest in studying past models. These people merely like to act the part of the photographer, but they seem to possess no appreciation for the fact that true photographers like looking at photographs. There is much to be learned from the great photographers. They possessed powerful hearts and minds. They loved the range of materials that the medium had to offer. The possibilities of their work gave them excitement, and the complexity of the process fired their imaginations. The care that great work reveals suggests the mastery of tasks needed to perform visual feats. These masters were not afraid to work. Their images were produced out of knowledge and love. This enabled them to create complex works with the power to endure because the photographers did not hold anything back.

This book offers a variety of photographic approaches. This information allows the expressive printmaker to understand how photography has evolved and in turn to be ready to explore future possibilities in the making of images.

Additional Information

Adams, Ansel. The *New Ansel Adams Photography Series*. Boston: Little, Brown, 1981.

Crawford, William. *The Keepers of Light: A History and Working Guide to Early Photographic Processes*. Dobbs Ferry, NY: Morgan and Morgan, 1979.

Green Jonathan. *American Photography: A Critical History 1945 to the Present*. New York: Harry N. Abrams, 1984.

Newhall, Beaumont. *The History of Photography*. Revised Edition. New York: The Museum of Modern Art, 1982.

Rosenblum, Naomi. *A World History of Photography*. Revised Edition. New York: Abbeville Press, 1989.

Taft, Robert. *Photography and the American Scene: A Social History, 1839-1889*. New York: Dover Publications, 1964.

Chapter **3**

Safety

Photographers must be aware of certain health and environmental concerns to ensure a safe and creative working atmosphere. Before beginning to work with any of the processes mentioned in this text, it is necessary to follow these basic precautions and procedures (see Color Plate II) outlined in the next section.

Basic Safety Procedures

1. Read and follow all instructions and safety recommendations provided by the manufacturer *before* undertaking any process. This includes mixing, handling, disposal, and storage.

2. Become familiar with all the inherent dangers associated with any chemicals being used. When acquiring chemicals, ask about proper handling and safety procedures.

3. Know the antidote for the chemicals you are using. Prominently display the telephone numbers for poison control and emergency treatment centers in your working area and near the telephone.

4. Many chemicals can be flammable. Keep them away from any source of heat or open flame to avoid a possible explosion or fire. Keep a fire extinguisher that can be used for both chemical and electrical fires in the work area.

5. Work in a well-ventilated space. Hazardous chemicals should be mixed under a vented hood or outside.

6. Protect yourself. Wear thin, disposable plastic gloves, safety glasses, and a plastic apron. Use a disposable face mask or respirator when mixing chemicals or if you have had any previous allergic reaction. If you have any type of reaction, consult a physician immediately and suspend work with all photographic processes.

7. Follow mixing instructions precisely.

8. Keep all chemicals off your skin, out of your mouth, and away from your eyes. If you get any chemicals on your skin, flush the area immediately with cool running water.

9. Do not eat, drink, or smoke while handling chemicals.

10. Always pour acids slowly into water; never pour water into acids. Do not mix or pour any chemical at eye level, as a splash could be harmful. Wear protective eye wear when mixing acids.

11. Avoid touching any electrical equipment with wet hands. Install shock-proof outlets in your darkroom.

12. Follow instructions for proper disposal of all chemicals. Wash yourself and any equipment that has come into contact with any chemicals. Launder darkroom towels after each session. Dispose of gloves and masks to avoid future contamination. Keep your work space clean and uncontaminated.

13. Store all chemicals properly. Use safety caps or lock up chemicals to prevent other people and pets from being exposed to their potential dangers. Store chemicals in a cool, dry area away from any direct sunlight.

14. If you are *pregnant* or have any pre-existing health problems, read the pertinent materials under "Additional Information" before carrying out any process described in this book.

15. Remember, people have varying sensitivities to chemicals. If you have had allergic reactions to any chemicals, you should pay close attention to the effects that darkroom chemicals have on you, and you should be extra careful about following all safety procedures.

Specific safety measures and reminders are provided in the chapters on each process. These guidelines are not designed to produce paranoia but to ensure that you have a long and safe adventure in uncovering the many possibilities that are available in the realm of photography. Remember that your eyes, lungs, and skin are porous membranes and can absorb chemical vapors. It is your job to protect yourself.

Additional Information

Books
McCann, Michael. *Artist Beware*. New York: Watson-Guptill, 1979.
Shaw, Susan. *Overexposure: Health Hazards in Photography*. San Francisco: The Friends of Photography, 1983.
Tell, Judy. "Making Darkrooms Saferooms," 1989. Available from National Press Photographers Association, 3200 Croqsdaile Drive, Suite 306, Durham, NC 27705.

Other Sources
Center for Occupational Hazards, 5 Beekman Street, New York, NY 10038; (212) 227-6220.
Ilford, North America, 24-hour hot line, (914) 478-3131.
Kodak, Australia/Asia/Western Pacific, 24-hour hot line, 03-350-1222.
Kodak, North America, 24-hour hot line, (716) 722-5151.
Kodak, United Kingdom/Europe/Africa, 24-hour hot line, 01-427-4380.

Special-Use Films and Processing

Film and the Photographer

To be a photographer, you must have a camera and learn how to make it function to fulfill specific purposes. The photographer uses the camera to make visual records of the subject in front of the lens. Traditionally, the camera has used a light-sensitive substance on a support base of film to accomplish this task. In the 1980s, cameras that were capable of recording an image electronically on a disk without film became available for commercial use. Although electronic imaging is a revolutionary breakthrough in how a camera can capture a scene, film continues to be the method on which the vast majority of photographers rely to record their subjects. (Electronic imaging is covered in Chapter 14.)

You should feel confident in camera handling and exposure and in processing a wide variety of general-purpose black-and-white films before proceeding. If you have any problems in these areas, a review of working procedures is in order. (This chapter will not cover color films. For information on this subject consult *Exploring Color Photography* by Robert Hirsch, Wm. C. Brown Publishers, 1989.)

Film Selection

Film is the agent that records the initial scene, and its basic characteristics are crucial in determining the look of the final image. Brands and types of film differ in contrast, grain structure, sensitivity, sharpness, and speed. These characteristics are manufactured into film and are difficult to alter to any large degree. For these reasons, it is important for the photographer to base his or her selection of film on the aesthetic and technical criteria of the situation.

Manufacturers have been altering existing films, discounting old favorites, and introducing new films at a rapid rate. It is difficult for any photographer to keep up with all these changes. The life span of technical information has been greatly reduced. It can become obsolete almost as soon as it is printed. To deal with this problem, a photographer must have a sound conceptual understanding of a wide array of photographic processes. A process or product may change, but the underlying principles remain the same. Many photographers find that refining their working methods with one film-developer combination can be effective for most general situations. But a photographer must be willing to try new films in noncritical situations and make a judgment based on personal experience.

Selecting a film is an individualistic matter in which many subjective concerns take precedence over technical matters. It is important to talk with other photographers and read the magazine test reports. Remember, you can read and discuss photography all night, but this is not photography. Being a photographer means being involved in making images. The only way to know what is going to work in photography is to do it yourself. The multiplic-

ity of human experience shows that reality is not an inert and simple matter. Let the selection of film reflect what actually works.

Compiling Sources of Information

The information provided in this chapter is designed to offer aesthetic and technical possibilities that cannot be achieved through the use of conventional films. The information has been compiled through the personal working experiences of professionals, teachers, and students. The technical information was up-to-date at the time of writing, but you should check it against the manufacturer's data sheet before beginning to work with the film.

These methods have been successful for others. If the results you obtain with them are not satisfactory, do not hesitate to alter them. Make these working procedures your own by changing them to suit your personal requirements. Keep a detailed notebook of procedures, ideas, and sources. Record keeping can save time and act as a springboard for new directions in your work.

General Working Procedures for Film Processing

Certain general working procedures should be followed in all film processing to ensure consistent high-quality results. These include the following:

1. Read, understand, and follow all technical and safety data before processing the film.

2. Check the thermometer and timer for accuracy.

3. Be certain that all other equipment and your general working area are clean, dry, and in proper working order.

4. Make sure there are no light leaks in film-loading and film-processing areas.

5. Lay out all the equipment you will need in a location where you can find it without the aid of a light.

6. Plastic funnels, graduates, mixing pails, stirring rods, and bottles should be durable, easy to clean, inexpensive, and applicable to almost any process. To avoid any possible contamination, use separate graduates and containers for developer and fix. Rinse all mixing equipment after each use.

7. Store all developers in clean brown bottles, with as much air as possible removed from the bottles, to ensure maximum life.

8. Do not exceed the working capacities (the amount of film that may be processed) of any of the solutions.

9. Mix the developer with distilled water to ensure consistency, especially in areas with problematic water.

10. Use an accurate thermometer for processing consistency. This is necessary to ensure that all solutions are at their proper operating temperatures.

11. Presoak the film for 1 to 2 minutes before beginning to process. This is an optional step, but many people feel that it prepares the film for developer and eliminates air bubbles, thus helping deliver superior quality. If you use a presoak, you may have to extend the developing time. Try it and see.

12. Follow recommended agitation patterns for each step of processing.

13. Mix the stop bath from a 28 percent stock solution to avoid the problems that can occur when working with the highly concentrated 99 percent glacial acetic acid. Dilute the 28 percent stock solution to its working strength. Use it one time (one shot) and dispose of it. If you want to reuse the stop bath, get one that contains an indicator dye that changes color to inform you when the solution is becoming exhausted. Discard the indicator stop after its orange color disappears. If you wait for it to turn purple, it may already be exhausted. Indicator stop bath may be used to make all film and paper stop baths.

14. Fixer or hypo comes in two forms—regular, which consists mainly of sodium thiosulfate powder, and rapid, which is usually ammonium thiosulfate in a liquid form. Either may be used for most processes. Check to make sure the dilution is correct for the process being carried out. Both types may be reused. Keep a record of the number of rolls processed or use a hypo test solution that will indicate when the fixer has become exhausted. This test solution can be purchased commercially or made following this formula: 100 milliliters distilled water to 2 grams potassium iodide. This solution can be stored in a dropper bottle, available at most drugstores. It should keep indefinitely.

To use this solution, put 1 or 2 drops into the used fixer. Wait a few seconds. If a cloud forms, discard the film fixer. If any cloudiness is visible within about 10 seconds, replace the print fixer.

15. Film may be washed in the processing tank. Make certain that the water is changed often, at least 12 complete changes of water, or get a film washer that does this automatically.

16. Use a hypo clearing agent to help remove fixer residue and reduce washing time.

17. Place the film in a wetting agent for about 2 minutes with light agitation before hanging it to dry in a dust-free area. Always mix the wetting agent with distilled water. Dispose of the used solution after each use.

18. If there are problems with particles drying on the film, try this procedure: Upon removing the film from the wetting agent, shake off excess solution in the sink. Hang film up and clip it on the bottom. If your fingers are clean and smooth, put your index and middle fingers in the wetting solution and shake them off. Now use these two fingers to gently squeegee both sides of the film. With a lint-free disposable towel, such as a Photo-Wipe, carefully wipe the nonemulsion (shiny) side of the film from top to bottom. Do not wipe the emulsion side, as it is still soft and can be easily damaged. Hold the film at a slight angle with one hand. Using the other hand, slowly bring the disposable towel down the full length of the film. Keep your eye on the film just behind where the towel has passed to check for any spots, streaks, or particles. If any is visible, go back and remove it. A rainbow effect on the film surface indicates that you are carrying out the procedure correctly. Do not use any heat or forced air to speed film drying.

19. After the film is dry, place it in archival plastic sleeves or acid-free paper envelopes. Store it in a cool, dry place. Do not use glassine, kraft paper, or polyvinyl chloride materials for storage, as they all contain substances that can be harmful to film over the long term.

20. Keep a notebook of all the procedures. List the date, type of film, developer, time, and temperature; any procedures that are different from normal; the outcome; and the changes to be made in working methods if a similar situation is encountered in the future.

21. Refrigerate the film before and after exposure for maximum quality. Let the film reach its operating temperature before loading, exposing, or processing it.

Kodak High Speed Infrared Film 4143

Black-and-white infrared (IR) film is sensitive not only to the visible spectrum of light but also extends into the IR region. IR film is sensitive to radiation that the human eye is not capable of detecting. Conventional panchromatic film, sensitive to the visible spectrum, is designed to record a subject in tones that approximate those of human perception. IR film sees and records beyond human parameters. It renders objects differently than panchromatic film and can cause dramatic shifts in tone, producing surrealistic images.

Figure 4.1 Gore used infrared film in conjunction with a three-mirror kaleidoscope held against the camera's lens and rotated for effect. This combination of film and equipment alters the sense of customary tonal and spatial relationships.

© Tom Gore. "Untitled," 1987. Gelatin silver print. 22 x 24".

To understand this film, it is necessary to do some experimenting and testing. This will make you familiar with the changes it can produce in the sense of pictorial space by altering the tonal relationships of a scene. This different set of tonal relationships can distort the normal sense of photo-graphic time. All the information discussed in this section refers to Kodak High Speed Infrared Film 4143, which is the most readily available IR film. It comes in 35mm cassettes and 50-foot rolls and sheets.

Handling

Since IR film is sensitive to IR radiation, you should handle it in total darkness when loading or unloading either the camera or the developing tank. The felt strips of the film cassette can permit IR radiation leaks. Check the darkroom to make certain it is light-tight. You can use a high-quality changing bag when a darkroom is not available during field use. Use the bag in an area shaded from direct sunlight. Be aware that changing bags can leak IR radiation, so check the bag with a test roll. IR film can be fogged by heat. Whenever possible, keep it refrigerated before and after exposure.

Focusing

IR radiation has longer wavelengths than those of the visible spectrum. Regular camera lenses are not designed to focus IR wavelengths. To correct this problem, most lenses have an IR focusing index marker engraved on the lens barrel. It is often a red dot or the letter R located close to the normal focusing mark on the lens. Check the camera manual if you are not sure of the marking.

When using IR film, focus the camera in the normal manner. Note the distance indicated by the regular focusing index mark, then manually rotate the focusing ring to place that distance opposite the IR focusing index mark. The image may be fuzzy in the viewfinder, but the IR film will record it sharply. It is not necessary to make this adjustment when using a wide-angle lens or a small lens aperture, as the increase in depth of field will compensate. It is necessary to do this at distances of five feet or less and with all telephoto lenses. View camera corrections can be made by adding 25 percent of the focal length to the lens-film distance.

Filters

Because IR film is sensitive to visible and IR spectra, filters can be used to alter and control the amount of spectrum that the film records. The following sections describe some of the filters commonly used with IR film.

Wratten No. 87 The Wratten No. 87 filter absorbs all visible light, allowing only IR radiation to pass through and be recorded. With a single lens reflex (SLR) camera, it is necessary to remove this filter to focus, as it appears opaque to the human eye. Subjects will be recorded in tones proportional to the amount of IR radiation they reflect. Those reflecting the most IR radiation will appear in the lightest tones. Objects that appear to be the brightest to the human eye are not necessarily those that reflect the most IR radiation. For this reason, the tonal arrangement of the scene recorded by the IR film will often seem unreal when compared with the same scene recorded on a panchromatic film that is sensitive to the visible spectrum.

Red Filters The Wratten No. 25 filter (red) is the most commonly used filter with IR film. It prevents blue and green light from passing through but transmits red and IR radiation. It enables the photographer to focus through the SLR viewfinder. This filter can produce bold visual effects. The sky may appear black, with clouds seeming to pop out into the third dimension. Caucasian skin can lose detail and take on an unworldly glow. Surface veins in the skin can become extremely noticeable. The Wratten No. 29 (deep red) filter can produce an even greater effect but requires one f-stop more exposure than the Wratten No. 25.

Polarizer IR film is excellent for use in penetrating haze when using a polarizer in conjunction with a No. 87 or No. 25 filter.

Other Filters Almost any colored filter will block certain wavelengths of visible light and permit IR radiation to pass through. A polarizer and the Wratten No. 12 (yellow), Wratten No. 58 (green), and Wratten No. 15 (orange) filters offer varying effects by removing part of the blue wavelengths of light. Try different filters and see what happens. Keep notes so that you can replicate the results.

No Filters

Without filtration, IR film reacts more strongly to the visible spectrum. This produces less dramatic images than those produced with filters and results in a noticeable increase in graininess.

Exposure

Determining the correct exposure for IR film requires experience. It is impossible to determine the precise film speed needed to set the exposure

Table 4.1 Meter Settings for Kodak High-Speed Infrared Film

Wratten Filters	Type of Illumination	
	ISO for Daylight*	ISO for Tungsten*
No filter	80	200
No. 25, 29, 70, and 89B	50**	125
No. 87 and 88A	25	64
No. 87C	10	25

*Film processed in Kodak D-76.
**When in doubt, use this ISO rating as a starting place.

meter. This is because the ratio of IR to visible light is variable and most metering systems do not respond to IR radiation. Table 4.1 lists starting points that are useful in determining the exposure under average conditions with Kodak High Speed Infrared Film. If possible, use a hand-held meter or remove the filters from in front of through-the-lens (TTL) metering systems, as the spectral sensitivity of the meter can be affected by the filters.

Changes in exposure cause noticeable differences in how IR film records the image. A correct exposure delivers a scene with a wide contrast range that is easy to print. Underexposure causes the scene to lose depth and appear flat. Details in the shadow areas are lost. Overexposure produces a soft, grainy image often possessing a sense of weightlessness when compared to the original scene.

The amount of IR radiation will vary depending on the time of day, season, altitude, latitude, and distance of the camera from the subject. Faraway scenes such as a landscape often require less exposure than a close-up such as a portrait. This is due to the increased amount of IR radiation that is reflected and scattered by the atmosphere over greater distances. Since variations are likely and unpredictable, it is advisable to bracket exposures by at least two f-stops in each direction to ensure the desired aesthetic and technical results with IR film.

Processing

Handle IR film with care, as it seems to be more prone to damage from handling than conventional film. Handle IR film only by its edges when loading it onto a processing reel, as it has a remarkable ability to capture and incorporate fingerprints into the processed image.

Process the film in closed stainless steel tanks. Some plastic tanks can leak IR radiation and fog the film. Test them to be safe.

Table 4.2 lists suggested beginning processing times for the two most commonly used developers with Kodak IR film. D-76 produces a tonal range similar to that of a panchromatic film. D-19 greatly increases contrast and graininess. After development, follow standard processing procedures. Do not hesitate to modify these recommendations.

Table 4.2 Development Times for Kodak High-Speed Infrared Film*

	Temperature				
	65°F	68°F	70°F	72°F	75°F
Developer**	(18°C)	(20°C)	(21°C)	(22°C)	(24°C)
D-76 (for pictorial effect)	13	11	10	9 ½	8
D-19 (for high-contrast effect)	7	6	5½	5	4

*Development time in minutes for small tanks. Initial constant 30-second agitation; 5-second agitation every 30 seconds thereafter.
**Film may be presoaked if desired.

Flash

IR film can be used with an electronic flash in a variety of ways, including the following:

- Use a Wratten No. 25 filter and normal flash methods.
- Cover the flash tube with Wratten No. 87 gel. This will make the flash almost invisible to the human eye, enabling the photographer to use a flash without anyone being aware of it.
- Get a special IR flash unit designed to emit light at the wavelengths to which IR film is most sensitive. Some flash units have detachable heads that can be replaced with the infrared type.

Getting Experience

Obtain three rolls of IR film. Try photographing a number of different subjects—people, buildings, plant life, and landscapes—at different distances and at different times of the day. Bracket your exposures. Process one roll in D-76 and another roll in D-19. Keep a record of what you do. Make contact sheets of each roll. Now take the third roll and apply what you have learned.

Additional Information

IR film is also available in color stock. For further information on IR film, see *Applied Infrared Photography*, Kodak Publication No. M-28. Konica also makes an IR film in 120 roll size that is slower than Kodak IR film. You may have to order the Konica film from a large photographic supplier.

Kodak Recording Film

Kodak Recording Film is a very fast panchromatic stock with extended red sensitivity. It was designed for low-level light situations such as indoor sports, press work, police and surveillance photography, or any time when a flash cannot be used. Until recently, this film was one of the fastest black-and-white film stocks available. Today there are films that are faster, produce less grain, and deliver a wider tonal range. Why would a photographer still want to try Recording Film? If the aesthetic interpretation of the subject calls for visibly heightened grain, this film can produce this effect in either a close to normal or high-contrast tonal range. The film is available in 36-exposure cassettes and 125-foot rolls.

Handling and Storage

Due to Recording Film's sensitivity to light, it is advisable to load it in total darkness or in very subdued light. You can use a changing bag for fieldwork. Keep this film refrigerated before and after exposure.

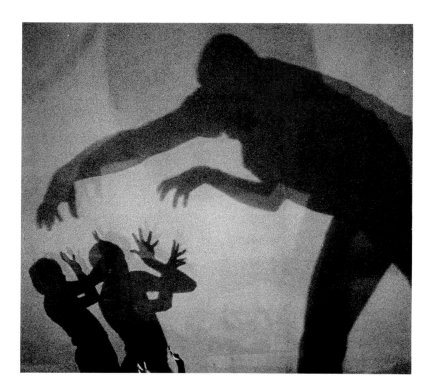

Figure 4.2 Kodak Recording Film is useful for producing much larger than normal grain size. While doing an album cover, McJunkin observed band members playing with their shadows cast by his lighting equipment. He quickly made this shot, which was used for the back cover of the album.

© James McJunkin. "Shadow Play," 1985. Gelatin silver print. 11 x 14".

Exposure

Kodak Recording Film should be tested under typical working conditions. It has a useful speed rating of 1,000 to 4,000 ISO. The film's rating will determine its development time. For general pictorial work, begin with a speed of 1,000 and bracket, in one-half f-stops, two full f-stops in the minus direction (underexpose). This will provide exposures at 1,000; 1,500; 2,000; 3,000; and 4,000. Based on this visual test, select the exposure that best represents the subject. Exposures need to be calculated with care, as this film does not have much leeway for error. Continue to bracket and analyze the results until you gain confidence and experience.

To use Recording Film in conventional lighting situations, it is helpful to have a camera with high-speed shutter capabilities. The shutter speed should at least be able to equal the film's speed rating. If it is not possible to use such a camera, neutral density (ND) filters can be used to reduce the amount of light reaching the film.

Table 4.3 Developing Kodak Recording Film for Pictorial Results

Speed	Developer*	Time (Minutes)**
1,000	DK-50	7
1,000	T-Max (1:5)	12
1,500	DK-50	7 ½
2,000	DK-50	8
3,000	DK-50	8 ½
4,000	DK-50	9

*Follow standard agitation patterns.
**Times based on a temperature of 68°F (20°C).

Processing

Table 4.3 suggests film speeds, developer types, and development times for Kodak Recording Film. You will probably have to modify these for individual situations. Use only fresh developer and an acid stop bath to reduce the chance of *dichroic fog*, which is produced when excess silver is deposited on an already developed portion of the image. It causes interference between the wavelengths of transmitted and reflected light. While this deposit is still wet, you can try to wipe it off the negative with a Photo-Wipe. Once dry it can be difficult to remove. A very brief treatment with Farmer's Reducer also might remove the fog.

Recording Film can be processed in a high-contrast developer such as D-19 to produce a much grainier image with a marked increase in contrast. D-19 does not give the film as much speed as DK-50. The film speed tends to be about one f-stop less than your established norm. Dektol is a paper developer, but you can use it with film to produce a much coarser grain than normal and an increase in contrast, though not as much as D-19. Table 4.4 provides a starting point for these procedures. After development is complete, follow standard film-processing procedures.

Table 4.4 High-Contrast Processing of Kodak Recording Film

Speed	Developer*	Time (Minutes)**
500	D-19	8
1,000	Dektol (1:1)***	5

*Follow standard agitation patterns.
**Time based on a temperature of 68°F (20°C).
***Dektol must be fresh.

Additional Information
See Recording Film 2475 (*ESTAR-AH* Base), Kodak Publication No. G-160.

Additional Methods to Heighten Grain and Contrast

Kodak Tri-X in Dektol

Generally the faster the film, the more grain it will produce. Using a conventional, moderately fast film such as Tri-X, you can increase the amount of grain by altering the standard processing method. Developing Tri-X in Dektol produces much coarser grain than normal, with an increase in contrast. This combination works well in both flat and average contrast situations, but there is a noticeable reduction in the tonal range.

Exposure Rate Tri-X at 1,600 for daylight and 800 for tungsten. Bracket your exposures—one f-stop under and two f-stops over. Developing Tri-X in Dektol reduces the film's exposure latitude, but this method allows a wider margin for exposure error than developing Kodak Recording Film in DK-50.

Development Table 4.5 gives a starting point for development. After development is completed, continue to process normally.

Table 4.5 Development Times for Kodak Tri-X in Fresh Dektol*

Temperature	Time (Minutes)
68°F (20°C)	4
72°F (22°C)	3 ½

*Use continuous agitation for the first 15 seconds and then agitate for 5 seconds every 15 seconds to avoid potential streaking, which may be caused by the high activity and strength of the developer.

Kodak Tri-X and Sodium Carbonate

Another way to increase the grain pattern in films such as Tri-X is to use sodium carbonate. Expose the film normally, then soak the film in a 10 percent solution of sodium carbonate for 2 to 5 minutes before putting it in its normal developer. The amount of soaking time determines the increase in the grain pattern.

Kodak Technical Pan Roll Films

When you need a film to deliver extremely fine grain and high resolution, Kodak Technical Pan Films (2415 and 6415) are the answer. Technical Pan is a high-contrast scientific film with applications in photomicrography, astrophotography, laser recording, slide making, and copying procedures. By using a low-contrast compensating developer, you can produce incredibly sharp normal contrast pictorial images. An 8 x 10" enlargement from a 35mm Technical Pan (2415) negative is difficult to distinguish from the same scene photographed on a traditional 4 x 5" negative.

Pictorial Procedures

It is necessary to choose the correct combination of Technical Pan Film and developer (see Table 4.6). With 35mm Technical Pan Film, use either Kodak Technidol LC powder developer or Kodak Technidol Liquid to achieve pictorial effects. Technidol LC offers lower contrast and a better tonal range. It is less convenient to use, however, because it must be mixed with water and requires a longer development time than the liquid. With 120 size film and sheet film, use only Kodak Technidol Liquid. Each developer has an entirely different agitation pattern that you must follow to ensure proper results.

Figure 4.3 Kodak Technical Pan Film, when processed with a POTA developer, delivers extremely fine grain, which can produce a very smooth gray scale in the prints. It allows small-format negatives to be enlarged while still retaining maximum detail. Strom used this combination to come to terms with the landscape. Here she attempts to integrate many of the details into a single vision. She wants each individual frame as well as the complete set to constitute an image. The viewer should be able to see one image close up and then step back and see another from a distance. The black spaces between the frames help the viewer to make the connections between the component images.

© Karen M. Strom. "Road to Taos," 1983. Gelatin silver print. 16 x 20".

Table 4.6 Film–Developer Combinations for Pictorial Effects with Technical Pan Film

Film Size	Developer
35mm	Technidol LC or Technidol Liquid
120	Technidol Liquid
Sheets	Technidol Liquid

Check the instructions with each film-developer combination before processing.

Exposure

For pictorial photography, begin with a film speed of 25 and bracket, in either one-third or one-half f-stops, one f-stop in each direction to determine which film speed works best in your situation. Normal seems to be between 25 and 32. Determining the proper exposure is important because Technical Pan film does not have much exposure latitude. Keep accurate exposure notes so that you will not have to bracket under similar conditions in the future.

Development

Technidol LC is intended to be mixed as a one-shot solution that will be used within 24 hours and discarded. Technidol Liquid must be used within one week after it is prepared. It may be reused one time by increasing the suggested development time by 1 minute. Carefully follow the mixing and storage instructions that come with each developer. Using distilled water for mixing these developers is recommended.

Processing

Technidol LC Table 4.7 lists suggested development times for 35mm Technical Pan Film. The biggest problem in working with Technical Pan Film is the failure to follow the special agitation pattern that each film-developer combination requires. Technical Pan is subject to nonuniform processing effects, which include streaking and variations in density, especially near the film edges, when proper agitation procedures are not carried out. These difficulties can be avoided by following these steps:

1. Pour the working solution of Technidol LC into the empty processing tank.

2. In total darkness, quickly and smoothly drop the loaded reel of Technical Pan Film directly into the solution. Do *not* pour developer onto the dry film through the light trap in the top of the tank, as doing so may cause nonuniform processing effects. Presoaking Technical Pan Film is *not* recommended as this also may cause nonuniform effects.

3. Secure the tank top and gently tap the bottom of the tank on the work surface to dislodge any air bubbles from the film.

4. For initial agitation, extend your arm and rotate or invert the tank four times, without any lateral movement, by twisting your wrist 180 degrees in both directions (to the right and then to the left). Steps 2 through 4 should be completed in about 10 to 15 seconds.

5. Allow the tank to sit for 15 to 20 seconds.

6. After the first 30 seconds, begin agitating for 5 seconds at 30-second intervals following the method outlined in step 4. The 5-second agitation cycle should consist of three to five rotations of the tank.

Feel free to modify the above procedure if it does not prove satisfactory. After the development cycle is complete, process the film following standard working procedures. The temperature for the other steps in the process should be within 3°F of the development temperature and for the wash within 5°F of the development temperature.

Table 4.7 Development Times for 35mm Technical Pan Film Rated at 25 in Technidol LC*

Temperature	Time (Minutes)
68°F (20°C)	15
77°F (25°C)	11
86°F (30°C)	8

*Follow special agitation pattern for Technidol LC.

Technidol Liquid Table 4.8 lists suggested starting points for developing both 35mm and 120 film in Technidol Liquid. To ensure proper processing with Technidol Liquid, it is necessary to follow a special pattern of agitation.

1. Pour the mixed solution of Technidol Liquid into the empty processing tank.

2. In total darkness, quickly and smoothly drop the loaded reel of Technical Pan Film directly into the tank. Do *not* pour the developer onto dry film through the light trap in the top of the tank. Do *not* use a presoak. Both of these procedures may result in nonuniform processing effects.

3. Secure the tank lid and gently tap the bottom of the tank on the work surface to dislodge any air bubbles from the film.

Table 4.8 Development Times for 35mm and 120 Film Rated at 25 in Technidol Liquid*

Temperature	Time (Minutes)
68°F (20°C)	9
77°F (25°C)	7 ½
86°F (30°C)	6 ½

*Special agitation techniques are required for Technidol Liquid. This developer may be reused one time by increasing the development time by one minute during the second process. Store used developer in an airtight opaque bottle and use within one week.

4. Immediately agitate the tank by very vigorously shaking it with an up-and-down motion about 10 to 12 times for about 2 seconds. Do *not* rotate the tank.

5. Let the tank sit for the remainder of the first 30 seconds.

6. Repeat this agitation pattern every 30 seconds for the rest of the development cycle.

After development is complete, process the film as usual, keeping the temperature of the remaining steps within 3° F of the development temperature and the temperature of the wash within 5° F.

Technical Pan Film and Landscapes

This film can be very useful in landscape photography. It allows the photographer to work with a smaller format camera, rather than a view camera, under a number of different working situations. The extended red sensitivity has a haze-cutting effect that makes distant objects appear sharper.

Technical Pan Film and Portraits

Due to Technical Pan Film's sharpness, some people may find it unsuitable for portrait work, as defects in the sitter's face are recorded in great detail. Others say that Technical Pan Film's extended red sensitivity, which allows flesh tones and areas of red to appear lighter than they would with conventional black-and-white film, makes up for this characteristic. This sometimes conceals slight blemishes and adds a luminous quality to the skin.

If accurate conventional panchromatic tones are required, the red sensitivity of the film may be corrected by using color-compensating (CC) filters. Begin correction with either a CC40 cyan or CC50 cyan. Technical Pan Film can also reveal minor faults such as camera movement, slight errors in focusing, and lens distortion that may have not been visible with traditional black-and-white films.

Differences in Printing

Properly exposed and processed Technical Pan Film may appear to look thinner than what you are accustomed to seeing. Technical Pan Film has a neutral density base that is one-third to one-half thinner than those of conventional 35mm films. Take this into consideration when evaluating your negatives. Make certain the film is properly seated and flat in the negative carrier, as the thinness of the film's base results in a tendency to curl.

Due to its extremely fine grain, you may have trouble focusing the negative with a grain focuser. If so, switch to a focusing magnifier, which simply magnifies the image.

Expose Technical Pan to a variety of different subjects to see what it will deliver. Try developing it in both types of developer and compare the results.

Additional Information

For detailed information on all the applications of Technical Pan Film, read *Kodak Technical Pan Films*, Kodak Publication No. P-255.

Kodak Professional B/W Duplicating Film SO-339

When you need to make black-and-white copy negatives or positives, Kodak Professional B/W Duplicating Film SO-339 (Dupe Film) is a simple solution. Dupe Film is a direct positive orthochromatic (not sensitive to red light) film designed for this purpose. It provides for one-step duplication from black-and-white continuous-tone negatives or positives by contact printing or enlarging. It can deliver duplicates, also known as dupes or second originals, with a

quality and sharpness comparable to those of the original. The dupes are formed with a single exposure and with conventional development. Dupe Film is available in 4 x 5" and 8 x 10" sheets. If you need to make a negative directly from a transparency, use Kodak Fine Grain Release Positive Film (covered later in this chapter under "Other Kodak Graphic Arts Films").

Applications
Dupe Film allows you to make duplicates of any size from a small-format camera, such as a 35mm, up to 8 x 10". These dupes can be used to make contact prints or enlargements in a number of the printing processes discussed later in this book. Other applications include copying negatives from glass plates or from nonsafety stock, such as a nitrate base, in order to preserve them. Dupe Film enables you to recycle or give new purpose and meaning to old negatives by incorporating them into your present working scheme. Dupes also allow you to work within any process without the fear of damaging the original.

Handling
This orthochromatic film can be handled under a 1A safelight filter with a 15-watt bulb at a distance of at least 4 feet from the film. This allows you to develop Dupe Film by visual inspection.

Speed
Dupe Film does not conform to the ISO testing procedures and has no assigned film speed rating. Exposure must be determined by testing.

Exposure
Dupe Film can be exposed with any conventional tungsten, fluorescent, or tungsten-halogen light source. An enlarger is an ideal source of exposure. This film's lack of an ISO rating makes visual testing a necessity. Dupe Film behaves differently than conventional films when exposed. It is pre-exposed in manufacturing, so the density of the final image is inversely proportional to the length of exposure. This means that the longer the film is exposed, the *lighter* the resulting image will be. To produce more density with Dupe Film, give it less exposure. To make it lighter, give it more exposure.

Thinking in Reverse
Remember to think in reverse from your normal working procedures. A 10-second exposure will produce more density than a 20-second exposure. On a test strip, the lightest area has received the greatest amount of exposure and the darkest area the least amount of exposure. Burning will produce less density, and dodging will produce greater density. The other principles of development remain the same: the longer the development, the greater the density and contrast. A reduction in development time will decrease the contrast and density.

Determining the Emulsion Side of the Film
Many people who do not work regularly with sheet film have a problem determining the emulsion side. To make this determination, hold the film vertically with the coded notches at the top right or bottom left. In either position, the emulsion will be facing toward you.

Basic Procedures to Make an Enlarged Continuous-Tone Negative

1. Set up the darkroom for normal tray processing under proper safe-light conditions. Use a tray that is at least slightly larger than the film being processed.

2. Place a clean negative in the enlarger. If you plan to use the dupe negative with its emulsion side against the surface of the paper—for example, to make a nonsilver print—reverse the original negative in the carrier, or the final print will be reversed from right to left.

3. Open the enlarging lens aperture to maximum and focus the image on the easel. If the easel has not been painted black, tape a piece of black matte paper on it to reduce halation from the light reflected off the easel. Use a piece of white paper the same thickness as the film as a focusing target. After focusing, remove the white paper.

4. If you have a footcandle meter, place the probe on the easel under the projected image and adjust the lens aperture to give a reading of 3 footcandles. Make a trial test strip at that lens opening at 10, 20, 30, 40, and 50 seconds. If you do not have a footcandle meter, stop the lens down to f-8 or f-11 and make a test strip at 10, 20, 30, 40, and 50 seconds.

You can copy an original positive the same way you produce a dupe positive.

Basic Procedures to Make a Contact Continuous-Tone Negative

You can produce contact negatives or positives using a contact frame or a clean piece of clear glass and a piece of opaque paper. Remember, the image that has been exposed emulsion to emulsion will come out reversed unless you reverse the negative before exposure.

1. Thoroughly clean all materials.

2. With a contact frame, place the negative, emulsion side down, on the glass. Cover it with a sheet of Dupe Film, emulsion side facing the non-emulsion side of the original. Attach the back and expose the film in the same manner as is recommended for enlarging from a negative.

3. Without a contact frame, place a piece of opaque paper, larger than the film size being used, directly under the light source. Put the Dupe Film emulsion side up on top of the paper. Put the original over the Dupe Film, with its emulsion side facing up. Place the glass over the entire sandwich and expose.

Processing

The suggested starting point for processing Dupe Film is in Dektol (diluted 1:1) at 70°F (21°C) for 2 minutes with continuous agitation. A presoak can be effective in preventing uneven development patterns at short times.

Dupe Film has a wide exposure latitude, which allows you to vary the proc-essing time to control the contrast of the dupe. Development time can be extended to up to 8 minutes, and the developer can be diluted up to 1:5 or even used straight.

Enhancing Image Stability

After completing all the normal processing steps, you can treat Dupe Film with Rapid Selenium Toner to increase its image-keeping properties. This treatment will protect the silver image from oxidizing gases, high temperatures, humidity, and high-intensity illumination. This treatment can be carried out as follows:

1. If film is dry, presoak it for several minutes before treating it with toner.

2. Put the Dupe Film in a solution of Rapid Selenium Toner diluted 1:29 (1 part toner to 29 parts water) at 70°F (21°C) for 3 minutes with occasional agitation. You can reuse this solution, which has a capacity of about 15 4 x 5" sheets per quart.

3. Rewash the film in running water at 65°F to 75°F (18°C to 24°C) for 20 to 30 minutes.

4. Dry and store the film.

The Rapid Selenium Toner should be used after the hypo clearing solution. The use of drying aids such as Photo-Flo is not recommended after the toning treatment. These can reduce the image stability of the toner. The toning treatment should be the last step before drying the film.

This process may be carried out as a direct extension of the normal processing methods or at a later time. If the film has been dried, soak it in distilled water for a few minutes to resoften the emulsion before beginning the treatment.

Additional Information

For more detailed information, see *Kodak Professional B/W Duplicating Film SO-339*, Kodak Publication CIS-128.

High-Contrast Litho Films

High-contrast litho films are orthochromatic (not sensitive to red) and can be handled under a red safelight. They are designed primarily for the production of halftones (they create a dot pattern, based on tonal graduations, that allows a photograph to be reproduced using printer's inks) and line negatives and positives for use in photomechanical reproduction. They can be used for dramatic pictorial effects because of their ability to drop out most of the mid-range tonal gradations of a subject. This creates a composition that relies on graphic black-and-white shapes for visual impact.

High contrast can be produced in two general ways. First, the effect can be achieved by exposing Kodak Ektagraphic HC Slide Film directly in a 35mm camera. Second, it may be produced later from a continuous-tone negative in the darkroom through the use of a graphic arts litho film such as Kodalith Ortho Film Type 3 in conjunction with high-contrast litho developers such as Kodalith Super RT. Litho films are manufactured by a number of firms and are available in rolls and sheets.

Applications

Litho films offer an extensive visual array of effects that cannot be achieved with conventional films. Litho films also offer a quick and convenient method for producing many generations, in different forms, from an image on a negative or transparency. A normal negative can be used to make a high-contrast

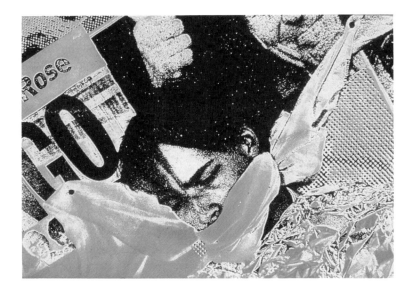

Figure 4.4 To make a bold and graphic self-portrait, Davis intentionally overexposed the original negative by one f-stop, then made positive and negative lithos from this film. The lithos were sandwiched together, slightly out of register, and printed on color paper using two different filter packs.

© Ben Davis. "Self-Portrait," 1988. Type C print. 8 x 10". Original in color.

positive, which can be used to form a new high-contrast negative, which in turn can be reversed back to a positive. This film can be drawn or painted on, sandwiched together with other film images, scraped, scratched, or cut up and collaged. Small-format images can be enlarged to be contact printed in a variety of other processes.

Images from other sources also can be incorporated into the process. For instance, a magazine picture can be contact printed, ink side down, on litho film. Both sides of the image will be visible. If this is not acceptable, try one of the transfer methods discussed in Chapter 13. Litho films may be exposed directly in a 35mm, view, or pinhole camera. Photograms can be created by placing objects on top of the film and exposing it. A bas-relief print can be made by combining a contact-size positive, slightly out of register, with the original continuous-tone negative. For instance, a high-contrast bas-relief can be produced if a litho negative and positive of the same size are sandwiched slightly out of register. A high-contrast black-and-white positive can be used to make a high-contrast positive print. The original negative and the contact litho positive and negative can all be sandwiched together and printed. Posterizations are possible by making a series of positives and negatives to be combined and printed.

Unfortunately, some people have abused litho films' ability to transform a subject. For example, someone might try to make a boring and trite image magically daring and strong by converting it to a high-contrast print. An image that is dull to begin with will not become new and exciting by transferring it to a litho film.

Do not force the process on an image. Use only an image that will be enhanced by the process. Do feel free to experiment with this type of film, however, for it offers the thinking photographer an abundant source of possibilities.

Litho Production and Materials

You can make litho negatives and/or positives by contact or projection methods starting with a negative or a positive (slide). You need these basic materials:

- An original continuous-tone negative (black-and-white or color)
- A contact printing frame or clear glass
- Litho film, such as Kodalith Ortho Film Type 3
- Litho film developer, such as Kodalith Super RT
- An orthochromatic safelight filter, such as Kodak's 1A (red)

The darkroom setup, with the exception of the litho developer and 1A safelight, is the same as for processing a regular black-and-white print. Follow the manufacturer's instructions for mixing the litho developer. Mix all chemicals in advance and allow them to reach a processing temperature of 68°F to 72°F (20°C to 22°C). A working solution of litho developer is generally prepared by combining equal amounts of mixed stock solutions at the time of processing. Use trays that are slightly larger than the size of the film being processed. Have enough solution to cover the film completely during each step. One quart of working litho developer solution will process about fifteen 8 x 10" sheets before exhaustion.

Making an Enlarged Litho Positive

1. Place a clean original continuous-tone negative in the enlarger.
2. Project the image onto a clean opaque surface, such as an easel that has been painted with a black matte finish. Black paper may be attached to the easel instead. Set for the desired enlargement size. Focus on a piece of white paper.

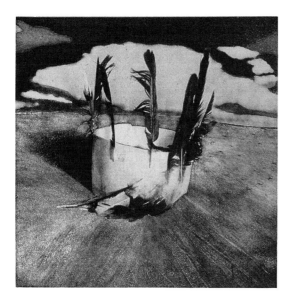

Figure 4.5 Nettles photographed the original still life on 120 roll film, then used the resultant print to make an ortho film halftone positive from which the photo-etching was made. Additional etching techniques (aquatint and etched lines) were used to accentuate areas of the image and to create a feeling of deep space around the headband.

© Bea Nettles. "Headband," 1985. From the Landscapes of Innocence. Photo-etching. 9-3/4 x 9-3/4".

3. Place the litho film on the opaque surface, emulsion side up. The emulsion side is lighter colored and more reflective than the base side. Cover it with a clean piece of glass.

4. Set the lens to about f-11 and make a test strip at 3-second intervals. The times should be similar to those used for making test strips with black-and-white paper of the same size.

5. Develop the film by sliding it, emulsion side up, into the developer solution. Agitate by lifting one corner of the tray slightly and setting it down. Repeat by lifting the opposite corner. Standard development time is between 2-1/4 and 2-3/4 minutes. Development time can be altered to change the contrast and tone. Development can be carried out by visual inspection. To duplicate the results, use the same developing time. Normal development is complete when the dark areas are completely opaque. Not enough development time can produce pinholes and streaks. If the image appears too quickly, reduce the exposure time. If it looks too light after 2 minutes, increase the time. You can reduce the contrast of litho film by developing in Dektol 1:2 instead of litho developer.

6. After development is complete, follow normal processing procedures. Fixing time should be twice the time required for the film to clear.

7. Based on the test, determine the correct exposure and make a new high-contrast positive.

This process can be carried out by contact printing the original negative, emulsion to emulsion, with the litho film, following the procedures outlined in the section on Dupe Film.

Making a Litho Negative

To make a litho negative, take the dried positive and contact print it, emulsion to emulsion, with an unexposed piece of litho film. Follow the same processing procedures as in making a litho positive. Starting with a positive (slide film) will enable you to make a direct litho negative, thus eliminating the need to make a litho positive. Bear in mind that litho film is orthochromatic and may not properly record the reds and oranges from the slide.

Continuous Tones from Litho Film

You can produce a usable continuous-tone negative or positive by overexposing litho film and underdeveloping it in Dektol diluted from 1:6 to 1:15 at 68°F (20°C) for 1-1/2 to 3 minutes. You can create an interesting visual mix by developing the positive in litho developer and the negative in Dektol. Combine the two slightly out of register for an unusual bas-relief effect.

Retouching

Litho film is highly susceptible to pinholes, which you can block out by opaquing the base side of the film. Opaque also conceals scratches or unwanted details. Place the litho film, emulsion side down, on a clean light table. Apply the opaque with a small, pointed sable brush (size 0 to 000). Opaque is water soluble, so you can fix mistakes with a damp Photo-Wipe.

Random Dot Pattern

Litho film can be processed in Kodak Fine Line Developer to yield a very fine random dot pattern that is the equivalent of about a 100-line halftone screen. This can be used in place of a halftone screen for many applications. In this process, Kodalith Ortho Film Type 3 is developed in freshly mixed Kodalith Fine Line Developer in a flat-bottom tray at 70°F (21°C). The film is given 45 seconds of continuous agitation and is then allowed to rest at the bottom of the tray for 2 minutes. The developer must be changed often, as it quickly becomes exhausted. Carefully follow the instructions included in the package.

With the exception of the developer, the darkroom setup is the same as for other litho films. The completed random-dot litho can be contact or projection printed onto another sheet of litho film to make a negative or positive.

Other Kodak Graphic Arts Films

Kodak Autoscreen Ortho Film
This film makes a 133-line halftone dot pattern. It is processed in Kodalith Developer following the same procedures as for regular litho film. This film is not recommended for processes requiring multiple exposures because it can make moiré patterns (the visible interference produced, in this case, when two different dot patterns are superimposed out of register).

Kodak Translite Film
This film produces positive transparencies from black-and-white negatives. It is exposed and processed like black-and-white paper using Selectol Developer (1:1) and can easily be hand-colored or toned.

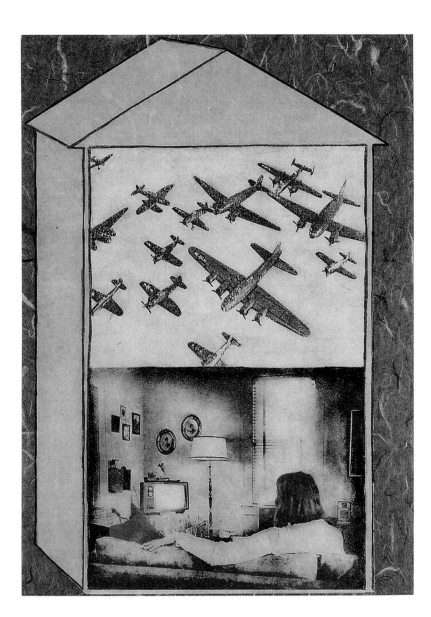

Figure 4.6 In producing this photo-etching, Bimrose projected the negative used in the original lower image onto Kodak Fine Grain Positive Film. It was processed in Dektol (1:12) for 2 minutes to produce a positive with very flat contrast. Bimrose did this to retain maximum detail, as the additional steps in making the photo-etching result in a loss of detail and an increase in contrast.

© Ron Bimrose. "Pilot," 1989. Photo-etching with line etch and *chine collé*. 17 3/4 x 12 3/4" on 26 x 19 3/4". Original in color.

Kodak Fine Grain Release Positive Films (5302 and 7302)

Fine Grain Release Positive Films are designed to make positive transparencies from black-and-white negatives. By reversing the intended use of these films, you can make negatives directly from transparencies. This can save time in many nonsilver and hand-altered processes. These films are exposed and processed like black-and-white paper. Their speeds are determined in the same way as the speeds of papers, so they do not have an ISO rating. They can be processed by visual inspection under a Kodak OA or 1A safelight filter in a wide range of developers for different contrast effects. A normal negative is processed in Dektol diluted 1:2 at 68°F (20°C) for 2 to 4 minutes. Contrast can be reduced by developing in D-76 at 68°F (20°C) for 4 to 10 minutes. The contrast of a flat original can be increased in D-11 at 68°F (20°C) for 10 minutes. This film is available in 35mm rolls (Fine Grain Release Positive Film 5302) and in sheets of 4 x 5" and 11 x 14" (Fine Grain Release Positive Film 7302).

Kodak Ektagraphic HC Slide Film

This film has the same base and emulsion as Kodak Ortho Film 6556 Type 3 (which has a thicker base than 2556), but it comes in 36-exposure 135 magazines. Its applications and processing methods are the same as those for Kodalith Ortho Film Type 3. This film has a suggested ISO of only 8, so additional lights may be needed to make an exposure. Shoot a test roll and bracket to determine your proper film speed. Starting development time is 2-3/4 minutes at 68°F (20°C) in Kodalith Developer. Slight changes in exposure and developing time will greatly affect contrast. This film may be inspected during development with a Kodak 1A safelight filter. Ektagraphic HC can also be developed in Kodak D-11 with a starting ISO of 25 for 2 1/2 minutes at 68°F (20°C). Bracketing is also highly recommended.

Additional Information

Boyd, Harry, Jr. *A Creative Approach to Controlling Photography.* Austin, Tex.: Heidelberg Publishers, 1974.

Hirsch, Robert. *Exploring Color Photography.* Dubuque, Iowa: Wm. C. Brown Publishers, 1989.

Stone, Jim. *Darkroom Dynamics.* Stoneham, Mass.: Focal Press, 1979.

Kodak T-Max P3200 Professional Film

When extremely fast film speeds are required without sacrificing image quality and tonality, Kodak T-Max P3200 is a film to consider. T-Max P3200 is a multispeed black-and-white panchromatic negative film available in 35mm cassettes. It is capable of delivering high to ultrahigh film speeds with a fine grain and broad tonal range, good shadow detail, and open highlights. It is the fastest of any of the films in the T-Max group. If T-Max P3200 is not available, Fuji Neopan 1600 is a suitable alternative.

The fast speeds are possible through Kodak's T-grain technology, which improves the silver halide sensitivity by the use of tabular (T) silver grains. These grains provide a larger surface, enabling the emulsion to capture more light than was possible using the conventional pebble-shaped silver crystals. This technology allows the film to be exposed at very high ISO ratings while still retaining a fine grain structure and a great amount of sharpness that permits the retention of detail in big enlargements. It offers good tonal separation, wide exposure latitude, and minimal reciprocity failure.

Applications

T-Max P3200 is designed for low-light situations in which it is not possible to use a flash or additional sources of illumination, when subjects require a high shutter speed while retaining good depth of field, for use when holding long

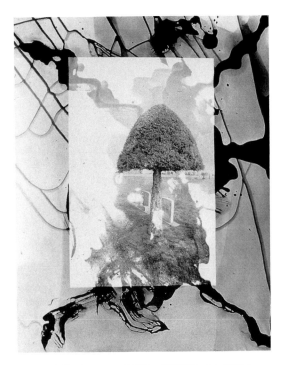

Figure 4.7 I exposed T-Max P3200 at 1,600 to record the scene at twilight. The film's high speed enabled me to make a sharp image with good depth of field in this low-light situation without putting the camera on a tripod. During printing, to increase the illusion of depth, I masked the latent image after its initial exposure, then exposed the paper to white light. Edwal T.S.T. Developer (1:7 with no B solution) was applied locally with a brush to deconstruct further the traditional sense of space.

© Robert Hirsch. "Dreamland, Version 3," 1989. Gelatin silver print. 20 x 16".

telephoto lenses, for nighttime and indoor events, and for surveillance applications requiring ultrahigh-speed films. This remarkable film enables the photographer to make images in previously impossible situations without the disadvantages of push processing conventional film.

Handling and Storage

T-Max P3200's high-speed emulsion makes it extremely sensitive to environmental radiation, which can fog and degrade the latent photographic images. This increased sensitivity gives P3200 a shorter life span than conventional film, and consequently it should be exposed and processed promptly. T-Max P3200 should always be hand-inspected rather than X-rayed at airport security stations. To ensure quality, refrigerate the film when the temperature is above 75°F (24°C).

Exposure

As T-Max P3200 is a multispeed film, its rating depends on its application. This film has a nominal speed of 1,000 when processed in Kodak T-Max Developer and 800 with other black-and-white developers. Its amazing latitude permits exposure at 1,600, which results in high-quality negatives with no apparent change in grain size and only a slight loss of detail in the shadow areas. P3200 film can easily be exposed at speeds of 3,200 or 6,400 by increasing the development time. This will produce a slight increase in contrast and grain size, as well as a loss of detail in shadow areas. Testing is necessary to determine the correct speed for your equipment and circumstances. For general high-speed applications, begin rating the film at 3,200 and bracket two f-stops over (1,600 and 800) and four f-stops under (6,400; 12,500; 25,000; and 50,000). There is a big increase in contrast and graininess, with a distinct loss of shadow detail at speeds above 6,400, but image sharpness remains surprisingly good.

Many cameras have ISO settings that go only up to 1,600. If your camera has an exposure compensation dial, set it at minus 1 to get a speed of 3,200 or minus 2 to achieve an ISO of 6,400. With both long and short exposures, T-Max P3200 requires less compensation than traditional films. There is no correction at speeds between 1 and 1/10,000 second. At 10 seconds, the lens aperture needs to be opened an additional two-thirds f-stop, or the time must be increased by 5 seconds to provide a total exposure of 15 seconds.

Darkroom Handling

T-Max P3200 must be handled in absolute darkness and cannot be developed by inspection. Timers and watches with fluorescent faces should be turned away from the unprocessed film. Even the afterglow of certain white lights (incandescent bulbs) can fog this film. Double-check to be sure the darkroom is totally dark before handling the unprocessed film.

Development

T-Max P3200 is designed to be processed in T-Max Developer or T-Max RS Developer and Replenisher to provide improved shadow detail in both normally and push-processed T-Max films. Both T-Max developers are all-liquid formulas that can be used to process other black-and-white films that are not in the T-Max group. T-Max films also may be processed in other developers.

Processing

Table 4.9 lists starting points for developing T-Max P3200 to produce a normal-contrast negative for use in printing with a diffusion enlarger. With a condenser enlarger, a lower contrast negative may be desirable. This is done by using a development time for a film speed rating of one f-stop lower than the speed used to expose the film. For instance, if the film was exposed at 6,400, develop it at the time indicated for 3,200.

Drop the loaded reel of T-Max P3200 directly into the developer and put the lid on the tank. Tap the tank on a flat surface at a 30-degree angle to dislodge any air bubbles. Give an initial agitation of five to seven inversions within 5 seconds by extending your arm and twisting your wrist 180 degrees to the right and then to the left. Repeat this procedure at 30-second intervals for the remaining development time.

Additional Processing Differences

After development is complete, process T-Max P3200 in the normal fashion with the exception of the fixing step. P3200 requires careful fixing using a rapid fixer for 3 to 5 minutes with vigorous agitation. This film will exhaust the fixer more quickly than conventional films. If the film shows a pinkish magenta stain or is blotched or streaked with an intense purple, the fixing time is too short or the fix is nearing exhaustion. These problems can be corrected by refixing the film in fresh fixer. A slight stain, caused by the in-

Table 4.9 Development Times* for T-Max P3200 Film

Developer	Film Speed	Temperature			
		70°F (21°C)	75°F (24°C)	80°F (27°C)	85°F (29°C)
T-Max	400	7	6	5	4
	800	7 ½	6 ½	5 ½	4 ½
	1,600	8	7	6	5
	3,200	11	9 ½	8	6 ½
	6,400	13	11	9 ½	8
	12,500	15 ½	12 ½	10 ½	9
	25,000	17 ½	14	12	10
	50,000	20	NR	NR	NR
T-Max RS	400	7	6	5 ½	5
	800	8 ½	6 ½	6	5 ½
	1,600	9 ½	7 ½	7	6
	3,200	12	10	9	8
	6,400	14	11	10	9
	12,000	16	12	11	10
	25,000	NR	14	13	11
D-76	400	9 ½	7 ½	6	4 ½
	800	10	8	6 ½	5
	1,600	10 ½	8 ½	7	5 ½
	3,200	13 ½	11	8 ½	7 ½
	6,400	16	12 ½	10 ½	9
HC-110	400	6 ½	5	4 ½	3 ½
(Dilution B)	800	7	5 ½	4 ¾	4
	1,600	7 ½	6	5	4 ½
	3,200	10	7 ½	7	5 ¾
	6,400	12	9 ½	8	6 ¾

*All development times are in minutes.
NR = not recommended.

creased amount of residual sensitizing dyes used to make the film panchromatic, should not affect the film or its printing characteristics even with variable-contrast paper. This slight stain tends to fade with time and exposure to light.

Some General Characteristics of T-Max P3200 at Different Speeds

400 This produces an extremely solid, not quite bulletproof (opaque) negative that results in a mushy print lacking in sharpness and having blocked highlights. It is not recommended for general pictorial use.

800 One f-stop faster delivers much better results but still lacks good tonal range and sharpness.

1,600 This speed produces gorgeous quality. Shadows are fully separated, and highlights are open and unblocked. Tonal range is excellent, with grain and sharpness compatible with conventional 400 films. A slight increase in contrast results in a snappy print and is useful with low-contrast subjects.

3,200 The negative has a full tonal range with a tiny loss of detail in the shadow areas. Grain and sharpness are outstanding. The results at this speed were unattainable until recently. P3200 dispenses with the technique of "cooking" film in exotic developers, which often produces chalky and extremely grainy images at this speed.

6,400 This speed still produces a highly acceptable negative, but the loss of shadow detail is more apparent. Contrast and grain size begin to pick up, but highlight retention and tonal range remain good.

12,500 Tonal range is compressed, contrast starts to become excessive, and granularity is worse. Pictorial print quality begins to degrade, but good press prints can be made.

25,000 This is about the outer limit for a printable negative. Highlights begin to become chalky, and shadows lack detail. Subtleties disappear as the tonal range becomes greatly compressed. Image quality remains sharp but grainy. Prints are still reproducible for newspapers and some magazines.

50,000 This astronomical speed pushes the film's capability to the edge. Try it when the a picture is a "must" and traditional print quality is not a major factor. Contrast and grain are way up, but the image is still sharp. Shadow detail is almost nonexistent. Printing requires expert care and patience, with dodging needed to make shadow areas recognizable.

Paper Negatives and Positives

Today most photographers use clear-base flexible film to record images in the camera. This was not always the case. Photographic pioneer William Henry Fox Talbot invented a process called photogenic drawing. This process used paper sensitized with salt and silver nitrate to make photograms and contact-print copies of drawings and objects. By 1835, Talbot was using this paper process to record images in a camera obscura. The process relied on a printing-out exposure (light made the complete image) for camera negatives and prints. In 1841, Talbot patented an improved process called the calotype or talbotype. It was much faster because the light was used to create a latent image that was completed during the development process. This process has served as the model for all current negative/positive image-making systems.

Compared with clear film negatives, paper negatives are less sensitive to light, do not record as much of the visible spectrum, record less detail, and have a reduced tonal range and higher contrast. Since the final image is printed through the fibers of the paper, the completed photograph has a soft, highly textured, impressionistic appearance.

Applications

Any paper may be treated with a light-sensitive emulsion and exposed (see Chapter 9). Regular photographic paper is usually used. Paper can be exposed directly in a view or pinhole camera. The processed paper negative can be contact printed with an unexposed piece of photographic paper to make a positive print. An image from a normal negative can be used by enlarging it on a piece of photographic paper at the desired size. This paper positive is contact printed onto another piece of photographic paper to form a paper negative. The paper negative is now contact printed onto another piece of photographic paper to create the final print.

A slide image can be used to make an enlargement on a piece of photographic paper. Since the slide image is a positive, it can be used to produce a paper negative, which is in turn used to produce a paper contact print. Images on any type of translucent surface, such as the paper used in magazines, newspapers, and posters, can be contact printed and used in this process. Paper negatives can be combined with normal negatives to make a multi-image composition. Paper negatives and positives are easy to retouch. The photographer can make additions such as clouds or remove unwanted items.

Paper Negative and Positive Process

1. Place a continuous-tone negative in the enlarger and make a print at the exact size of the final image. The print should be flatter in contrast and darker than normal, having discernible detail in both key highlight and shadow areas. Use a low-contrast single-weight paper. Variable-contrast papers are handy for this process. Avoid papers that have the manufacturer's name imprinted on the back. Resin-coated (RC) paper can be used because the plastic diffuses the trademark so it is not visible in the final print. RC paper makes good contact when two pieces are placed together for contact printing. Kodak Document Paper and Kodak Translite Film Type 5561 are also good choices.

2. Tape the corners of the completed print, image side down, to a light table for retouching. Dark areas can be intensified by adding density on the back of the print, thereby giving the printmaker control over the shadow areas. Soft pencils, pastels, or even a ballpoint pen can be used. If retouching materials do not adhere properly, coat them with McDonald's Retouching Spray.

3. Contact print the retouched print onto a piece of unexposed photographic paper to make a paper negative. Remove the enlarger's lens board to reduce exposure time. Make sure the two pieces of paper are in as close contact as possible. If you are having trouble making good contact, try soaking the paper positive and the unexposed paper in water and pressing them together with a squeegee or roller.

4. After processing and drying the paper negative, tape it, image side down, to the light table for retouching. During this stage, added density from retouching will block out and intensify the highlight areas.

5. Contact print the retouched negative onto unexposed paper. The choice of paper will determine the amount of control the printmaker has over contrast and surface texture. Coating the back of the paper negative with a thin layer of oil often increases the contact, makes the negative more transparent, and reduces exposure time.

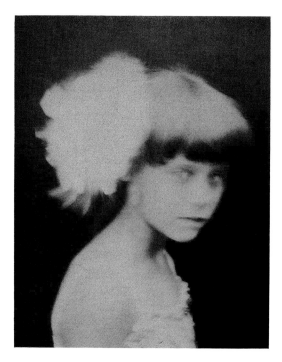

Figure 4.8 Birdsall exposed photographic paper instead of film in an 8 x 10" camera to achieve a soft, impressionistic portrait. The paper negative was used to produce a print made from one layer of cyanotype emulsion (applied first) and several layers of different-colored gum bichromate emulsion.

© Jeanne Birdsall. "Allyn," 1988. Cyanotype and gum bichromate. 7 1/2 x 9 1/2". Original in color.

Control of Detail and Texture

For maximum texture in the final print, expose the paper normally, emulsion side up. For minimum texture and maximum detail, briefly flash light from the enlarger through the paper's base side (emulsion side down). Turn it over (emulsion side up) and contact print it with the paper negative. For minimum detail and texture, expose the paper through its base side with no flash exposure.

Reversing Black-and-White Film

Lantern Slides

Today most photographers present prints as their finished product. This has not always been the case. At the turn of the 19th century, lantern slides were most popular in photographic clubs and salons. A lantern slide is a positive transparency, named after the 19th-century projectors called magic lanterns, made or mounted on glass for projection. With slides, what you see is what you get. There is no second step needed to arrive at the final image as in the negative/positive process. This enables the slide to depict a greater amount of detail and a wider range of tones than can be expressed by a traditional print. This is because film (the lantern slide) has a wider tonal range than paper. Lantern slides were fragile, heavy, thick, and larger than their 35mm heirs. The glass ensured image flatness during projection, giving the scene incredible sharpness. The bigger formats added to the retention of detail and the luminosity of the original subject.

Current Uses for Black-and-White Slides

A modern photographer could still choose to work with black-and-white positives when making photographs expressly for reproduction in the print media, when images are needed for a slide presentation, for copying any continuous-tone material, when a complete darkroom with a printing facility is not available, or simply for the sheer beauty the slide image is capable of bestowing on the subject.

Kodak Direct Positive Film Developing Outfit

The Kodak Direct Positive Film Developing Outfit is an all-liquid kit that delivers black-and-white slides from Kodak T-Max 100 Professional Film and Technical Pan Film. With T-Max 100, this outfit provides continuous-tone slides of the original subject. This film is recommended for making copy negatives from black-and-white or color negatives, for duplicating black-and-white slides, for making black-and-white slides from color slides, or for general pictorial purposes. When used with Technical Pan Film, the kit can be used to make high-contrast title slides or slides of computer-generated graphs and line art. Kodak no longer makes Direct Positive Panchromatic Film 5246, which was designed to make black-and-white transparencies.

Exposure

For normal contrast use, such as producing slides from continuous-tone photographs or artwork, and for general pictorial work, set the ISO for T-Max 100 at 50. For high-contrast use, such as making slides from line art, set the ISO for Technical Pan Film at 64. For initial use, make a series of exposures in which you bracket, in small increments of one-third f-stop, one full f-stop over and under the indicated exposure to determine the correct speed for your situation.

Processing

Film must be handled in total darkness until bleaching is completed, after which the film can be examined under a Kodak OA safelight filter. Do not use white light until the film has been fixed.

Table 4.10 lists the tank processing steps for the Direct Positive Film Developing Outfit. Read the instructions supplied with the developing kit before mixing and processing. Wash, hypo clear, final wash, Photo-Flo, and dry following normal procedures.

Table 4.10 Tank Processing Steps for Kodak Direct Positive Film Developing Outfit at 68°F (20°C)

Step	Time (Minutes)
First developer	7*
Rinse	½
Bleach	1 ½
Rinse	½
Clearing bath	2
Redeveloper	7*
Rinse	½
Fixer**	5

*This time is for fresh solutions. For partially used solutions, you must adjust the times in both the first developer and the redeveloper, using the tables provided in the kit, to compensate for the number of rolls already processed. Using this method, each 1-quart outfit allows up to 12 rolls of 35mm film (36 exposures), 12 rolls of 120 film, or twelve 8 x 10" sheets to be processed. Follow suggested agitation patterns.
**The processing outfit does not include fixer. Any rapid or regular fixer may be used.

Contrast Control

It is not possible to alter the contrast of the final positive image to a large extent by changing the temperature or time of the first developer. An increase in time or temperature in the first developer will produce an effect similar to overexposure of slide film. There is a general loss of density, as the entire image is lightened, with highlight detail becoming washed out. A decrease in the time or temperature of the first developer produces a result similar to underexposure. The overall density is increased, and the highlights begin to darken.

Contrast is controlled most effectively at the time of initial camera exposure by bracketing, in one-third f-stops, within an effective range of about one f-stop in the plus or minus direction. Slight changes in contrast can be achieved with T-Max 100 by modifying the first developer solution. This will produce something similar to the result of printing a black-and-white negative on the next higher or lower contrast grade of paper (see outfit for details). This procedure has very little effect on the contrast of Technical Pan film.

The blacks can be intensified by combining 20 milliliters of Rapid Selenium Toner with 1 liter of hypo clear solution.

One-Step Enlarged Negatives

One-step enlarged negatives can be produced with T-Max 100 film processed in the Kodak Direct Positive kit by following these guidelines:

1. Expose film in the same way you would to make a print. Since the film is panchromatic, it must be handled in total darkness.
2. Place the original negative, emulsion side *up*, in the enlarger.
3. Use a black easel surface or cover it with a piece of opaque paper to reduce fog and flare.
4. Use brief exposure times. Set the enlarging lens to f-22 or f-32 (a neutral density filter may be needed to reduce the amount of light). Set the timer for 1/2 second intervals (a digital timer is recommended for repeatable results).

5. Make a series of eight 1/2 second exposures (from 1/2 to 4 seconds).

6. Process normally following the instructions supplied with the kit.

Reversing Other Black-and-White Films

It is possible to perform reversal processing on other black-and-white films. Other reversal films and kits are available, and some conventional films also can be reversed. Check the reversal kit you are using before processing, as certain films and film sizes do not yield good results.

A positive image can be obtained from a nonrecommended film by developing it normally and then processing it on Fine Grain Release Positive Film. If there is no darkroom available for processing or if time is of the essence, try using Polaroid Polapan, which is a continuous-tone black-and-white positive material (see Chapter 7).

Additional Information

Pamphlet

Kodak T-Max 100 Direct Positive Film Developing Outfit, Kodak Publication No. J-87.

Other Source

Photographers' Formulary, P.O. Box 5105, Missoula, MT 59806.

Film for Classic Cameras

Manufacturers stopped making film for most classic cameras years ago. If you would like to do more than admire these machines, you can use a black-and-white ortho copy emulsion rated at ISO 32 in many of the older cameras. This film can be handled like Kodak Ortho Copy Film. This film is available in five sizes corresponding to Kodak 101, 116, 122, 124, and 616. There are plans to expand the line to include 118, 620, and 828. For more information, contact Film for Classics, P.O. Box 486, Honeoye Falls, NY 14472.

Processing Black-and-White Film for Permanence

Most serious photographers would like their efforts to last at least as long as they live. To accomplish this goal, you must follow working procedures that will deliver maximum permanence from the materials being processed. With archival methods, it is possible for contemporary black-and-white film to last thousands of years. Table 4.11 lists the basic working procedures to process film for maximum permanence.

Additional Information

Books

American National Standards Institute (ANSI) catalog of photographic standards. Contact: ANSI, Sales Department, 1430 Broadway, New York, NY 10018.

Clark, Walter. *Caring of Photographs.* Vol. 17 of the *Life Library of Photography.* New York: Time-Life Books, 1972.

Conservation of Photographs. Kodak Publication No. F-40, 1985.

Keefe, Laurence E., Jr., and Dennis Inch. *The Life of a Photograph: Archival Processing, Matting, Framing, and Storage, Second Edition.* Stoneham, Mass.: Focal Press, 1990.

Sources of Archival Equipment and Supplies

Calumet, 890 Supreme Drive, Bensonville, IL 60106 (archival washers).

Conservation Resources International, 1111 North Royal Street, Alexandria, VA 23314.

Table 4.11 Steps for Processing Black-and-White Film for Permanence*

Step	Time
Presoak (optional)	1 minute
Developer	As required
Acid stop bath	1/2 minute
Fixer (one or two baths)	Twice the clearing time
Selenium toner (1:20) (optional)**	Until a slight change in color occurs (about 6 minutes)
First wash	2 to 5 minutes
Washing aid	2 minutes
Final wash	10 minutes minimum
Wetting agent in distilled water	1 to 2 minutes
Air-dry	As needed

*Use fresh solutions at 68°F (20°C).
**Film is immersed in toning solution directly from the fixer with no water rinse. Toner is used only once and then discarded.

Custom Archival Folios, 1202 Greenwood Drive, Ruston, LA 71270.

Darkroom Aids Company, 3449 North Lincoln Avenue, Chicago, IL 60657 (new and used archival equipment).

Kostiner Photographic Products, Box 322, Leeds, MA 10153 (archival washers).

Light Impressions, 439 Monroe Avenue, Rochester, NY 14607.

Oriental Photo Distributing Co., 3701 West Moore Avenue, Santa Ana, CA 92704 (archival washers and storage containers).

Salthill Photographic Instruments, Wildcat Road, Chappaqua, NY 10514 (archival washers and dryers).

Summitek, P.O. Box 520011, Salt Lake City, UT 84152 (archival washers).

TALAS Division, Technical Library Services, 130 Fifth Avenue, New York, NY 10011

20th Century Plastics, 3628 Crenshaw Boulevard, Los Angeles, CA 90016 (archival storage).

University Products, Inc., P.O. Box 101, Holyoke, MA 01041.

Zone VI Studios, RFD 1, Putney, VT 05346 (archival washers).

Sources of Photographic Chemicals

Bryant Laboratory, 1101 Fifth Street, Berkeley, CA 94710.

Photographers' Formulary, P.O. Box 5105, Missoula, MT 59806 (bulk chemicals and classic formulas that are no longer commercially available).

Chapter 5

Preparing Your Own Formulas

Prepared Formulas versus Mixing Your Own

Commercially Prepared Chemistry

A wide variety of commercially prepared formulas are available for use in photographic processes. These prepared formulas are accurately compounded and easy to mix, and they provide consistent purity and uniformity, which ensures high-quality results.

Why Mix Your Own?

It can be valuable to any photographer to know how to prepare a formula from scratch. Mixing your own formulas can provide a clear, concrete cause-and-effect demonstration of how various photographic processes work. You can use this understanding to achieve better control of the medium. Mixing your own formulas also can be less expensive than buying packaged preparations. This process offers you a chance to experience further visual adventure, and it is fun. (See Color Plate III.)

You do not have to be an expert in math or science to get involved in this area of photography. This chapter provides the basic information you need to begin conducting experiments in controlling and heightening the final image with nonprepared photographic formulas. Specific details and formulas are included in the appropriate chapter sections dealing with specific processes.

Before attempting to mix any formula, read and follow all handling, mixing, and safety instructions included with the chemicals being used. Also read and follow all the general safety guidelines outlined in Chapter 3 of this book. Wear protective equipment such as safety glasses, a plastic apron, rubber gloves, and a mask to avoid allergic reactions, burns, and irritation to the skin or lungs.

Basic Equipment

Many photographers have most of the items needed to prepare their own formulas. These include graduates, mixing containers, stirring rods or paddles, a funnel, an accurate thermometer, opaque storage bottles, protective gear, and a well-ventilated area that is not used for preparing food and is free from children and animals. The items that may be lacking are a scale and a mortar and pestle. All equipment must be easily washable.

Scales

A small accurate scale is essential for weighing chemicals. Scales are available in a variety of sizes, styles, and price ranges. Balance scales are recommended because they are readily obtainable, reliable, long-lived, easy to use, and affordable. When purchasing a balance scale, be sure the sliding scale is easy to read and that the scale has removable pans for convenience of use

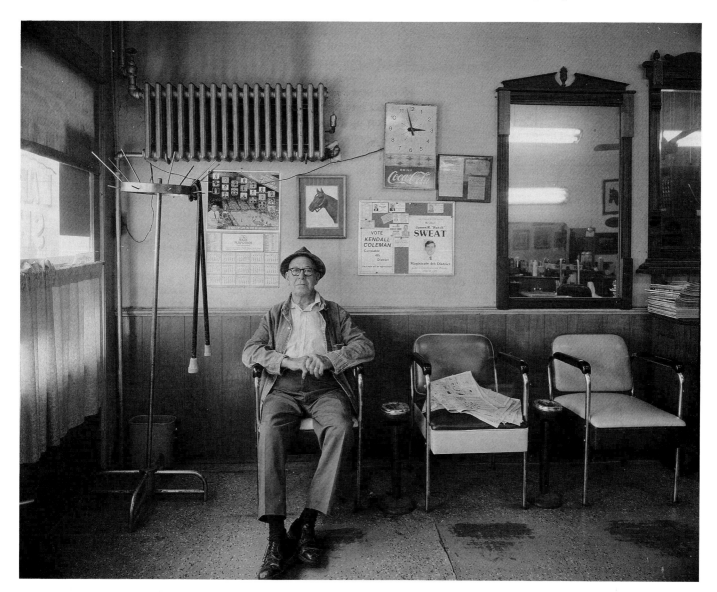

Figure 5.1 To get the results he wanted from printing-out paper, Hunter needed a negative with much greater than normal contrast. He achieved this by rating 8 x 10" Tri-X film at 100 and developing it in modified Pyro ABC developer. The printed-out image was treated with Gold Chloride Toner. This reduces the image and plates it with gold, producing a lavender tone.

© Frank Hunter. "Frank Ross's Barber Shop, Lebanon Jct., Kentucky," 1985. Printing-out paper. 8 x 10".

and cleaning. The Ohaus Scale Corporation makes a triple-beam balance scale that is superb for photographic purposes. The scale's standard capacity range is suitable for most individual needs and can be extended by using attachment weights. It is sensitive to 0.1 gram. If you plan on doing a good deal of your own mixing, this scale is a good investment.

The Pelouze Scale Company makes the Pelouze R-47 scale, which is about half the price of the Ohaus scale. This is a good choice for mixing small quantities, for the occasional user, and for those on a more modest budget. It is equipped with two pans, one for the chemicals and the other for the weights. It is available in either metric or avoirdupois (U.S. customary weights). The metric weights would be my choice, as they are the world standard and are easy to use, since everything is divisible by ten.

Electronic scales, often battery powered, are available for those who want a simple digital readout.

Scales are available from large professional camera stores, through mail-order photo and scientific houses, from chemical supply houses, or directly from the manufacturer. Here are a few manufacturers to contact: Balancing

Act Corporation, 2114 Fifth Avenue, Tempe, AZ 85282; Ohaus Scale Corporation, 29 Hanover Road, Florham, NJ 07932; Pelouze Scale Company, P.O. Box 1058, Evanston, IL 60204.

Mortar and Pestle

A mortar and pestle made out of glass or porcelain can be a useful item for breaking up chemicals that are not in powder or grain form. Do not use marble or wooden sets, as they will absorb chemicals and could contaminate other formulas.

Spoons

A set of plastic or stainless steel spoons for transferring chemicals from the bottle to the scale can prevent messy spills, which are wasteful and can cause contamination.

Mixing Equipment

Accurate, easy-to-read graduates in small and large sizes, clearly marked in both milliliters (ml) and ounces (oz), are essential. Plastic containers of various sizes make good mixing pails, and stirring paddles are helpful for mixing.

Storage Containers

Different-size brown or opaque bottles made of glass or plastic make excellent storage containers for mixed solutions. Opaque containers prevent deterioration caused by light. Plastic is more durable than glass and can be squeezed to eliminate most of the air to lessen the effects of oxidation. Medicine-dropper bottles, available at drugstores, are great for keeping small amounts of expensive solutions.

Certain chemicals are *hygroscopic* (absorbing water from the air) and can form a hard crust upon exposure to air. Others are *efflorescent*, losing their normal water content when exposed to air. Either of these conditions can make accurate weighing impossible. Still other chemicals can evaporate or fume. Avoid these problems by tightening the lids on all bottles.

Clearly label every bottle with its contents and the date it was mixed.

Chemicals

Obtaining Chemicals

You can obtain many of the chemicals used in contemporary processes from your local photography store. Kodak sells a line of commonly used bulk chemicals. When you are working with some of the more unusual or older processes, obtaining the required chemicals can be more problematic. Check with a local chemical supply company. Some companies may not want to sell chemicals in small quantities for individual use. If possible, represent yourself through a business or educational facility. You also may be able to obtain chemicals from the photography or chemistry department of a local college, and many large mail-order photography stores carry chemicals. A few companies specialize in stocking photographic chemicals. Check the ads in photography magazines and newspapers.

If time permits, shop around, as the prices of chemicals can vary greatly. In addition, manufacturers often give different trade names to the same chemical. For example, the developing agent methylaminophenol sulfate is known as Kodak Elon, Agfa Metol, Pictol, and Rhodol. Spelling also can vary. For instance, the British spelling of *sodium sulfite* is *sodium sulphite*, and the British spelling of *sodium sulfate* is *sodium sulphate*. Chemicals come in different grades or classifications. Be sure the price obtained is for the exact chemical of the same grade you need.

Chemical Classification Chemicals are given the following three standard classifications reflecting their purity:

1. *Analytical Reagent* (AR) is the highest standard for purity and uniformity. This grade is the most expensive and is not generally needed for most photographic purposes. It is usually labeled ACS (American Chemical Specification). In the United Kingdom, it is labeled ANALAR.
2. *Pharmaceutical* or *Practical* is about 97 percent pure and can be used for almost all photographic work. It is labeled USP (United States Pharmacopeia) or NF (National Formulary). In Great Britain, it is labeled either BP (British Pharmacopeia) or BPC (British Pharmaceutical Codex).
3. *Technical* or *Commercial* is approximately 95 percent pure and is subject to variations that could alter the visual outcome. It is not recommended for important work.

Sources of Supply The following are offered as supply sources of photographic chemicals:

- Gallard Schlesinger Chemical, 584 Mineola Avenue, Carle Place, NY 11514
- Photographers' Formulary, P.O. Box 5105, Missoula, MT 59806
- Student Science Service, 622 West Colorado Street, Glendale, CA 91204
- VWR Scientific (International Headquarters), P.O. Box 7900, San Francisco, CA 94120 (can provide you with a regional distributor)
- Zone V, Stage Road, South Stratford, VT 05070.

Storage

Keep all chemicals away from children and pets. If necessary, lock them up. Label and date all bottles of mixed solutions. Be sure storage bottles have a secure cap. Protect all chemicals from air, heat, light, moisture, and contamination from other chemicals.

Disposal and Safety

When working with any chemical, you assume the responsibility for its safe use and disposal. Follow any special instructions included with each chemical or process being used. Laws concerning disposal of chemicals vary widely. Check with your local health department to get advice. Hazardous liquids can be poured onto kitty litter and placed in a plastic bag. Dry chemicals or contaminated materials can be disposed of by sealing them in a plastic bag. Both should be put in a closed outside dumpster. Do not mix liquid and solid wastes together, as dangerous reactions might occur. Be sure to read and follow all safety recommendations in Chapter 3, as well as those that come with the chemicals.

Preparing Formulas

Weighing Chemicals

Place your scale on a level surface, protected from spills with newspaper or plastic, and zero it. Put a piece of filter paper, any clean paper, or a paper cup in the middle of the balance pan. For critical measurements with a triple-beam scale, weigh the paper or cup first and include its weight plus that of the chemical. When using a double-pan scale, place the same size paper in both pans so their weights will cancel each other out. Line up the chemicals needed in an orderly fashion. Put the chemical being measured in the center of the pan to avoid any leverage errors. Use fresh paper for each chemical to prevent contamination and facilitate cleanup. Immediately recap the bottles to avoid confusion, spills, or contaminating one chemical with another.

Figure 5.2 The straight image of this composite was shot with an 8 x 10" camera, processed in D-23, and treated with a gold protective solution. Pen and ink drawings were done on clear acetate. The acetate drawing was used first as a negative and then as a positive negative after a Kodalith negative was made from the clear acetate. This newly created combination of sources was used in conjunction with the original negative and contact printed on Azo paper. Progressive exposure was given to the Kodaliths to create gradations of gray. The paper was processed in Ansco 135 Developer to give a very warm tone. The print was bleached and toned in selenium. Finally, it was treated with Gold Chloride Protective Solution to cool down the warm-tone look of the image.

© DeWayne A. Williams. "Transition II," 1985. Gelatin silver print. 10 x 8".

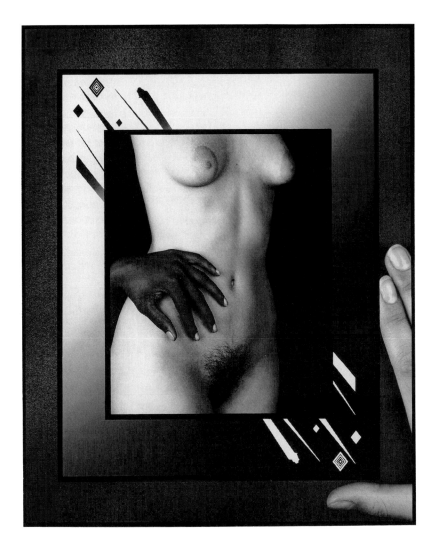

Temperature

Closely follow the temperature recommendations given with each formula. If the chemicals need to be heated, carry out this procedure in a double boiler, not in a pan directly over the heat source. Direct heat can alter or damage the chemical. The solubility of many chemicals is increased with heat. For this reason, the mixing temperature of the water may vary from the solution's working temperature. Other chemicals may release heat when dissolved, creating an exothermic reaction, and need to be mixed in cool water. Endothermic chemicals absorb heat when mixed and may require hotter water for complete mixing.

Mixing Chemicals

Always follow the prescribed order of chemicals given in the formula, as any changes may prevent the solution from being properly mixed. Follow specific recommendations provided with the formula. In general, start with two-thirds to three-quarters of the total amount of water at the correct mixing temperature. Slowly pour the first properly measured chemical into the water while stirring vigorously, not permitting any chemical to settle at the bottom of the container. Wait until each chemical has been completely dissolved before adding the next one. When the correct sequence has been followed and all the chemicals are thoroughly mixed, cold water can be added to bring the so-

lution to room temperature. If you are not confident of the purity of the water being used, mix all developers with distilled water.

- When you are mixing an acid, always pour the acid into water. Do not pour water into an acid, as splattering can cause dangerous burns. Be sure to wear eye protection.
- Use a funnel when pouring mixed solutions into bottles. Tightly secure the top and label the bottle with the name of the solution and the date. Most developers are good only for a few months after they have been mixed.
- Keep a written record of what you do so that you can judge the results. This permits easy adjustment and customization of the formulas.

Percentage Solutions

In some formulas, where the amount of a chemical may be too small to be weighed accurately, the amount is given as a percentage solution, or in terms of weight per volume. For photographic purposes, this can be simply stated as how many grams of a chemical are dissolved in 100 milliliters of water. For instance, a 5 percent solution has 5 grams of a chemical dissolved in 100 milliliters of water. Regardless of the amount needed, the percentage (how many parts of the chemical to be mixed into 100 parts of water) is always the same.

When making a percentage solution, mix the chemical in less than the total volume of water required. After the chemical is dissolved, add the remaining water. For instance, in preparing a 7 percent solution, dissolve 7 grams of the chemical in about 75 milliliters of water. After mixing is complete, add more water so that the final volume is exactly 100 milliliters.

Formulas in Parts

Older photographic formulas were often given in parts. Parts can be converted into the equivalent number of grams and milliliters or ounces and fluid ounces. For example, a formula calling for 10 parts of a chemical and 80 parts of water can be translated as calling for 10 grams of the chemical and 80 milliliters of water or 10 ounces of the chemical and 80 fluid ounces of water.

pH Scale

Most photographic solutions have a definite pH (potential of hydrogen), which is a way to measure the acidity or alkalinity of a chemical. Acidity is measured by the number of hydrogen ions present, and alkalinity is measured by the concentration of hydroxide ions in a solution. The scale runs from 1 to 14, with 7 being neutral. Pure distilled water has a pH of 7. Chemicals with a pH below 7 are considered to be acids. Chemicals with a pH above 7 are alkalines. The change of one whole increment in the pH scale indicates a tenfold change (plus or minus) in the intensity of the acid or alkaline reaction.

All photographic processing solutions perform best within a specific pH range. For example, developers must be alkaline to work, stop baths must be acid, and fixers are normally neutral to slightly acid. The pH of most of the commonly used working solutions in today's photographic processes is 5 to 9. The pH can be measured with pH test paper or with a pH meter. The paper is inexpensive but not very reliable. A pH meter, which is expensive, is required for accuracy. Fortunately, most black-and-white formulas do not require stringent pH monitoring. Small changes produced by variations in pH usually do not cause severe visual defects. Most of these changes can be corrected during the printing of the negative. The use of distilled water will eliminate most difficulties in controlling pH as long as the chemicals are good and the procedures being followed are correct.

Chemicals possessing either a high or low pH should be handled with care. Acids on the low end of the pH scale get progressively stronger. Acids

can dehydrate the skin and, in high concentrations, produce burns. Highly alkaline substances, such as calcium hydroxide, can degrease the skin and cause burns.

Acetic acid is the most commonly used acid in photography. It is a relatively weak acid and does not react as vigorously as other acids, but it can cause tissue damage in a concentrated form.

Prolonged exposure to photographic chemicals can cause allergic reactions, cracking, dehydration, or discoloration of the skin. Allergic reactions tend to be cumulative. When mixing or working with any concentrated chemicals, wear full protective gear.

U.S. Customary Weights and Metric Equivalents

When preparing your own chemicals, you will probably encounter formulas given in both the U.S. customary and metric systems. The scientific world has adopted the metric system, but the United States at large has not followed suit. The British use still another system called British Imperial Liquid Measurement. These systems are not compatible. Many older formulas may be written only in one system, so it is often necessary to translate from one system to the other.

Additional Information

Books

DeCock, Liliane, ed. *Photo Lab Index, Lifetime Edition.* Dobbs Ferry, N.Y.: Morgan and Morgan, 1990.

Wall, E.J., and F.I. Jordan; rev. and enlarged by John S. Carroll. *Photographic Facts and Formulas.* Englewood Cliffs, N.J.: Prentice Hall, 1976.

Other Source

Chemical Manufacturers Association, 1825 Connecticut Avenue N.W., Washington, DC 20009.

Chapter *6*

Black-and-White Film Developers

Choosing a film developer requires intelligent consideration. You have a wide range of possibilities to choose from in selecting a developer that is appropriate for the film and its intended application. A developer is not a magical concoction that can correct mistakes made at the time of exposure, but it does play a vital role in determining a number of key factors in the final negative. These include acutance (sharpness), contrast, useful density range (the difference between the brightest highlight and the darkest shadow areas from which detail is wanted in the final print), fog level, grain size, speed, and the progression, separation, and smoothness of the tonal values.

The developer formula selected—its dilution; degree of exhaustion; temperature of use; frequency, duration and degree of agitation; and time the film is in the solution—are all controls that the photographer can use to adjust the results obtained from any developer.

What Happens to Silver-Based Films during Exposure and Processing

Upon exposure, the light-sensitive emulsion produces an electrochemical effect on the silver halide crystals of the emulsion. This changes the electrical charge of the silver halide crystals, making them responsive to the developer. The exposure produces an invisible latent image made up of these altered crystals. The developer reduces these exposed crystals to particles of metallic silver, forming the visible image on black-and-white film. The extent of this reaction is determined by the amount of light received by each part of the film. The more light striking an area, the more reduced silver there will be, resulting in a higher density.

Chromogenic Film Differences
In chromogenic black-and-white film, as in most color films, the developing process creates both silver particles and dyes. During processing, the silver is removed in a bleaching process, leaving a negative image formed only by the dyes. Agfa and Ilford both make chromogenic black-and-white films that are developed in the C-41 color negative process.

Remaining Processing Steps
After being developed, the negative has tiny particles of metallic silver and residual silver halide that were not exposed and therefore not developed. This halide must be removed, or it will discolor the negative when it comes in contact with light.

To complete the developing process, a mild acid stop bath, sometimes called a short-stop, is used to neutralize the alkaline developer still in the emulsion. The film is then transferred into an acidic fixing bath to remove any of the unreduced silver halide in the emulsion. Fixer or hypo (once

known as sodium hyposulfite) is usually made up of sodium thiosulfate. Rapid fixer generally contains ammonium thiosulfate as its fixing agent. After fixing, the remaining thiosulfate compounds must be eliminated. The film is rinsed and treated with a hypo clearing solution, which changes the thiosulfate into a compound that washes off the film more easily. Any residual fixer will discolor, stain, and ultimately destroy the image. Finally, the film is thoroughly washed and dried.

Image Characteristics of Film

Grain

The silver particles that make up the image structure are called grain. The grain size is determined by two major factors. The first is the inherent natural characteristics of the film. Generally, the faster the film is, the coarser the grain. Fast films have a thicker emulsion, permitting more vertical clumping of the grain. The second factor determining grain size is development. The individual silver grains tend to gather together and overlap, creating larger groups that form a pattern. This is not very noticeable in the negative but becomes visible in an enlarged print. The grain we see in the print is not the individual grains but the spaces between the grains on the negative. These grains hold back the light during printing, so they appear white in the print.

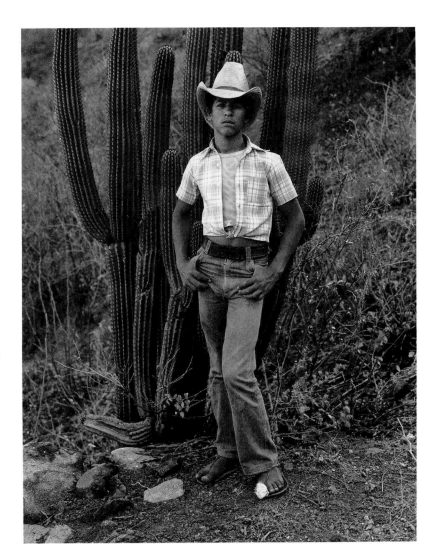

Figure 6.1 Many large-format photographers use Kodak Tri-X developed in Kodak HC-110 (dilution B) to get excellent tonal gradation and good separation of high values. This film-developer combination was one of Ansel Adams's favorites, and he promoted its use. In a series documenting the land and people of rural Mexico, Lambert used this combination to make a portrait of a young man undaunted by a recent encounter with a sharp rock. The photograph was made on a shadowed mountainside just before sundown. The Tri-X/HC-110 combination produced excellent gradation in both the low and high values of the print.

© Wayne Lambert. "Eloy Simmons Fallet, Batopilas, Chihuahua, Mexico, 1981." Gelatin silver print. 8 x 10".

The number and size of the grains in any part of the negative give it density. Graininess is increased by excessive density. This can be produced by overexposure or overdevelopment. Improper film processing, including rough agitation, temperature shock, excessive fixing, and lengthy wet time, increases the size of the grain. Visible grain also increases as the contrast of the print increases.

Acutance

Acutance describes the ability of film, when exposed to a point light source, to form a sharply defined image of a knife edge. The nature of the grain and how it is distributed affect the film's acutance. Fine-grain films with a thin emulsion have a high acutance value. They produce less spreading of the light because there is not as much emulsion through which light must travel.

Developers do play a role in how we perceive a film's acutance. An acutance developer develops less of the faintly exposed portions of the knife line, reducing the gradient width and giving the impression of increased edge sharpness, even though the film may not measure out as having a higher acutance. The sharper the grain is, the greater the appearance of acutance. Softer grain produces a diffused edge, giving the impression of less acutance.

Resolution

The film's ability to reproduce fine detail is called resolution. Resolving power is determined by both the camera equipment and the film. These factors include lens sharpness and freedom from aberrations, the graininess of the emulsion, the contrast of the subject, the contrast characteristics of the film, and the degree of light scattering throughout the system. Slow, fine-grain films have a greater resolving power than faster films containing larger grains. Fine-grain films have a greater acutance, producing sharper outlines and higher contrast. The thinner emulsion yields less irradiation (internal light scattering), which can blur distinctions between details. Excess density produced by overexposure or overdevelopment increases light scattering in the emulsion. This reduces edge sharpness and contrast, which results in less overall resolving power.

The sharpness of the grain produced by the developer influences resolution. Grain that is not very sharp can reduce the resolution of an image made through a first-rate optical system. The sharper the grain is, the higher the degree of apparent resolution.

Fog

Fog is any tone or density in the developed image that is produced by stray, non-image-forming light or by an unwanted chemical action. Fog adds density and is first noticeable in less dense areas. In a negative, it results in a loss of contrast and detail in the shadow areas. Light fogging is caused by lens flare, camera light leaks, improper handling, loading or unloading of film, light leaks in the darkroom, or poor safelight conditions.

Chemical fog results from the development of unexposed halides. This happens all the time in small amounts, causing what is known as the base-plus-fog density of film. Fog amounts greater than base-plus-fog degrade the image. A restrainer, often potassium bromide, is added to the developer to reduce fog. Improper storage or out-of-date film often produces high levels of fog because the silver halides become more developable with age. High development temperature, excessive agitation, or chemical activity increases the fog level. Fog and other visible stains can result from fine-grain developers used with fast films or from the use of nearly exhausted chemicals. Letting the emulsion come in contact with an excessive amount of air during development produces an oxidation effect called aerial fog. Chemical dust,

from the mixing of chemicals, also is a source of fog. To prevent fog, make sure both camera and darkroom are light-tight, use fresh films and solutions, follow proper operating procedures and temperatures, and maintain clean working conditions.

Components and Characteristics of Black-and-White Developers

Developer formulas contain a number of different chemicals required to perform specific functions in the development of the film. Getting to know the basic ingredients and the roles they perform helps the photographer to make adjustments to meet individual requirements in different situations.

Developing Agent

The role of the developing agent is to reduce the silver halide salts in the emulsion to metallic silver. The developing agent is oxidized during this process. Since the beginning of photography, countless chemicals have been tried in the hope of producing a developing agent with improved properties. Most of the developing agents currently in use were discovered before the turn of the century, although new developing agents are probably being used in proprietary formulas that manufacturers have not revealed to the public.

The most common contemporary developing agents are Metol (Kodak's Elon), hydroquinone, and phenidone. Older formulas are amidol, glycin, and pyrogallol (pyro). Most general-purpose developers are compounded pairs of developing agents that complement each other's action during the development process. The most popular combinations are Metol and hydroquinone, known as an MQ developer, and phenidone and hydroquinone, sometimes called a PQ developer. The M stands for Metol, the Q comes from Quinol, the old Kodak trade name for hydroquinone, and the P represents phenidone. The characteristics of these developing agents are discussed later in this chapter.

Metol and phenidone provide good low-contrast shadow detail in the negative but produce very little density in the highlights. Hydroquinone acts more intensely in the highlight areas, adding density and contrast. The combination of the two developing agents results in greater development of the entire negative than the sum of the development given by equal amounts of the individual developing agents. In effect, when MQ or PQ combinations are used, $1 + 1 = 3$. This effect is called superadditivity and is used in the majority of contemporary formulas. The MQ and PQ combinations yield good shadow and mid-range detail, while still retaining easily printable density in the highlights.

Metol should be handled with care, as it has been known to produce a skin irritation that resembles poison ivy. If you have a reaction to Metol, use a developer based on phenidone. Note that most of Kodak's developers have Elon (Metol) in them.

Phenidone behaves much like Metol. It is more expensive, but it is used in smaller quantities. Phenidone has a low oral toxicity and is considered nontoxic. With normal use, it is unlikely to cause dermatitis. In combination with hydroquinone, it can produce higher useful contrast. It is not as sensitive to bromide, giving the solution more constant and longer keeping properties. Phenidone can be more difficult to dissolve and can require very hot water (175°F or 80°C) to go into solution easily. Check the formulas carefully before mixing. Many people use a percentage solution when mixing their own phenidone-based formulas, since only a small amount is required.

Some popular commercial developers that claim to be Metol free include Edwal's FG-7, Acufine, Diafine, Acufine ACU-1, Agfa's Rodinal, Ilford's Microphen, Kodak's HC-110, and Unicolor's Black-and-White Film Developer.

Accelerator

Developing agents used by themselves can take hours to produce useful density, are quickly oxidized by air, and yield a high level of fog. An alkaline accelerator creates an environment that greatly increases the developing agent's activity, dropping processing times from hours to minutes. The amount of alkalinity in the accelerator determines how much increase takes place in the developer. Alkalinity is measured on the pH scale: the higher the pH, the greater the alkalinity. Some commonly used alkaline chemicals are borax or Kodalk (Kodak's trade name), with a pH value of 9; sodium carbonate, with a pH of 10; and sodium hydroxide, also known as caustic soda, with a pH of 12.

A developer containing sodium hydroxide, which has a high pH, greatly accelerates the action of the developer. It increases contrast and is often used for high-contrast applications such as graphic arts films. The higher the pH value, the more quickly the alkalinity drops off when used in a solution. Developers with a high pH accelerator oxidize very rapidly and have a very brief life span. To combat these difficulties, the developer and alkaline (accelerator) are stored as separate A and B solutions that are mixed immediately before use.

A developer with a low-pH accelerator such as borax produces less contrast and takes longer to work, but it remains stable for a longer period of time in a working solution.

Preservative

When a developing agent is dissolved in water, especially with an alkaline chemical present, it oxidizes rapidly, causing the solution to turn brown, lose its developing ability, and produce stains on the emulsion. To prevent the developing agent from oxidizing, a preservative is added, usually sodium sulfite. This increases the working capacity of the developer. It also can act as a silver solvent during the long developing time, and in large quantities, as in D-23, it produces the mild alkalinity needed to make the developer work. In the A solution of the Pyro ABC formula, sodium bisulfite prevents the oxidation of the pyro developing agent. Potassium metabisulfite is sometimes used in two-solution formulas instead of sodium sulfite.

Restrainer

During the development process, some unexposed silver halides are reduced to black metallic silver before development is complete, producing unwanted overall fog. A restrainer is added to the developer to reduce the fog level. Bromide, with derivatives of either potassium or sodium, is the primary restrainer found in most developers. Potassium bromide is more commonly used. The restrainer increases contrast by preventing the reduction of the silver halides; hence, the production of metallic silver, in the slightly exposed areas, giving a lower overall density to the shadow areas. This inhibiting of silver halide reduction also tends to produce a fine-grain pattern. A potassium bromide restrainer is used only in small amounts, as it holds back the overall developing action, reduces the speed of the film, and has a greater effect on the low-density areas, diminishing the amount of useful density created in the shadow areas. Some low-alkaline developers do not produce much fog and therefore do not require a restrainer.

As the emulsion is developed, soluble bromide is discharged into the developer, increasing the proportion of restrainer in the solution and thereby slowing the action of the developer. If these soluble bromides are not removed through proper agitation of the solution, they can inhibit the developing process.

Some developer solutions use benzotriazole, marketed as Kodak Anti-Fog No. 1, instead of potassium bromide. These two restrainers cannot always be

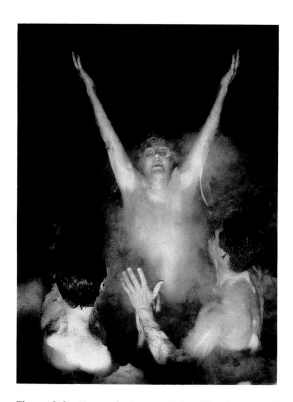

Figure 6.2 Known for her portraits, Noggle created this scene outdoors in the winter by using a fogger and bubble bath in the Jacuzzi. It was lit by two 800-watt Speedotran strobes, one placed at a high angle and the other at almost ground level. The film was processed in a Metol-free developer, Edwal's FG-7. The print was made on a multigrade paper.

© Anne Noggle, "Stellar Star Light #1," 1986. Gelatin silver print. 20 x 24".

interchanged, as the benzotriazole does not have the same effect with all developing agents.

Other Ingredients

Alcohol solvents can be found in certain concentrated liquid developers to increase the solubility of specific chemicals and to prevent freezing. Sulfates are sometimes added to a developer to reduce emulsion swelling, which keeps the grain size down.

Keeping Qualities

The keeping qualities of any developer will be affected by the following factors:

- Purity of water. Use distilled water and avoid water that has been softened.
- Chemical makeup. All developers should be protected from the air. Most normal developers containing sodium sulfite are slow to oxidize. High-energy and pyro developers oxidize quickly after a working solution has been prepared and should be used immediately.
- Storage containers. Use dark brown or opaque containers. Glass or stainless steel are best. Plastic can be used, but be aware that some plastic containers allow oxygen to pass through their walls and interact with the developer. This speeds up the oxidation process and leaves brownish stains inside the container. Do not use plastic for long-term storage.
- Contamination. Follow the preparation instructions and mixing order carefully. Do not allow the developer to come into contact with other chemicals. Wash all equipment completely after use.

Basic Factors in Selecting a Developer

The photographer must bear in mind the nature of the subject, the type of enlarger light source, and the size of the final print. For a subject calling for maximum retention of detail, as in architectural work, traditional landscapes, or photographs for reproduction, a normal developer with maximum acutance is preferred, even at the expense of increased grain size. For a subject requiring a softer look with less sharply defined grain and a flowing progression of tones, as in some portrait work, a fine-grain developer that gives the grain a more rounded look might be appropriate.

Photographers using condenser enlargers, which emphasize contrast and crispness, may wish to use a softer negative with lower grain acutance. Those using a diffusion enlarger generally prefer maximum sharpness, since the diffused light softens the image slightly. Many photographers who use diffusion enlargers extend the development time to create a slightly denser negative than they would use with a condenser enlarger. This is done to retain some of the contrast that is lost in diffusion systems.

The development time of most developers can be varied to compensate for high-contrast or flatly lit scenes. For example, if the entire roll of film was exposed in brighter than normal lighting conditions, the photographer may wish to decrease the normal development time by 10 to 25 percent to reduce the overall contrast. This narrows the distance between the key highlights and shadows, giving the negative a tonal range that will be easier to match with the paper to make a normal print. If a roll of film is exposed in flatter than normal light, the photographer can increase the normal development time by about 25 percent to produce added contrast in the image.

Liquid versus Powder Chemistry

Developers are available in liquid and powder form. Neither is better than the other, as both are valuable in various situations. Most photographers work with both types. It is a good idea to experiment with both in noncritical situations to see the visual results they are capable of delivering.

Figure 6.3 Connor holds to the maxim of Robert Bly: "Whoever wants to see the invisible has to penetrate more deeply into the visible," Connor likes to keep her technical operations simple. Her 8 x 10" Ektapan film is processed in Kodak HC-110, a convenient, one-shot liquid developer. This image was sun printed on printing-out paper toned with gold chloride.

© Linda Conner. "Skull, Peru," 1984. Printing-out paper. 8 x 10".

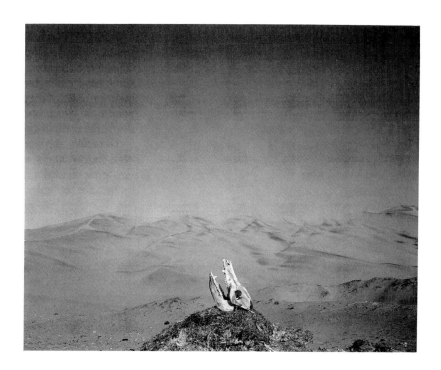

Liquid Developers

Many liquid developers are proprietary formulas—that is, not published for use by the public—and cannot be obtained in any form other than those the manufacturer provides. Some proprietary formulas include Kodak's HC-110 and T-Max developers, Edwal's FG-7, and Agfa's Rodinal. These formulas are convenient, consistent in quality, and high in price. Many of the liquids are extremely concentrated and can be difficult to measure out in small quantities. Rodinal, sometimes used at dilutions of 1:100, can be accurately measured by using a hypodermic needle. HC-110 is too syrupy for this technique and can be measured in small amounts in a 1-ounce graduate. With this method, always measure on a level surface. Pour the developer into a mixing container filled with half the water required for the proper dilution. Add the remaining water by pouring it, an ounce at a time, into the small graduate and then into the working solution. This ensures that none of the developer will remain in the graduate. Other people prefer to make a stock solution from these concentrated liquids that is later diluted to make a working solution. Most of these developers are intended to be used one time (one shot) and then discarded.

Powder Developers

Powders can be more difficult to mix, and their dust can contaminate the darkroom. Prepare the solutions where the chemical dust will not land on surfaces where film is handled. When mixing powders, wear a mask to avoid breathing in the dust. Clean the mixing area with a damp paper towel. Ideally, powders should be mixed 24 hours before use to ensure that all the chemicals are dissolved and stable. This lack of convenience is offset by the fact that the formulas for many contemporary and older powder developers are available. The photographer who takes the time to mix a formula from scratch can save money and customize the formula for individual needs. He or she is not restricted to what is available commercially, will gain a better understanding of what happens in the process, will learn how to influence the development process, and will increase visual possibilities.

Basic Developer Types

Categorizing developers can be difficult. The visual results one photographer considers to be normal might be unacceptable to another. This chapter offers some basic characteristics of developers, how they are typically applied, and their formulas, if they are available. This information is intended as a starting point from which photographers can conduct experiments to see which film-developer combinations offer visual satisfaction.

Generally, developers are divided into four categories: normal, fine-grain, high-energy, and special-purpose. Formulas for the nonproprietary developers—that is, formulas that are published for public use—mentioned in this section are presented at the end of this chapter.

Normal

The normal developer is one that provides high acutance, a moderate grain pattern, and a good range of clearly separated tones; maintains the film's regular speed; and is simple to use. These developers can be used with roll or sheet film in a tank or tray. Common examples include HC-110, D-76, and FG-7. The key difference between a normal developer and a fine-grain developer is how the grain looks. A normal developer yields a sharp, toothy grain, similar to the shape of a pyramid. A fine grain developer produces a softer grain, similar to a rounded dome.

Many developers can be classified as either normal or fine-grain. D-23 is one such formula. D-23 is a Metol developer yielding a moderately fine grain due to the solvent action produced by its higher than normal content of sodium sulfite. In the case of D-23, the sodium sulfite's main purpose is not to create a finer grain but to produce the alkalinity needed for development to take place. The finer than normal grain is a by-product of this action. D-76 contains the same amount of sodium sulfite as D-23, but its MQ formula of Elon and hydroquinone gives it more energy. This reduces the developing time, so there is less silver reduction and the grain remains more well defined. HC-110, D-76, and FG-7 are available from the manufacturer in packaged form. D-23 is not.

Figure 6.4 The 8 x 10" Tri-X film was exposed at a slow shutter speed under very low contrast light. To increase the contrast, the film was given extended development in straight D-23 for 36 minutes. D-23 allows much longer than normal developing times while still yielding a printable negative on a grade 2 paper. The processed negative was treated with gold protective toner and printed on Azo paper, which was developed in Ansco 130. The resulting print was bleached for 10 seconds, and the leaf in the center was bleached for an additional 10 seconds. The final image was treated with selenium toner and a gold protective solution.

© DeWayne Williams. "Leaves on Water," 1974. Gelatin silver print. 8 x 10".

Fine-Grain Developers

Fine-grain developers increase their silver halide solvent power by chemical means, usually with a higher level of sodium sulfite. This increased solvency yields a reduction in graininess. Unfortunately, this is accompanied by a reduction in film speed and acutance, producing a negative in which the grain is actually softer than that of a normal developer. Instead of the grains looking like the well-sharpened point of a pencil, they appear to have been rounded off. The negative will actually deliver a less well defined grain pattern. This is not good or bad, it is simply different from the results obtained with a normal developer. It is a matter of how the photographer wants the final print to look. Prints made from such negatives are softer and smoother looking.

D-25 is a classic example of such a developer. Its basic formula is the same as that for D-23, but sodium bisulfate is added as a buffer to reduce the developer's pH value (alkalinity). This buffering effect increases the development time, resulting in increased solvent action of the sulfite on the silver, giving it a fine-grain effect. D-25 must be mixed from scratch.

Kodak's Microdol-X is a fine-grain, Metol-only, high-sulfite developer that is similar to D-25. Microdol-X is available in packaged form.

Other fine-grain developers, such as Ethol Blue and Acufine, are designed for pushing film to achieve maximum speed.

High-Energy Developers

High-energy developers are often used for graphic arts work or rapid processing. They tend to produce high contrast, eliminating the middle tones and giving areas either a black or clear density. They are generally not intended for normal pictorial use, but they can be diluted and the exposure time manipulated to produce continuous-tone results. In many of these formulas, such as Kodalith Liquid Developer, the developing agent and the alkali are stored separately and mixed only at the time of use. Once they are combined into a working solution, they oxidize very rapidly. The level of bromide in these formulas is generally increased to keep the fog level down. This also helps to produce the completely clear areas on the film for high-contrast effects. Other widely used high-energy developers include Kodak's D-11 and D-19 and Ilford's ID-13.

Special-Purpose Developers

Special-purpose developers are designed for specific uses such as direct-positive, high- or low-temperature, and low-contrast/low-energy processing; reproduction work; X-ray development; nonstandard visual effects; and monobath or two-solution development methods.

Two-Solution and Water-Bath Development Both these procedures can be effective in reducing overall contrast while maintaining useful density in the key shadow areas. They permit the developer to soak into the emulsion before the film is placed in a bath of mild alkali or water. When the film is taken out of the developer and placed in the second solution, the developer in the highlight areas rapidly exhausts itself, while the developer in the shadow areas continues to act. The cycle may be repeated to achieve the desired range of contrast. Either method works well with fast, thick-emulsion films such as Tri-X and HP-5. The alkaline solution method is more effective with a broader range of films, including slower, thin-emulsion ones. When working with either method, you may have to give about one f-stop more exposure than you normally would.

Diafine is a commercially available two-bath formula designed to produce the highest effective film speed, ultrafine grain, maximum acutance, and high resolution. It is usable over a wide temperature range (70°F to 85°F, or 21°C

Figure 6.5 Here 5 x 7" Tri-X was exposed for about 1 minute at f-22. Two flashbulbs were fired during the exposure to paint the subjects at appropriate and unpredictable points in time. To compensate for the long, imprecise exposure with mixed lighting, Feresten used a double-bath development of exhausted Kodak Microdol-X followed by a Kodalk solution. This reduced the overall contrast while maintaining detail in the key shadow areas. Feresten likens his method to casting a net into unknown waters. The results contain a collection of nonsimultaneous truths connected by time.

© Peter Helmes Feresten. "Javier Gracia Wake, Fort Worth, Texas," 1987. Gelatin silver print. 12 5/8 x 18".

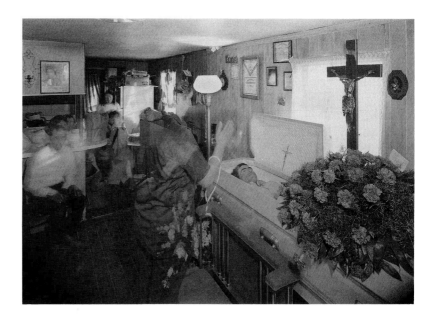

to 29° C) with a single developing time for all films. Diafine permits a wide latitude of exposure without having to adjust the time or temperature of the developer.

Processing with D-23 and Kodalk

The Single-Cycle Method Film is developed in D-23 for 3 to 7 minutes at 68° F (20° C) and then allowed to soak, without agitation, in a 1 percent solution (10 grams per liter) of Kodak Balanced Alkali (Kodalk). The process raises the film's base-plus-fog level, but this fog can usually be printed through without difficulty. The fog level can be combated by adding a 10 percent potassium bromide solution to the Kodalk or by adding Kodak Anti-Fog No. 1 at the rate of 1 tablet per liter of Kodalk. The resulting negative will appear to be soft but will contain fully developed shadow area detail.

The Multicycle Method The multicycle method can produce a more completely developed negative, with additional compensating effects, than the single-cycle procedure. In this process, the film is developed in D-23 for 30 to 60 seconds, then put into the 1 percent Kodalk solution for 1 to 3 minutes with no agitation. The film is then put into a weak acid stop bath and completely rinsed in water. After these procedures, the film is returned to the D-23 for the second cycle. This entire procedure may be repeated three to five times to achieve the desired contrast range.

Postdevelopment Processes

Replenishment

A developer loses its potency as it carries out the task of reducing the exposed silver halides. During this process, contaminants, mainly soluble bromides, which are a by-product of the chemical reaction, build up in the solution. A replenisher is a chemical solution added to the original developer and designed to return the developer back to its original strength, allowing it to be reused many times. Not all developers can be replenished. Check with individual manufacturers to find out whether you can replenish a specific developer.

Generally, for replenishment to be economical and effective, the developer must be used in at least one-gallon tanks. Also, the solution must have film run through it regularly (preferably daily) to keep the developer at working strength. Careful records of the amount of film processed must be maintained to determine the amount of replenishment required. For these reasons, large-volume users primarily use replenishment.

Many photographers prefer one-shot (nonreplenishable) developers because of their consistency and ease of use. If the volume of work is great enough, however, replenishing is more economical. Some photographers like the look of a negative processed in a replenished solution. This preference derives from the fact that during long development times, some of the residue silver in the solution attaches itself to the developed emulsion in a process called plating, which adds a slight amount of contrast and density. In 1989, with the introduction of Kodak T-Max RS Developer and Replenisher, replenishing became easier for people processing small amounts of film.

T-Max RS Developer and Replenisher

The T-Max RS Developer and Replenisher is an all-liquid system designed to provide a number of advantages over traditional replenisher methods. The mixed T-Max RS acts both as a working solution and as a replenisher. No starter solution or separate replenisher solution is required. At its recommended temperature of 75°F (29°C), RS gives better shadow detail than regular T-Max Developer. This makes it an excellent choice for both normal and push processing. It is suitable for low-volume, small-tank processing because it can be mixed in quantities as small as one gallon, does not require a daily run of film, and has a good storage life. A working-strength solution will keep for six months in a full, tightly closed bottle, while a half-filled bottle will last for two months. T-Max RS can be used to process any T-Max or conventional black-and-white film, such as Tri-X. It also may be used in an unreplenished system, one-shotted, and dumped. Kodak says not to use RS to replenish regular T-Max Developer.

T-Max RS Developer is easy to replenish. You simply mix one gallon of RS and pour the required amount of solution into the developing container. After the film is developed, save the used developer in a separate bottle. For each 135-36, 120 roll, or 8 x 10" sheet processed, 1-1/2 ounces (45 milliliters) of fresh RS Developer is added to the used solution. For example, if four rolls of 135-36 film were processed, you would add 6 ounces (180 milliliters) of fresh RS Developer to the used solution. All future development is done in the used solution after it has been replenished with fresh RS Developer. Check the RS Developer instructions for detailed processing information, or get *Kodak T-Max Developers*, Kodak Publication No. J-86.

Reticulation

Reticulation is caused by excessive swelling of the emulsion during processing. It wrinkles the emulsion into a random weblike pattern that is more visible than the grain itself. The major cause of reticulation is temperature fluctuations between the different processing steps. Traditionally, reticulation has been considered a mistake that destroys the detail and uniformity of a negative. Reticulation can be purposely induced for a graphic, textured effect, however. Improvements in contemporary emulsions have reduced the likelihood of accidental reticulation. In fact, it can be difficult to induce reticulation with many modern films. Reticulation methods are covered in Chapter 13.

Intensification

Intensifiers are used to increase the density and contrast of an already processed underexposed or underdeveloped negative or positive. An intensifier cannot create something from nothing. Some density must be present for the

Figure 6.6 This image of desert mythology and iconography was brought to mind by Carlos Castaneda's books. The pony and snake were positioned for the camera. Falke likes to work with soft, flat light. To compensate for this, the 8 x 10" Tri-X film was given extended development in HC-110 (1:15). The resulting negative was intensified through the use of a selenium intensification procedure. From this, a contact print was made on a grade 3 paper, and it was slightly reduced with a weak ferricyanide bath.

© Terry Falke. "Cainsville Desert," 1987. Gelatin silver print. 7-1/2 x 9-5/8". Courtesy of The Afterimage Gallery, Dallas.

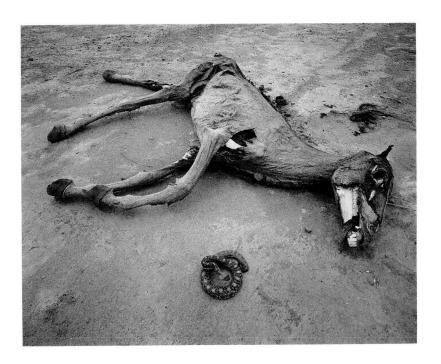

intensifier to have any effect. An intensifier will not save a grossly underexposed negative. When using any intensifier, read and follow all safety and handling instructions.

The safest, simplest, and most permanent intensifier is selenium. It is called a proportional intensifier, and it has a greater effect in the high-density areas than in the low-density ones. Selenium can add up to the equivalent of one f-stop of density to the upper highlight regions, which also increases contrast. This added density drops off through the mid-tone areas and falls drastically as the shadow areas deepen. Selenium intensification is an excellent choice with roll film because it does not increase grain size.

The selenium intensification process is as follows:

1. Soak the processed and completely washed film for a few minutes in distilled water.
2. Refix with plain hypo (no hardener) for 2 minutes. This is easy to do with liquid fix by not mixing any of the hardener into the solution.
3. Place the film in the selenium toner solution diluted 1:2 or 1:3 with Kodak Hypo Clearing Agent or Perma-Wash for 2 to 10 minutes at 68° F (20° C) with constant light agitation. Dilution and time are determined by visual inspection and will vary depending on the amount of intensification required. Some hypo clearing baths may produce discoloration when mixed with selenium toner. Test your hypo clear with some unwanted film before using it with important work.
4. Put the film in a plain hypo clearing bath, at normal working strength, for 2 minutes with constant agitation.
5. Wash the film for a minimum of 5 minutes.
6. Dry the film.

Kodak also makes Chromium Intensifier, a two-part package containing bleach and a clearing bath. To use this intensifier, follow these steps at 68° F (20° C):

1. Fix the film in an acid hardening fixer. If the film is dry, soak it for 10 minutes in water before carrying out the next step.

2. Immerse only one piece of film at a time in the bleach for 3 to 5 minutes, until the black image becomes yellow.
3. Rinse the film in water.
4. Immerse the film in a clearing bath for 2 minutes, until the yellow stain is removed and a white image remains.
5. Rinse the film in water.
6. Redevelop the film in a low-sulfite developer such as Dektol or D-72 (1:3) until the white image is totally black (about 5 minutes). Do not use a high-sulfite fine-grain developer such as D-76 or Microdol-X.
7. Wash the film for 10 to 20 minutes. No refixing is required.
8. Repeat the process if desired for greater effect.
9. Dry the film.

Negatives intensified with this process are not considered to be permanent.

Reduction

Reducers are used to subtract density from completely processed film that has been overexposed or overdeveloped. Reduction can be a tricky undertaking. If an important piece of film needs to be reduced, make some dupes and run tests to determine the correct procedures before undertaking a reduction of the original. Reducers are classified into three general types:

1. *Cutting* or *subtractive reducers* act first on the shadow areas and then on the mid-range and highlights. They are excellent for clearing film fog. The net effect is to increase the overall contrast. Kodak R-4a (also known as Farmer's Reducer) is the most widely used and easiest to control cutting reducer. It is recommended for film that has been overexposed.
2. *Proportional reducers* decrease the image density throughout the film in proportion to the amount of silver already deposited. The effect is similar to that achieved with giving the film less development. Kodak R-4b is an example of a proportional reducer. It is suggested for use with overdeveloped film.
3. *Super-proportional reducers* have a considerable effect on the highlight areas but hardly act on the shadow densities. They are the trickiest and most unpredictable reducers and are not used very often.

Farmer's Reducer (Kodak R-4a) Procedure

Prepare stock solution A:
Water	250 milliliters
Potassium ferricyanide (anhydrous)	37.5 grams
Cold water to make 1/2 liter (500 milliliters)	

Prepare stock solution B:
Water	1,500 milliliters
Sodium thiosulfate (hypo)	480 grams
Cold water to make 2 liters	

To use, take 30 milliliters of solution A, add 120 milliliters of solution B, and add water to make 1 liter. Immediately put the film in this working solution. Watch the reducing action very carefully. After about 1 minute, remove and wash the film. Examine it. If it needs more reduction, return it to the solution. Repeat the examination steps every 30 seconds or so thereafter. Transfer the film to a water wash *before* the desired amount of reduction has taken place. (To slow the activity of the reducer, making it easier to control, cut the amount of solution A by 50 percent.) When the reduction is complete, wash the film for 5 minutes. Fix the film with an acid hardening fixer and give it a final wash before drying. Any residue left on the film can be removed during the final wash with a Photo-Wipe or cotton ball.

Farmer's Reducer (Kodak R-4b) Procedure

Prepare solution A:

Water	750 milliliters
Potassium ferricyanide (anhydrous)	7.5 grams
Cold water to make 1 liter	

Prepare solution B:

Water	750 milliliters
Sodium thiosulfate (hypo)	200 grams
Cold water to make 1 liter	

Place the film in solution A for 1 to 5 minutes at 68° F (20° C) with constant agitation. Transfer it to solution B for 5 minutes, then wash it. You may repeat this process if necessary. After the desired degree of reduction has been achieved, place the film in an acid fixer for about 4 minutes. Follow with a hypo clearing bath and a final wash.

Film Developer Formulas and Their Applications

This section provides a number of useful formulas and their general applications. They are listed by their major developing agent and are offered as points of departure. Photographers should feel free to experiment and modify these formulas to reach their full visual potential. Tests should be carried out with all formulas before attempting to use them for critical work. Read and follow the information in Chapters 3 and 5 before using any of the formulas presented here. Many of the chemicals used are dangerous if not properly handled. Mix all formulas in the order they are given. Formulas are presented in both metric and U.S. customary units (when available).

Amidol Developer

Amidol (2,4 Diaminophenol hydrochloride) was a popular developing agent earlier in the 20th century because of its high reduction potential. It was often used in a water-bath combination, since a small amount of amidol is capable of efficiently converting the silver halides into metallic silver. It contains no alkali, so there is minimum softening of the emulsion. Amidol does have a tendency to produce stains. It is used more today as a paper developer noted for its beautiful blue-black tones. Wear gloves at all times when working with amidol to avoid absorption of this substance through the skin. Ilford ID-9 is an easy-to-use amidol developer.

Ilford ID-9 Formula

Water (125° F or 52° C)	24 ounces (750 milliliters)
Sodium sulfite (desiccated)	3 ounces (100 grams)
Amidol	1/2 ounce (20 grams)
Potassium bromide	88 grains (6 grams)
Cold water to make 32 ounces (1 liter)	

This developer should be used as soon as possible after being mixed. Starting development time with a medium-speed film is 8 minutes at 68° F (20° C). Its standard useful range is 6 to 10 minutes.

Glycin Developer

Glycin was used in the early part of the 20th century by Alfred Stieglitz and Joseph T. Keiley as a contrast control for a developing technique used in making Plainotypes. Glycin has since been used in modern fine-grain developers such as Ilford ID-60.

Ilford ID-60 Formula

Water (125°F or 52°C)	24 ounces (750 milliliters)
Sodium sulfite (desiccated)	291 grains (20 grams)
Potassium carbonate	2 ounces (60 grams)
Glycin	1 ounce (30 grams)
Cold water to make 32 ounces (1 liter)	

Dilute this formula at a ratio of 1:7. Starting development time with a medium-speed film is 15 minutes in a tank and 12 minutes in a tray at 68°F (20°C).

Hydroquinone Developer

Hydroquinone is usually used as a developing agent in combination with Metol (MQ formula) or phenidone (PQ formula). It can be used as the sole developing agent in conjunction with an alkali, found in a B solution, to produce extremely high contrast images. It loses much of its activity at a temperature of 55°F (12°C) or lower. It is used for line and screen negatives or for special high-contrast visual effects. Ilford ID-13 is a hydroquinone developer.

Ilford ID-13 Formula

Stock Solution A

Water (125°F or 52°C)	24 ounces (750 milliliters)
Hydroquinone	365 grains (25 grams)
Potassium metabisulfite	365 grains (25 grams)
Potassium bromide	365 grains (25 grams)
Cold water to make 32 ounces (1 liter)	

Stock Solution B

Sodium hydroxide	1-3/4 ounce (50 grams)
Cold water to make 32 ounces (1 liter)	

Caution: Sodium hydroxide generates heat when mixed and should be mixed only in cold water. If mixed in warm water, it can boil up explosively. Do not handle this chemical without full safety protection.

Equal parts of Stock Solutions A and B are combined immediately before use. This solution should be discarded after each use. Normal development time is 2-1/2 to 3 minutes at 68°F (20°C).

Metol Developers

Metol, also known as Elon and Pictol, is most often used in combination with a contrast-producing developing agent such as hydroquinone in an MQ formula. By itself it is used as a fine-grain, low-contrast, soft-working developer yielding excellent highlight density. If you have any allergic reactions to Metol, try switching to a phenidone-based developer. Agfa 14, Kodak D-23, and Kodak D-25 are classic metol developers.

Agfa 14 Formula

Water (125°F or 52°C)	24 ounces (750 milliliters)
Elon	65 grains (4.5 grams)
Sodium sulfite (desiccated)	3 ounces (85 grams)
Sodium carbonate (monohydrate)	18 grains (1.2 grams)
Potassium bromide	7-1/2 grains (0.5 gram)
Cold water to make 32 ounces (1 liter)	

Development time at 68°F (20°C) is 10 to 20 minutes depending on the contrast desired.

Kodak D-23 Formula This Elon-sulfite developer is suitable for low- and medium-contrast applications. It produces negatives with grain and speed comparable to those developed with Kodak D-76.

Water (125°F or 52°C)	24 ounces (750 milliliters)
Elon	1/4 ounce (7.5 grams)
Sodium sulfite (desiccated)	3 ounces (100 grams)
Cold water to make 32 ounces (1 liter)	

Average development time for a medium-speed film is 12 minutes in a tank or 10 minutes in a tray at 86°F (20°C).

Kodak D-25 Formula This is a fine-grain developer for low- and medium-contrast uses. The grain is softer than that produced with D-23.

Water (125°F or 52°C)	24 ounces (750 milliliters)
Elon	1/4 ounce (7.5 grams)
Sodium sulfite (desiccated)	3 ounces (100 grams)
Sodium bisulfate	1/2 ounce (15 grams)
Cold water to make 32 ounces (1 liter)	

With a medium-speed film, an average starting development time in a tank is about 20 minutes at 68°F (20°C).

Metol-Hydroquinone Developers

These MQ agents make up one of the most popular combinations for normal developers. The soft-working Metol (Elon) and the density-providing hydroquinone act together to create a phenomenon known as superadditivity—that is, the energy of the combination of the two is greater than the sum of the energies of the individual parts. This combination can deliver a good balance between the shadow and highlight areas while maintaining the film's speed, a tight grain pattern, and good tonal separation. Kodak D-19, DK-50, D-76, and D-82 are all metol-hydroquinone developers.

Kodak D-19 Formula When mixed in the correct proportions, Metol and hydroquinone can produce a high-contrast, high-energy developer. Kodak D-19 was originally used to process X-ray film, but has now come into use for continuous-tone scientific and technical work requiring higher than normal contrast, as well as for special effects, including infrared processing.

Water (125°F or 52°C)	16 ounces (500 milliliters)
Elon	30 grains (2 grams)
Sodium sulfite (desiccated)	3 ounces (90 grams)
Hydroquinone	115 grains (8 grams)
Sodium carbonate (monohydrate)	1-3/4 ounces (52.5 grams)
Potassium bromide	75 grains (5 grams)
Cold water to make 32 ounces (1 liter)	

Average starting development time is 6 minutes in a tank or 5 minutes in a tray at 68°F (20°C).

Kodak DK-50 Formula DK-50 is widely used in commercial and portrait work to produce a crisp negative.

Water (125°F or 52°C)	16 ounces (500 milliliters)
Elon	37 grains (2.5 grams)
Sodium sulfite (desiccated)	1 ounce (30 grams)
Hydroquinone	27 grains (2.5 grams)

Figure 6.7 Finding D-76 too low in contrast, O'Dell processed his infrared film in straight Kodak D-19 for 5 minutes at 68°F (20°C). The snappy negative was exposed with a cold-light enlarger on grade 2 paper and given a two-bath development. The first developer was Kodak Selectol-Soft (1:1), and the second was Kodak Dektol (1:2), with a total development time of three minutes. The final image was toned with selenium.

© Dale O'Dell. "Untitled," 1987. Gelatin silver print. 14 x 11".

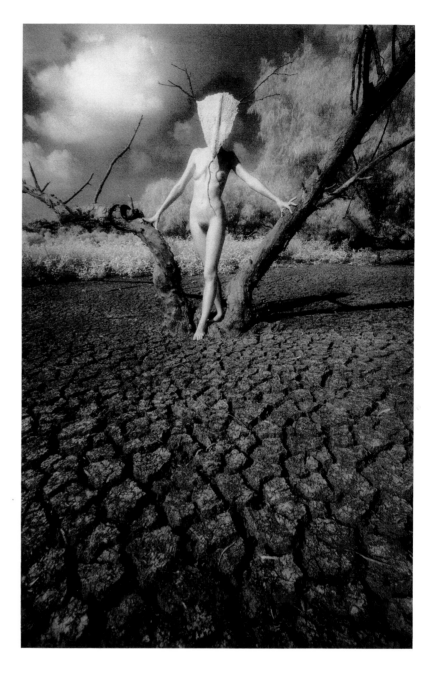

Kodak Kodalk	145 grains (10 grams)
Potassium bromide	7-1/2 grains (0.5 gram)
Cold water to make 32 ounces (1 liter)	

For commercial work, DK-50 is generally used without dilution. An average starting time would be 6 minutes in a tank or about 4 1/2 minutes in a tray at 68°F (20°C). For portrait work using tank development, DK-50 is often diluted 1:1 and used for about 10 minutes at 68°F (20°C). In a tray, it is used undiluted for approximately 6 minutes at 68°F (20°C).

Kodak D-76 Formula D-76 was introduced in 1927 as a fine-grain developer for motion picture and still-camera films. It remains popular with pictorial photographers for its ability to deliver full emulsion speed, its handling of low-contrast scenes, and its provision of maximum detail in shadow areas.

Water (125°F or 52°C)	24 ounces (750 milliliters)
Elon	29 grains (2 grams)
Sodium sulfite (desiccated)	3 ounces (100 grams)
Hydroquinone	73 grains (5 grams)
Borax (decahydrate)	29 grains (2 grams)
Cold water to make 32 ounces (1 liter)	

Average development time with D-76 undiluted in a tank is 8 to 10 minutes and in a tray 6 to 9 minutes at 68°F (20°C). With certain films, D-76 may be diluted 1:1 for greater sharpness and increased grain. Development time will be about 1 minute longer.

Kodak D-82 Formula D-82 is a high-energy formula for underexposed negatives. It provides the utmost density with a minimum of exposure.

Water (125°F or 52°C)	24 ounces (750 milliliters)
Wood alcohol	1-1/2 ounces (48 grams)
Elon	200 grains (14 grams)
Sodium sulfite (desiccated)	1-3/4 ounces (52.5 grams)
Hydroquinone	200 grains (14 grams)
Sodium hydroxide (caustic soda)	125 grains (8.8 grams)
Potassium bromide	125 grains (8.8 grams)
Cold water to make 32 ounces (1 liter)	

Caution: Dissolve sodium hydroxide only in cold water, as a great deal of heat is created when it is mixed. It is best to dissolve sodium hydroxide in a separate container of water and then add it to the solution after the hydroquinone. Stir vigorously.

Starting development time in a tank is 6 minutes and in a tray 5 minutes at 68°F (20°C).

Phenidone Developers

People who are allergic to Metol (Elon) should use phenidone developers, which produce results very similar to those produced by Metol developers. In combination with hydroquinone, a phenidone developer becomes a superadditive PQ formula. Unlike Metol, phenidone is actively regenerated by the hydroquinone, resulting in a developer that retains its activity longer.

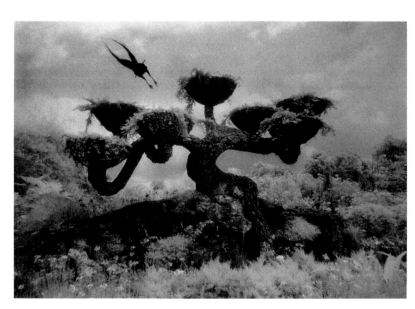

Figure 6.8 Winnett used infrared film, developed in D-76 (1:1), to reveal cloud detail on a hazy day. The film's fluffy rendition of live foliage lends an other-worldly look to the subject.

© Merry Moor Winnett. "Shangri-La," 1988. Gelatin silver print. 9 x 13-1/2".

The activity of phenidone is about ten times that of Metol. Phenidone developers produce a denser fog than Metol developers. Since the type of fog created cannot be eliminated with potassium bromide, an organic restrainer such as benzotriazole is used. The purpose of the potassium bromide in phenidone formulas is to stabilize the developer against the changes produced by the release of bromide during the development process.

Ilford Microphen Formula Microphen is a fine-grain phenidone developer that can also produce an effective increase in film speed without yielding a corresponding increase in grain size. Its high speed/grain ratio permits an increase of one-half f-stop without a change in the grain pattern. For example, HP5 can be rated at 650 ISO instead of 400.

Water (125°F or 52°C)	24 ounces (750 milliliters)
Sodium sulfite (anhydrous)	3 ounces (100 grams)
Hydroquinone	77 grains (5 grams)
Borax	46 grains (3 grams)
Boric acid (granular)	54 grains (3.5 grams)
Potassium bromide	15 grains (1 gram)
Phenidone	3 grains (0.2 gram)
Cold water to make 32 ounces (1 liter)	

Starting development times range from about 4-1/2 to 6 minutes at 68°F (20°C). Microphen can be diluted 1:1 or 1:3. The greater the dilution, the greater the acutance. Diluted developer works well for retaining key shadow and highlight details in subjects possessing a wide tonal range. Depending on the film and dilution of the developer, development times can range from 5 to 21 minutes, with an average being about 8 to 11 minutes, at 68°F (20°C).

Ilford ID-62 Formula ID-62 is a good general-purpose phenidone developer.

Stock Solution

Water (125°F or 52°C)	24 ounces (750 milliliters)
Sodium sulfite (anhydrous)	1-3/4 ounce (50 grams)
Hydroquinone	175 grains (12 grams)
Sodium carbonate (desiccated)	2 ounces (60 grams)
Phenidone	7-1/2 grains (0.5 gram)
Potassium bromide	30 grains (2 grams)
Benzotriazole	3 grains (0.2 gram)
Cold water to make 32 ounces (1 liter)	

For tank development, dilute 1:7 and develop 4 to 8 minutes at 68°F (20°C). For tray development, dilute 1:3 and process 2 to 4 minutes at 68°F (20°C).

Ilford ID-68 Formula ID-68 is a low-contrast, fine-grain phenidone developer.

Water (125°F or 52°C)	24 ounces (750 milliliters)
Sodium sulfite	3 ounces (85 grams)
Hydroquinone	75 grains (5 grams)
Borax	92 grains (7 grams)
Boric acid	29 grains (2 grams)
Potassium bromide	15 grains (1 gram)
Phenidone	1.9 grains (0.13 gram)
Cold water to make 32 ounces (1 liter)	

Use undiluted. Starting times for tank development are 7 to 11 minutes and for tray development 4 to 7 minutes at 68°F (20°C).

Ilford ID-72 Formula ID-72 is a high-contrast phenidone developer.

Water (125°F or 52°C)	750 milliliters
Sodium sulfite (anhydrous)	72 grams
Hydroquinone	8.8 grams
Sodium carbonate (monohydrate)	57 grams
Phenidone	0.22 gram
Potassium bromide	4 grams
Benzotriazole	0.1 gram

—OR—

Benzotriazole 1% solution	10 milliliters
Cold water to make 1 liter	

Use undiluted. Starting development time is approximately 5 minutes at 68°F (20°C).

POTA Developer

POTA is a very low contrast developer. It is used primarily at present to develop Kodak Technical Pan Film to normal contrast for general pictorial use.

Water (100°F or 38°C)	750 milliliters
Sodium sulfite	30 grams
1-phenyl-3-pyrazolidone	1.5 grams
(Ilford Phenidone-A or Kodak BD-84)	
Cold water to make 1 liter	

Use immediately, as the solution deteriorates very quickly after it has been mixed. Starting development times range between 11-1/2 to 15 minutes in a tank and 6-1/2 minutes to 8 minutes in a tray at 68°F (20°C).

Pyro Developers

Pyrogallol, known as pyro and pyrogallic acid, has been used as a developing agent since the 1850s. Pyro creates a yellow stain in proportion to the metallic silver formed in the negative. Wear protective gloves, as pyro also will stain your fingers and nails. This yellow stain will block some of the blue light during the printing process. Although the negative may look flat, it will print with good contrast. Pyro also has been useful in developing underexposed film because the stain reinforces the silver image enough to make the thin negative more printable. It is even possible to bleach the silver away and print only from the stain, yielding a very fine grain image. Pyro also has a tanning effect on the emulsion, hardening it during development. This reduces the lateral movement of the silver, producing a high degree of acutance. The tanning effect is more pronounced in fast, thick-emulsion films.

Pyro oxidizes swiftly. This can make it unpredictable when you are using the standard time/temperature method of development, as the amount of image stain depends on the degree of oxidation. For this reason, traditional workers, such as Edward Weston, developed the film by visual inspection under a faint green safelight. At present, pyro is not used very often. With fast, highly sensitive modern films, this process of visual inspection is not recommended, as the fog level might become too high.

Pyrocatechin (catechol) can be used with contemporary films to create a staining and tanning effect similar to that produced by pyro. It works well with fast, thick-emulsion films, especially when dealing with high-contrast scenes. It provides excellent separation in the highlight areas but reduces the speed of the film by about 50 percent. (See Color Plate III).

Figure 6.9 Using printing-out paper, which works well with a strong, contrasty negative (Tri-X at 100), Hunter achieved the results he wanted by using a modified Pyro ABC developer. This developer was a favorite when printing-out paper was most popular (1850 to 1920). The paper was exposed in sunlight until the highlights were slightly degraded and then fixed in two baths of rapid fix. The image was toned with gold chloride until the darkest shadows lost their green cast and took on a lavender color.

© Frank Hunter. "Methodist Church, Mexico, New York," 1986. Printing-out paper. 8 x 10".

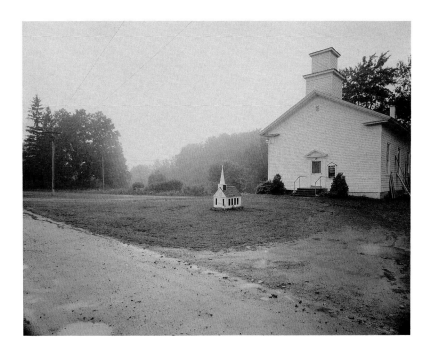

Kodak D-1/Pyro ABC Formula

Stock Solution A

Water (65°F or 18°C)	24 ounces (750 milliliters)
Sodium bisulfite	140 grains (9.8 grams)
Pyrogallol	2 ounces (60 grams)
Potassium bromide	16 grains (1.1 grams)
Water to make 32 ounces (1 liter)	

Stock Solution B

Water (65°F or 18°C)	24 ounces (750 milliliters)
Sodium sulfite (desiccated)	3-1/2 ounces (105 grams)
Water to make 32 ounces (1 liter)	

Stock Solution C

Water (65°F or 18°C)	24 ounces (750 milliliters)
Sodium carbonate (monohydrate)	2-1/2 ounces (90 grams)
Water to make 32 ounces (1 liter)	

Mix and use fresh developer immediately. For tray development, the normal dilutions are 1 part each of stock solutions A, B, and C with 7 parts water. Develop for 6 minutes at 65°F (18°C). With a tank, take 9 ounces (285 milliliters) of solutions A, B, and C and add water to make 1 gallon (about 4 liters). Develop for about 12 minutes at 65°F (18°C). To minimize oxidation, mix solution B, solution C, and the water and then add solution A immediately before using. If there is any scum on the surface of the developer, remove it with blotting paper before developing, or unwanted stains may result.

Pyrocatechin Compensating Developer Formula

Solution A

Water (68°F or 18°C)	100 milliliters
Sodium sulfite (desiccated)	1.25 grams
Pyrocatechin	8 grams

Solution B

Sodium hydroxide	1 gram
Cold water to make 100 milliliters	

Caution: Mix sodium hydroxide only in cold water.

Immediately before use, mix solutions A and B in the following proportions: 20 parts A and 50 parts B to 500 parts water. Starting development times are 10 to 15 minutes at 68° F (20° C).

Paraminophenol/Rodinal Developers

Paraminophenol, better known by its trade name, Rodinal, has been used as a developing agent since the 1890s. It can be prepared in a very concentrated solution that lasts for a long time and diluted with water to create an excellent general-purpose developer. When used with fast film having an ISO of 400 or more, Rodinal produces a visible but very tight, sharp-edged grain pattern.

Paraminophenol Formula

Stock Solution A

Boil 10 ounces (625 milliliters) of water, then allow it to cool for 5 minutes. Add a few crystals of potassium metabisulfite, then add the following:

Paraminophenol hydrochloride	384 grains (50 grams)
Potassium metabisulfite	2 ounces (150 grams)

Stir until dissolved.

Stock Solution B

Sodium hydroxide (caustic soda)	3 ounces (215 grams)
Cold water	8 ounces (500 milliliters)

Caution: Use cold water only.

Add 6 ounces (350 milliliters) of the B solution to the A solution, stirring constantly. A precipitate of the paraminophenol solution will form but will dissolve as more sodium hydroxide is added. Put in enough sodium hydroxide to almost dissolve this precipitate.

Add cold water to make 16 ounces (1/2 liter). Place in a tightly closed opaque bottle and allow to cool. If any of the paraminophenol crystallizes, add more sodium hydroxide to nearly dissolve it. It is necessary to leave some of the paraminophenol undissolved to make the developer work properly.

Mix 1 part of the bottled solution with 10 parts of water for use with negatives. Starting development times are about 6 to 10 minutes at 68° F (20° C).

Uncle Joe's Rodinal Formula This is a modified formula based on commercially prepared Rodinal that can deliver better performance in the highlight areas with contemporary films.

Water (70° F or 21° C)	350 milliliters
Rodinal	7 milliliters
Hydroquinone	1.3 grams, or 1 level film can capful
Water to make 500 milliliters	

This formula is for only one roll of film to be developed in a two-reel tank. For two rolls, double the amount of Rodinal and water and process in a four-reel tank. Starting development times at 70° F (21° C) are as follows: one roll of Plus-X or FP4, 11 minutes; two rolls, twelve minutes; one roll of Tri-X or HP5, about 15 minutes. Agitate the film for the first complete minute, then 10 seconds for each minute after, allowing the tank to stand still between agitations.

Why Bother?

You may ask, "Is all this really necessary? What difference does it make whether I know the components of a developer and how they work?" The information provided in this chapter increases your visual options. In many photographic situations, you cannot control the circumstances under which you make the picture. On the contrary, you are forced to work with conditions as you find them. This additional information will help you to make the most out of what has been dealt you. Mixing your own formulas is another way for you to educate yourself. This knowledge can give you the flexibility and power to repudiate conformity. It provides an alternative to mediocrity and stagnation by helping you realize the full potential of your vision. Strong feeling and passion are not enough to make the complete statement. Photographers also need craftsmanship and precision. The blend of spirit and knowledge can result in the organization of chaos, enabling photograpers to picture what is inside their hearts and minds.

Additional Information

Adams, Ansel. *The Negative*. Boston: Little, Brown, 1983.
DeCock, Liliane, ed. *Photo-Lab-Index, Lifetime Edition*. Dobbs Ferry, N.Y.: Morgan and Morgan, 1990.
Wall, E.J., and F.I. Jordan; rev. and enlarged by John S. Carroll. *Photographic Facts and Formulas*. Englewood Cliffs, N.J.: Prentice-Hall, 1976.

Chapter *7*

Polaroid Instant Films

Remember the first time you saw an instant photograph develop before your eyes? What did you think? Most of us thought it was an amazing and magical feat. Now that we have gotten more serious about photography, most of us tend to dismiss these instant adventures as kid stuff. We associate good photography with hard work. Our nose-to-the-grindstone mentality does not offer much opportunity for fun. But instant materials offer the expressive photographer a unique chance to be serious, have fun, and astonish—all at the same time without the need of a darkroom.

There are many advantages to working with instant materials. These are: no need for a darkroom or wet processing solutions; rapid feedback, allowing corrections and changes to be made while still shooting; a good way to test equipment, lighting, and subject poses; and a good icebreaker that can help establish a rapport between the photographer and the subject. Finally, instant pictures make great gifts for those who are working with you. (See Color Plate IV.)

On the downside is the fact that all the instant materials, except the Positive/Negative (P/N), are unique items. To duplicate them, you have to make copies. This is a problem because the emulsions of instant films tend to be very fragile and must be handled with care to avoid damage. Instant color films also are much slower than conventional films, and 35mm instant slide films tend to be grainier, less accurate in their color rendition, and designed for projection, rather than printmaking or critical viewing with a loupe. The additive screen in the 35mm color slide film adds neutral density and becomes quite visible at magnifications of 6X to 10X. These films often have a reduced brightness range, are not able to separate dark tones, and have very little margin for exposure error.

Despite these problems, the photographer who has studied these materials and their characteristics can use them to deliver exciting results. Learning to handle these materials provides the informed photographer with a greater selection of aesthetic possibilities to call upon when making photographic decisions.

The Polaroid 35mm Instant Slide Film System

Polaroid makes a compatible family of color, black-and-white, and special-purpose instant slide films that can be exposed in a 35mm camera. All these films are designed to be processed in the Polaroid AutoProcessor without using a darkroom or any wet solutions. Each roll of film is supplied with its own processing pack, which is placed in the processor with the film to carry out the processing operation. Each processing pack is labeled and color coded to match the film being processed. The pack contains a black polyester strip sheet that is coated with a jelly-like chemical reagent needed to process the film. All these films are intended for projection, but it is possible to make

Table 7.1 Polaroid Instant Slide Films

Film	Special Characteristics	Speed	Development Time*
PolaChrome	Pastel colors	ISO 40	60 seconds
HC PolaChrome	Highly saturated colors	ISO 40	60 seconds
PolaPan	Continuous-tone B&W	ISO 125	60 seconds
PolaGraph	High-contrast B&W	ISO 400	2 minutes
PolaBlue	Black reads as white; white reads as blue	ISO 8	4 minutes

*At 75°F (24°C).

prints or copies from them. Table 7.1 lists the special characteristics and speeds of the Polaroid instant slide films.

After exposing the instant slide film, leave the leader out of the cassette when rewinding the film. If you forget, use the special film retrieval device Polaroid provides to fish the leader out. The leader of the film and the chemical pod strip sheet leader must be joined together in the AutoProcessor before processing can take place.

The AutoProcessor is available in manual and electric versions. Read the directions for exact operating instructions of each model. Regardless of which processor you use, the basic operations are the same. Place the processing pack in its designated slot in the processor and attach the chemical pod strip sheet leader to the take-up spool. Place the film cassette in its designated slot and attach the film's leader to the take-up spool directly on top of and in contact with the chemical strip sheet. Close the lid, breaking the chemical pod seal, and wind the film and chemical strip sheet together onto the spool. (An electric processor will automatically wind it.) During this operation, the processing fluid evenly coats the strip sheet, which is then laminated onto the exposed film.

After the proper amount of development time has elapsed, 1 to 4 minutes depending on which film is being used, rewind the film and the strip sheet coated with the processing fluid back to their original positions. (Again, an electric processor will automatically rewind the film and the strip sheet.) This separates the strip sheet from the film and returns the strip sheet to the processing pack. This step strips off the upper emulsion in all the films except PolaBlue. During this last procedure, the fully processed film is simultaneously rewound into its cartridge. It is dry and ready for immediate viewing, cutting, and mounting.

How Polaroid 35mm Instant Slide Films Operate

The Polaroid 35mm instant slide films, with the exception of PolaBlue, work on the silver diffusion-transfer process as used in the Polaroid peel-apart films. PolaBlue is a chromogenic dye-coupled film and is described later in this chapter.

The Diffusion-Transfer Process

In the diffusion-transfer process, the exposed light-sensitive silver halide grains travel through a thin liquid layer to a different layer. The grains that have been exposed are changed to silver. The unexposed grains are dissolved and migrate to the top image-receiving layer. During the final processing step, the exposed silver halides are stripped away from the film. With PolaPan and PolaGraph films, a clear base provides a black-and-white silver image. In PolaChrome, the amount of developed silver halide behind the single layer of red, green, and blue stripes making up the additive line screen forms the colors.

Exposure Latitude

Exposure with all these films is critical. The color and continuous-tone black-and-white films have an exposure range of about plus or minus one-half f-stop. Overexposure washes out detail and/or color, while underexposure produces a loss of shadow detail and an increase in grain size. PolaGraph and PolaBlue, both high-contrast films, have even less exposure latitude, about plus or minus one-third f-stop.

When using any of these materials for the first time, bracketing in one-half or one-third f-stop increments is highly recommended. Keep a record of the exposures and their results. Apply what you have learned the next time you encounter a similar situation to reduce the need for bracketing.

Metering Problems

The high reflectivity of the base side of these instant film emulsions precludes their use with off-the-film (OTF) metering systems. Camera meters can be used in any mode, such as TTL (through-the-lens), except OTF. If your camera only uses OTF metering, Polaroid provides a set of ISO compensations to correct this problem.

At this time, none of these instant slide films are DX coded. Thus, they can be used only in cameras with manual ISO film speed settings.

Film Curl

The Polaroid instant slide films have a thinner emulsion than conventional films. When the relative humidity drops below 30 percent, these films may curl slightly in the camera, reducing image sharpness. You can compensate for this by avoiding using the lens's maximum aperture under these conditions. It is advisable to close down the lens aperture at least two f-stops from wide open to reduce any focus error due to film curl.

Development Times

The standard development times in the Polaroid processor vary from 1 to 4 minutes at 75°F (24°C) depending on the film being used. Many photographers like to extend the development, as underdevelopment produces grainy, muddy results. These films seem to be able to tolerate development times up to 30 minutes with no ill effects.

Temperature Range

The standard development temperature is 75°F (24°C). Variations in the temperature cause changes in the contrast and color balance of these films. A cooler than normal developing temperature produces an increase in contrast, loss of shadow detail, and general color shift in the cool (blue) direction. Increasing the processing temperature results in a reduction in contrast, a color shift in the warm direction, and a weaker maximum black.

Mounting

Since these films have a thinner and more delicate emulsion than conventional films, they are more susceptible to creasing and scratching. Thus they need to be handled with a little more care. Polaroid makes special clip-down slide mounts for these materials. Avoid using slide-in mounts, as they have a tendency to damage the emulsion layer.

Viewing

All these films should be projected for accurate viewing. Under casual viewing, the heavier base density of the PolaChrome film makes them appear underexposed with a bluish magenta cast. Viewing PolaChrome with a loupe will reveal its line screen.

Storage

All these films can be refrigerated before and after exposure but do *not* freeze them. Development should be carried out as soon as possible after exposure.

Polaroid 35mm Instant Slide Film Types

PolaChrome

PolaChrome is an additive color, line-screen, daylight-balanced slide film with an ISO rating of 40 in daylight and 32 with tungsten light. It is available in 12- and 36-exposure loads and is intended for projection viewing. The grain pattern is coarse, similar to very high speed conventional color films. If prints are made, the grain and screen start to become noticeable at enlargements of about 5 x 7". Single-tone and shadow areas reveal more graininess. Underexposure and underdevelopment also increase the film's graininess. Contrast is similar to that of conventional slide films having the same ISO rating, but PolaChrome does not separate shadow detail clearly, especially in contrasty lighting situations.

How PolaChrome Records Color Conventional chromogenic color films have three separate emulsion layers to record the red, green, and blue parts of the visible spectrum. These are used to form complementary (opposite) dyes of cyan, magenta, and yellow during the development process. When white light passes through the developed film, each layer passes only its own color and subtracts its opposite, or complementary, color. After the correct amounts are subtracted, the remaining light, which passes through the slide, recreates the scene in its original colors. This is known as the *subtractive process*, and most conventional color films use it. Polaroid is an exception.

PolaChrome recreates the color spectrum by using the *additive process*. PolaChrome has only one light-sensitive layer, which is coated with a microscopic pattern of red, green, and blue (RGB) filter stripes. The width of each stripe is about 0.0003 inch. There are about 1,000 of these RGB triplets per inch. The human eye cannot differentiate the separate colors easily and blends the various combinations of stripes into areas of unbroken color. The individual stripes do start to become visible at magnifications of 6X to 10X. An average combination of screen width and viewing distance gives a typical slide projection of about 2X to 4X, so the stripes are not very detectable by the human eye.

Unlike conventional film, PolaChrome's base side, on which the screen is coated, faces the lens of the camera during exposure. Directly behind this screen is a single panchromatic light-sensitive silver halide emulsion. During exposure, the RGB color stripes, which make up the screen, filter the light before it strikes the emulsion. After the film is processed, these same RGB stripes filter the light during viewing, adding the proper amounts of red,

Figure 7.1 Erikson brackets her exposures to achieve a distinctive PolaChrome look. To protect PolaChrome's fragile surface, she glass-mounts the images as soon as they have been processed. Images to be printed are copied on color duplicating film to eliminate some of the problems caused when printing through the film's additive line screen. From these dupes, straight prints are made on Cibachrome material.

© Wendy Erickson. "Dahlia," 1987. Cibachrome print. 16 x 20". Original in color.

green, and blue light needed to recreate the scene in color. The amount of developed silver halide behind each stripe determines the amount of light it passes during viewing. This method is known as the additive line-screen process.

A History of the Additive Screen Process In 1861, James Clerk Maxwell, the noted Scottish scientist, made the first color photograph based on the additive process. This was accomplished by photographing a tartan ribbon three separate times through three individual filters (blue-violet, green, and red) on three different pieces of black-and-white film. These three separate images were projected, each by its own projector, in register through the same colored filter used to make the original exposure.

In 1869, Louis Ducos du Hauron, a French scientist, proposed an additive line-screen method consisting of ruled lines in the primary colors that would act as filters to make a color picture in a single exposure instead of three. By 1896, Charles Jasper Joly, a Dublin doctor, had introduced Joly Color, the first line-screen process for additive color photography. This process is the forerunner of the current PolaChrome process. The width of each of the RGB stripes on today's PolaChrome is about 100 times narrower than Joly's 1896 configuration.

Color Quality PolaChrome has a distinctive color palette that is unlike that of any of the conventional slide films. In comparison with these films, PolaChrome tends to produce soft pastel colors. Red and orange are more exaggerated, while yellow appears as a weak, flat ocher. Blue and green reproduce quite well. The overall effect has been compared with that of the early Autochrome process. If enlarged prints are made from PolaChrome, the screen becomes evident and complementary colors tend to break up into closely packed clumps, creating the look of a pointillistic painting.

Exposure PolaChrome performs well in flat light, having a brightness range of about three f-stops between the key shadow and key highlight areas. In average daylight conditions, which possess about a seven f-stop brightness range, PolaChrome will have a useful exposure latitude of about plus one f-stop overexposure and minus one-half f-stop underexposure. Unlike conventional slide material, PolaChrome is generally not underexposed, as doing so increases its graininess and blocks shadow detail. Many photographers change the ISO from 40 to 32 or 25, slightly overexposing the film.

Contrast Scenes containing a brightness range of seven f-stops or more can be problematic. PolaChrome possesses about one and a third f-stops less ability to record shadow detail than normal color slide film, causing it to render dark tones as black. To get around this problem, try moving the subject completely into the sun or shade. You can also block direct light with a board or diffuse it with a piece of white, loosely woven material. You can use electronic flashfill or a reflector board to add more light in the shadow areas. On the positive side, this effect can be used to make a brightly lit subject pop out from a dark background. Bracketing in contrasty light is recommended.

Filters Conventional filters can be used to make changes and corrections with PolaChrome. This film is very sensitive to ultraviolet (UV) light. A UV filter or Wratten No. 1A filter is suggested for all outdoor and electronic flash work. To eliminate the bluish cast of photographs made on overcast days, in open shade, or of large expanses of mountains or water, use a Wratten No. 81 filter.

Unlike regular color slide film, PolaChrome shows no color shift due to reciprocity failure at exposures of 1/30,000 second to 20 minutes. With a conventional color slide film, each of the different-colored emulsion layers pos-

sesses varying reciprocity characteristics. Very brief or long exposures affect each layer differently, causing an overall color shift. Since PolaChrome has only one light-sensitive layer, it does not have this problem.

PolaChrome does require an increase in exposure with shutter speeds of one-eighth second or longer. Table 7.2 lists recommended corrections for reciprocity failure with PolaChrome.

Table 7.2 Reciprocity Corrections for PolaChrome

Indicated Exposure	Aperture Adjustment **	Corrected Exposure**
1/4 second	+ 2/3 f-stop	1/2 second
1/2 second	+ 1 f-stop	1 second
1 second	+ 1 f-stop	3 seconds
2 seconds	+ 1-1/3 f-stops	6 seconds
4 seconds	+ 1-2/3 f-stops	20 seconds
8 seconds	+ 2 f-stops	60 seconds

*No color filtration correction is needed.
**Use either the aperture adjustment or the corrected exposure, but not both.

HC PolaChrome

HC (high-contrast) PolaChrome is made from the same emulsion as regular PolaChrome. The higher contrast is achieved by altering the reagent (processing fluid) in the processing pack. It was designed primarily for copying charts and computer screens but can be applied to other picture-making situations in which highly saturated colors are required. This film produces a more intense, bold palette. The colors have a deep, flashy look similar to that of fresh acrylic paint. You might want to consider using HC PolaChrome in flat lighting situations or anytime you wish to create nonnaturalistic color effects. HC comes in 12-exposure rolls and has a standard development time of 2 minutes at 75°F (24°C).

PolaPan

PolaPan is a continuous-tone black-and-white instant slide film. It has an ISO of 125 in daylight and 80 with 3,200K tungsten light sources. The film's rapid feedback time makes it ideal for use in the following situations: photojournalism; teaching photography; testing equipment, lights, and the general setup; making copy slides of original work; and taking images from a computer screen. PolaPan does not use a screen of color filter stripes to produce an image. It is available in 36-exposure cassettes and has a standard development time of 1 minute at 75°F (24°C).

PolaPan shares PolaChrome's limited exposure and brightness range. It is advisable to give dark subjects one to two f-stops more exposure than the meter or gray card indicates to retain detail in the shadow areas. Underexposure increases graininess, blocks shadow detail, and washes out highlights. PolaPan has an exposure latitude of about plus one f-stop overexposure and about minus one-half f-stop underexposure. For critical work, bracketing in one-half f-stop increments is suggested. PolaPan exhibits reciprocity failure with exposure times of 1 second or longer. Table 7.3 lists corrections for these situations.

You can manipulate the grain pattern of PolaPan to create a gritty, expressionistic feeling by increasing the development temperature. Decreasing the temperature increases contrast. Filters can be used as with any conventional black-and-white film. PolaPan is capable of delivering an excellent range of tones possessing a deep, rich black with good highlight detail as long as contrasty scenes are avoided or corrective action is taken.

PolaGraph

PolaGraph is a high-speed, high-contrast black-and-white positive film. It has an ISO of 400 in daylight and 320 with 3,200K lights. PolaGraph's image formation and development are similar to those of PolaChrome, except it does not use a screen to form the image. It is available in 12-exposure loads and has a standard developing time of 2 minutes at 75°F (24°C).

This film was designed to make slides of graphic originals such as line art, text, charts, pen-and-ink drawings, engravings, and woodcuts. It also can be used to convert continuous-tone subjects into high-contrast graphic images. PolaGraph generally produces no gray tones, just very dense black images on a clear base. Very low contrast subjects can, however, be reproduced with limited shades of gray. More graphic results can be produced by lowering the ISO to 200 in daylight and 100 in tungsten. Striking results can be obtained by printing these images on color paper, adjusting the filter pack on your color enlarger to alter the color effects. PolaGraph also can be used as an intermediate copy step when making slide sandwiches or posterizations or with other printmaking techniques such as photo silk-screening.

PolaGraph's high speed invites the photographer to take this film into the field. Average- and low-light situations with compositions emphasizing simple forms offer exciting starting points for experimentation.

The exposure range of PolaGraph is extremely critical and totally unforgiving. The narrow exposure latitude tends to block highlights and produce a pure black in the shadow areas. Bracketing is almost essential until you gain some experience with the film. PolaGraph will behave like conventional panchromatic films when filters are used. The reciprocity characteristics of PolaGraph are the same as those of PolaPan. For correction information, see Table 7.3.

When copying an original work, place an 18 percent card temporarily over the work to make an initial exposure reading. Do not meter directly off the original, as large areas of dark or light will give a faulty reading. In difficult situations, bracketing will ensure good results. Make the indicated exposure and then bracket in one-third f-stops. Plus or minus one f-stop, depending on whether you want the image darker or lighter, is usually sufficient.

PolaBlue

PolaBlue is a high-contrast, white-on-blue negative film designed to produce white artwork on a blue background. This film renders a light background from original flat art as blue and the lines as white. It is an orthochromatic film (not sensitive to red). PolaBlue has an ISO of 8 with an electronic flash or daylight and an ISO of 4 with 3,200K tungsten light. It comes in 12-exposure cartridges and has a standard developing time of 4 minutes at 75°F (24°C).

The slow speed of this film makes it suitable for use with a copy stand or tripod. It is not intended for general-purpose photography but for making copy slides of graphs and type. PolaBlue also can be used as an instant cyanotype or blueprint process. Negative prints can be used to create a final positive image with this material by enlarging a positive (slide) on black-and-white paper. When this positive is copied onto PolaBlue, it will be reversed to give a graphic image that reads correctly.

Table 7.3 Reciprocity Corrections for PolaPan and PolaGraph

Indicated Exposure	Aperture Adjustment
1 second	+ 2/3 f-stop
10 seconds	+ 1 f-stop
100 seconds	+ 2 1/3 f-stops

Figure 7.2 Using symbols and history, Campbell comments on the contradiction of our society's simultaneous acceptance and rejection of irrational phenomena. This image is part of a triptych pieced together from 20 x 24" Polaroid prints. Life-size backdrops were painted for the models, and their clothing was dyed or chosen to match or complement the colors in the painted image. Before exposure, a piece of glass selectively covered with Vaseline was placed in front of the lens so certain areas would be blurred. During exposure, the scene was flashed and the shutter was held open manually for a few seconds as the model swayed to soften the flash effect. Polaroid material allowed Campbell to ascertain whether her ideas were being recorded successfully.

© Kathleen Campbell. "Triptych: Ominous Prophecy: Part One," 1988. Polaroid prints. 20 x 24"(entire piece 48 x 60"). Original in color.

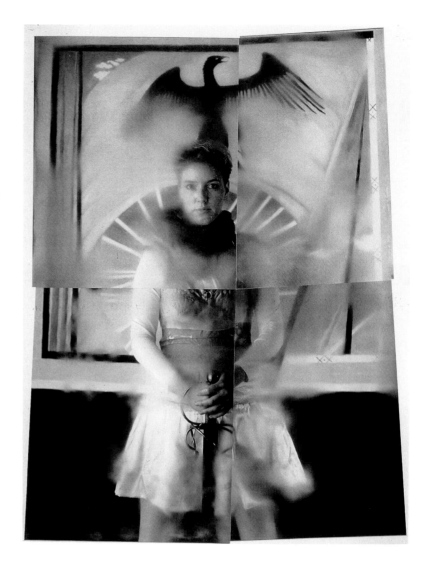

PolaBlue, like all high-contrast films, has a limited exposure latitude. When copying, the type and age of the lights, the amount of magnification, and the contrast and colors of the original can affect the exposure. Take a light meter reading with a gray card and bracket in one-half f-stop increments. Exposure times of 10 seconds or longer will cause reciprocity failure. Additional time will be needed to compensate. Table 7.4 lists suggested corrections.

Table 7.4 Reciprocity Corrections for PolaBlue

Indicated Exposure	Aperture Adjustment*	Corrected Exposure*
10 seconds	+ 1/2 f-stop	15 seconds
100 seconds	+ 1 f-stop	180 seconds

*Use either the aperture adjustment or the corrected exposure, but not both.

Other Polaroid Materials

Polaroid produces about 40 different instant print and transparency films that have been designed for exposure in a special Polaroid film back. The most widely used of these films are those that can be exposed in 4 x 5" and 8 x 10"

view cameras. There are also special film backs that allow the exposure of instant materials in roll film cameras. Polaroid also makes instant films in sizes up to 20 x 24". The company has studios and cameras that photographers can rent or use under a Polaroid grant program. (See Color Plate IV).

Polaroid instant films are not typical of the materials most photographers are accustomed to working with. While they may not be your standard everyday materials, the thoughtful photographer can use them to travel in directions not possible with conventional films. Direct experience is the best way to discover whether any of these films can help you achieve your photographic goals.

Instant Color Print Films

The Polacolor 50 Series (4 x 5" sheets) and the Polacolor 800 Series (8 x 10" sheets) are daylight balanced with an ISO of 80 and have a standard developing time of 60 seconds at 75°F (24°C). The 8 x 10" format requires its own special Polaroid processor.

Instant Black-and-White Films

Polaroid offers a variety of black-and-white films in the 4 x 5" format. High Speed Print Film (Type 57) has an ISO of 3,000 and a standard development time of 15 seconds at 75°F (24°C). This is an excellent general-purpose high-speed film. Fine Grain Print Film (Type 52) has an ISO of 400 and the same development time as Type 57. This product has good speed and a wide tonal range with fine detail. Fine Grain Print Film (Type 53) possesses an ISO of 800 with a standard development time of 30 seconds at 75°F (24°C). It offers one f-stop more exposure than Type 52 and an increase in contrast. High Contrast Print Film (Type 51) is an orthochromatic film with an ISO of 320 in daylight and 125 in tungsten. It has a standard development time of 15 seconds at 75°F (24°C). This blue-sensitive film produces an excellent high-contrast graphic image.

Positive and Negative Film

One of the more interesting and versatile materials produces a black-and-white positive and negative. Polaroid Positive and Negative (P/N) Film (Type 55) has an ISO of 50 and a standard development time of 20 seconds at 75°F

Figure 7.3 Often working around people whom he does not know, Stone appreciates Polaroid's Positive and Negative Film. In twenty seconds, he has a small print and a negative against which he can check his expectations. The print can be shared or given away to his subject, thus taking the subject into the process. The final image pays homage to the family album, with its handwritten titles giving the specific location and circumstance of the photograph.

© Jim Stone. "Cajun with Homemade Christmas Decorations: Bayou LaFourche, Louisiana," 1983. Gelatin silver print. 20 x 24".

Figure 7.4 Originally, Zelle used single images, which served as stopping points within the flow of time and heightened the interaction of movement within time and space. Working with three images allowed her to develop more complex images of visual/conceptual movement. The subtle echo of religious imagery suggested by the triptych form makes modern icons out of contemporary objects. Since the images were made in cold weather, Zelle developed the SX-70 prints in her shirt pocket, using her own body heat to increase color saturation.

© Ann Zelle. "From the Series: Baltimore Days," 1982–83. Polaroid SX-70 prints. 10 3/4 x 3 1/2". Courtesy of the Collection of Elizabeth Hess. Original in color.

(24°C). The processing of this material is different from that of other instant films in that the negative must be cleared in a sodium sulfite solution, then washed and dried before printing. (Polaroid provides the chemical with the film.) The negative can be stored for up to 72 hours in a holding tank before it is dried. The sodium sulfite removes the processing gel and makes the image visible.

Polaroid P/N film can be archivally processed. After the sodium sulfite bath, the printmaker fixes the negative for 2 minutes in a rapid acid-hardening fixer and then continues to process the film following the same procedures as are used in regular black-and-white archival film processing.

The problem with this film is that the perfect exposure may be slightly different for the negative and the print, with the negative sometimes requiring more time. The negative is more fragile than a conventional film negative and must be handled carefully. These negatives can deliver beautiful prints and can be used in many nonsilver processes.

Polaroid Camera Systems

The SX-70 and Spectra systems are examples of Polaroid products that require the use of a Polaroid camera if they are used as Polaroid intended. These instant systems should not be ignored. Photographers such as Ansel Adams have used the SX-70 very successfully.

One of the more unusual applications of the self-developing SX-70 film is its ability to be manipulated following exposure. After the film is exposed and ejected from the camera, you can use a stylus to move the still-malleable emulsion. Almost any object can serve as a stylus, from a coin to a pencil or a piece of bone. This permits you to participate in altering the physical and visual reality of the image.

Additional Information

Books

Hirsch, Robert. *Exploring Color Photography.* Dubuque, Iowa: Wm. C. Brown Publishers, 1989.

Leftkowitz, Lester. *Polaroid 35mm Instant Slide System: A User's Manual.* Stoneham, Mass.: Focal Press, 1985.

Other Source

To obtain information about Polaroid products, call 1-800-343-5000 from 8:00 A.M. to 8:00 P.M. EST Monday through Friday. You can also request a copy of Polaroid's *Instant Projects* for ideas on how to use Polaroid materials.

Chapter *8*

Printmaking: Equipment, Materials, and Processes

The Printmaking Process

The printing process offers the photographer countless ways of interpreting what has been recorded on film. It is not a mechanical process of simply translating what is on the negative into a print. The negative is only a point of departure. It provides the photographer with the ingredients to prepare the final product. If nine different photographers were given the same negative to print, the chances are nine different renditions would be made. Ansel Adams once said that "the negative is like a musical score and the print is the performance." What has been recorded on the negative is like an unborn child. When the photographer makes a print from the negative, it begins a life of its own.

The negative provides the basic construction and information for the creation of the print. Although printing offers the photographer a second chance to correct for technical errors in exposure and processing, defects such as poor lighting or unsharp focus cannot be corrected. More importantly, however, printing gives photographers the opportunity to express themselves further by defining their relationship to and with the subject.

Some photographers, such as Henri Cartier-Bresson, do not make their own prints but direct others to carry out this process. For most photographers, this is not an acceptable procedure. The act of printmaking offers them the final degree of personal satisfaction in dealing with the subject. Printmaking means taking control, making decisions, and becoming physically involved in the process of determining the final outcome of the image.

The printmaking process is the bringing together of all a photographer's ideas, knowledge, equipment, and technique in an attempt to express what was seen and felt in a concrete form. A good print demonstrates both the objective and subjective experience, conveying a sense of the physical reality and the photographer's reaction to it. Good printing reflects a combination of technical knowledge, practice, and patience and is constantly open to reevaluation.

Styles in Printmaking

Beginning in the 1930s and going through the late 1960s, the "straight" aesthetic dominated printmaking. The straight style is reflected in the work of photographers such as Paul Strand, Edward Weston, and Ansel Adams. Generally, their prints are made on a silver-based glossy paper from a negative that is not altered except to correct for technical shortcomings. Their prints express a complete range of clearly separated tones, which reveal form and texture in the key highlight and shadow areas.

Figure 8.1 The style of printmaking must fit the subject and the photographer. Levitt's straightforward approach was the ideal way to translate what she saw and felt into a concrete form that could be shared with others.

© Helen Levitt. "New York," 1940. Gelatin silver print. 11 x 14". Courtesy of Laurence Miller Gallery, New York.

A movement in alternative printmaking, started in the 1960s, has expanded the definition of good printmaking. The alternative printmakers revived old processes and experimented with new ones. They used different types of paper and emulsion, manipulated the negative for subjective reasons, combined photography with other media, and in general dispensed with the rules of what was considered acceptable. This chapter deals with the printing of traditional silver-based materials. The other styles of printmaking are discussed in later chapters.

Learn What Is Available

It is important for photographers to become acquainted with all the avenues available to express their vision. Imagine how boring it would be if all photographs were required to be printed according to the same set of guidelines. Tremendous visual possibilities lie in producing quiet, soft, subtle prints with a limited range of tones. In other cases, snappy renditions with strong contrast, stressing deep blacks and solid whites, may be required. It is up to

the photographer to decide which style best expresses the sentiments of the situation.

There is no right or wrong style of printmaking. The photographer needs to make prints in a variety of ways to expand his or her personal expression. Printmaking is a highly personal and subjective response to the factual and emotional experience of the subject. It is unlikely that a photographer's response to a negative will remain the same over a period of time. An actor's performance in the same role will vary every time it is given. The aesthetic and emotive relationship of the photographer to the negative will alter his or her response every time a print is made.

You become a good printer by printing. This involves making lots and lots of prints to see what happens. The best way to see visual possibilities is to make one more print and compare it with the previous ones. This means following through with additional ideas. Becoming a good printer means overcoming fears and prejudices, temporarily suspending judgment, and trying a different approach to see what occurs. In black-and-white printing, the amount of sensitivity displayed in rendering the scale of tones in relation to the aesthetic and emotive concerns of the subject determines how well the print succeeds.

The best printmakers learn all they can about their craft and then they forget it. This means they have mastered and can control the process but are not bound to a set of established rules. Good printers use their knowledge as a point of departure to travel into the unknown. Nietzsche said, "The powerful man is the creative man, but the creator is not likely to abide by the previously established laws." A good printmaker is like a magician who is able to amuse, amaze, astonish, enchant, and reveal.

To help ensure that you do not overlook any possibility, inspect your negatives on a light table and make a contact sheet. Closely examine the contact sheet and select the negatives you want to print. In the darkroom, through visual trial and error, make a series of test prints to determine the correct exposure time for the grade of paper that will yield the desired amount of contrast. Generally, a properly exposed negative having good shadow detail provides the information needed to permit a successful visualization of the subject. Continued difficulties with weak, underexposed negatives indicate the need to (1) make sure all equipment is functioning properly; (2) review exposure methods; and (3) go over film processing procedures. Without a good negative, printmaking becomes a difficult, joyless chore.

What Makes a Good Printmaker?

Good printmakers retain their sense of wonder. They continue to get a thrill every time the image emerges in the developer. For them it is more than completing the process of transforming negative tones into positive ones. It is a flexible, creative, and expressive act that requires thought, feeling, and control. The camera provides the appearance of the subject, and the intelligent printmaker supplies meaning and emotion. Good printers are dreamers and risk takers. They are the people who find ways to breathe life into the image so the viewer can interact visually, intellectually, and spiritually with it. Printmaking is an art that blends concrete technical processes with subjective feelings. If a print is lacking in one of these areas, it will not be successful.

The technique is not difficult to learn and can be mastered with practice, patience, and discipline. Finding the inner voice to express yourself is a much more complex matter. In photography, it means listening to yourself and then pursuing that direction by exposing film and making prints. The key is to devote the time needed to explore these inner processes.

As you gain printing experience, you will acquire items of personal preference. There is no need to rush out and buy everything at once. Find out exactly what you need before making any purchases. Do not get carried away.

More equipment will not necessarily make you a better printer or produce a more powerful image. If lack of specific equipment is preventing you from producing photographs, however, you must acquire what is necessary to make the image. The printmaker's job is to find the way to give form to the dream that is encapsulated in the negative.

Printing Equipment

The Enlarger

The enlarger is the most important instrument in most photographers' darkrooms. Considerable thought should be given to the following items when choosing an enlarger.

Size The size of an enlarger refers to the maximum negative size it can enlarge. Enlargers are widely available in sizes from 35mm (24 x 36mm) up to 8 x 10" (20.3 x 25.4cm). When purchasing an enlarger, you must choose a machine capable of handling the largest negative that you anticipate using. A 4 x 5" enlarger is generally a good investment because it is versatile and allows you room to work with all the widely used negative sizes. Even if you plan to work only with roll film, a larger format enlarger can ensure uniform light coverage of the negative. Some enlargers have a falloff of light in the corners when used with their maximum negative size.

Illumination Any size of enlarger can distribute light evenly across the negative in a number of different ways. The two major methods are the condenser and the diffusion systems.

In a *condenser system*, the illumination generally comes from one very bright tungsten bulb, which may be frosted to reduce contrast. In the better systems, the light is focused through plano-convex lenses, with the convex sides facing each other. The lenses focus the light into straight parallel lines known as a collimated beam. A condenser enlarger provides greater image sharpness and contrast than a diffusion enlarger. Many 35mm photographers prefer this system because of its ability to retain image sharpness at high levels of magnification. Condenser enlargers generally form brighter images and thus provide the fastest exposure times.

The disadvantages of condenser systems include the fact that any defects in the negative, as well as grain and dust, are emphasized in the print. There also can be a loss in tonal separation in the highlight areas due to the Callier effect.

The *Callier effect* refers to the way the light is scattered by the silver grains that form the image. In a condenser system, the highlights of the negative, which have the greatest deposits of silver, scatter and lose the most light. The shadow areas, having the least amount of density, scatter the least amount of light. The net effect is that the upper highlight values can become blocked and detail is lost. The Callier effect also accentuates the differences between the shadow and highlight areas, delivering a print with greater contrast.

The degree to which this effect is revealed in the print varies widely due to differences in the design of the various enlargers. The Callier effect is not as noticeable in films with a thin emulsion. It is almost nonexistent in chromogenic films, which form the final images with colored dyes instead of silver.

To compensate for the Callier effect when printing with a condenser system, some photographers reduce the development time slightly. This produces more separation in the highlight areas. If the development time is reduced too much, there will be a loss of separation in the lower shadow tones.

Figure 8.2 Walsh developed his Ilford FP-4 in Rodinal (1:50) because he likes the tightly patterned, sharp-edged grain this combination produces. Hydroquinone was added to boost the negative's contrast to the proper level for his cold light enlarger and a grade 3 paper. These methods deliver a snappy print with a long, smooth tonal range. The cold-light minimizes the effects of dust and other minor imperfections in the negative, thus reducing the need to spot the print.

© Joseph Walsh. "Untitled," 1983. Gelatin silver print. 9-1/2 x 11-1/2".

In a *diffusion system*, the illumination is diffused. The most popular diffused-light source is the cold light. It consists of a fluorescent grid or tube that is situated behind a diffusing screen. The cold light produces very smooth, uncollimated light, which is not affected much by the Callier effect. This enables the upper highlight areas to be printed without blocking up. Also, since the cold light does not produce much heat, there is no problem with negatives buckling. The cold light tends to minimize the effect of dust and minor imperfections in the negative, thus reducing the amount of spotting required in making the print.

Cold lights require their own transformers and are extremely sensitive to voltage fluctuations and temperature changes. A voltage stabilizer or a light-output stabilizer, which monitors the intensity of the tube and automatically adjusts it, is recommended to make printing more consistent. Certain solid-state digital timers cannot be used with cold lights because the surges of current produced by the tube can damage the timers. Diffusion systems that operate with tungsten bulbs help you avoid these difficulties, but they tend to produce enough heat to cause buckling with larger negatives.

Diffusion systems are generally slower than condenser systems, and they require a longer exposure time. Prints made with a diffusion enlarger also tend to appear less sharp. Diffusion models work best with larger negatives, when sharpness is not as important. Compared to a condenser, a diffusion enlarger will reduce overall contrast. A cold light tends to lower contrast in the shadow areas. This effect is not as noticeable with diffusion systems using incandescent bulbs.

Both condenser and diffusion systems offer advantages and disadvantages. Ideally, it would be great to have access to both types. When the opportunity presents itself, try out both systems and see if your aesthetic and technical considerations are fulfilled more by one system than the other.

Negative Carriers The negative carrier is made to hold the negative flat and parallel to the enlarging lens. There are two basic types of carriers: glass and glassless. A glassless carrier is most often used with negative sizes up to 4 x 5". A glass carrier is usually recommended with negative sizes of 4 x 5" or larger to make sure that the film remains flat. Two advantages of glassless carriers are that you only have to worry about keeping the two sides of the

negative (rather than the four additional surfaces of the two pieces of glass) from collecting dust and also that there are no Newton rings to worry about.

Newton Rings Newton rings are the iridescent concentric circles that occur when the film and glass are pressed together with an uneven amount of pressure. They are caused by the interference effect of light reflecting within the tiny space between the glass and the base side of the negative. They do not occur between the glass and the emulsion side of the film. Changing the amount of pressure between the glass and the negative should cause the Newton rings to disappear. Some photographers have reportedly solved this problem by gently rubbing the glass surface of the negative carrier with jeweler's rouge to roughen the glass. An unexposed sheet of Kodak Translite Film (available only in 8 x 10" sheets) can be fixed, washed, cut to size, and placed between the glass and the negative to eliminate this problem.

Negative Curl Most negatives will curl slightly toward the emulsion side. This can cause the image to be slightly less than sharp. You can correct this by stopping the lens down to a smaller aperture to increase the depth of focus.

Negative Pop If the enlarger light is left on for a long time during composing and focusing, the negative can overheat and pop up, changing its position. If this happens, let the negative cool down and refocus.

Enlarging Lenses Enlarging lenses need to be sharper than camera lenses to resolve the grain or dye pattern in the film during printing. A typical 35mm camera lens may record 100 line pairs per millimeter (lp/mm) of information on the film, while a good enlarging lens is capable of resolving 300 lp/mm. This translates into better grain definition, meaning sharper prints and clearer separation of tonal values. The higher resolving power of an enlarging lens also enables it to outperform most camera lenses when doing flat copy or macrophotography. Adapter rings are available to mount enlarging lenses on cameras for such purposes.

Field Flatness The characteristics that make a good enlarging lens are not the same as those that determine a good camera lens. Since the negative and paper are flat during the exposure of the print, a good enlarging lens needs to have a flat field of focus. The problem is that the field curvature of a lens changes with distance, meaning a lens can have a truly flat field at only one distance.

Most camera lenses can tolerate some field curvature, but enlarging lenses cannot. A camera lens typically has a flat field of focus at about thirty feet. The average enlarging lens has a flat field at a magnification of about 4X, with an acceptable flatness range from about 2X to 6X.

If the lens does not produce a flat field of focus, it will not be possible to get both the center and edges of the image sharp. Stopping down the lens to a small f-stop, thus increasing the depth of field, can help correct focusing problems caused by a lack of field flatness.

Focal Length of Enlarging Lenses It is essential to have a lens of the proper focal length to match the format size of the negative. The general rule is to have the focal length of the lens about equal to the diagonal measurement of the negative.

A wide-angle lens has a focal length 20 to 25 percent shorter than that of a normal lens. This means the wide-angle lens is capable of increasing the image size by about 30 percent at the same enlarger height as a normal lens. The biggest problem with wide-angle lenses is that they have more image

Table 8.1 Enlarging Lenses Compatible with a Given Format Size

Format	Normal Focal Length	Wide-Angle Focal Length
35mm	50mm	40mm
6 x 6cm	75mm to 80mm	60mm
6 x 7cm	100mm to 105mm	80mm
6 x 9cm	100mm to 105mm	80mm
4 x 5"	150mm to 160mm	135mm
5 x 7"	210mm (8 1/2")	Not recommended
8 x 10"	300mm to 360mm (12" to 14")	Not recommended

falloff in the corners than an enlarging lens with a normal focal length. Table 8.1 lists the type of enlarging lenses that are compatible with given negative formats.

All lenses make a somewhat brighter image in the center than they do at the edges. Just as with a camera lens, an enlarging lens generally provides optimum image sharpness if it is stopped down two to three f-stops from its widest aperture.

Using Longer than Normal Focal Length Lenses Some printers require a longer focal length lens than normal because they use only the center of the lens's field of view. This means that resolution will be at its peak, making for better definition at any given f-stop, and it avoids the problem of illumination falling off at the edges. The disadvantage is the need for a greater distance from the lens to the easel, which means the enlarger must be raised to a higher level. This increases the exposure time and can surpass the capacity of the enlarger's bellows to focus the image.

Focus Shift An enlarging lens should be color corrected and free from major aberrations. Poorly corrected lenses can create spherical aberrations, which lower image definition and produce focus shift. When a lens is at its maximum f-stop (wide open), the image is created by the center and edges of the lens. When the lens opening is stopped down to a small f-stop to make the print, only the center of the lens is used to form the image. If the lens is poorly corrected, using only this tiny central portion can cause the point of focus to shift, which results in a loss of image sharpness.

Dirt and Flare Make sure the enlarging lens is always clean and there is no light flare from leaks around the enlarger. Both these conditions will produce a loss of contrast in the print.

Inexpensive enlarging lenses usually have four elements. Lenses having fewer than four elements are not recommended. Better quality lenses normally have six or more elements. They are better corrected for color and may be labeled APO (apochromatic). They probably will deliver better definition in black-and-white printing as well.

Safelights

Most conventional black-and-white papers can be conveniently used under specific safelight conditions. Normal-graded papers are sensitive only to blue light and can be handled under a fairly bright yellow safelight. Variable-contrast papers are sensitive to a wider band of the spectrum and may require a different safelight filter. A light amber filter, such as Kodak's OC, is a good general choice when working with both graded and variable-contrast papers. Check the specific manufacturer's instructions before use.

Figure 8.3 Matching the safelight conditions to the type of paper being handled is essential to avoid safelight fog. Safelight testing can be carried out to ensure that proper conditions are met. If Goldberg's safelight conditions were not correct, his print could have lost the contrast and subtlety that it requires to function as a successful photograph. Safelight fog is often first noticeable in the highlight areas.

© Gary Goldberg. "Fence, Mexico City," 1986. Gelatin silver print. 11 x 14".

For use with contact papers, Kodak recommends using its OA filter (greenish yellow). Panchromatic papers (sensitive to the full visible spectrum), such as Kodak Panalure, are designed to produce an accurate tonal translation of a color negative into a black-and-white print. They are sensitive to a much broader range of the spectrum and should be handled under a No. 13 safelight filter or in total darkness. Orthochromatic materials (not sensitive to red)—for instance, litho films such as Kodalith—need to be handled under a red safelight such as a Kodak No. 1A, No. 1, or No. 2. These filters are safe for most papers except the panchromatic types.

Safelights come in a variety of styles and price ranges, from inexpensive models that screw into a light fixture to powerful ceiling-mounted sodium-vapor units. Some lamps offer the versatility to switch filters to match whatever paper is being used. Ruby lamps, having the filter built into the glass, are a very inexpensive alternative to safelights, although some workers claim that some of these bulbs are not safe and will fog the paper. It is best to test all safelights periodically with the specific materials being handled under them. In addition, the distance of the safelight from the paper, the brightness of the bulb, the age of the filter, and the number of safelights used are all factors in fogging.

If a safelight fogs the paper before it is exposed, this process is called hypersensitization. The most frequent cause of safelight fog is latensification, which occurs if the safelight fogs the paper after it has been exposed. Minimum amounts of safelight fog are noticeable as a loss of contrast in the upper highlight values. This causes the tones to become more compressed and lowers the overall contrast of the image. As the fog level increases, the print becomes denser (darker), most noticeably in the highlight areas.

Safelight Testing The safelight's bulb size and distance from the print should permit safe handling of the material for about 5 minutes. You can perform several different tests to ensure selection of the proper safelight.

Quick Test Under operating safelight conditions, place an opaque object, such as a coin, on a piece of printing material. Leave it there for 5 minutes

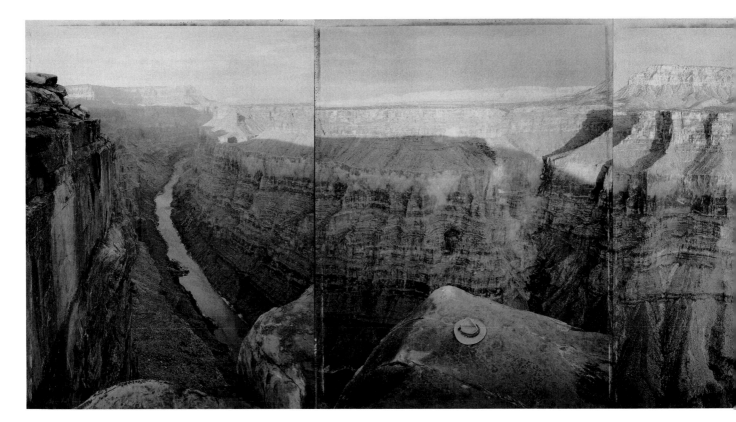

Figure 8.4 When making a series of images to be used in concert, as in Klett's five-panel piece, it is important to have each print match as closely as possible for the sake of visual continuity. To obtain these results, the printmaker must be consistent in all procedures, such as focusing the image. All mechanical equipment must be checked to make sure it is in top working order to deliver accurate and repeatable results.

© Mark Klett. "Around Toroweap Point, Just Before and After Sundown, Beginning and Ending with Views Used by J.K. Hillers, Over 100 Years Ago, Grand Canyon," 1986. Gelatin silver prints. 20 x 80". Courtesy of Pace/MacGill Gallery, New York.

and then process the paper. If a white area is visible, safelight correction is required.

Pre-exposure Test Using the enlarger, pre-expose the paper to make a very faint gray tone. Pre-exposed paper is more sensitive to small amounts of light than unexposed paper and so pre-exposing the paper makes the test more accurate. After pre-exposing the paper, place an opaque object in the center of it and position the paper at the normal distance it will be from the safelight. Leave it there for 2 minutes. After processing, the outline of the object should not be visible. To find the maximum safelight time, repeat the test, adding 1 or 2 minutes of safelight exposure until the outline of the object becomes visible.

Real-Thing Test In total darkness, make an exposure that will produce a full tonal range print. After making the exposure, cover half the paper with an opaque piece of paper, turn on the safelight, and put the paper under the safelight, at its normal distance, for 2 minutes. Turn the safelight off and process the paper. After processing, visually compare the two halves. If a careful examination of the two, especially in the highlight areas, does not reveal any loss of contrast or increase in density, the safelight can be considered safe with that particular paper.

General Safelight Guidelines

1. Match the safelight designation with the type of paper being used.
2. Minimum distance with a single direct safelight and normal graded paper is about 4 feet with a 15-watt bulb.
3. A 25-watt bulb can be used in a single indirect safelight hung from the ceiling in an 8 x 10' darkroom.

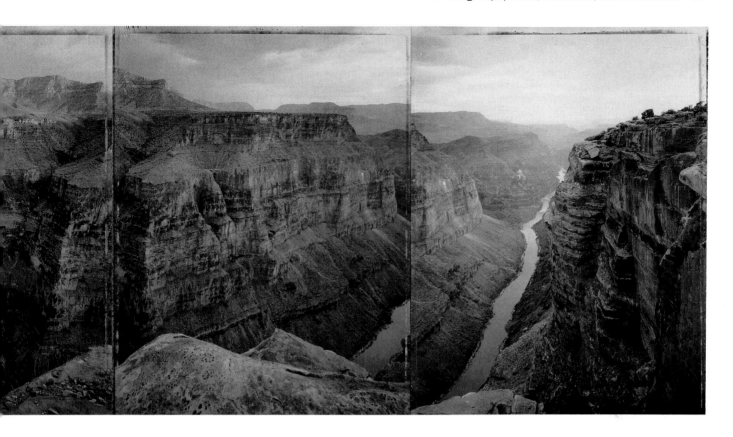

4. Avoid having a direct safelight too close to the enlarger or processing sink. Follow the manufacturer's guidelines as a starting point for correct distance placement.

5. Check the condition of the filters periodically. They can deteriorate over time without any visible change in color. A safelight that shows any signs of deterioration or uneven density should be replaced.

6. For added protection, process prints facedown during most of the development time.

7. Test safelights regularly and whenever you are using a new printing material.

Easels

In addition to providing a stable surface for composing and focusing the image, an easel must be able to hold the printing material flat and parallel to the negative. It also provides a stable surface for composing and focusing the image. Easels with independently adjustable blades are recommended because they allow you to change the paper size and the size of the print borders. Easels with a white focusing surface can reflect enough light back through certain single-weight papers to produce a change in the overall print values. This can be corrected by painting the easel yellow or by taping a thin sheet of opaque cardboard to it. This is not usually a problem with double-weight papers.

Focusing Devices

The image must be critically focused on your easel to ensure the maximum benefit of the camera and enlarging lenses. When making enlargements, optimum focus occurs when the grain of the negative is sharp over the entire image. You can achieve this through the use of a grain focuser or magnifier. These devices generally have a mirror that diverts part of the projected im-

age to an eyepiece for viewing. Adjust the fine-focus control of the enlarger until the grain appears sharp in the eyepiece.

With large-format negatives and some fine-grain films such as Kodak Technical Pan Film, focusing on the grain can be difficult. In cases such as these, use a focusing device that simply magnifies a small part of the image in the eyepiece for viewing. These devices also are useful for checking the corner sharpness of the image. Many people use both types of focusing aids to ensure optimum focus.

Whenever you are using filters, such as those used with variable-contrast papers, you will obtain the best results if you place the filters between the light source and the negative. Filters used below the negative can affect the optical quality of the image and the focus. If you are using filters below the negative, recheck the focus with the filter in place.

The following guidelines will help you produce sharply focused enlargements:

1. Adjust the enlarger to get the proper print size.
2. Open the lens to its maximum aperture, to produce the brightest possible image.
3. Place a scrap sheet of paper, the same type as you will use for the final print, in the easel as a focusing target.
4. Adjust the fine-focus control on the enlarger.
5. Stop the lens down to the working aperture, f-8, or f-11, to improve image sharpness.
6. Recheck for possible focus shift. Make any final adjustments after the working lens aperture is set.
7. Remove the scrap focusing paper, insert the printing paper, and make the exposure.

Timers

Accurate and repeatable results are required ingredients in the timing of all photographic procedures. Timers are available with mechanical or electronic operating gear, having both a visible display and audible signal to indicate when the timing operation is complete.

Electronic timers are extremely accurate, especially for short times. They can be set to give repeatable results in units as small as a fraction of a second, which can be useful for fine-tuning a print. Some can be set to run an entire processing program. The digital electronic timers are generally the most expensive and may not work with cold-light enlarging heads.

Mechanical timers are less expensive and are compatible with any standard photographic equipment. They are not as accurate as electronic timers at brief exposures and cannot be set to run a processing program.

Trays

Good quality photographic trays that are impervious to chemical contamination are available in heavy plastic or stainless steel. To facilitate agitation of the solutions, the trays should be slightly bigger than the print being processed. For example, an 8 x 10" print should be processed in an 11 x 14" tray.

Trays are available with flat or ribbed bottoms. Some workers prefer the ribbed bottom because they say it is easier to pick the print out of the tray. Others say the ribbed bottom can damage the print by scratching it against the ribs or causing the print to bend or fold more easily. Generally, having several of both types is useful. Try each type and see if you have a preference.

When the printing session is complete, discard the developer and pour the stop bath into the developer tray. This will neutralize the residual alkaline developer solution. Thoroughly wash all trays with warm water. Many printers label or color coordinate their trays so that they always use the same tray

for each solution to avoid chemical contamination. Commercial preparations compatible with environmental concerns are available to clean stubborn stains.

Enlarging Meters

Enlarging meters are okay for mass-production situations, but in the making of a fine print, the artist should be actively involved in appraising the tonal range of the print and not spending time programming a meter. The expressive print is a unique and highly subjective item and does not lend itself to a cool, mechanical process of analysis. If you want machine prints, take the film to your local one-hour processing shop.

Miscellaneous Equipment

Negative Cleaning Materials A clean negative ensures maximum quality and reduces the headache of spotting the print later. *Antistatic devices* can help you achieve this goal. Antistatic brushes, such as the Staticmaster, do a good job but contain small amounts of radioactive polonium. If this is a concern, use an antistatic device such as the hand-held Zerostat gun. Just point the Zerostat at the film and squeeze the trigger, showering positive ions onto the film. When you release the trigger, the film is struck by a stream of negatively charged ions, which neutralize both the positive and negative charges. The Zerostat is more likely to be sold in record stores than in camera shops, as it works well on any plastic-based surface, such as a record or disk. It requires no batteries and does not use any radioactive materials. In conjunction with the Zerostat, you can use a good sable brush to clean the negative.

Canned air, another cleaning device, is not recommended, as it simply blows the dust around. Some products spit their propellant out of the can along with the air, which can stain the negative. If you must use canned air, get a brand that does not contain fluorocarbon propellants, which damage the earth's atmosphere.

Dealing with Scratches Products such as Edwal No-Scratch can be used with small-format negatives to hide scratches that do not go completely through the emulsion. Clean the negative before painting on No-Scratch. After printing the negative, remove the No-Scratch completely with film cleaner and lint-free towels such as Photo-Wipes, as this and other defect-hiding products will diffuse and soften the image.

Other Tools Other important printing items are a reliable thermometer, burning and dodging tools (which can be homemade from an opaque board and wire), print tongs to avoid getting chemical solutions on your skin, thin surgical gloves for handling prints (especially during toning), and a collection of graduates and storage bottles.

A Notebook Keep a notebook to record the details of how each print was made. Typical information should include negative identification, type and grade of paper, type and dilution of developer, f-stop, exposure time, and burning and dodging instructions. This record can save you time if you have to reprint the negative and can refresh your memory when you are creating new prints.

Standard Printing Materials

All black-and-white photographic printing materials consist of a base or support, generally paper, coated with a light-sensitive emulsion. The emulsion is made of silver halide crystals suspended in gelatin. Silver chloride, silver bro-

mide, and silver iodide are the most widely used silver halide salts in contemporary photographic emulsions. The individual characteristics of an emulsion, such as contrast, image tone, and speed, are determined by the type of silver salt or salts, how they are combined in coating the base, and any other ingredients added to the emulsion.

Silver chloride papers are generally very slow and are used for contact printing. They have excellent scale and tonal values and are easy to tone. Bromide emulsions are much faster, can be used for either enlarging or contact printing, and usually have a cool or neutral tone. Bromide and chloride are often combined in the making of warm-tone papers.

The speed of the emulsion is determined by its ANSI (American National Standards Institute) number and is comparable to the ISO rating system for films. These numbers are not of any particular use in the making of an expressive print, except as an indicator for comparing relative increases or decreases in exposure times when changing papers.

Modern papers come in a variety of surface textures and sheens, different weights, and various base tints. There are no industry standards in these areas. Each manufacturer creates its own set of guidelines, so the photographer must sort through the options and find what is appropriate for a particular situation.

Paper Types

Currently there are three basic commercially prepared paper types: conventional fiber-based papers, resin-coated (RC) papers, and papers for activation or stabilization processing.

Fiber-Based Papers Fiber-based papers are coated with baryta (a clay substance) beneath the emulsion. This provides a smooth, clean white background that covers the inherent texture of the paper and provides a reflective surface for the emulsion. Cool or warm coloring is often added to the baryta, since it covers the paper base and provides the white that you see in a print. Beware of papers that have "optical brighteners" added to increase the reflectance in the highlight areas of the print, as they can lose their effect over time

Figure 8.5 To produce this multi-image print, 6 x 7cm negatives were cut and taped to an 8 x 10" sheet of acetate, which was put into a homemade horizontal 8 x 10" enlarger. A projection was made on Kodak Polycontrast Rapid II N surface RC paper. Dingus selected this paper because he likes the way it accepts graphite and silver-colored pencil, which is essential for creating the spirit of the piece.

© Rick Dingus. "Empty Soda Well Near San Ysidro, New Mexico," 1987–88, 16 x 20". Courtesy of James/Schubert Gallery, Houston. Original in color.

and drastically alter the look of the print. Fiber-based papers produce the greatest range of clearly defined tones and provide maximum life span and overall print quality.

Resin-Coated Papers RC papers have a polyethylene coating on both sides of the paper base, making them water-resistant so that chemicals cannot soak into the paper fibers. This allows RC papers to be processed and washed very quickly, as all the chemicals are easier to remove.

RC papers can be marked with a pen or pencil, dry fast, and have a minimum amount of curl. The problems with RC papers include the following:

- The polyethylene layer tends to deteriorate and crack over time.
- They cannot be processed to archival standards.
- They often have a reduced range of visible tones with poor separation in the dark values, and they may lack a good maximum black.
- The brighteners that are commonly used in RC papers have a tendency to migrate into the shadow areas during washing. This produces a veiling effect that reduces the overall tonal range.
- The high reflectivity of the RC coating tends to create viewing problems.
- The picture elements often appear to sit on the surface, giving the image a lack of visual depth.

Papers for the Activation and Stabilization Processes
Papers that have developing agents incorporated directly into the emulsion are designed for activation and stabilization machine processing (although they can be processed in a tray). When a print is needed immediately, this is the route to go, although the print quality will suffer. Both stabilization and activation processes are desirable for their convenience and immediacy. These papers are not intended for work requiring long-term keeping capabilities and cannot be processed to archival standards.

Stabilization Process With the stabilization method, the processing time can be as short as 15 seconds for an 8 x 10" print. The print comes out of the machine damp but air-dries within minutes at normal room temperature. This type of print will last for several days before beginning to deteriorate. Its life span can be increased by fixing and washing it, following regular print processing procedures.

Activation Process The activation process, such as Kodak's Ektamatic Processors and companion Ektamatic paper, takes about 1 minute dry-to-dry time (the time the print enters the processor to the time it emerges) for an 8 x 10" print. This process is designed for deadline work, such as for a newspaper, where print stability is not important. The contrast of Ektamatic papers can be controlled with the use of Polycontrast filters. These papers can be conventionally processed in a tray and then fixed and washed to extend their life. If this is done, Kodak claims these prints will last as long as conventionally processed RC prints. Most activation papers, such as Ektamatic, use fluorescent optical brighteners to produce a cleaner white. Ektamatic papers produce a warm black tone with the processor and a neutral black tone with tray processing.

The Double-Density Effect
Why does a slide provide more detail and subtlety than a print of the identical scene? Slides are viewed by transmitted light---that is, the light passes through the slide one time before being seen by our eyes. With a print, light passes through the clear gelatin emulsion and strikes the base support of the paper, resulting in a reflection rate of about 90 percent. Light that is not pure

white (which is almost always the case) has to pass through the silver densities of the print twice, once when it strikes the paper and again when it is reflected back, and creates what is known as the double-density effect.

For example, imagine that the silver density in the emulsion of one part of a print allows 60 percent of the light to reach the base of the paper. Since only 90 percent of this light is reflected back from the base, only 54 percent of the light remains. Now this 54 percent has to pass through the same silver density again as it is reflected back, subtracting another 50 percent. Thus only 27 percent of the original light strikes the eye from this part of the print. The silver deposits in the print screen the light twice, creating the double-density effect. This results in a loss of detail, limiting the amount of separation between tones.

Paper Colors

Manufacturers make the base of their papers in a variety of colors. The color variations include brown-black, bluish black, and neutral black through a slightly warm to a very warm buff or ivory. There is no one standard for comparison. To get an idea of what the paper looks like, carefully examine and compare paper samples from each manufacturer. Most camera stores have these samples, or the company will send you a set upon request.

The image color will be affected by the choice of developer and can be further altered through toning. For instance, processing a warm-tone paper in a warm-tone developer can produce a print so warm it will have olive green values (these can be neutralized by toning).

Selection of paper color should be given serious thought, but it remains a highly subjective and personal matter. It should reflect the photographer's overall concerns and the mood he or she wants to achieve.

Paper Surface and Texture

Papers are available with a number of different surfaces. Smooth, glossy papers have the greatest reflectance range. They present the most brilliant images with the widest range of tonal separation and good detail in key highlight and shadow areas. Matte surfaces have a reduced reflection-density range, with the amount depending on the degree of texture. They produce a print with much less brilliance. The matte surface is a good choice when extensive retouching or hand-altering of the print is planned. Matte paper takes airbrush, regular brush, and pencil retouching extremely well. Once again, there are no industry standards that permit direct comparison. Each manufacturer has its own system for designating the surface and texture characteristics.

Ferrotyping

If you desire a high-gloss finish, you can dry a glossy paper on a special metal ferrotype plate. Ferrotype prints can produce a tremendous amount of glare. Using a glossy paper and not ferrotyping will deliver a smooth, semigloss finish with much less glare.

Grades of Paper

Matching the density range of a negative to the exposure range of a paper is necessary for a print to reveal the complete tonal range of the negative. To accomplish this, photographic papers are made in various degrees of contrast. Papers are given a number, called a paper grade, to indicate their relative degree of contrast. The higher the number is, the harder or more contrasty the paper. There is no industry standard, as each company uses its own grading system. Table 8.2 lists some paper grades and their general contrast characteristics.

Table 8.2 Contrast Characteristics of Paper Grades

Paper Grade	General Contrast Characteristics
0	Very soft, extremely low contrast
1	Soft, low contrast
2	Normal, average contrast
3	Slightly above normal contrast
4	Hard, above normal contrast
5	Very hard, very contrasty

A normal negative, with a complete range of values, will produce a full-range print on grade 2 or 3 paper. A normal negative can be printed on a lower grade of paper for a softer, less contrasty look or on a higher grade to achieve a harder, more contrasty appearance. If you want to make a long tonal range print from a contrasty negative, you should use a low-contrast paper. A high-contrast paper can be used to extend the tonal range of a low-contrast or flat negative. Soft, low-contrast papers are fast and have a long tonal scale. Hard, high-contrast papers are slower and have a shorter scale.

Even though a grade 2 paper is considered to be normal, there is really no standard for normal in printmaking. You should never feel locked into trying to print on only one grade of paper. Expressive printing means that each negative must be evaluated in terms of how the final print should read and feel, and the grade of paper should be selected accordingly.

Variable-Contrast Papers

Variable-contrast papers have a blend of two emulsions. Usually the high-contrast emulsion is blue sensitive, and the low-contrast emulsion is orthochromatic, which is sensitive to blue and green. By exposing the paper through special variable-contrast filters or a variable-color light source, the different proportions of the two emulsions are exposed. Since variable-contrast papers are sensitive to a broader band of the spectrum than regular graded papers, you should read and follow the specific manufacturer's instructions for proper safelight conditions. Variable-contrast papers are designed to be exposed with tungsten or tungsten-halogen light bulbs. Their use with other sources, such as cold lights, may require experimentation.

Advantages Only one box of variable-contrast paper is needed to produce a wide range of contrast. Filters are even available in half-grade steps such as 1 -1/2, 2 -1/2, and 3 -1/2. Also, various sections of the paper can be exposed with different filters to alter the contrast locally within the print. For instance, imagine a landscape having a dark, flatly lit foreground and a bright, contrasty sky. A higher than normal filter could be used to expose the shadow areas of the foreground and increase contrast. Then a lower than normal filter could be used to make a second exposure for the sky.

Disadvantages Variable-contrast papers tend to print flatter than graded papers at any given level of contrast. They do not print as deep a cold-tone black as do graded papers, and the exposure time is longer with higher filter numbers. Also, using variable-contrast filters below the lens, as is most commonly done, can result in a loss of image contrast, cause distortion of the image, and reduce overall sharpness. It may be necessary to refocus the image after the filter is placed in front of the lens. This may be a problem depending on the intensity of the filter, as it might be difficult to see the image clearly enough to check the focus accurately. This problem can be eliminated by

Figure 8.6 A 17mm fish-eye lens and a mirror allowed Jachna to play with our traditional sense of perspective and space. A high-contrast print was achieved by exposing variable-contrast paper through a color enlarger with 40 points of magenta filtration. Many variable-paper manufacturers supply a guide that tells how the paper can be exposed by using the filters in a dichroic color enlarger.

© Joseph D. Jachna. "Door County, Wisconsin," 1970. Gelatin silver print. 8 x 12".

printing with a dichroic color head enlarger. When working with a color enlarger, most manufacturers provide magenta and yellow filtration that is equal to the filter numbers.

Variable-contrast papers can be compared to a zoom lens. A lens with a single fixed focal length should always deliver a sharper image than a zoom lens set at the same focal length. This does not mean you should never use a zoom lens, but it does mean that the lens has certain limitations. Likewise, variable-contrast papers can be used with great success in a wide variety of photographic applications. When the opportunity presents itself, try some of the variable-contrast papers and see if they meet your needs.

Current Papers

More good photographic papers are being made today than in the past several years. The major manufacturers are Kodak, Oriental, Agfa, Ilford, Mitsubishi, PAL, Artista, and Zone VI Studios. Every paper has its own distinct personality, and the makers may alter its characteristics over a period of time. The only surefire way to find out what these papers will or will not do for your work is to use them.

Special Printing Materials

Panchromatic Papers

Panchromatic means sensitive to the full range of the visible spectrum. Panchromatic papers are designed to produce an accurate black-and-white tonal rendition from a color negative. Regular printing paper is not panchromatic.

It is sensitive mainly to the blue portion of the visible spectrum and distorts the tonal range of the original color negative (especially in the red part of the spectrum) when a black-and-white translation is created. Panchromatic papers, such as Kodak Panalure, should be handled under a color safelight filter, such as Kodak No. 13, or in total darkness.

Direct Positive Papers

Direct positive papers, such as Kodak Direct Positive Paper, are intended to produce a positive rather than a negative image. This material can be exposed in a view camera and may be used to make direct positive enlargements from color slides. It is used in the coin-operated portrait booths that deliver a strip of pictures while the subject waits. For more information, see *Direct Positive Photography with Kodak Direct Positive Paper*, Kodak Publication No. G-14.

Black-and-White Transparency Films

Material such as Kodak Translite Film 5561 permits black-and-white transparencies to be made in the same way as paper prints. This material can be toned with regular paper toners and is easy to hand-color.

Liquid Emulsions

Liquid emulsions give the photographer the freedom to go beyond two-dimensional paper-based printing. Liquid emulsions can be applied to almost any inanimate surface, including paper, canvas, china, glass, leather, metal, plastic, rock, and wood. It allows the photographer to consider the possibilities of extending the photographic medium into the third dimension.

Liquid Light

Liquid Light is a commercially prepared direct silver nitrate emulsion. After it is applied to a surface, it is handled and processed in the same manner as the emulsion on normal photographic paper. Refrigerated, Liquid Light has a shelf life of up to two years. Here are some guidelines for using Liquid Light:

1. Place the bottle of solid emulsion in a pan of hot water until its contents become liquid (usually a couple of minutes). Open the bottle only under normal paper safelight conditions.

2. In the darkroom, under a paper safelight, pour some emulsion into a glass or plastic bowl. Do not use a metal bowl, as silver nitrate reacts with metal. Rapidly apply the emulsion with a soft, clean brush. Coat a piece of paper at the same time to serve as a test strip for determining the correct exposure. Mark the back of any paper that is coated because the emulsion can be hard to see once it dries.

3. Allow the coated material to dry in total darkness until it is at least tacky. After it is dry, it can be stored and handled like normal photographic paper. Best results are usually obtained if the coated material is used as soon as possible after drying.

4. The emulsion is slow and not very sensitive to light. When making an exposure, open the enlarging lens to about f-4 and make a series of about six exposures in five-second increments on the test strip.

5. All processing solutions must remain between 60° F (16° C) and 68° F (20° C), as the emulsion will soften at temperatures above 70° F (21° C). Process following normal paper procedures.

6. Determine the correct time, make the exposure on the coated material, and process.

Liquid Light will produce a warm black image with soft contrast. The contrast can be controlled, to some degree, by using a normal paper developer

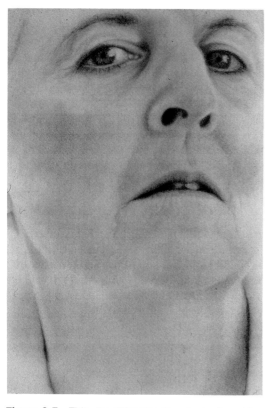

Figure 8.7 This ghostlike image was produced by diluting Liquid Light Emulsion as follows: Mix 500 milliliters of methyl alcohol with 50 milliliters of butyl alcohol; add 50 milliliters of distilled water and 5 milliliters of formaldehyde. Stir this mixture into 1 liter of Liquid Light right before use and roll it onto Italia paper by Fabriano. Wessner carried out these operations in a well-ventilated area while wearing an organic respirator.

© Robyn Wessner. "Rosemary Series, #26," 1982. Liquid Light on paper with pastel. 28 x 22". Original in color.

Figure 8.8 Photo linen is a manufactured cloth that has been treated with a photographic emulsion. It tends to have more contrast than emulsions that are applied to fabric by hand. DiVola used mural-size photo linen to produce an image that has the feel, look, and scope of a large-scale canvas painting.

© John DiVola. "Quarter Moon," 1987. Photographic linen. 42 x 42". Courtesy of Jayne H. Baum Gallery, New York.

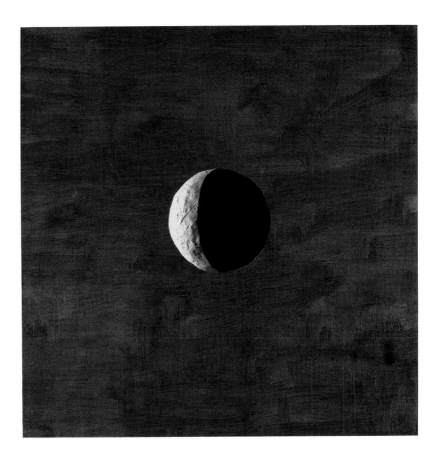

such as Dektol or Selectol and varying the rate of dilution. When the emulsion is very fresh, it lacks contrast. As the emulsion ages, it gains contrast but requires the use of an antifog agent, which is included with the emulsion.

Paper-based images can be colored with Rockland PrintTint or regular photographic toners. Rockland also makes a contact-speed emulsion designed to be used on fabric called Rockland Fabric Emulsion Sensitizer FA-1.

For more information on Liquid Light and other Rockland products, contact Rockland Colloid Corp., 302 Piermont Avenue, Piermont, NY 10968. See *Making a Photographic Emulsion*, Kodak Publication No. AJ-12, for instructions on how to prepare a photographic emulsion from scratch.

Luminos Photographic Linen

Luminos Photographic Linen is a commercially prepared cloth that has been treated with a photographic emulsion. It is available in a number of standard photographic paper sizes as well as in mural lengths and is handled and processed like regular photographic paper. It tends to have a deeper black and more contrast than the Rockland emulsions.

For more information, contact Luminos Photographic Corp., 25 Wolffe Street, Yonkers, NY 10705.

Processing Prints for Permanence

"Eternal duration is promised no more to men's work than to men," said Marcel Proust. The processing of prints to archival standards ensures that the work will have the opportunity to communicate with others in the future. A properly processed and stored print should last at least hundreds of years. Table 8.3 summarizes the guidelines for achieving maximum life for black-and-white fiber papers.

Table 8.3 Archival Processing for Silver-Based Fiber Papers at 68°F (20°C)

Step	Approximate Time
Developer	1 1/2 to 3 minutes
Acid stop bath	1/2 minute
First fixing bath	3 minutes
Second fixing bath	3 minutes
Quick water rinse	As needed
First wash	5 to 10 minutes
Washing aid or hypo eliminator**	2 to 6 minutes
Express method: Perma-Wash and toner	1 to 10 minutes
Toning**	1 to 10 minutes
Final wash	60 minutes minimum
Air-dry	As needed

*Exact times are determined by the needs of the photographer through testing.
**The express method combines the washing aid and toning steps.

Additional Information

For a list of information sources, see Additional Information at the end of Chapter 4.

Black-and-White Paper Developers

Learning to become a good printer requires curiosity about all aspects of making an expressive print. The more information you have about developers, the more control you can exercise over the image. As your knowledge and competence increase, so do the visual possibilities.

Paper versus Film Developers

All silver-based developers, whether they are for paper or film, are very much alike (see Chapter 6). The major difference between paper and film developers is that paper developers are generally more alkaline, which increases their energy. If a film developer is used to process a print, the image will appear gray with no maximum black (the deepest black the paper is capable of producing) and will lack contrast.

What a Developer Can Do

It is important to know what chemicals make up a typical paper developer and the functions they perform in printmaking. The choice of developer influences the tonal range, contrast, and image color of the print, but it cannot make up for a poorly exposed negative. The best way to get the type of print you want is to work from a properly exposed negative.

Developing-Out Papers

Developing-out silver-based papers (those requiring a chemical developer to bring out the image) have a thin emulsion that is designed to be chemically developed to finality. Developing time varies depending on the type of developer, its dilution, the temperature, and the type of paper. All these factors will affect the outcome of the final print.

Components of Black-and-White Silver Print Developers

Major Developing Agents

Metol and Hydroquinone Metol and hydroquinone are used in various combinations to form the majority of black-and-white print developers. Metol (Kodak Elon) produces a delicate, soft, neutral gray image with low contrast. With prolonged development, both contrast and density increase. Metol is energetic, has a long shelf life, and is commonly blended with hydroquinone to increase contrast.

Hydroquinone makes a high-contrast image with a brownish tint. It works best in the low and middle range of tonal values and is rarely used by itself because it requires lengthy development times. Combining hydroquinone with another developing agent, such as Metol, activates it. Hydroquinone has

a short life span and starts to become ineffective at temperatures below 60°F (15°C).

Metol-hydroquinone developers are convenient, economical, and extremely versatile, and they have a long life span. By varying the proportions of Metol and hydroquinone, the photographer can alter the color and contrast of the print.

Phenidone Phenidone is the proprietary name of Ilford's developing agent that acts like Metol. Phenidone produces a low-contrast image with a gray color. It is more expensive than Metol, but it also is more potent and can be used in much smaller amounts. Phenidone is recommended for people who are allergic to Metol. It acts as a superadditive agent (see Chapter 6) when combined with other developers such as hydroquinone. Phenidone has a long storage and tray life.

Amidol This longtime favorite of expressionistic printmakers such as Edward and Brett Weston is used to produce rich images with cold, blue-black tones. Amidol is often used at high dilutions such as 1:20 (1 part amidol to 20 parts water) with an extended development time of 10 minutes to produce soft images. This also can be effective when working with a very contrasty negative. Using amidol at reduced rates of dilution and at higher than normal temperatures can produce brilliant high-key prints. These have excellent highlight detail and retain subtlety without dulling the high tonal values.

Amidol is expensive and can stain the print, your skin, and clothes. Since amidol is poisonous, you must wear thin rubber gloves or use print tongs when working with it. Amidol is another alternative for those suffering from Metol poisoning.

Amidol must be mixed just before use, as it will keep only a couple of hours in solution. The addition of citric acid (60 grams per quart) as a buffer will help prolong amidol's useful life and will minimize the stain it produces.

Glycin When used with bromide papers, glycin produces a straightforward black tone. With chloride or chlorobromide papers, it delivers soft brown or sepia tones. Glycin is often used with Metol and hydroquinone in developers such as Ansco 130, which favors the highlight areas of the print. With some papers, it produces a very slight stain in the upper tonal range, often resulting in a soft glowing quality.

Figure 9.1 Smith processed his 8 x 20" Super XX film in Pyro ABC. The resulting negative was contact printed on Azo paper, which was developed in amidol. This combination delivers a luxuriously detailed print that retains subtlety in both the high and low values and invites the viewer to linger over the image.

© Michael A. Smith. "New Orleans," 1985. Gelatin silver print. 8 x 20".

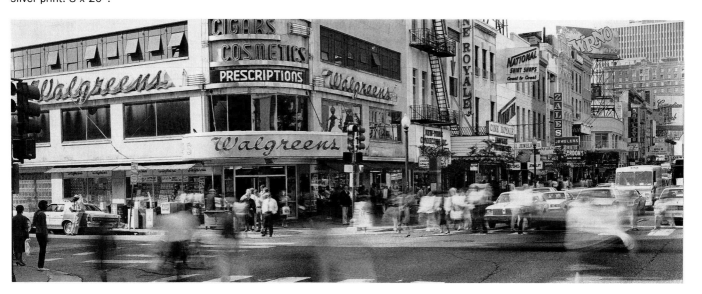

Reduction Potential

The strength of a developer's activity is known as its reduction potential (how rapidly the developer converts the silver halides to metallic silver). The relative reducing energy of a developer is measured against hydroquinone, which has been assigned an arbitrary reduction potential of 1. The reduction potentials of other commonly used developing agents are as follows: glycin, 1.6; Metol, 20; amidol, 30 to 40.

Other Paper Developer Ingredients

Accelerator The energy and stability of a developer depends on the alkalinity (pH) of the solution. Most developers have an alkali added to serve as an accelerator. A greater concentration of alkali will produce a more energetic but short-lived solution.

The most commonly used accelerator is sodium carbonate, which is favored because its buffering action helps the developer maintain the correct pH level, thus prolonging its usefulness. Sometimes borax is used as the accelerator. On rare occasions, sodium hydroxide (caustic soda) is used for extremely active formulas or for high-contrast effects. It has a high pH and should be handled with full safety measures.

Certain developers, such as amidol, do not use an accelerator. In amidol, the reaction of the sodium sulfite with the water produces the needed pH for the developing action to take place.

Preservative A preservative, usually sodium sulfite, absorbs the free oxygen molecules in the developer. This retards oxidation and extends the working life of the solution.

Restrainer The restrainer slows down the reduction of the silver halides to metallic silver, slightly reducing the speed of the paper and increasing the development time. This is important in preventing fog caused by high-energy developers, extended development times, or out-of-date papers. A developer without a restrainer will reduce some of the unexposed silver halides to metallic silver, producing an overall fog. You can print through a light fog, but as the fog becomes denser, it also becomes visible in the finished print. The fog is most noticeable in the highlight areas. The upper range of tones will appear veiled and lacking in separation. The restrainer will keep the highlights clear and increase the apparent visual contrast of the print.

The most widely used restrainer is potassium bromide. If used in a high concentration, it will cause many papers to take on a greenish cast. This can be neutralized by selenium toning (see Chapters 11 and 12).

Benzotriazole is a popular organic restrainer that can be used to help clear fog and produce cleaner-looking highlights. It tends to produce colder tones than potassium bromide, shifting the image color to bluish black. Benzotriazole is available in prepared form as Kodak Anti-Fog No. 1 (tablets) and Edwal Orthazite (liquid). It also is available in powder form.

Water The key ingredient in any developer is water. Generally, if the water supply is safe for human consumption, it is safe for photographic purposes. The amount of chlorine added to many water supplies is too small to have any effect. The same applies to copper sulfate, which is often added to kill bacteria and vegetable growth. The most important consideration is to be sure the water is close to neutral on the pH scale (7). If the water is more alkaline (having a pH greater than 7), it will cause the developer to be more active, thus reducing the total amount of time for development.

If the water contains a large number of impurities, boil it and let it stand until the precipitate settles. Then gently pour it, without disturbing the sedi-

ment, through prewashed cheesecloth or a paper filter. Distilled water may also be used.

If you suspect there is a problem with the water, do a comparison test by mixing two solutions of developer, one with tap water and the other with boiled or distilled water. Process and compare the results. Film is generally more susceptible to variations in water quality than prints. The most common problems are foreign particles, which can damage the emulsion, and changes in the pH, which can affect the speed of the materials.

The amount of calcium, magnesium, and iron salts found in water determines its hardness. The greater the concentration of these minerals, the harder the water. Very hard water produces nonsoluble precipitates that collect on equipment and materials. The use of a water softener is not recommended because the softening process can remove too many of the minerals, especially calcium carbonate, and affect processing. Water softeners can drop the calcium content to below 20 parts per million (ppm). If the calcium carbonate level is too low, it can affect the activity and stability of the developer.

Many taps contain an aerating filter, a small screen screwed into the end of the faucet that adds oxygen to the water to improve its taste. Remove this filter. Added oxygen can increase the oxidation rate of many solutions, thus reducing their life span.

The perfect water supply for photographic purposes has a pH of about 7, contains 150 to 250 ppm of calcium carbonate, and is free of most particle matter.

Other Processing Factors

Temperature
The rate of development depends on the reducing potential of the developing agent and its dilution, the characteristics of the emulsion, the amount of time in the developer, and the temperature of the solution. All developers work more quickly as their temperature rises. Just as with film development, 68°F (20°C) has been adopted as the standard processing temperature for most silver-based papers. All processing solutions, including the wash, should be kept as close to the temperature of the developer as possible.

Changes in the temperature affect not only the processing time but also the characteristics of the developing agents themselves. Metol performs consistently over a wide range of temperatures, but hydroquinone does not. It becomes extremely active above 75°F (24°C) and loses much of its effect below 55°F (13°C). For example, as the temperature drops below 68°F (20°C), a Metol-hydroquinone developer will produce a softer, less contrasty print than normal. As the temperature rises above 68°F, the print will become harder and more contrasty. Changes in temperature also will change the image color of various papers from their normal appearance.

Time
Chloride papers are the fastest, having a developing time of about 1 minute. Bromide papers are the slowest, requiring times of 3 minutes or longer. Chlorobromide papers (widely used for enlarging) have the widest time latitude. Exposure and development times can be varied to produce different image colors. Chlorobromide papers have a normal developing range of 1-1/2 to 3 minutes. Generally, more exposure and less development will result in a warmer image tone than normal. Depending on the paper, less exposure and more development time will result in a colder image. A developing time that is too short will not allow the developer to permeate the emulsion evenly. This can result in flat, uneven, and muddy-looking prints. Too long a developing time can fog or stain the paper.

Agitation

To avoid uneven processing and streaking, prints should be agitated constantly by rocking the developer tray in different directions. First slide the paper, in a quick fluid motion, into the developer. Then lift up the front of the tray so that it is at a 15- to 30-degree angle and set it back down. Do the same thing on the right side of the tray. Repeat the procedure at the front of the tray and on the left side. Return again to the front and repeat this pattern of agitation until the development time is up.

Prints should be kept under the developer during the entire processing time. Do not remove them from the developer for inspection, as exposure to the air can fog the developer-saturated emulsion.

Dry-Down Effect

Determining the correct exposure for an expressive print can be accomplished only through visual inspection. There are a number of factors to consider here. Under safelight illumination, prints tend to appear darker than they do under white light. Prints always have a richer, more luminous look when glistening wet than after they have dried. All papers darken, losing some of their reflective power, as they dry. This dry-down effect can cause subtle shadow areas to become blocked. The highlight areas appear brighter in a wet print because the swelling of the emulsion causes the silver to spread apart slightly. This permits more light to be reflected back from the base of the paper. After the print is dry, the silver becomes more tightly grouped, so the density appears greater, reducing some of the brilliance of the highlight areas.

You can compensate for the dry-down effect by reducing the exposure time by 5 to 10 percent depending on the paper. Some photographers dry a test print or strip with a hair dryer or in a microwave oven to obtain an accurate exposure. They can then compare the dried print with a wet one to get an idea of what changes will occur. This is important when working with an unfamiliar paper.

Edge Burning

Although edge burning is not a development technique per se, you should take it into consideration when deciding on the correct exposure. Many prints can benefit from additional exposure at the edges (5 to 10 percent of the total exposure is a good starting point). Making the edges darker can help keep the eye from wandering out of the corners of the print. This method is effective when there are bright highlights in a corner. Edge burning creates a definite separation between the print and its matte or mount board, keeping the two from visually blending together.

Edge-Burning Method 1 The simplest method is to hold an opaque piece of cardboard that is larger than the print over the print, revealing the edge and about 25 percent of the image into the print. Then make an exposure equal to about 5 to 10 percent of the total print time. During the exposure, move the card away from the center of the print out to its edges. Each corner will receive two edge exposures, making them darker than the center portion of the entire edge. This can be visually effective, allowing the light to act as a visual proscenium arch that contains and frames the image.

Edge-Burning Method 2 This technique permits all four edges to be burned in at the same time, thus giving all the edges and corners an equal increase in density. This is done by using an opaque board cut in the shape of a rectangle or oval in proportion to the image size and format. Center the board above the print so that it reveals the image area about 25 percent of the distance into the print. Set the timer for the desired amount of additional ex-

Figure 9.2 This scene was captured with a 5 x 7" camera equipped with a 90mm lens, a very wide angle lens for this format. To compensate for light falloff in the corners, Johnson dodged the edges of the print. The center portion of the print was burned in to equalize the center and the edges.

© Michael Johnson. "State Road Cemetery," 1986. Gelatin silver print. 25 x 35". Courtesy of The After-image Gallery, Dallas.

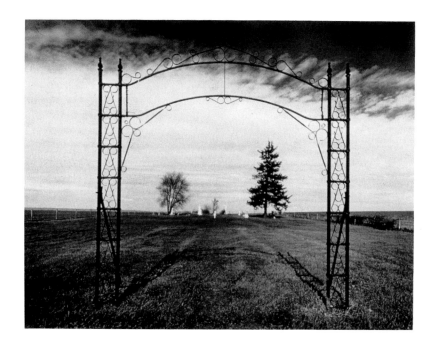

posure, then using a smooth, steady motion, move the opaque board toward and away from the paper.

Controlling Contrast during Development

After you have selected the developer and grade of paper, you can alter the contrast of the final image in a number of simple, straightforward ways.

Two-Solution Development

You can reduce contrast and bring out shadow detail by transferring the paper from the developer to a tray containing a 10 percent sodium carbonate solution or plain water and then transferring it back to the developer. You may repeat this process until you obtain the desired results. The following guidelines are a starting point for this procedure, but you will probably want to modify them as you go along.

1. Immerse the print in the developer for about 30 seconds.
2. Place the print in a 10 percent sodium carbonate solution without agitation for about 90 seconds. You can use plain water, but it will increase the chances of your getting a mottled effect. This can be very noticeable in textureless highlight areas such as a cloudless sky. The carbonate results in a more uniform density.
3. Return the print to the developer for an additional 30 seconds.
4. Place the print in the stop bath and continue to process normally.

Local Controls

In situations where it is not practical to burn or dodge, you can apply various solutions to change the print's tonal value. These operations can be carried out in a flat-bottom tray. Care must be taken to avoid getting the solution in areas where it is not wanted, as a dark or light halo effect might be created in the treated area. Use a brush or cotton swab to apply the solution. The type of paper being treated greatly affects the degree to which these controls can be applied without fogging or staining the print.

- *Glycerin* can be applied directly to the print to hold back (lighten) specific areas.
- *Hot water* can be used to increase the developer's activity in selected areas. Begin processing the print in a developer that is weaker than normal. After about 30 seconds, remove the print, place it on a flat surface, and brush very hot water on areas requiring more development. Give the print a number of brief applications, for about 10 to 15 seconds, and then return it to the developer. This process may be repeated.
- Straight, undiluted *stock developer* can be applied to specific areas for increased development and contrast. Begin by processing the print normally for 30 seconds. Remove the print from the developer, place it on a smooth, flat surface, wipe off all the developer, and apply the stock developer, which has been heated to about 100°F (38°C). Let the print sit for 10 to 30 seconds, then return it to the regular developer. This process may be repeated as needed.
- *Alkali* may be applied to heighten the developer's effect. Prepare an accelerator such as sodium carbonate in a saturated solution, dissolving as much accelerator as possible in about 6 ounces of water. Follow the same application procedure as in the hot water method. This technique often produces the most noticeable visual effect.
- A small pocket *flashlight* whose bulb has been wrapped in opaque paper to form an aperture from which the light source can be controlled may be used to darken small portions of the print. This is accomplished by removing the print from the developer after about 30 to 45 seconds and wiping off all the chemical with a squeegee or chamois cloth. The selected area is given extra exposure, and the print is returned to the developer tray for completion of the process.
- *Print flashing* is another effective way to reduce contrast and improve highlight detail. In traditional print flashing, the negative is removed from the enlarger and the paper is given a brief (1 second or less) exposure with white light. These short exposures can be difficult to control without an accurate digital timer.
- An alternative method that uses a longer flash time can be carried out with a mechanical timer. Here is what you do. Before or after the print is exposed, hold a piece of tracing vellum such as Clearprint 1000H under the enlarging lens. Give the print a flash exposure of 10 to 20 percent of that required for the normal exposure. For instance, if the total exposure time was 15 seconds, the flash time would be 1-1/2 to 3 seconds. There is no need to remove the negative from the enlarger, as the tracing vellum acts as a light mixer. The time will be determined by the effect desired and the light transmission qualities of the vellum.
- Finally, *altering the formula* of the developer will alter the contrast of the print. Contrast can be increased by adding more hydroquinone and/or potassium bromide to the formula. Contrast can be decreased by increasing the amount of Metol (Elon) in the formula. Blacks can be deepened through the addition of carbonate. The increase in Metol depends on the desired outcome, but a range of about 10 to 25 percent is suggested.

Matching Developer and Paper

Cold-Tone Papers

Fast, coarse-grain chlorobromide papers generally produce cold black through blue-black image color. The normal developer for these papers is a Metol-hydroquinone combination containing a large amount of accelerator (alkali) and a minimum of restrainer (bromide) to prevent fog. Complete development in a full-strength developer should deliver a print with rich, deep, luminous tones and full detail in key highlight and shadow areas. Shortened

development times produce less than a maximum black, preventing details in the upper range of highlights from becoming fully visible. They permit mottling in clear areas; produce uneven effects with streaks; and give the image an overall greenish tone.

Warm-Tone Papers

Slower, fine-grain papers have a higher proportion of silver chloride than cold-tone papers. These papers work best when processed in Metol-hydroquinone developers that contain less accelerator (sodium carbonate) and more restrainer (potassium bromide) than those used with cold-tone papers. Even warmer tones can be created by increasing the exposure time and reducing the development time. One of the best ways to accomplish this is by diluting the developer with two to three parts of water and/or increasing the amount of potassium bromide. Less active developers such as glycin tend to produce warmer tones than the Metol-hydroquinone combinations. For maximum effect, use these methods with warm-toned papers, as they tend to have almost no effect on cold-tone papers.

Developer Applications and Characteristics

Kodak Dektol

The most commonly used paper developer is Kodak Dektol, which is a Metol-hydroquinone formula. Dektol is a cold-tone developer that produces a neutral to blue-black image on cold-tone papers. It is available as a prepared powder or can be made from the D-72 formula (below) which is very similar. Dektol's standard dilution is 1:2 (1 part developer to 2 parts water) with a recommended developing range of 45 seconds to 3 minutes at 68°F (20°C). It can be used straight to increase contrast or diluted 1:3 or 1:4 to cut contrast and produce warmer tones on certain papers. If you do this, add a 10 percent solution of potassium bromide for each 32 ounces of working solution. Almost every manufacturer makes a developer that is very similar to Dektol. People who are allergic to Metol developers can use phenidone-based prepared formulas such as Ilford Bromophen, Ilfordbrom, and Ilford ID-36.

Kodak D-72 Formula This is a cold-tone paper developer.

Water (125°F or 52°C)	16 ounces (500 milliliters)
Metol (Elon)	45 grains (3 grams)
Sodium sulfite (desiccated)	1-1/2 ounces (45 grams)
Hydroquinone	175 grains (12 grams)
Sodium carbonate (monohydrate)	2-3/4 ounces (80 grams)
Potassium bromide	30 grains (2 grams)
Cold water to make 32 ounces (1 liter)	

Processing procedures are the same as those for Dektol. For colder, blue-black tones, reduce the amount of bromide (start by reducing it by one-half).

Kodak Ektaflo, Type 1

Ektaflo, Type 1, is a liquid developer designed to produce a neutral to cold-black image on cold-tone papers. It has a standard dilution of 1:9 (1 part developer to 9 parts water) with a useful range of processing times from 1 to 3 minutes at 68°F (20°C).

Kodak Hobby-Pac

Hobby-Pac is a liquid, one-shot cold-tone developer that produces results similar to those produced by Ektaflo, Type 1. It comes in foil packets, each of which makes 32 ounces of working solution, which will process up to fifteen 8 x 10 " prints.

Ilford Bromophen

Bromophen is a phenidone-hydroquinone–based cold-tone developer that is available in prepared powder form. It is normally diluted 1:3 (1 part developer to 3 parts water) and has a developing time of 1-1/2 to 2 minutes at 68°F (20°C).

Ilford Ilfordbrom

Ilfordbrom is a liquid phenidone-hydroquinone cold-tone developer. It has a standard dilution of 1:9 (1 part developer to 9 parts water) and a useful development range of 2 to 4 minutes at 68°F (20°C).

Ethol LPD

LPD is a phenidone-hydroquinone developer available in both liquid and powder form. LPD can be used with both cold- and warm-tone papers. Varying the dilution of the stock solution can alter the tone of the final print. LPD is designed to maintain uniform contrast even if the dilution of the stock solution is changed. It has a standard dilution of 1:2 (1 part developer to 2 parts water) and a standard development time of 1-1/2 to 2 minutes at 70°F (21°C) to produce a neutral tone. A dilution of 1:4 gives warm tones, while a dilution of 1:1 or even full strength produces colder tones. LPD offers great print capacity and may be replenished.

Sprint Quicksilver

Quicksilver is a pyrazolidone-hydroquinone developer that develops all image tones at a constant rate. This means that overall print density increases with development, and contrast remains fairly stable. It has a standard dilution of 1:9 (1 part developer to 9 parts water) with a useful range of 1 to 4 minutes at 65°F to 77°F (18°C to 25°C). At the standard dilution, it produces a neutral tone on cold-tone papers. It gives warm-tone papers a more neutral color than other developers and is not recommended for certain cold-tone chloride papers (contact papers) such as Azo. Quicksilver may be converted to other Sprint Systems developers such as Direct Positive B&W and color slide and print developers.

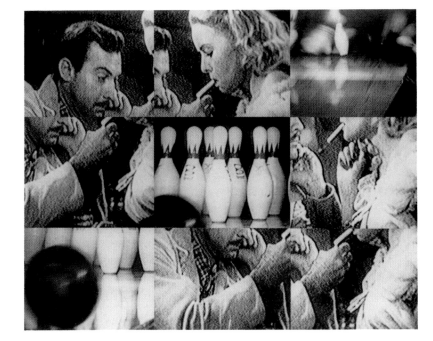

Figure 9.3 The image, photographed directly from a television, was projected in an enlarger to about 30 x 40". Eight- by ten-inch pieces of paper were exposed under specific areas of this projection. All the paper was processed in Sprint Quicksilver, which is known for its ability to develop image tones at a very steady rate. The final composite was made by gridding together the various 8 x 10" sections.

© Karl Baden. "Strike," 1985. Gelatin silver prints. 24 x 30".

Kodak Selectol

Selectol is designed to produce a warm black to a brown-black image with normal contrast on warm-tone papers. It is available as a packaged powder or can be mixed using the D-52 formula (following). Selectol is generally mixed 1:1 (1 part developer to 1 part water) and is developed for 2 minutes at 68°F (20°C). Increasing the exposure and reducing the development time to 1-1/2 minutes can produce a slightly warmer image color. Increasing the development time and reducing the exposure can result in colder tones and a slight increase in contrast. The effectiveness of either technique depends on the paper being used.

Kodak D-52 This is a warm-tone paper developer.

Water (125°F or 52°C)	16 ounces (500 milliliters)
Metol (Elon)	22 grains (1.5 grams)
Sodium sulfite (desiccated)	3/4 ounce (21.2 grams)
Hydroquinone	90 grains (6 grams)
Sodium carbonate (monohydrate)	250 grains (17 grams)
Potassium bromide	22 grains (1.5 grams)
Cold water to make 32 ounces (1 liter)	

Follow the same processing methods as for Kodak Selectol. For warmer tones, increase the amount of bromide (start by doubling it).

Kodak Ektonol

Ektonol is a warm-tone developer available in prepared powder form and designed for images that are going to be toned. Ektonol's standard dilution is 1:1 (1 part developer to 1 part water) with a recommended developing time of 1 1/2 minutes at 68°F (20°C). It contains no carbonate, giving it a lower pH than most cold-tone developers. This makes it good for rapid-process papers that have a developing agent built into the emulsion. The lower activity of this developer does not trigger the developing agent in the paper, thus permitting some control over development (see Chapter 8).

Kodak Ektaflo, Type 2

Ektaflo, Type 2, is a liquid developer for warm-tone papers. At a dilution of 1:9 (1 part developer to 9 parts water), it has a development time of 1 1/2 to 4 minutes. The warmest tones are produced by the lowest development times. An increase in time will produce colder tones.

Kodak Selectol-Soft

Selectol-Soft is a packaged powder proprietary formula similar to Selectol, but it develops the print to a lower contrast and favors the development of highlight areas. Selectol-Soft is known as a surface developer. It penetrates the emulsion slowly, acting on the highlights first and then on the middle and lower tonal areas. It gets stronger as the development time increases. Selectol-Soft acts like a low-contrast, Metol-only developer such as Ansco 120 (below). It has a regular development time of 2 minutes at 68°F (20°C) and a standard dilution of 1:1 (1 part developer to 1 part water). Changes in the dilution and development time affect the image color on warm-tone papers. Extending the development time to 8 to 10 minutes deepens the blacks, creating a rich print with a fairly neutral tone. Selectol-Soft can be used in conjunction with a cold-tone developer such as Dektol for additional contrast control (see the next section on variable-contrast development). Its warm-tone characteristics are not noticeable on cold-tone papers, but it will develop a cold-tone grade to a lower level of contrast.

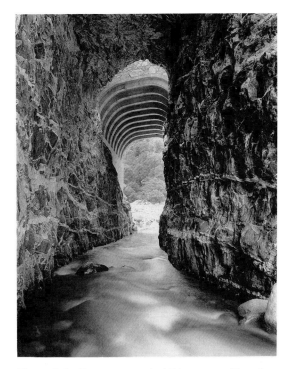

Figure 9.4 Dawson recorded this scene with a 4 x 5" camera using a 90mm lens. To help reduce the contrast, the Agfa 400 film was developed in Edwal FG-7 and the negative was exposed with a cold-light enlarger. To fine-tune the print and control contrast further, grade 3 paper was given a variable-contrast development in Selectol-Soft (1:1) for 3 minutes and then Dektol (1:2) for 30 seconds. Extensive burning was done in the center of the image and on some of the side walls of the tunnel to achieve the final look.

© Robert Dawson. "Tunnel, Feather River, California," 1987. From the Water in the West Project. Gelatin silver print. 16 x 20".

Ansco 120 Formula This is a low-contrast Metol developer.

Water (125° F or 52° C)	24 ounces (750 milliliters)
Metol	1/4 ounce (12.3 grams)
Sodium sulfite (desiccated)	1 ounce (36 grams)
Sodium carbonate (monohydrate)	1 ounce (36 grams)
Potassium bromide	27 grains (1.8 grams)
Cold water to make 32 ounces (1 liter)	

Ansco 120 is usually diluted 1:2 (1 part developer to 2 parts water), but it may be used at full strength or at a higher dilution. Its normal developing time ranges from 1-1/2 to 3 minutes at 68° F (20 C).

Variable-Contrast Development

Variable-contrast developers are useful for making small adjustments (less than a full paper grade) that permit precision adjustments of the tonal range of the print. Three separate approaches to working with variable-contrast developers are offered: (1) using a combination of the standard Kodak developers Dektol and Selectol-Soft; (2) working with a two-part developer like Edwal T.S.T.; and (3) using the classic Dr. Roland Beers formula that must be mixed from scratch. (See "Other Paper Developer Formulas" at the end of this chapter).

Dektol and Selectol-Soft Stock solutions of Dektol and Selectol-Soft can be combined to provide almost as much contrast control as the Dr. Beers developer. They have the advantage of being able to be mixed from widely available commercial formulas. Two methods have been successful in varying the contrast with Dektol and Selectol-Soft.

In the first method, you can add contrast to a long tonal range print and build up a good solid maximum black by adding 50 milliliters of straight stock Dektol per liter of Selectol-Soft stock solution (1-1/2 ounces per quart). Increase the amount of Dektol in 50-milliliter increments until you achieve the desired contrast. The maximum that can be added is about 350 milliliters of Dektol per liter of Selectol-Soft stock solution (10 ounces per quart). Beyond this limit, the outcome resembles that achieved with Dektol alone. Do not add any additional water to this solution.

In the second method, begin print development in Selectol-Soft until good highlight separation is evident. Then transfer the print into Dektol to complete its development. Different times in each solution and different amounts of dilution permit a good deal of variation in contrast. As a starting point, placing a print in Selectol-Soft for about 90 seconds and then in Dektol for 90 seconds will produce results that are about halfway between those of developing the print in either solution by itself. Prints not receiving full development will lack a rich maximum black.

Edwal T.S.T. Edwal T.S.T. (Twelve-Sixteen-Twenty) is a liquid two-part developer capable of controlling both the contrast and tone of an image. T.S.T. is very convenient and versatile and can deliver distinct visible results on a wide range of papers. T.S.T. can be diluted from 1:7 (1 part developer to 7 parts water) up to 1:39 to achieve varying effects. At 1:7, T.S.T. produces the coldest tones and the deepest blacks. At 1:15, it produces a neutral black. Warm tones on warm-tone paper begin to occur at a 1:19 dilution. The softest warm tones occur at a dilution of 1:39. T.S.T. will not produce a brown-tone image on cold-tone paper.

For normal contrast and image tone, Edwal recommends using 1 ounce of solution B for every 8 ounces of solution A, regardless of the dilution used. Development times for normal contrast prints are 2 to 2-1/2 minutes at 70° F (21°C).

Reducing the amount of solution B will proportionally increase the contrast. Solution B can be eliminated entirely for maximum effect. Reducing solution B also increases the developer's activity, and it may be necessary to reduce the standard development time.

If you want maximum contrast, you can add Edwal Liquid Orthazite, a restrainer containing benzotriazole, to T.S.T. to prevent fog. Use 1/2 to 1 ounce of Orthazite per quart of T.S.T. at the 1:7 dilution to maintain clean, clear highlight detail.

You can decrease print contrast by increasing the amount of solution B up to double the normal amount. When you increase the amount of solution B, you can extend the development time up to 4 minutes.

Solarizing Developer/Solarol

The Sabattier effect, commonly called solarization, is achieved by re-exposing the print (it may be done on film) to white light while it is being developed. The problem with this procedure is one of control. The print tends to get dark and muddy very rapidly. Solarol is a prepared powder developer that has been specially formulated to maintain print contrast during this procedure. Following are some guidelines for working with Solarol:

1. Prepare a stock solution of Solarol developer and dilute it 1:1 (1 part developer to 1 part water) for use at 70°F (21°C).
2. Make a normal print on high-contrast paper to determine the correct exposure and development time. This information is vital because the ideal time for re-exposure is at about one-third the time needed for total development. High-contrast paper tends to deliver a more pronounced effect. Simple scenes emphasizing strong graphic form are usually good subjects for initial experiments.
3. Place a 40-watt light bulb with a shockproof switch about 3 feet above the area where the developer tray with the print will be placed for reexposure.
4. To achieve the Sabattier effect, expose a piece of paper at one-third less time than the normal test print in step 2. For example, if the exposure time for the test print was 12 seconds, the correct exposure for the Sabattier effect would be 8 seconds.

Figure 9.5 To make this picture, Lebe made a photogram directly on the paper. This photogram was contact printed on high-contrast paper processed in Solarol. The image was then very slightly bleached with potassium ferricyanide, with specific areas being bleached with a brush or Q-Tip. Finally, the print was painted with liquid watercolors. To make application easier, Phot-Flo was added to the mixing water to help the watercolors penetrate the print surface.

© David Lebe. "Garden Series, #2," 1979. Gelatin silver print with paint. 16 x 20". Original in color.

Figure 9.6 Using nonrecommended developers can produce unusual results. To achieve a soft, less homogeneous print quality that Blau calls polylith, Polyfiber G paper was developed in Kodalith developer for 2 to 3 minutes. The developing time affects the contrast and the image color, which can vary from pink to walnut brown. The print will appear darker after development than when it is complete, as it tends to bleach out in the fixer.

© Eric Blau. "A Taste for Death," 1988. Gelatin silver print. 11 x 14". Original in color.

5. Develop the paper faceup in Solarol for one-third the established developing time. For instance, if the developing time for the test print was 120 seconds, the ideal time for reexposure would be at about 40 seconds. At this point, turn on the 40-watt bulb, without removing the paper from the developer, for 1 second.

6. Continue the developing process for the total established time.

7. After development is complete, finish processing the print following normal procedures.

The intensity of the Sabattier effect can be altered, from strong to gentle, by the following: (1) varying the distance of the white reexposure light from the developer tray, (2) using different-strength light bulbs (10 to 200 watts), (3) increasing or decreasing the amount of re-exposure time, or (4) printing on different grades of paper. Practice, patience, and experimentation are needed to discover the full range of possibilities with the Sabattier effect.

For more information on Solarol, contact The Solarol Company, P.O. Box 1048, El Cerrito, CA 94530.

Nonrecommended Developers

It is possible to achieve unusual effects by processing in nonrecommended developers. Normal silver-based paper can be processed in a litho developer, with the rest of the steps remaining the same, to produce different tonal and color effects than those produced with a normal paper developer. For example, Kodak Polyfiber Paper can be processed in Kodalith Super RT developer to create a very soft, low-contrast image with a pinkish brown color. Depending on the paper, Kodalith Super RT has a useful development range of about 1-1/2 to 4 minutes at 68°F (20°C). The print may appear dark after it comes out of the developer, but it tends to bleach out in the fixer. Image color can often be controlled through a combination of exposure and development time (long exposure with short development or short exposure with extended development). Print mottling can result from this technique, but some people find that this enhances the look. Experimentation is in order (see Figure 9.6).

Other Paper Developer Formulas

The following formulas can be helpful in controlling the contrast and image tone of silver-based black-and-white photographic papers.

High-Contrast Developer

Agfa 108 Formula

Water (125°F or 52°C)	24 ounces (750 milliliters)
Metol	75 grains (5 grams)
Sodium sulfite (desiccated)	1-1/2 ounce (40 grams)
Hydroquinone	88 grains (6 grams)
Potassium carbonate	1-1/2 ounce (40 grams)
Potassium bromide	30 grains (2 grams)
Cold water to make 32 ounces (1 liter)	

This paper developer will produce higher than normal contrast on many cold-tone papers with a hard, cool blue-black tone. It is generally used at full strength with a development time of 1 to 2 minutes at 68°F (20°C).

Warm-Tone Developers

It is possible to produce tones through warm black, luminous brown, and sepia by varying the type of developer. The effects generated are determined by the type of paper used. Fast neutral-tone papers yield warm blacks and brown-blacks, and slower warm-tone papers produce brown-black through very warm brown in the same developer. Experimentation is required to find the combination that will produce the desired image tone.

Agfa 120 Formula This is a warm-tone hydroquinone developer.

Water (125°F or 52°C)	24 ounces (750 milliliters)
Sodium sulfite (desiccated)	2 ounces (60 grams)
Hydroquinone	350 grains (24 grams)
Potassium carbonate	2-1/2 ounces (80 grams)
Water to make 32 ounces (1 liter)	

Standard starting procedure is to dilute the developer 1:1 (1 part developer to 1 part water) at 68°F (20°C) and process 1-1/2 to 3 minutes. On a paper such as Agfa Brovira, this combination produces a warm black tone. Agfa 120 can deliver a variety of warm black to brown tones depending on the paper, dilution, and exposure time. For instance, a brown-black tone can be pro-

duced on Agfa Portriga Rapid by increasing the exposure time by up to about 50 percent, diluting the developer 1:5, and processing 4 to 5 minutes.

Agfa 123 Formula This is a brown-tone hydroquinone developer.

Water (125°F or 52°C)	24 ounces (750 milliliters)
Sodium sulfite (desiccated)	2 ounces (60 grams)
Hydroquinone	350 grains (24 grams)
Potassium carbonate	2 ounces (60 grams)
Potassium bromide	365 grains (25 grams)
Cold water to make 32 ounces (1 liter)	

Agfa 123 is designed to produce brown-black through olive-brown tones on warm-tone portrait paper. For example, you can get a neutral to sepia brown on Agfa Portriga Rapid by doubling the normal exposure, using a dilution of 1:4 (1 part developer to 4 parts water), and processing for about 2 minutes. If you increase the exposure time to 2-1/2 times normal, use a dilution of 1:1, and extend the processing time to 5 to 6 minutes, Portriga Rapid can produce a brown-black tone.

Amidol Formula

Water (125°F or 52°C)	20 ounces (800 milliliters)
Amidol	120 grains (10 grams)
Sodium sulfite (desiccated)	365 grains (30 grams)
Citric acid (crystal)	60 grains (5 grams)
Potassium bromide (10% solution)	3/4 ounce (30 milliliters)
Benzotriazole (1% solution)*	1/2 ounce (20 milliliters)
Cold water to make 32 ounces (1 liter)	

*Edwal Liquid Orthazite or Kodak Anit-Fog No. 1 can be used.

Amidol is designed to be used full strength and developed for 2 minutes at 68°F (20°C) to get blue-black tones. It may be diluted and have the developing time lengthened to obtain softer, high-key prints. Amidol must be mixed fresh before each use because it will keep for only a few hours in stock solution. Since amidol has no carbonate, it does not require exact mixing. Variations in the amount of amidol affect the developing time. Variations in the amount of sodium sulfite affect the keeping qualities of the solution. Amidol is not very sensitive to bromide, so the amount of potassium bromide may be adjusted to ensure clear highlights. Contact papers often need only about half as much bromide as enlarging papers.

Glycin Developers

Glycin is a versatile paper developer that produces a strong, deep black on bromide papers and brown to sepia tones on warm-tone chloride and chlorobromide papers.

Glycin Formula

Water (125°F or 52°C)	24 ounces (750 milliliters)
Sodium sulfite	3-1/3 ounces (100 grams)
Trisodium phosphate (monohydrate)	4-1/6 ounces (125 grams)
Glycin	375 grains (25 grams)
Potassium bromide	45 grains (3 grams)
Water to make 32 ounces (1 liter)	

With bromide papers, the normal dilution is 1:4 (1 part developer to 4 parts water), and with chloride and chlorobromide papers, the dilution is 1:3. Normal developing time is 2 to 3 minutes at 68°F (20°C). A wide range of tonal effects can be achieved by altering the exposure, dilution, and processing time.

Ansco 130 Formula Ansco 130 is an all-purpose Metol-hydroquinone-glycin developer that produces smooth, deep, well-separated black tones while retaining highlight detail and brilliance with a wide range of processing times.

Water (125° F or 52° C)	24 ounces (750 milliliters)
Metol	32 grains (2.2 grams)
Sodium sulfite (desiccated)	1-3/4 grains (50 grams)
Hydroquinone	50 grains (11 grams)
Sodium carbonate (monohydrate)	2-1/2 ounces (78 grams)
Potassium bromide	80 grains (5.5 grams)
Glycin	50 grains (11 grams)
Cold water to make 32 ounces (1 liter)	

It is normal for this developer to appear to be slightly colored. For normal results, dilute 1:1 (1 part developer to 1 part water) at 68° F (20° C). Cold-tone papers can be developed for 2 to 6 minutes, while warm-tone papers have a range of 1- 1/2 to 3 minutes. Higher contrast can be achieved by using Ansco 130 straight. Softer prints can be created by increasing the dilution to 1:2.

Figure 9.7 Van Cleef finds Dr. Beers two-solution developer to be effective in refining the contrast of her final print. To retain the subtle nuances of the texture of this image, Beers solution #3 (slightly lower contrast than normal) was used with grade 2 Agfa paper. The Metol developing agent in solution A acts on the high tonal values while the hydroquinone develops the middle and lower tonal values.

© June Van Cleef. "Retired Farmer and His Wife," 1988. Gelatin silver print. 11 x 14": Courtesy of The Afterimage Gallery, Dallas.

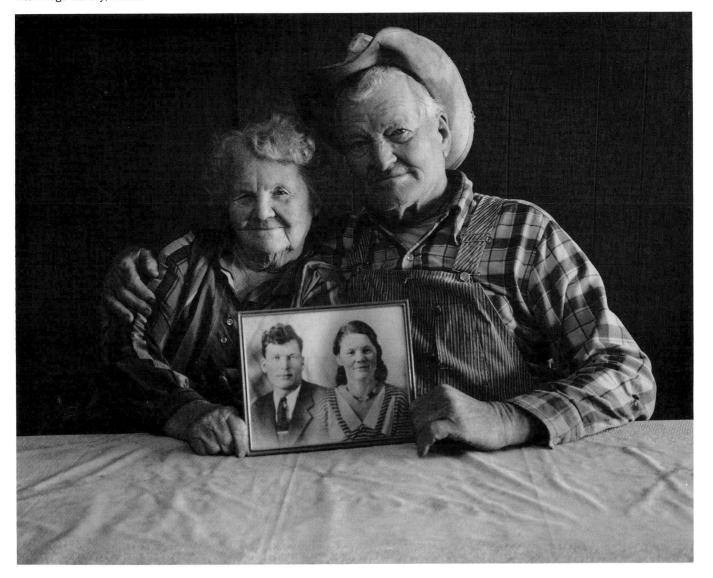

Ilford ID-78 Formula ID-78 is a phenidone-hydroquinone warm-tone developer.

Water (125°F or 52°C)	24 ounces (750 milliliters)
Sodium sulfite (desiccated)	1- 3/4 ounce (50 grams)
Hydroquinone	175 grains (12 grams)
Sodium carbonate (desiccated)	2 ounces (62 grams)
Phenidone	7- 1/2 grains (0.5 gram)
Potassium bromide	6 grains (0.4 gram)
Cold water to make 32 ounces (1 liter)	

Dilute 1:1 (1 part developer to 1 part water) at 68°F (20°C) and process for 1 minute. To extend the developing time, increase the dilution to 1:3 and process for 2 minutes.

Pyrocatechin Formula Pyrocatechin yields exceedingly rich brown tones on bromide papers.

Water (110°F or 43°C)	22 ounces (700 milliliters)
Pyrocatechin	60 grains (4 grams)
Potassium carbonate	1 1/2 ounces (45 grams)
Potassium bromide	6 grains (0.4 gram)
Water to make 30 ounces (900 milliliters)	

Pyrocatechin works best at about 100°F (38°C) with exposure times greatly reduced from those used with normal cold-tone developers. After development, the print is cooled in a water bath and then processed following normal procedures.

Dr. Beers Variable-Contrast Formula

Dr. Beers is the standard against which variable-contrast developers are generally measured. Varying the proportions of the stock solutions A and B results in a progressive range of tonal contrasts.

Stock Solution A

Water (125°F or 52°C)	24 ounces (750 milliliters)
Metol	120 grains (8 grams)
Sodium sulfite (desiccated)	350 grains (23 grams)
Sodium carbonate (desiccated)*	300 grains (20 grams)
Potassium bromide	16 grains (1.1 grams)
Cold water to make 32 ounces (1 liter)	

Stock Solution B

Water (125°F or 52°C)	24 ounces (750 milliliters)
Hydroquinone	120 grains (8 grams)
Sodium sulfite (desiccated)	350 grains (23 grams)
Sodium carbonate (desiccated)*	400 grains (27 grams)
Potassium bromide	32 grains (2.2 grams)
Cold water to make 32 ounces (1 liter)	

*The original Dr. Beers used potassium carbonate. Sodium carbonate may be substituted, as it is less expensive and more widely available. It should not produce any observable differences.

Stock solutions A and B are mixed in varying proportions to yield a progressive range of contrasts, as listed in Table 9.1. Dr. Beers has a developing range of 1- 1/2 to 5 minutes at 68°F (20°C). The low-number solutions can be diluted even further with water for extremely soft effects.

Table 9.1 Dr. Beers Variable-Contrast Developer Dilutions

	Contrast							
	Low		Normal					High
	Sol. 1	Sol. 2	Sol. 3	Sol. 4	Sol. 5	Sol. 6	Sol. 7	Sol. 8
Parts of A	8	7	6	5	4	3	2	1
Parts of B	0	1	2	3	4	5	14	15
Parts of water	8	8	8	8	8	8	0	0

Sol. = solution.

Additional Information

Adams, Ansel. *The Print.* Boston: Little, Brown, 1983.

DeCock, Liliane, ed. *Photo-Lab Index, Lifetime Edition,* Dobbs Ferry, N.Y.: Morgan and Morgan, 1990.

Wall, E.J., and F.I. Jordan; rev. and enlarged by John S. Carroll. *Photographic Facts and Formulas.* Englewood Cliffs, N.J.: Prentice-Hall, 1976.

Toning for Visual Effects

Toning plays a vital role in translating the photographer's visual intent into a concrete reality. Alterations in the color relationships of a print can dramatically change the emotional impressions of the piece.

Processing Controls

When working with black-and-white materials, the following four factors play a role in determining the final color of the photograph:

1. Paper type and grade
2. Developer type, dilution, and temperature and length of development
3. Processing and washing
4. Chemical toner type, dilution, and temperature and length of toning

The paper-developer combination plays a key role in determining the look of the print, regardless of which type of toner is selected. Similarly, toner that delivers the desired visual effect with one paper-developer combination can be ineffective or produce undesirable effects with another. Most manufacturers provide charts that list widely used and recommended paper-toner combinations. For example, if the printmaker wanted to achieve the maximum warm brown color from a toner, a paper such as Kodak Ektalure developed in Selectol might be recommended. Almost all papers respond to some degree to most toners. Generally, warm-tone, silver chloride papers (contact papers) show a more pronounced toning effect than cold-tone, silver bromide papers (enlarging papers).

Extended development times tend to limit the effect of a toner. A warm-tone developer, such as Kodak Selectol or Selectol-Soft, used in place of a cold-tone developer, such as Kodak Dektol, will produce even warmer images. Thorough washing is important to avoid print staining. Experience, testing, and careful observation are necessary for consistent and repeatable results. Keeping a written record of procedures can help you build a storehouse of toning knowledge. Experimentation is the only way to see what works best in your situation.

Basic Types of Toners

Many toners are available in prepared liquid or powder form, and even more variations may be derived by mixing from formulas. Chemical toners can be divided into three major types: replacement, mordant dye, and straight dye.

Replacement Toners

The use of inorganic compounds (salts) to replace or partially replace the silver in a fully processed photograph makes for a wide variety of image colors. In this process, the silver is chemically converted with toners such as gold,

Figure 10.1 Toning can offer the photographer the opportunity to reenter the photograph to make visual alterations in the work. The photographer's knowledge of materials and expressionistic drive can come together in this process. Byrd used an etching needle on his 6 x 7cm negative (emulsion side for black lines and base side for white lines). The print was made by exposing through wet tissue paper on the paper's surface for 50 percent longer than the normal time. Then the interior rectangle was masked, and the print was given additional exposure. The paper was processed in Ethol LPD (1:1) for 3 minutes. After the final wash, the print was immersed in copper toner for 10 minutes, redeveloped in LPD (1:9) for 20 seconds, treated with a silver toner for 5 minutes, washed in a hypo clearing bath, and reimmersed in the copper toner for 5 minutes.

© Jeffery Byrd. "Life Is Splendid and Obscure and Long Enough," 1989. Gelatin silver print. 20 x 16". Original in color.

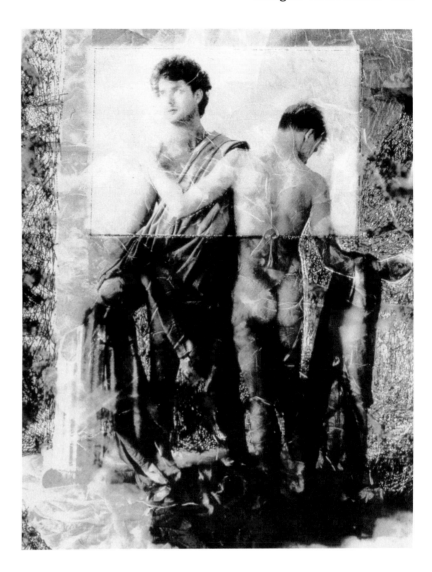

iron, selenium, sulfur, and other metallic compounds. Some of these toners act directly on the silver image, while others are used by bleaching the image and then redeveloping it in a toning solution. It is possible to achieve muted and subtle visual effects with replacement toners, which are also permanent and stable.

Mordant Dye Toners

A *mordant* is a compound that combines with a dye so the color cannot bleed or migrate within the dyed medium. In mordant dye toning, the image is converted to silver ferrocyanide through the use of a mordant such as potassium ferricyanide. A mordant acts as a catalyst, permitting the use of dyes that would not normally combine with silver. The dye is deposited in direct proportion to the density of the ferrocyanide (mordant) image. This process allows dye toners to be used to produce a wide variety of vivid colors. Image color can be further altered by immersing the photograph in a bath containing different-colored dyes or by combining dyes. Some of the problems with mordant dye toners are that they are not as stable as replacement toners, they are more likely to fade upon long exposure to UV light, some of their initial intensity is often lost during the washing process, and traces of the toner are often left in the white base areas of the paper even after a complete wash.

Straight Dye Toners

With these toners, the silver is not converted and the dye affects all areas equally. These toners are widely available and very easy to use. Although they can produce vivid colors, the lack of difference in toner intensity between the highlight and shadow areas tends to create a flat color field effect. This can unify a composition, or it can create a sense of sameness that can be visually dull.

Processing Prints to Be Toned

The following procedures are recommended starting points for all toning procedures discussed in this chapter, unless otherwise noted. Table 10.1 summarizes the processing steps in toning for visual effects.

Table 10.1 Processing Steps in Toning for Visual Effects at 68°F (20°C)

Step	Summary	Time
1. Developer	Select a developer-paper combination to match the toner.	1-1/2 to 5 minutes
2. Stop bath	Use a regular acetic acid stop bath.	1/2 minute
3. First fix	Use only fresh fix. Check to see if hardener is needed. Do not overfix.	3 to 5 minutes
4. Second fix	Same as step 3.	3 to 5 minutes
5. Rinse	Remove excess fix with water.	
6. First wash*	Begin the removal of chemicals.	5 minutes minimum
7. Washing aid	Use Perma-Wash or Kodak Hypo Clearing Agent.	2 to 5 minutes
8. Second wash*	Remove fixer residuals to prevent staining.	10 to 60 minutes
9. Toning	Use a minimum of three trays: Tray 1—water holding Tray 2—toner Tray 3—collection tray Tray 4—running water (optional)	As needed
10. Washing aid	Same as step 7.	2 to 5 minutes
11. Final wash*	Remove all chemicals from the paper.	60 minutes
12. Drying	Air-dry, face down, on plastic screens. Do not use heat.	As needed

*All washing times must be established for specific conditions. The times given should be adequate to prevent print staining in most applications.

Printing and Development

To a certain degree, almost all toners affect the contrast and/or density of a print, so it is a good idea to experiment before toning any final prints. Some toners lighten and others darken the final print. Changes in exposure and/or development time may be needed to adjust for these effects. Many toners' instructions tell you whether to expect such changes. When first working with a toner, it is a good idea to make extra prints, including duplicates of what is believed to be the proper exposure and prints having more and less exposure than normal. The making of additional prints also permits variation in toning times, thus increasing your selection of color effects.

Stop Bath

After development is complete, prints should be drained and then immersed in an acid stop bath for 30 seconds with constant agitation at 68°F (20°C).

Figure 10.2 Proper fixing and washing are necessary for consistent toning without staining. The images that make up this composite were toned with selenium (1:12) for 5 minutes. To make sure that all checmical residues were removed, the print was given a final wash of 75 minutes. These processing procedures not only affect the image color but also ensure that the print has a long (archival) life span.

© Karl Baden. "Domesticity," 1985. Gelatin silver prints. 32 x 30".

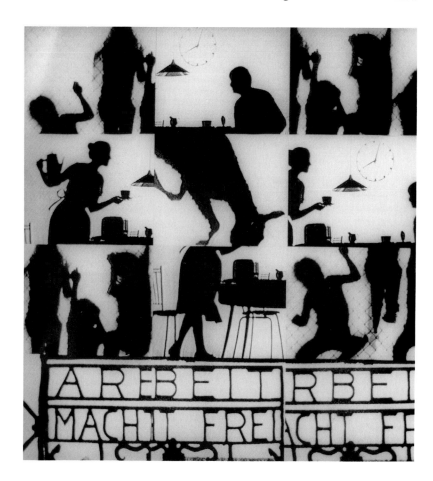

Fixer

Proper fixing, with fresh fix, is a must to ensure high-quality toning results. Either a single rapid fixing bath or a two-bath method can be used. Incomplete fixing will fail to remove residual stop bath and silver thiosulfate compounds, resulting in an overall yellow stain on prints toned with selenium or sulfide. These stains are most visible in the border and highlight areas of the print. Purplish circular stains are often due to improper agitation during fixing. Excessive fixing can bleach the highlight areas and produce an unexpected change in the color of the toned image.

Many papers tone more easily if the paper is fixed without any hardener. Some toners specifically require the use of fix without hardener. Check the directions *before* processing.

Prints toned with nonselenium brown toners can be treated with a hardener to increase surface durability. This is done right before the final wash. A hardening bath such as Kodak Liquid Hardener is diluted 1:3 (1 part hardener to 3 parts water), and the prints are immersed in it with constant agitation, for 2 to 5 minutes. The print is then given a final wash.

Washing before Toning

After proper fixing, rinse excess fixer off the print and begin the first wash of at least 5 minutes at 68° F (20° C). Photographs can be stored in a water holding bath until the printing session is complete. This allows the remaining washing and toning steps to be carried out at the same time.

After the first wash, prints are immersed in a washing aid or hypo eliminator for recommended times, usually about 2 to 5 minutes. The print is then washed for a minimum of 10 minutes, after which it is ready to be toned.

Previously processed and dried prints can be toned, but first they must be allowed to soak in a water bath and become completely saturated. If you do not do this, the toner might be unevenly absorbed, resulting in a mottled finish.

Washing after Toning

After the print has been toned, it must be washed. The washing time will vary depending on the combination of paper, toner, and washing technique. Check the manufacturer's recommendations for suggested starting washing times. A general guideline is to rinse the print immediately after it comes out of the toner, immerse it in a washing aid, with constant agitation, for 2 to 3 minutes, and then give it a final wash of 1 hour.

The wash and washing aids can affect certain toner-paper combinations. For instance, mordant dye toners tend to lose intensity during the final wash. You can compensate for this loss by extending the toning time. When the print is immersed in a washing aid, sepia toners may be intensified or a shift in tonality may occur, while blue toners may lose intensity.

Drying

Toned prints should be allowed to air-dry, facedown, on plastic screens. Heat-drying can produce noticeable shifts in color.

General Working Procedures for Toners

Safety

Review and follow all safety rules outlined in Chapter 3 before beginning any toning operation. Always wear thin disposable rubber gloves and work in a well-ventilated area. Some toners, such as Kodak Poly-Toner and certain sepia toners, release sulfur dioxide (rotten-egg smell) and should be properly ventilated with a fan. Have no other photographic materials in the toning area. Certain toners can release hydrogen sulfide gas, which can fog unexposed film and paper and oxidize unprotected silver images on film and prints.

Equipment

When working with a single-bath toner, a minimum of three clean trays, slightly larger than the print, are required. The first tray is used to hold the prints waiting to be toned. The second contains the toner. The third contains a water bath to hold the prints after they have been toned. A fourth tray with a running water bath is desirable to rinse off excess toner. The action of the toner will continue as long as there is any toner remaining on the paper. Different tonal effects can be achieved by varying the dilution rates of the single-bath toners.

Reuse of Toners

Once toners have been diluted and used, they cannot be reliably stored or reused. An exception is hypo alum sepia toner, which actually improves with use and can be kept for years. Generally, the correct amount of toner solution for the number of prints being toned should be mixed for each toning session and discarded after it has been used.

Use of a Comparison Print

Keep a wet, untoned print next to the print being toned as a visual guide to the toner's action. This is the only accurate way to measure how much effect has taken place. A disposable work print can be placed on the backside of a flat-bottom tray and propped up next to the toning tray for easy viewing.

Brown Toners

Brown toners are the most widely used and diverse group of toners. They are generally considered to have a warm, intimate, and engaging effect. They are divided into three major groups. Purplish to reddish brown tones are delivered by selenium toners such as Kodak Rapid Selenium Toner. Cool chocolate browns are created from single-solution, sulfur-reacting toners such as Kodak Hypo Alum Sepia Toner T-1a, Kodak Polysulfide Toner T-8, and Kodak Brown Toner. Very warm browns are produced by bleach and redevelopment sulfide toners such as Kodak Sulfide Sepia Toner T-7a. Any Kodak toner with a T in the name is a formula toner and must be prepared by you. Berg and Edwal also make brown toners.

Some toners are capable of producing a wide range of effects and cannot be put into a single category. These include Kodak Poly-Toner, which can yield a wide range of colors, and Kodak Gold Toner T-21, which produces a range of neutral brown tones on warm-tone papers.

Brown Tones on Warm-Tone Papers

Many warm-tone papers, such as Kodak Ektalure, lose contrast and density in polysulfide brown toners such as Kodak Brown Toner and Kodak Polysulfide Toner T-8. These toners also bleach the image slightly, producing a yellow-brown color that may not be visually acceptable. You can compensate for these effects by modifying the development time. Using Ektalure paper as an example, process it in Selectol (1:1) for 2 minutes at 68°F (20°C). Use the same exposure time to make another print, but increase the development time to 3-1/2 minutes. The extra development time increases both the contrast and the density, offsetting the bleaching effect of the toner. Warm-tone papers can deliver even richer browns when processed in a cold-tone developer such as Dektol (1:3) for 3-1/2 minutes at 68°F (20°C).

Brown Tones on Neutral- and Cool-Tone Papers

Neutral and cool-tone papers, such as Kodak Polycontrast, do not produce a yellow cast. You can maintain contrast and density by increasing the developing time by about 25 percent and leaving the exposure time the same.

Kodak Rapid Selenium Toner

Kodak Rapid Selenium Toner is a prepared single-solution toner that can be used to make purplish brown to reddish brown colors on neutral and warm-tone papers. Rapid Selenium Toner converts the silver image into brown silver selenide and causes a slight increase in print density and contrast. The increased density is more noticeable in the highlight areas, while the increased contrast is more noticeable in the shadow areas. To compensate for these characteristics, a slight reduction (often less than 10 percent) in development time may be necessary.

The standard dilution rate for Rapid Selenium Toner is 1:3 (1 part toner to 3 parts water). The normal toning time range is 2 to 8 minutes. Diluting the toner 1:9, 1:20, or 1:30 slows the toning action, producing a variety of intermediate effects. Allow for the fact that toning will continue for a brief time in the wash. A faint smell of sulfur dioxide may be noticeable when you are working with this toner. After toning is complete, treat the print with a washing aid and then wash for 1 hour.

Kodak Poly-Toner

Kodak Poly-Toner is a versatile, single-solution, commercially made toner. Poly-Toner changes the silver image into part selenide and part sulfide. It is capable of producing a variety of brown tones, from sepia on cold papers to warm browns on warm papers. Table 10.2 provides some common starting

points for working with Kodak Poly-Toner. Following toning, immerse the print in a washing aid and then wash for at least 1 hour.

Table 10.2 Toning with Kodak Poly-Toner at 70°F (21° C)

Dilution	Tone Produced	Time
1:4	Reddish brown	1 minute
1:24	Brown	3 minutes
1:50*	Warm brown	7 minutes

*A loss of density can occur at this dilution. Compensate by increasing the print's development time.

Kodak Brown Toner

Kodak Brown Toner is a packaged single-solution toner that produces sepia tones on most papers. This is accompanied by a loss in contrast, which can be offset by increasing the development time. Brown Toner changes the silver image into brown silver sulfide. This toner does contain potassium sulfide and should be used only in a well-ventilated area.

Kodak Brown Toner has a normal toning range of 15 to 20 minutes at 68°F (20°C) with agitation. When toning is finished, treat the print with a washing aid and then wash for at least 1 hour. Increasing the temperature will increase the toner's activity and reduce the toning time. Kodak Polysulfide Toner T-8, whose formula is provided later in this section, can produce results very similar to those produced by Kodak Brown Toner.

Kodak Sepia Toner

Kodak Sepia Toner is a prepared two-solution toner that can provide good sepia tones on cold-tone papers such as Kodabromide and Polycontrast or yellow-brown tones on warm-tone papers. Varying the toning time to alter the color is ineffective with Kodak Sepia Toner and is not recommended. This toner changes the silver image into brown silver sulfide. It results in some loss of print density, which can be corrected by increasing the exposure time.

With Kodak Sepia Toner, the print is bleached in solution A for approximately 1 minute, until the blacks in the shadow areas disappear. A light brown image in the shadows, with the lighter tones becoming invisible, indi-

Figure 10.3 Brown toners are popular and versatile, delivering diverse visual effects. Fish altered the way Rapid Selenium Toner is generally used in making this partially toned photograph. A one-half-second exposure was made, during which a nonsynchronized flash was fired into the foreground. To add contrast, the print was developed on grade 3 paper in Dektol (1:1) for 3 minutes, fixed in two hypo baths, treated with a hypo clearing agent, and immersed in a strong dilution of selenium (1:3). It was removed from this solution after it had been partially toned.

© Alida Fish. "Untitled," 1976. Gelatin silver print. 11 x 14".

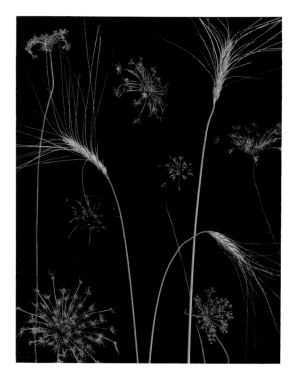

Figure 10.4 Using his own retoning method (see steps 1 through 10 at right), Kaplowitz produced a light golden brown instead of a reddish brown color. Retoning with Kodak Sepia Toner is most noticeable in the gray values. It tends to leave the black areas with little or no additional effects. The subtle change works to enhance this delicate composition.

© Kenneth Kaplowitz. "Fireworks," 1988. Gelatin silver print. 20 x 16".

cates that the bleaching is complete. If the print is not totally bleached before being put in the sulfide toner, irregular tones are likely to occur. After bleaching, the print is thoroughly rinsed for a minimum of 2 minutes in running water, then immersed in solution B for about 30 seconds, until the original density returns. Following the completion of the toning operation, the print is placed in a washing aid and then washed for a minimum of 1 hour. (See Color Plate V). Kodak Sulfide Sepia Toner T-7a, whose formula is provided in this chapter, delivers similar results to those achieved with Kodak Sepia Toner.

Retoning Process It is possible to retone prints in Kodak Sepia Toner to achieve a subtler, but nevertheless more striking, effect than can be produced from a fully toned sepia image. The gray areas are the most affected with this method, turning slightly golden brown rather than reddish brown. The black portions of the print change little or not at all.

For this retoning process, make a number of prints that are slightly darker than normal (start with a range of 10 to 25 percent darker). Papers such as Agfa Brovira and Ilfobrom deliver good results. Begin experimentation with test prints, as it may be necessary to adjust the processing times depending on the type of paper and its contrast. To achieve the most subtle effects, begin with a *dry* print that has been fixed and completely washed. Use the regular Kodak Sepia Toner mixture at about 68° F (20° C) and follow these steps:

1. Place the print in solution A (bleach) for about 30 seconds.
2. Wash in running water for 2 minutes.
3. Place the print in solution B (toner) for approximately 1 minute.
4. Wash in running water for 2 minutes.
5. Rebleach the print in solution A for about 15 seconds.
6. Wash in running water for 2 minutes.
7. Retone in solution B for approximately 1 minute.
8. Wash for 1 minute.
9. (Optional) Place the photograph in a 1:13 solution of Kodak Liquid Hardener (1 part hardener to 13 parts water) for about 3 minutes with occasional agitation.
10. Give the image a final wash in running water for a minimum of 30 minutes.

Kodak Hypo Alum Sepia Toner T-1a

Kodak Hypo Alum Sepia Toner T-1a is designed to deliver sepia tones on warm-tone papers. Hypo Alum Sepia Toner T-1a results in a loss of contrast and density, which can be offset by increasing the exposure time by up to 15 percent or increasing the development time by up to 50 percent. This toner is designed to be used at a high temperature, 120° F (49° C), for 12 to 15 minutes. Toning at above 120° F for longer than 20 minutes may cause blisters or stains on the print. The toner may be used at room temperature, but toning will take several hours. The solution should be agitated occasionally during this process. After completion, it may be necessary to wipe the print with a soft sponge and warm water to remove any sediment. The print is then treated with a washing aid, followed by a final wash of at least 1 hour.

Kodak Hypo Alum Sepia Toner T-1a Formula Prepare this formula carefully following these instructions:.

Water (68° F or 20° C)	90 ounces (2,800 milliliters)
Sodium thiosulfate (pentahydrate)	16 ounces (80 grams)

Dissolve completely and then add the following solution:

Water (160° F or 70° C)	20 ounces (640 milliliters)
Potassium alum (fine granular)	4 ounces (120 grams)

Now add the following solution, including the precipitate, slowly to the hypo alum solution while stirring rapidly.

Water (68° F or 20 °C)	2 ounces (64 milliliters)
Silver nitrate crystals*	60 grains (4 grams)
Sodium chloride	60 grains (4 grams)

*Dissolve the silver nitrate completely then the sodium chloride. Immediately add the solution along with the milky-white precipitate to the hypo alum solution. The formation of any black precipitate should not impair the action of the toner if it is properly handled. It is advisable to wear gloves because silver nitrate will stain anything it touches black.

After combining these two solutions, add water to make 1 gallon (3.8 liters).

When you are ready to use the toner, heat it in a water bath to 120° F (49°C).

Kodak Sulfide Sepia Toner T-7a

Kodak Sulfide Sepia Toner T-7a is a two-solution bleach and redevelopment toner. It is capable of delivering warm brown tones on many types of paper, including cold-tone papers. Its results and general characteristics are similar to those achieved with the packaged Kodak Sepia Toner.

The print to be toned is placed in solution A (bleach) until only a faint yellowish brown image remains. This takes 5 to 8 minutes. The print is then rinsed completely in running water for a minimum of 2 minutes. Next it is immersed in solution B (toner) until the original details return, about 1 minute. After this procedure, the print is given a thorough rinse and treated in a hardening bath for 2 to 5 minutes. The hardening bath can be prepared by mixing 1 part prepared Kodak Liquid Hardener with 13 parts water or using 2 parts Kodak Hardener F-5a stock and 16 parts water (see formula on next page). The hardening bath should not affect the color or tonality of the print. After toning (and hardening), place the print in a washing aid and then wash for a minimum of 1 hour.

Kodak Sulfide Sepia Toner T-7a Formula

Stock Bleaching Solution A

Water (68° F or 20° C)	32 ounces (1 liter)
Potassium ferricyanide (anhydrous)	2-12 ounces (75 grams)
Potassium bromide (anhydrous)	2-1/2 ounces (75 grams)
Potassium oxalate	6-1/2 ounces (195 grams)
28% acetic acid*	1-1/4 ounces (40 grams)
Water to make 64 ounces (2 liters)	

*To make 28 percent acetic acid from glacial acetic acid, combine 3 parts glacial acetic acid with 8 parts water.

Stock Toning Solution B

Sodium sulfide (*not* sulfite; anhydrous)	1-1/2 ounces (45 grams)
Water (68° F or 20° C)	16 ounces (500 milliliters)

Prepare the bleaching solution as follows:

Stock Solution A	16 ounces (500 milliliters)
Water	16 ounces (500 milliliters)

Prepare the toner as follows:

Stock Solution B	4 ounces (125 milliliters)
Water to make 32 ounces (1 liter)	

Mix the solutions directly before use and dispose of them after each session.

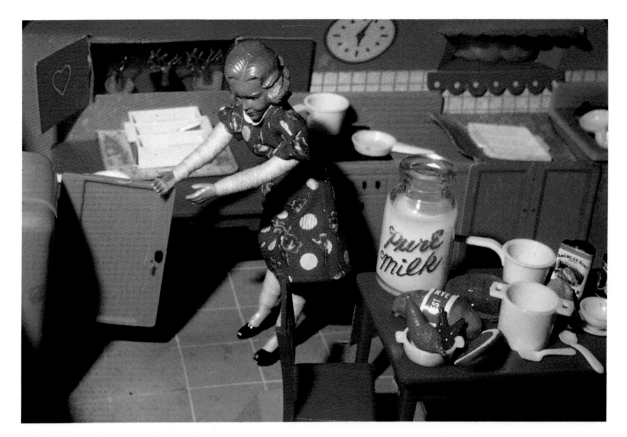

Color Plate I Simmons collects objects and materials that are essential for producing her densely packed tableaux of stereotypical situations. The act of collecting and arranging such objects can be a springboard for generating even more ideas. Since collecting can be spontaneous, it can be a window into the collector's subconscious by raising questions such as the following: Why did I react so strongly to this object? What made me want to save and incorporate it into my work? What meaning does it hold for me? How can I communicate this to the viewer?

© Laurie Simmons. "Woman Opening Refrigerator," 1979. Chromogenic color print. 6-1/8 × 9-1/4". Courtesy of Metro Pictures, New York.

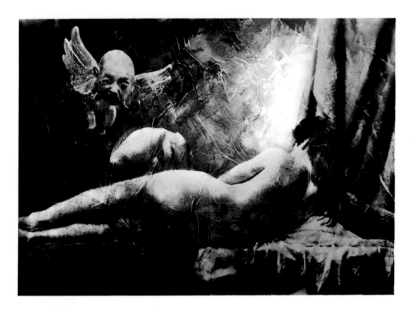

Color Plate II The print exposure for this image was made through wet tissue on the paper's surface. It was toned with copper toner applied undiluted with spotting brushes. The print was exposed 50 percent more than normal to allow for the bleaching effect of the copper toner.

© Jeffery Byrd. "All Difficult Music Must Be Heard More Than Once," 1988. Gelatin silver print. 12 x 16".

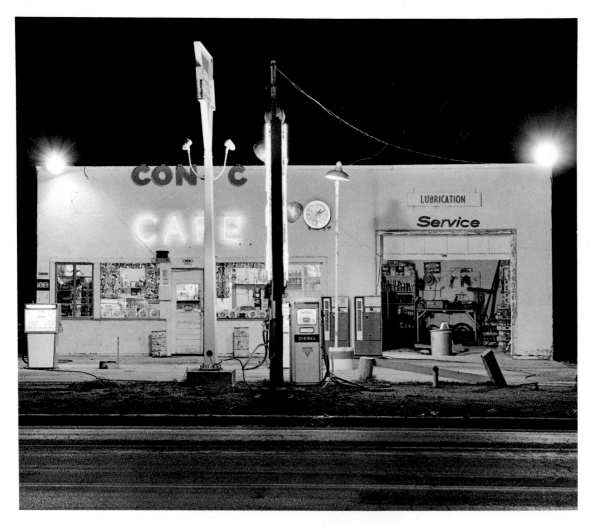

Color Plate III By preparing his own formulas, Fitch is able to exercise greater control over the final print. The negative for this print was processed in pyro to help retain detail and sharpness in a contrasty lighting situation. The staining action of pyro reinforced the silver image, thus making the underexposed parts of the scene more printable. The final print was treated in Nelson's Gold Toner to achieve a warm-tone appearance.

© Steve Fitch. "Gas Station, Highway 66, Vega, Texas," 1972. Gelatin silver print. 10 x 11 3/4".

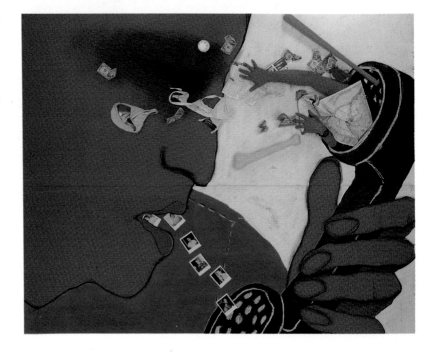

Color Plate IV The Polaroid process is ideal for questioning the process of creation because it allows immediate feedback. Robbennolt's image raises the question of whether our data base can provide meaningful answers or whether it is a circular chaotic event.

© Linda Murphy Robbennolt. "Garbage In/Garbage Out," 1987. Polaroid print. 20 x 24".

Color Plate V Dealing with the theme of alienation, Taylor used drawing and painting to alter the print to give it gestures of human emotions. This mixed-media piece was rephotographed, creating a photomontage, to produce an archival print in which all the hand marks are ultimately photographic. Sepia toner was selectively applied with a brush, adding color, contrast, and a further sense of fractured surrealistic time and space. The result is an image of an isolated figure in a metallic environment being pushed to his limits.

© Brian Taylor. "Praying Against Gravity," 1988. Gelatin silver print. 18 x 22".

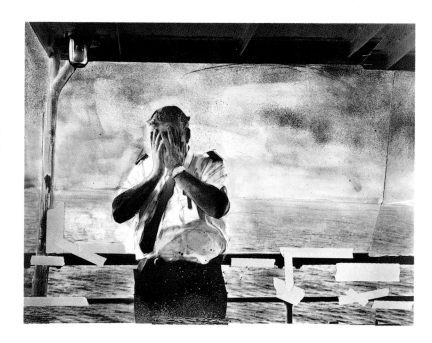

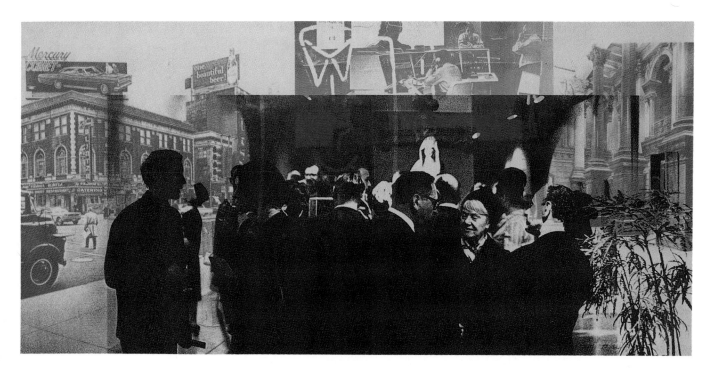

Color Plate VI Kwik-Print is a commercial bichromate process that is faster and simpler than gum printing. Since the Kwik-Print colors are translucent, a number of printings are usually done to build up saturated color. Hyde took advantage of this characteristic to make a multi-image print. Kwik-Print also is used to make one-of-a-kind prints and to proof images for more complex processes, such as silk-screening or offset lithography.

© Scott Hyde. "So. Broad," 1966. Kwik-Print. 7 x 13".

Color Plate VII In the tradition of Dadaism and surrealism, Smith-Romer takes images from old magazines and newspapers, as well as computer-generated images, and arranges them on a Canon Color Laser Copier. The rapid feedback of this mode of working enables the artist to evaluate her compositional arrangements and make new compositions while still in the midst of the creative process.

© Helene Smith-Romer. "Hitler Was a Romantic," 1989. Electrostatic print. 8 x 10".

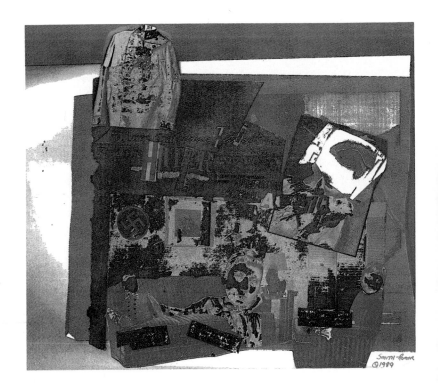

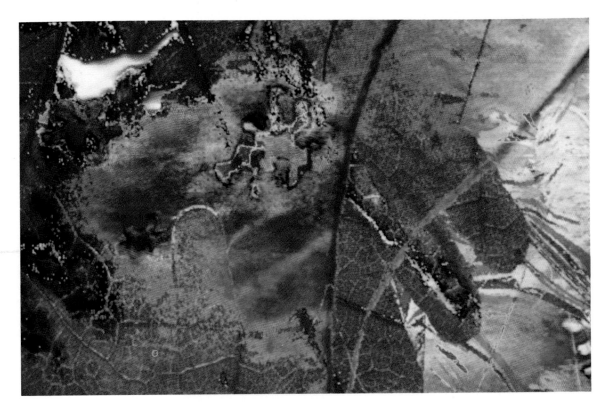

Color Plate VIII Leaves, gloves, and a watercolor were scanned with a flatbed color scanner, fed into a computer with a Targa 16 graphics board, and then processed with Lumena paint software. This is one of a series of works addressing the processes of change and transformation.

© Joan Truckenbrod. "Encoded Fertility," 1989. Heat-transfer Xerography on fabric. 3 x 4'.

Kodak Hardener F-5a Formula

Water (125°F or 50°C)	20 ounces (600 milliliters)
Sodium sulfite (anhydrous)	2-1/2 ounces (75 grams)
28% acetic acid*	7-1/2 ounces (235 millili-
ters)	
Boric acid crystals**	1-1/4 ounces (37.5 grams)
Potassium alum (fine granular, dodecahydrate)	2-1/2 ounces (75 grams)
Cold water to make 32 ounces (1 liter)	

*To make 28 percent acetic acid from glacial acetic acid, combine 3 parts glacial acetic acid with 8 parts water.

**Crystalline boric acid is suggested because it is difficult to dissolve boric acid in powder form.

The standard dilution for Kodak Hardener F-5a is 1:13 (1 part hardener to 13 parts water). Process for 2 to 5 minutes at 68°F (20°C).

Kodak Polysulfide Toner T-8

Kodak Polysulfide Toner T-8 is a single-solution toner delivering slightly darker brown tones than Kodak Sulfide Sepia Toner T-7a on warm-tone papers. Unlike Kodak Hypo Alum Toner T-1a, it has the advantage of not having to be heated. This toner is not recommended for use with cold-tone papers.

Kodak Polysulfide Toner T-8 Formula

Water	96 ounces (750 milliliters)
Sulfurated potash	1 ounce (7.5 grams)
Sodium carbonate (monohydrated)	145 grains (2.5 grams)
Water to make 32 ounces (1 liter)	

Prints are immersed in Polysulfide Toner T-8 for 15 to 20 minutes, with agitation, at 68°F (20°C). Raising the temperature increases T-8's activity and reduces the toning time to as low as 3 to 4 minutes at 100°F (38°C). After toning, the print is rinsed in running water for at least 2 minutes and can then be treated in a hardening bath, as mentioned in the Kodak Sulfide Sepia Toner T-7a section, for 2 to 5 minutes. If sediment forms on the print during the toning process, it should be removed with a soft sponge and warm water before the final wash. When these operations are complete, treat the print in a washing aid and give it a final wash of at least 1 hour.

Kodak Gold Toner T-21

Kodak Gold Toner T-21, also known as Nelson Gold Toner, is a single-solution toner that yields an excellent range of brown tones on most warm-tone papers but has little effect on most cold-tone papers. T-21 is unique in the fact that it tones the highlight and shadow areas at the same rate. This allows the toning action to be stopped any time the desired effect has been achieved without having to worry whether the highlight and shadow areas have received equal effects. It also makes possible a variety of even-toned effects that can be created by simply changing the time in the toning bath. T-21 has a normal toning time range of 5 to 20 minutes. This toner requires careful preparation to achieve the expected results. (See Color Plate III).

Kodak Gold Toner T-21 Formula

Stock Solution A

Water (125°F or 50°C)	1 gallon (4 liters)
Sodium thiosulfate (pentahydrate)	2 pounds (960 grams)
Ammonium persulfate	4 ounces (120 grams)

The sodium thiosulfate must be totally dissolved before adding the ammonium persulfate. Vigorously stir the solution when adding the ammonium persulfate. The solution should turn milky. If it does not, increase the temperature until it does.

Cool the solution to about 80°F (27°C), then add the following solution, including the precipitate, slowly, stirring constantly. If predictable results are desired, the first bath must be cool when these two solutions are combined.

Cold water	2 ounces (4 milliliters)
Silver nitrate crystals*	75 grains (5 grams)
Sodium chloride	75 grains (5 grams)

*The silver nitrate crystals must be completely dissolved before adding the sodium chloride. Wear gloves, as the silver nitrate will stain anything it comes in contact with black.

Stock Solution B

Water (68°F or 20°C)	8 ounces (250 milliliters)
Gold chloride	15 grains (1 gram)

Slowly combine 125 milliliters of stock solution B with all of stock solution A, stirring rapidly. Allow the bath to stand until it is cold and a sediment has formed at the bottom. Pour off only the clear liquid for use, leaving the sediment behind.

Pour this clear solution into a tray and heat it with a water bath to 110°F (43°C). During toning, maintain a temperature of 100°F to 110°F (38°C to 43°C). When toning is complete, treat the print in a washing aid and give it a final wash of at least 1 hour.

This bath may be revived by adding stock solution B. The quantity needed depends on the number of prints toned, the intensity of the tone desired, and the time of toning. For instance, when toning to a warm brown, add 4 milliliters of stock solution B after about fifty 8 x 10" prints or the equivalent have been toned.

Kodak Gold Protective Solution GP-1

For years Kodak Gold Protective Solution GP-1 has been the standard treatment to protect a silver-based photograph from atmospheric gases. Recent scientific evidence indicates that selenium toning can be more effective and a great deal less costly for protective measures. GP-1 is an extremely stable toner that is capable of yielding very pleasing brown tones. The high cost of gold has limited its widespread use. Gold toner protects all fiber-based papers and creates at least a slight visual effect in almost all cold-tone papers.

For protective toning, the print is immersed in the gold toner for about 10 minutes, with agitation, at 68°F (20°C), or until a barely perceptible change in image tone (a slight blue-black) occurs. The toning time can be increased up to 20 minutes for visual effect. Following the toning operation, treat the print with a washing aid and give it a final wash of at least 1 hour.

Kodak Gold Protective Solution GP-1 Formula

Water (68°F or 20°C)	24 ounces (750 milliliters)
Gold chloride (1% stock solution)	2-1/2 drams (10 milliliters)
Sodium thiocyanate	145 grains (10 grams)
Water to make 32 ounces (1 liter)	

A 1 percent stock solution of gold chloride can be made by mixing 1 gram of gold chloride in 100 milliliters of distilled water. Add the stock solution of gold chloride to the amount of water indicated (24 ounces). Mix the sodium thiocyanate separately in 4 ounces (125 milliliters) of water. While stirring rapidly, slowly add the thiocyanate solution to the gold chloride solution. GP-

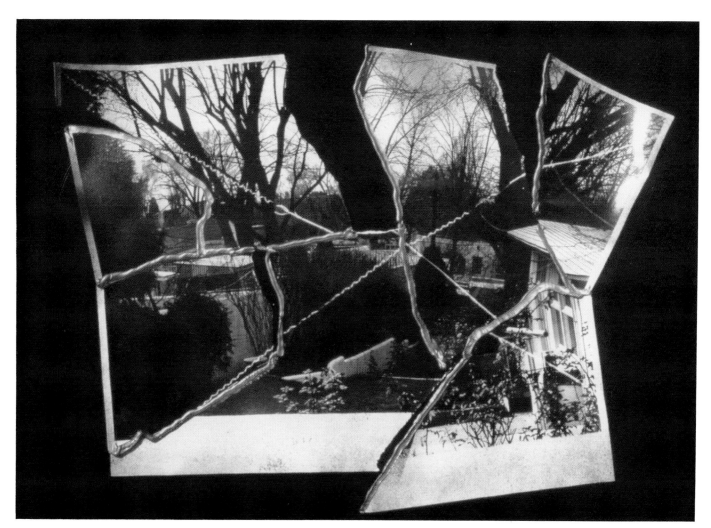

Figure 10.5 Barrow wondered how much he could alter the photographic image and yet retain its specific qualities. In putting together this work, he used gold toner at an elevated temperature of 135°F (57°C) to create extreme blue-blacks on a cold-tone paper. The print was torn apart and then reconstructed with staples and silicon caulking. Various areas of the image were fogged with spray lacquer paint.

© Thomas Barrow. "Yard Descent," 1982. Gelatin silver print with caulk and paint. 17 x 21". Courtesy of Andrew Smith Gallery, Santa Fe. Original in color.

1 deteriorates quickly and should be mixed right before use. It has a capacity of about thirty 8 x 10" prints per gallon. Work in a well-ventilated area and wear protective gloves when mixing this formula.

Blue Toners

Kodak Blue Toner T-26

Kodak Blue Toner T-26 delivers solid, deep blue tones on warm-tone papers and soft blue-black tones on neutral-tone papers. It has no effect on cold-tone papers. T-26 increases the contrast and density of the print slightly. This can be corrected by reducing the normal exposure time (a 10 percent reduction is a good place to start). This toner deteriorates rapidly and should be mixed immediately before use. Toning starts in the highlight areas and then slowly moves into the shadows. Careful observation is necessary to avoid getting a partially toned print with blue highlights and untoned shadow areas. Both Edwal and Berg also make blue toners.

The range of toning times is 8 to 45 minutes at 68°F (20°C). Increasing the temperature of the bath to 100°F to 105°F (38°C to 40°C) speeds up the toning action, thus decreasing the toning times to 2 to 15 minutes. Since toning is slow, only occasional agitation is needed to avoid streaking. For consistent results with a number of prints, slide them rapidly into the toner one

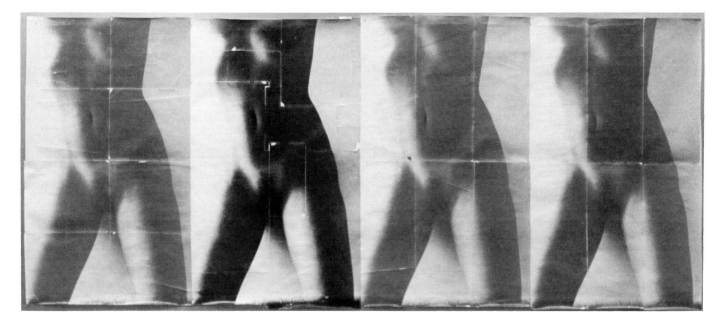

Figure 10.6 Reflecting on the idea of more than one, Doug and Mike Starn challenge many basic concepts of fine art photography. They are known for crumpled, scratched, torn, and taped-together images that have been thumbtacked to the wall. The Starn Twins make large-scale pieces designed to hold the wall in big gallery spaces alongside painting and sculpture. The three paper panels of this work were toned with sepia toner mixed with fixer. The ortho film panel was toned with blue toner.

© The Starn Twins. "Quadruple Nude," 1988. Gelatin silver prints and silver base film. 49 x 96". Courtesy of Stux Gallery, New York. Original in color.

after the other. T-26 exhausts itself very quickly. It has a capacity of only five to fifteen 8 x 10" prints or the equivalent per quart. When toning is finished, immerse the print in a washing aid and follow with a final wash of at least 1 hour.

Kodak Blue Toner T-26 Formula

Part A Solution

Water (68° F or 20° C)	31 milliliters
Gold chloride*	0.4 grams

Part B Solution

Powder thiourea	1 gram
Tartaric acid	1 gram
Sodium sulfate (anhydrous)	15 grams

*A 1 percent gold chloride solution can be used (available from chemical supply sources). Use 40 milliliters of this solution as part A and add 937 milliliters of water to make a total of 977 milliliters of solution.

Dissolve the gold chloride in the water to make part A. Add part A to 946 milliliters (1 quart) of water at 125° F (52° C). Stirring, add part B. Continue to stir until all the chemicals are totally dissolved.

Red Toners

Red toners can be intense and spectacular, but they require more work than brown or blue toners to achieve good results. Generally, the best and most varied results require toning the print in two separate toners. For example, a print is first toned in Kodak Sepia Toner or Kodak Brown Toner and thoroughly washed. Then it is immersed in Kodak Blue Toner T-26 for 15 to 30 minutes at 90° F (32° C) with occasional agitation. Cold-tone papers produce solid reds, while warm-tone papers yield orange-red hues.

Start with a print having more density and contrast than normal, as there is a loss of these qualities, especially in the shadow areas, with most papers. Red tones can be produced in a single bath of Red Toner GT-15 (see formula below). Regardless of which method you use, treat the completed toned print with a washing aid and give it a final wash of at least 1 hour. Berg and Edwal

also make red toners, which may be mixed to produce intermediate hues and intensities.

Red Toner GT-15 Formula

Stock Solution A
Potassium citrate .. 1-1/2 ounces (100 grams)
Water (68° F or 20° C) to make 16 ounces
 (500 milliliters)

Stock Solution B
Copper sulfate .. 115 grains (7.5 grams)
Water to make 8 ounces (250 milliliters)

Stock Solution C
Potassium ferricyanide .. 100 grains (6.5 grams)
Water to make 8 ounces (250 milliliters)

Mix stock solution B into stock solution A. While stirring, slowly add stock solution C. Red Toner GT-15 bleaches the print. Compensate by extending the printing time well beyond normal, up to 50 percent.

Green Toners

Green tones are possible with a toner such as Green Toner GT-16. This toner is most effective on warm-tone papers. It bleaches the image, so more exposure time than normal (10 to 25 percent) is necessary. Both Edwal and Berg make green toners.

Green Toner GT-16 Formula

Stock Solution A
Oxalic acid .. 120 grains (7.8 grams)
Ferric chloride .. 16 grains (1 gram)
Ferric oxalate .. 16 grains (1 gram)
Water (68° F or 20° C) to make 10 ounces
 (285 milliliters)

Stock Solution B
Potassium ferricyanide .. 32 grains (2 grams)
Water to make 10 ounces (285 milliliters)

*Stock Solution C**
Hydrochloric acid .. 1 ounce (28.4 milliliters)
Vanadium chloride .. 32 grains (2 grams)
Water to make 10 ounces
 (285 milliliters)

*First add the acid to the water. Then heat the solution to just below the boiling point and add the vanadium chloride.

Mix stock solution B into stock solution A. Stirring vigorously, add stock solution C.

Tone in the mixed solution until the print appears deep blue. Then remove and wash until the tone changes to green. After the green tone appears, continue to wash for an additional 10 minutes. Treat the print with a washing aid and give it a final wash of at least 1 hour.

If a yellowish stain appears, you can remove it by placing the print in the following solution:

Ammonium sulfocyanide .. 25 ounces (1.6 grams)
Water (68° F or 20° C) to make 10 ounces
 (285 milliliters)

This operation should be carried out before treating the print with a washing aid and giving the final wash.

Toning Variations

Selective Toning

It is possible to tone only selected areas of a print by brushing on a mask that prevents the toner from affecting the covered area (see Color Plate V).

To begin, you need frisket material such as Photo/Maskoid Liquid Frisket or rubber cement and thinner plus different-size brushes. Maskoid Liquid Frisket is handy because it is a brilliant red, making it easy to see where it has been applied. Rubber cement, thinned 1:1 (1 part rubber cement to 1 part rubber cement thinner), may be used instead. A third option is clear self-adhesive frisket, such as Photo/Frisket Film made by Badger Airbrush.

Working Technique Working on a dry print, brush the frisket or rubber cement onto the areas not to be toned. When using rubber cement, apply several thin coats, allowing one to dry before applying the next. This ensures complete coverage and reduces the likelihood of the toner's seeping into areas that are not fully protected.

To avoid leakage into protected areas, some printmakers place the dry print directly in the toner without any presoak. If you do this, you must constantly agitate the print to avoid streaks. Because of the mask, the print may buckle and curl due to uneven wetting, but this should not harm the print. If this method does not work, presoak the print for 3 to 5 minutes.

After toning is complete, follow the normal post-toning procedures. Remove the frisket *after* the print has been washed for about 30 minutes. You can remove Maskoid by picking it up with sticky masking tape. To remove rubber cement, simply rub your fingers across the covered area after the print has gone through about half of its final wash. After you remove the mask, wash the print for a minimum of 1 hour to get rid of any residue from the mask.

Multitoned Prints Different toners can be selectively applied to various areas of the photograph. If you are doing this, you must repeat the entire process, with the exception of the extra wash, which is given after all the toning is done. If you do not wish to combine toners, be certain to protect the previously toned areas with frisket.

Areas of a print can be selectively toned while it is still wet. Exact control and evenness of toning are extremely difficult to achieve, but interesting and unexpected possibilities exist with this technique.

To wet-tone a well-washed print, place it on a clean, flat surface and squeegee the back and then the front so it is completely free of water. Then apply the toner with a brush or cotton swab. You can add a couple of drops of a wetting agent such as Kodak Photo-Flo to the toner to prevent it from beading up on the print surface. For more intensity, rinse the print with water, squeegee, and apply a second coat of toner. Apply only one color toner at a time. You can repeat this process as many times as you wish to obtain the desired results.

Toning with Colored Dyes

Prints can be toned with almost any substance. Natural organic dyes made from beets, coffee, grapes, or tea are possibilities. Commercial dyes such as Rit are more commonly used. These are inexpensive and available in a wide range of colors.

Rit dyes come in powder form and are prepared by mixing the dye with a gallon of water at 125°F (52°C). Mix the dye thoroughly, as undissolved crystals will stain the print.

Dye Technique

1. Presoak the print in water for about 2 minutes.
2. Immerse the print, emulsion side down, in a tray of prepared dye at 100°F (38°C).
3. There is no standard dyeing time. The dye begins to work after about 1 minute depending on the type of paper used and the color desired. Agitate the print constantly. You can view it anytime, as the dye will continue to work until the print is removed from the solution.
4. When the desired color is achieved, remove the print and wash it for 15 to 60 minutes, or until all the excess dye is removed.
5. Air-dry the print, face down, on a plastic screen.

Selective Dyeing Dyes, like toners, can be used to make multicolored compositions. First apply the frisket to any areas you do not want dyed. After the first areas have been dyed, washed, and dried, remove the frisket or rubber cement from the next area that you want to dye. You can protect the previously dyed area with frisket or rubber cement. Then place the print in another tray containing a different color dye. You may repeat this process as many times as desired.

Mixing Colors A mixed-colored effect can be achieved by treating the print with different dyes without using any masking materials.

Bleaching Dyed Prints You can use plain household bleach or Farmer's Reducer, applied with a number 0 or smaller brush, to remove small areas of dye from the image. Bleaching can provide accents in highlight areas or be used to create white areas within the composition.

Split-Toning

Split-toning can visually expand the sense of space within a photograph by intensifying the differences between the cool white highlight areas and the warm brown shadow areas. This can create an unexpected and subtle sense of spatial ambiguity. Some photographers claim that split-toning can unify objects within a composition and give it added depth. Others do not care for it, saying it fractures the continuity of the photograph by making it seem disjointed and out of kilter. The only way to evaluate the effect of split-toning is to apply the technique to an image and decide whether it creates the desired visual effect.

Paper and Developer Selection As in all toning operations, the choice of paper and developer plays a key role in determining the visual outcome. Silver chloride contact papers, such as Kodak Azo, deliver a noticeable split-toning effect. The use of a warm-tone developer, such as Kodak Selectol, with such papers yields an even more vivid effect. Chlorobromide enlarging papers tend not to work as well, and bromide papers show almost no effect. If your negatives are not big enough to contact print, you can enlarge them (see Chapter 4). Photograms (cameraless images made by placing objects directly on the paper) also can be split-toned (see Chapter 13).

A more pronounced split-toning effect seems to take place with the developer temperature slightly above normal. A temperature of 77°F (25°C), with Azo paper in Selectol is a suggested starting point. Keep the temperature constant, as variations of even 1 degree can alter the results.

Processing Procedures Adjust the exposure time so that Azo paper can be developed in Selectol for 1 minute at 77°F (25°C) with constant agitation. Developing for more than 1-1/2 minutes tends to reduce the split-toning effect. Developing for less than 45 seconds can produce an image with streaks

or without the proper density. After development is complete, continue to process following normal print processing procedures, up through the first wash. Then you are ready to tone.

Split-Toning Formula A split-toning solution can be prepared by mixing the following formula:

Water (68°F or 20°C)	750 milliliters
Rapid Selenium Toner	70 milliliters
Perma-Wash	30 milliliters
Kodalk	20 grams
Water to make 1 liter	

Immerse the prints in the toner bath and agitate by continuously interleafing the prints (taking the bottom one and moving it to the top). Observe the prints carefully. Keep an untoned print available for visual reference. First the blacks will intensify. Next the print will exhibit an overall dullness. Finally the shadow areas will start to warm up, and the split between the highlights and shadows will begin to become evident. This should happen within about 4 to 5 minutes.

Continue toning until you like the color and effect. At this point, put the print in a water bath. If the print tones too long, the split will lose its intensity and eventually disappear, taking on a uniform brown color. When split-toning is complete, treat the print with a washing aid for 2 minutes, then wash for at least 1 hour. Air-dry the print, face down, on a plastic screen.

Toning Black-and-White Films

It is possible to tone black-and-white films for color effects. Kodak T-20 is a versatile, single-solution dye toner that can be used to produce many different color effects. Be certain to mix and use this formula only in a well-ventilated area.

Kodak T-20 Dye Toner Formula

Dye*	3 to 6 grains (0.2 to 0.4 grams)
Wood alcohol or acetone	3-1/4 ounces (100 milliliters)
Potassium ferricyanide	15 grains (1 gram)
Glacial acetic acid	1-1/4 drams (5 milliliters)
Water (68°F or 20°C) to make 32 ounces (1 liter)	

*The amount of dye needed depends on the type of dye being used, as follows:

Nabor Yellow 6G	3 grains (0.2 gram)
Nabor Orange G	3 grains (0.2 gram)
Nabor Brilliant Pink	3 grains (0.2 gram)
Nabor Blue 2G	3 grains (0.2 gram)
Bismark Brown	3 grains (0.2 gram)
Victoria Green	6 grains (0.4 gram)

These dyes are made by Allied Chemical Corp., Specialty Chemical Division, Morristown, NJ 07960. They are available in small quantities from Kodak, Eastman Organic Chemicals, Rochester, NY 14650.

Average toning time is 3 to 9 minutes at 68°F (20°C). The tone will vary depending on the film and length of toning time. Beyond about 9 minutes, there is a danger that the image will begin to bleach out. You should experiment on unwanted or duped film before attempting to tone a finished piece. After toning is complete, wash the film until the highlights are clear, then continue to give the film a final wash of about 15 minutes. These dyes are not considered archival and will fade over time.

Additional Information

Books
The ABC's of Toning. Kodak Publication No. G-23.

DeCock, Liliane, ed. *Photo-Lab Index, Lifetime Edition.* Dobbs Ferry, N.Y.: Morgan and Morgan, 1990.

Stone, Jim. *Darkroom Dynamics.* Stoneham, Mass.: Focal Press, 1979.

Wall, E.J., and F.I. Jordan; rev. and enlarged by John S. Carroll. *Photographic Facts and Formulas.* Englewood Cliffs, N.J.: Prentice-Hall, 1976.

Other Sources
Berg Color-Tone, Inc., P.O. Box 16, East Amherst, NY 14051.

Edwal Scientific Products, 12120 South Peoria Street, Chicago, IL 60643.

Photographers' Formulary, P.O. Box 5105, Missoula, MT 59806 (bulk chemicals and prepared versions of many formulas that are no longer commercially manufactured).

Chapter *11*

Special Cameras and Equipment

What Is a Camera?

A traditional camera, from a camera obscura to the latest automatic, is essentially a light-tight box. A hole (aperture) is made at one end to admit light, and some light-sensitive material (usually film) is placed inside the box opposite the hole. The camera's purpose is to enable the light to form an image on the film. This can be accomplished in a variety of ways, but most modern cameras have the same basic components. These include the following:

- A viewing system that allows accurate composition of the image.
- A lens, instead of a hole, that focuses the rays of light to form a sharp image at the back of the camera. This image is upside down and backward. The lens also determines the field of view and influences the depth of field in the scene.
- An adjustable diaphragm, usually an overlapping circle of metal leaves, that creates an adjustable hole called an aperture. The aperture controls the intensity of the light that passes through the lens. when it is widened (opened), it permits more light to pass through the lens. When it is closed (stopped down), it reduces the amount of light passing through the lens.
- A shutter mechanism that prevents light from reaching the film until the shutter is released. The shutter opens for a measured amount of time, allowing the light to strike the film. When the time has elapsed, the shutter closes, preventing any additional light from reaching the film.
- A focusing control, which changes the lens-to-film distance, thus allowing a sharp image of the subject to be formed at various distances.
- Light-sensitive material, traditionally film, that records the image created by the light. Most cameras use roll film, cassettes, or individual sheets. The latest electronic cameras record images magnetically on standard two-inch floppy disks.
- A holder for the light-sensitive material. This is a system or device designed to maintain the correct position of the film in relationship to the lens.
- A film advance mechanism, in roll and cassette cameras, that advances the film after an exposure is made to the next available unexposed portion of the roll or cassette. Sheet film is loaded into film holders that are put in the back of the camera. Electronic imaging cameras automatically go to the next free space on the disk.
- A light meter, usually built into the body of the camera, measures the intensity of the light.

The Role of the Camera

The camera is the primary tool that most photographers use to formulate an image. The selection of camera and lens can determine image characteristics such as sharpness, tonal range, field of view, and graininess of the final print.

Because of this, it is often possible to identify the type of camera used in the creation of a particular image. Consequently, the type of camera chosen should support the photographer's way of seeing and working, since it plays an integral role in determining the final outcome of the image.

Throughout the history of photography, the changing needs of the photographer, as well as the expanding applications of the medium, have led to the development of many specialized camera designs. This can be seen in designs from the past, such as Etienne Jules Marley's photographic gun (capable of capturing a sequence of images on a single round photographic plate), to those of the present, as in today's spy camera hidden inside a working digital watch.

The camera's design is a basic part of the photographer's visual language. It is up to the individual photographer to understand and apply a camera's capabilities, to learn its strengths and limitations, and to know when to use different cameras to achieve the desired results.

I will assume that the reader has a fundamental knowledge of the basic cameras currently in widespread use, including the single lens reflex (SLR), the range finder, the twin lens reflex, and the view camera. If you are not familiar with how these cameras operate, a review is in order before you continue with this chapter. The remaining sections of this chapter introduce some cameras and techniques that photographers have used to explore nontraditional photographic visions.

Additional Information
Adams, Ansel. *The Camera.* Boston: Little, Brown, 1983.

The Diana Camera

Are you feeling alienated by the latest high-tech camera equipment? If the answer is yes, try a Diana and escape into the simplicity of a totally plastic toy camera. Beginning in the early 1960s, the Diana was made by the Great Wall Plastic Factory of Kowloon, Hong Kong. In the United States, the camera was sold by the gross (twelve dozen) and cost one to three dollars per camera. It was also marketed under other names such as Arrow and Banner. The Diana is no longer made, and the main sources for these cameras are secondhand stores, yard sales, flea markets, and camera shows. A clone model is currently being manufactured, but true Diana fans say, "It just ain't the same."

Models
A number of different Diana models were produced. The original has only a single shutter speed (the shutter speed varies tremendously from camera to camera, from about 1/30 to 1/200 second). Some models have a B (bulb) setting for time exposures. The Diana F features a built-in flash, whose synchronization often does not work properly. The shutter on all these cameras can be fired as many times as wanted, so it is easy to make multiple exposures (often unintentionally). All these models have three aperture settings: sunny (f-16), cloudy (f-6.3), and dull (f-4.5). The cameras also have adjustable zone focusing areas, which can be set at 4 to 6 feet, 6 to 12 feet, and 12 feet to infinity. The Diana accepts 120 roll film and makes 16 exposures of about 2 x 2″ per roll.

Characteristics

Light Leaks Almost all the Dianas have light leaks. Many photographers wrap black tape around the camera body, after the film is loaded, to prevent stray light exposure of the film. The red transparent frame-counter window and the inside seams of the camera also can be taped. Some people paint the

camera's interior flat black. The area where the lens is attached to the camera has been known to leak light, requiring additional taping.

The film-advance mechanism does not always completely tighten the exposed film, resulting in a light fog when the film is removed from the camera. Many Diana users combat this by unloading the film in a darkroom or changing bag and then placing the film in an opaque container or wrapping it in aluminum foil. Others just go with the flow and take whatever surprises the camera may provide.

The Lens The plastic lens creates a soft-focus image that appeals to many photographers. The lens tends to be sharpest in the middle, with the focus falling off rather rapidly toward the edges. The lens is not color corrected, so unusual color effects and shifts are normal.

The Viewfinder The Diana's viewfinder is not corrected for parallax, so what you see in the viewfinder is not exactly the same as what the lens sees. This produces an image with a somewhat haphazard look because you have to figure out the composition by intuition and guesswork. Often what you see is higher than what the lens sees, so raising the camera slightly can compensate for this.

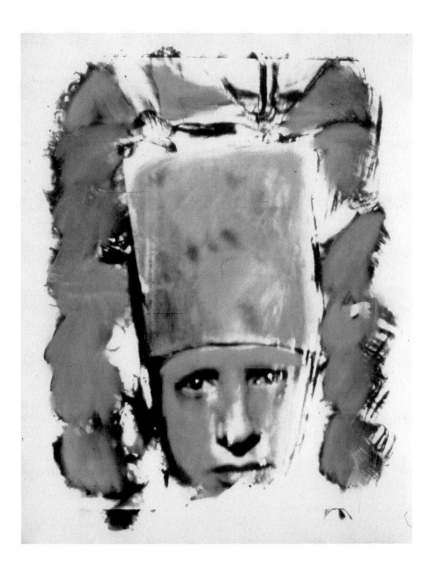

Figure 11.1 In an effort to dispense with the standard, hard-edged, rectangular photographic image, Wessner began by using the simple Diana camera to combine theater, drawing, painting, and photography. The prints were developed by painting nondiluted Dektol onto the paper with handmade brushes, feathers, reed pens, and rags. The effect disengaged the head of the figure from the background, causing it to float and breaking up the traditional sense of space. In the final step, the image was painted with metallic powders.

© Robyn Wessner. "Star Hats," 1987. Gelatin silver print with metallic powders. 31 x 25". Original in color.

Film Selection Black-and-white or color films may be used. Negative films having an ISO of 400 are often shot to compensate for the limited range of camera adjustments. These fast films provide a greater tolerance for exposures that are less than perfect (a likely situation with the Diana). The faster films tend to emphasize grain and texture, adding to the lack of traditional image clarity for which Diana photographs are known. Use only brand-name 120 roll film. Some of the off-brands use heavier spools and paper, which tend to bind in the camera or break the advance mechanism.

Why Choose the Diana?

The Diana questions many photographic axioms, such as "a photograph must be sharp," "a photograph must have maximum detail," and "a photograph must possess a complete range of tones to be considered good." The Diana challenges the photographer to see beyond the equipment and into the image.

This camera also is easy to use. There is no need to use a light meter or to calculate shutter speeds and f-stops.

Finally, the Diana summons up the Dadaist traditions of chance, surprise, and a willingness to see what can happen. This lack of control can free you from worrying about doing the "right" thing and always being "correct." Since the Diana is a toy, it allows you to look at and react to the world with the simplicity and playfulness of a child.

The Pinhole Camera

Would you like a new camera but do not think you can afford one? For a couple of dollars and a few hours of your time, you can build a simple pinhole camera. Pinhole cameras are commonly made from sheet-film boxes, oatmeal boxes, and coffee cans. Building cameras allows you to participate in an aspect of picture making from which you are normally excluded. Many photographers enjoy the feeling of creating the camera that in turn forms their photographic vision. The pinhole camera removes you from the expensive high-tech environment of the fully automatic camera and returns you to the basic function of vision.

An image formed by a pinhole instead of a lens has the benefit of universal depth of field. This means that everything from the foreground to the background appears to have the same degree of sharpness. A uniformly soft, impressionistic image is characteristic of pinhole photographs.

Building a Pinhole Camera

You can make a pinhole camera out of any structurally sound light-tight container (avoid shoe boxes). A 4 x 5″ film box (100-sheet size) makes a good first pinhole camera with a wide angle of view because the closer the light-sensitive material is to the pinhole, the wider the field of view and the shorter the exposure.

Get a thin (0.002) piece of brass or aluminum about two inches square from an automotive or hardware store. Also obtain a sharp, unused sewing needle. A number 13 needle is ideal for a 4 x 5″ film box (the smaller the pinhole, the sharper the image and the longer the exposure time). Since the distance between the front and back of the box is short, a larger needle hole could result in exposure times that are too short.

Hold the needle between your thumb and index finger and gently drill a hole in one side of the metal. Then turn the metal over and drill the other side. Do not stab a hole into the metal. Use very fine sandpaper to remove any burrs around the hole. Repeat this procedure until the opening is the same size as the diameter of the needle. By drilling, sanding, and slowly expanding the hole, you should end up with an almost perfectly round aperture

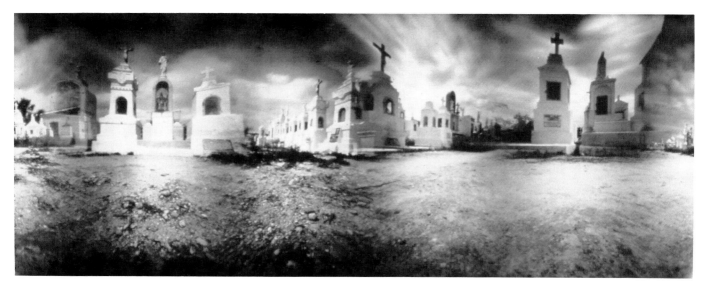

Figure 11.2 Building a pinhole camera allows you to create a machine that reflects your own personal vision. Renner constructed a six-pinhole panorama camera. Outdated aerial Plus-X film was exposed, processed in Dektol, and contact printed on grade 5 paper. The image presents a ghostly combination of space, time, and movement.

© Eric Renner. "Ticul/Graves," 1969. Gelatin silver print. 10 x 29".

without any burrs. The more perfectly round and burr-free the pinhole, the sharper the image will be.

After completing the drilling operation, find the center of the front of the camera box. At this center point, cut a square opening equal to half the diameter of the metal pinhole material (one inch square). Save this cutout for use as a shutter. Center the pinhole metal inside the box and secure it with black tape.

Darken the cutout on all sides with a black marker. If necessary, put black tape around the sides so it fits snugly back into the camera front, over the pinhole. Let a piece of tape stick out to act as a tab-type handle. This handle will allow the cutout to form a trapdoor-style shutter that can be removed and replaced to control the exposure time.

Exposing Paper

Begin by exposing black-and-white photographic enlarging paper outside in daylight. Single-weight fiber paper without any printing on the back works best. This paper is readily available, inexpensive, and easy to process, and you can see exactly what is happening under the safelight. Typical daylight exposures with a film-box camera can run from 1 to 15 seconds depending on the time of day, the season, the size of the pinhole, and the focal length (the distance from the pinhole to the paper).

Processing

After making the exposure, process the paper using normal black-and-white methods. If the paper negative is too dark, give it less exposure time. If it is too light, give it more exposure time. Trial and error should establish a paper negative with proper density within three exposures. When you get a good negative, dry it and then contact print it (emulsion to emulsion) with a piece of unexposed paper. Light will penetrate the paper negative. Process and then evaluate the paper positive. Make exposure adjustments and reprint until you are satisfied.

Exposing Other Materials

After you have mastered the camera and the black and white enlarging paper, you are ready to expose any type of photographic material in the pinhole camera. Materials may include film (black-and-white or color), regular Type C color paper, Cibachrome (which gives a direct positive), and even Polaroid materials such as SX-70.

Converting a 35mm Camera to a Pinhole Camera

You can convert a 35mm camera to a pinhole camera by covering a UV filter with opaque paper in the center of which you have made a good pinhole. Attach the pinhole filter to the camera's lens, and it becomes a pinhole camera. You also can convert an old snapshot-type or disposable camera to a pinhole camera by removing its lens and replacing it with a pinhole aperture.

Why Make Your Own Camera?

A small group of photographers build their own cameras or modify existing models (see Figure 11.3). Here are some of the reasons why they do this:

- For the aesthetic pleasure and craftsmanship of creating their own photographic instrument
- To build a camera to carry out a specific function for which there is no commercial equivalent
- For financial reasons, as it is often possible to make equipment for a great deal less than it would cost to buy it commercially

Additional Information

Books

Hirsch, Robert. *Exploring Color Photography.* Dubuque, Iowa: Wm. C. Brown Publishers, 1989.

Shull, Jim. *The Hole Thing: A Manual of Pinhole Fotography.* Dobbs Ferry, N.Y.: Morgan and Morgan, 1974.

Other Source

The Pinhole Resource, Star Route 15, Box 1655, San Lorenzo, NM 88057.

Disposable Cameras

A recent contribution to our throwaway culture is the disposable camera. It was conceived as a way to sell film and prints to people who do not own a camera, are caught without one at a special moment they wish to capture, or just have the urge to shoot some snapshots. Typically these cameras have a cardboard or plastic body containing a fixed-focus plastic lens with simplified internal workings.

These disposables offer photographers an inexpensive way to expand their image-capturing abilities. Two unusual models use 35mm film. The first is the Kodak Weekend 35, which is encased in plastic and is waterproof to a depth of 12 feet. This makes it an ideal camera for use during inclement conditions. It features a fixed-focus, single-element 35mm plastic lens with one exposure setting of f-11 at 1/110 second. A camera like this enables the photographer to take pictures without the fear of damaging expensive equipment.

The second 35mm disposable is the Kodak Stretch 35, which is actually a panorama-type camera producing an image almost three times longer than it is wide. It contains a fixed-focus 25mm f-12 lens with a shutter speed of 1/100 second. It records a 78-degree horizontal view on a 13.33 x 36.4mm band across the middle of a normal 35mm frame and has a curved film plane to ensure edge-to-edge sharpness. It is designed to make 3 1/2 x 10" prints.

You do not have to dispose of a disposable camera after a single use. Many disposables can be carefully opened, reloaded with whatever type of 35mm film is desired, resealed, and reused. The plastic lens tends to produce a rather soft image similar to that produced with the Diana. As long as relatively fine grain film is used and small prints are produced, the image quality should be acceptable. This soft effect can be exaggerated by making big enlargements. Using higher speed films is a way to achieve a heightened grain

effect. It is also possible to remove the plastic lens and replace it with a pinhole aperture, thus creating a store-bought pinhole camera.

Expanding the Angle of View

Many photographers find that their vision is limited by the normal lens that comes with their camera. These image makers want their work to reveal a larger sense of visual space. Dealing with larger expanses of space poses a number of problems. Aesthetically, there never seems to be enough visual information in this type of photographic image. This means that the image will not be successful in conveying to the viewer the sense of physical space at the site where the photograph was made.

Technically, due to distortion problems with cameras and lenses, it is problematic to achieve a realistic rendition of sweeping expanses of space. Traditionally, there are two approaches to solving this problem—the use of ultrawide-angle lenses and the use of special-purpose panoramic cameras. Some contemporary image makers have abandoned both these methods in search of a new aesthetic answer. They have come up with alternatives such as combining many individual images to create a single nontraditional representation of the scene. See the section on panoramic mosaics later in this chapter and Chapter 13 for discussions of some of these methods.

Rectilinear Wide-Angle Lenses

The first alternative most photographers think of when they want to portray an expanded sense of space is the ultrawide-angle lens. The newer and more expensive lenses are rectilinear, meaning that they are designed to reproduce straight lines without bending or distorting them. An example of such a lens is the 15mm Nikkor f-5.6, which produces a 100-degree sweep, giving a

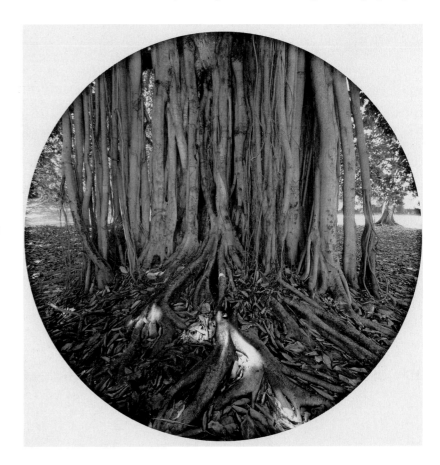

Figure 11.3 The camera used to make this circular image was hand-carved out of a solid piece of mahogany. It uses 5 x 7" film, and features a spring-loaded ground-glass back, and has a peephole viewfinder so that hand-held shots can be made. In blending traditional craftsmanship with electronic technology, Wang used Phil Davis's computer programs *(Beyond the Zone System)* to establish film speed, exposure, and development time. Wang has made other cameras as a way of escaping from the restrictions of the manufacturer's predetermined formats.

© Sam Wang. "Banyan Tree," 1988. Gelatin silver print. 14" circular image on 16 x 20" paper.

good sense of open visual space. The amount of distortion is minimal, providing the subject has been vertically aligned with the camera back on a leveled tripod. The slightest tilt will cause straight parallel vertical lines to converge. Circular spaces and rounded objects tend to reveal more distortion than those with straight horizontal planes. Many of these lenses have built-in filters, thus encouraging the photographer to interact with and further interpret the scene.

The cosine law dictates that there is always some light falloff with a rectilinear lens. This loss of illumination is noticeable in the corners of the frame (vignetting), making the center of the image appear brighter. The amount of falloff depends on the quality of the lens.

Full-Frame Fish-Eyes

A typical full-frame fish-eye (FFF) provides 180-degree diagonal coverage and about 150-degree coverage across the 36mm side of 35mm film. Unlike a rectilinear lens, a high-quality FFF should not produce any vignetting. However, these lenses do suffer from heavy barrel distortion. The center portion of the lens (about 5 to 10 degrees) usually has the least distortion, which becomes more pronounced toward the edges of the frame. Because of this, strong vertical lines on both sides of the frame will bend toward each other. Visually, this can result in a sense of closed space, which defeats one of the main reasons for using an FFF. If bending lines are not acceptable, you should not consider using an FFF. Some photographers like this barrel distortion and incorporate it in their imagery. When evenness of illumination is of prime importance, the FFF is preferable to a wide-angle rectilinear lens.

Panoramic Cameras

Why will an ultrawide-angle lens on a 35mm camera not produce a panoramic photograph? Regardless of how short (wide) the focal length of the lens happens to be, the aspect ratio remains unchanged. The aspect ratio is the height-to-width relationship of any film format. The 24 x 36mm format of a 35mm image has an aspect ratio of 1.5:1, making it 50 percent wider than it is high. A panoramic camera achieves its effect by altering the aspect ratio, making its horizontal plane two to five times wider than its vertical plane, thus increasing the sense of space.

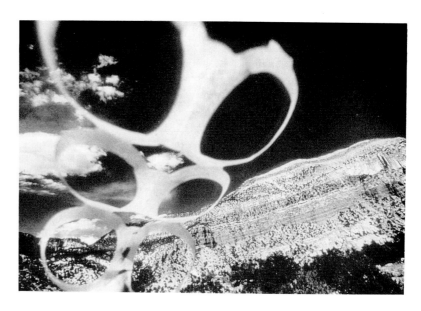

Figure 11.4 Walking alone in the countryside of northern New Mexico, D'Alessandro came across this plastic six-pack holder. Troubled to find it, he picked it up and looked at it through his camera. What he saw startled him. "Could this be a true contemporary fossil of our age?" he wondered. The sense of expanded space was established by using a 15mm Nikkor lens with its built-in red filter.

© Robert D'Alessandro. "Six-Pack Dinosaur Totem," 1980. Gelatin silver print. 16 x 20". Courtesy of Photo-Find Gallery, New York.

Types of Panoramic Cameras

Panoramic cameras can be divided into three basic designs:

1. A swing-lens camera having a curved film plane.

2. A roll film camera (not an SLR) capable of recording a horizontal slice of an image. This is done by using a longer than normal focal length lens designed to be used on a larger format (view) camera.

3. A 360-degree camera whose entire body rotates while the film is pulled past a stationary slit that acts as the shutter. These cameras are actually "any angle" cameras. The amount of visual coverage is determined by setting the camera to rotate for a prescribed number of degrees. Many can be reprogrammed to go past a complete 360-degree circle until they run out of film to expose.

Swing-Lens Cameras The 35mm Widelux, whose 26mm fixed focus lens provides a 24 x 56mm frame, produces a 140-degree view and is the best known and most widely used of the swing-lens cameras. It gives a wide field of view and offers good image size, and the image can be printed on a 2-1/4-inch enlarger. The Widelux image is made by a lens that swings left to right and has a curved film plane to compensate for the angle of the swinging lens. The camera does not have a conventional shutter but a focal-plane drum-slit mechanism to make and record the exposure. The Widelux 1500 works on the same principles but uses 120 roll film to give a 150-degree view on a 50 x 122mm frame. A 4 x 5" enlarger is needed to make prints larger than contact size.

The Cyclops Wide-Eye, with optional viewfinder, records a 110-degree view using either 120 or 220 roll film. It has adjustable f-stops from f-8 to f-45 and two transit (shutter) speeds of 1/60 and 1/120 second.

The Round-Shot 35 is a swing-lens camera that comes with a f-2.8 35mm lens. It produces a more "normal" perspective because the 35mm lens does not accentuate the foreground area of the frame as much as a 26mm lens. The Round-Shot has reflex viewing, so the photographer can preview the scene to see what the lens will take in at any given angle setting. It is controlled by a hand-held push-button microprocessor panel that includes a liquid crystal display (LCD) showing the preselected angle of view and a frame counter. The camera operates in 90-degree increments, allowing for up to six 360-degree views on a 36-exposure roll of 35mm film.

The swing-lens cameras all possess similar characteristics. They have limited shutter speeds, as the speed indicated applies only to the vertical section of the film being exposed by the focal plane slit at any given moment. The overall length of time it takes to make the exposure is longer than the indicated shutter speed. The actual exposure time is how long it takes the swinging lens to make its full sweep. For this reason, the sharpest results are obtained when the camera is on a tripod. Hand-held swing-lens cameras are sharp only at high shutter speeds. These cameras must be held on the top and bottom, not on the front and back, or your fingers might be included in the picture. Holding these cameras by hand can require some practice to produce a decent image. Most of these cameras work best on a precisely leveled tripod, as camera tilt results in either concave or convex horizons.

Since the lens is closer to the center of the subject than to either of its ends, the "cigar effect," which visually expands the center portion of the image, comes into play. It is most noticeable with straight parallel lines. Objects moving in the same direction as the lens rotation may be stretched, while those moving against the lens rotation may be compressed. By learning how this effect works, you can either use it to your advantage or compensate for it. A conventional flash generally cannot be used with this type of camera.

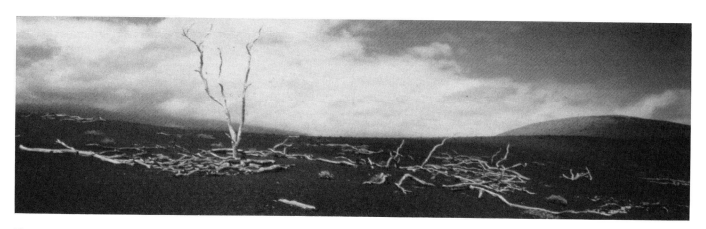

Figure 11.5 In some locations, the traditional camera format cannot fully describe the terrain. The panoramic camera allows photographers to extend the picture frame to reveal geological and geographical formations that make up the landscape.

© Roger Arrandale Williams. "Devastation Trail, Kona, Hawaii," 1987. Type C print. 9 x 30". Original in color.

Roll Cameras Roll cameras equipped with a view camera type lens produce a more limited panoramic effect but do not have the exaggerated perspective of an ultrawide-angle lens on a normal camera. This design alters the aspect ratio by providing an elongated frame. Examples of these cameras include the Fuji G 617, a 6 x 17cm format that has a 105mm lens providing a 78-degree view and can use either 120 or 220 roll film; the Linhof Technorama 612 PC, a 6 x 16cm format that has interchangeable 65mm or 135mm lenses providing views of 85 and 48 degrees, respectively, has a rising front movement, and takes 120 or 220 roll film; and the Art Panorama of Tokyo, a 6 x 24cm format with a 115mm lens that provides a 92-degree field of view.

360-Degree Camera The 360-degree cameras include the Globuscope, which has a 25mm lens capable of producing a complete circular image of 157mm on 35mm film; the Alpa Roto 60/70, which uses either 120mm or 70mm film, has a 75mm lens to deliver 360-degree views, and has a provision for a repeating flash; the Hulcherama, which uses 120 or 220 film with a 35mm lens to create views up to and beyond 360 degrees; and the Cirkut cameras, a series of 360-degree cameras that are no longer produced but are still widely used today.

Panoramic Effects without a Panoramic Camera

It is possible to simulate the look of a panoramic camera image with a normal single-frame camera by capturing a series of overlapping views. This is called the panoramic mosaic working technique.

With a 35mm camera, you would use a lens having a focal length of 35mm to 55mm. Lenses with wider or narrower focal length tend to create more distortion when you attempt to put the images together. To make the matching of the single frames easier, begin by photographing an outside scene that is evenly illuminated by daylight. Load the camera with a slow film (ISO 25 to 100) for maximum detail. Kodak Technical Pan Film is a good film to consider. Place the camera on a precisely leveled tripod with a panoramic head calibrated to show 360 degrees. Use a mid-range to small lens opening (f-8 or smaller) to ensure that you get enough depth of field. Using a cable release or self-timer, make a series of exposures covering the entire scene. Overlap each successive frame by about 25 to 33 percent.

After printing is complete, overlap the prints. For the most naturalistic look, carefully match the prints' tonality. (Extra care must be taken during the printing of the images to make sure the tonality is constant.) Trim and butt them together where the seam is least obvious. For the most accurate perspective, trim and butt together only at the center 10- to 15-degree portion of each image. Prints may be attached to a board using dry-mount tissue or

an archival white glue such as Talas. If you plan to dry-mount the print, be sure to tack the dry-mount tissue to the back of the print before trimming.

Instead of butting the images exactly together, you can mount them separately with space in between. This style of presentation is known as a floating panorama.

Minolta has made the first SLR panorama-adapter kit. It consists of a film mask, which fits and locks into the Maxxum-camera film plane (altering the aspect ratio), and a focusing screen with scribed lines indicating the field of view.

Sequence Cameras

Hulcher Sequence Cameras

Specially designed sequence cameras such as the Hulcher 35 (35mm), Model 112, and the Hulcher 70 (70mm), Model 123, are capable of exposing a prescribed number of frames during a specified period of time. You can load these cameras with magazines holding up to 400 feet of film, and they can make exposures as rapidly as 65 frames per second (fps). The limited hand-production of the Hulcher cameras makes them very expensive. Detailed information is available from the Charles A. Hulcher Company, 909 G Street, Hampton, VA 23661.

The Graph-Check Sequence Camera

The Graph-Check is a different type of sequence camera that makes frame-by-frame exposures on roll film. The Graph-Check has eight separate lenses, which are fired sequentially in a controlled time span of 1/10 to 4 seconds. All eight images are recorded on a single piece of 4 x 5" film (see Figure 11.6). This camera was originally intended to be operated by amateur photographers to record people's golf swings. To provide rapid feedback in this situation, the camera was designed to use a Polaroid 4 x 5" film back. A regular 4 x 5" film back may be used in place of the Polaroid back to expose individual sheets of film.

The Graph-Check comes in two basic models, each with a single fixed shutter speed. The Model 400 has a shutter speed of 1/250 second, and the Model 400A has a shutter speed of 1/1,000 second. Both have three aperture settings: dull (f-11), normal (f-19), and bright (f-32). There is no focusing device, and composing is loosely done with a pop-up finder. The Graph-Check is manufactured by Mitchell Camera, 11630 Tuxford Street, Sun Valley, CA 91352-3175. Used ones are usually reasonably priced. A good source of used equipment is Shutterbug, P.O. Box 1209, Titusville, FL 32781-9989.

The Action Tracker

Advance Design International of Japan makes an inexpensive point-and-shoot sequence camera. The Action Tracker, which features four single-element lenses that make four separate exposures about one-eighth second apart on a single frame of 35mm film, costs about $30. The Action Tracker is distributed by Marketing Plus International, 16478 Harbour Lane, Huntington Beach, CA 92649.

Power Winders and Motor Drives

Many 35mm cameras today come with a built-in power winder that can make exposures at the rate of 2 to 6 fps. Most 35mm SLRs have optional motor drives that are capable of exposing film at the same rate. Either type is usually more than adequate for most sequential uses. Some professional cameras have special film backs that increase the number of exposures (up to 250) that you can make without reloading.

Figure 11.6 Spano photographed this street scene using a Graph-Check Sequence Camera modified to extend the time between exposures. Instead of recording a single moment in time, the eight separate lenses record an activity over an extended period of time. This interaction between frames can produce unusual connections and juxtapositions that enable you to see and learn something new about the subject.

© Michael Spano. "Untitled," 1984. Gelatin silver print. 46 x 55". Courtesy of Laurence Miller Gallery, New York.

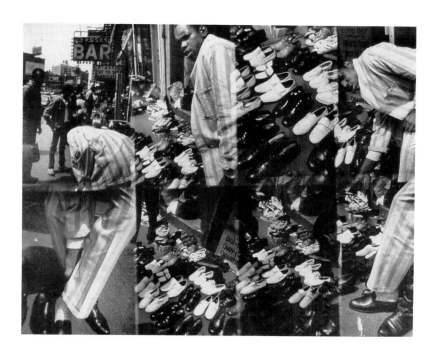

Single-Image Sequences/16mm Movie Cameras

Even without a sequence camera, power winder, or motor drive, you can achieve a sense of sequential time by stringing together a series of individual images into a single composition. If grainy enlargements are not a problem, you might consider using a 16mm movie camera to make sequential images. The video camera revolution has caused the prices of 16mm equipment to drop drastically, making them a more affordable option. Black-and-white 16mm negative film, such as Eastman Double-X (ISO 200 tungsten or 250 daylight) and 4-X (ISO 400 tungsten or 500 daylight), is available in 100-foot rolls. These films must be processed by a commercial lab with 16mm capability. Using a movie camera is ideal because it is designed to make a sequence of single-image exposures (typical speeds are 8, 16, 24, 32, and 64 fps).

Electronic Imaging

Still Video Cameras

Although many people may not have been aware of it, electronic still photographs made their public debut in the 1960s with images returned from space satellites and the lunar landing. Today electronic and computer technology is used in almost all current photographic equipment, carrying out functions from focusing the camera to determining the correct amount of flash-fill.

In 1986, Canon introduced the first fully integrated professional still video camera (SVC) system, signaling the arrival of electronic still imaging. Within two years, Canon unveiled its first consumer SVC, with other manufacturers following in close pursuit. The cost and image quality of these cameras vary widely.

At this time, a typical professional SVC is slightly larger than an equivalent autofocus 35mm SLR camera. Instead of film, an SVC uses a video floppy disk (2-3/8 x 2-1/8 x 1/8") that electronically records one frame at a time, thus eliminating the need for film processing. The manufacturers have agreed to a standard size and configuration of the disk, which can store 50 field-quality (low-resolution) or 25 high-resolution images. Like a regular vid-

eotape camera, the SVC uses a charge-coupled device (CCD) to translate brightness (the intensity of reflected light) into electrical charges. These charges are encoded in a pattern on the disk that is played back by a still video player to display or transmit the image taken through the lens. The player may be housed inside the camera itself, or it may stand alone as a separate unit.

A typical SVC can be plugged into a television, eliminating the need for any darkroom procedures and also permitting the direct viewing of the images recorded on the disk. Hard copies, in black-and-white or color, can be made in minutes by attaching the SVC to a special printer. With additional hardware, prints can be made on standard color, Polaroid, inkjet, or thermal transfer dot matrix paper. Images also can be photographed directly from the screen. The SVC can be plugged into a transmitter, and within minutes a complete image can be sent through a telephone line to a receiver anywhere in the world. The SVC can be connected to a computer through a cable plugged into a digitizing device, thus permitting the image to be manipulated and printed through the computer (see Chapter 14). Currently, several companies are making a still video adapter that fits onto the back of a regular camera to allow for the use of electronic images instead of film.

Although an SVC may resemble a film-based camera, there are two major differences that can significantly affect the nature of photography. The first is that the CCD cells make it possible to photograph in extremely low light without a tripod or additional artificial light. The second is that the SVC has enhanced telephoto capabilities. Since the size of the cell area receiving the image signal is much smaller than a typical 35mm negative, a 50mm lens, which is considered normal for a regular 35mm camera, has the approximate effect of a 200mm telephoto lens. This quadrupling (4X) effect drastically reduces the cost of telephoto power.

The electronic resolution, which is comparable to sharpness of edge or detail in a film image, is determined by the number of CCD elements in the camera's image sensor. Right now film is unquestionably superior to still video when it comes to delivering high image quality. High-resolution 35mm color slide film can have 20 million pixels of information. The current SVCs produce a resolution of 200,000 to 600,000 pixels. Slow, fine-grain slide film has a resolution about 50X that of still video. The resolution quality of still video can be expected to improve rapidly, however, as technological advances in the imaging sensor chips of the cameras are made.

Electronic Editing

Once the image is converted through a *digitizing* device (see Chapter 14) into electronic bytes, it can be manipulated electronically with a computer. The image information, in the form of pixels, may be moved and changed in color and shape through a computer keyboard. At this time, due to high cost, the most sophisticated manipulations are carried out by big companies and institutions. What was once done with brushes, knives, bleaches, and dyes can be carried out electronically in a fraction of the time.

In 1988, *Life* magazine showed the capabilities of the current equipment by making a nonexistent political event appear to be a reality. This was done by taking three different photographs made by three different photographers at three different times and locations. They were of U.S. president Ronald Reagan, Israeli prime minister Yitzhak Shamir, and Palestine Liberation Organization (PLO) chairman Yasser Arafat. These images were used to create a new second-generation original composite of the three leaders in an apparently friendly get-together. The image conveyed the idea that peace was at hand. Looking at the finished composite in *Life*, the average reader would have had no way of knowing that this was a fictional event if *Life* had not spelled it out clearly in the text accompanying the picture. Some immediate questions that come to mind are "What would someone who could not read

English think upon seeing this image?" and "What could happen if an unscrupulous publisher began to use this technology?"

Image manipulation is not a new phenomenon. It is common in advertising work, but now it is starting to appear in photojournalism. An example of this is the controversy concerning the February 1982 issue of *National Geographic*. In the cover photographs, the editors decided to shift one of the great pyramids at Giza to make the image more aesthetically appealing. Although they did not intend to alter the underlying meaning of the subject, their failure to acknowledge that the image had been reworked upset *National Geographic* readers.

Where will the ethical lines of electronic manipulation be drawn? The credibility of the photographic image in journalism could be jeopardized as it becomes easier to combine several images to create a new one. In addition, how will ownership and control of an image be decided? These are only two of the questions that are being raised with the advent of electronic imaging.

On the plus side, this new technology will bring more people of varied backgrounds into the world of image making, thus expanding creative possibilities. For example, stock picture agencies are beginning to use computers to store digitized images that can be retrieved or sent directly to a client for inspection and approval. In the future, the agencies will be able to electronically combine these images to create new ones based on specific client needs. This would endanger the jobs of many photographers but allow for the incorporation of other professionals in the image-making process.

Photography is poised to make one of its greatest technical leaps—from a chemical process to an electronic one. As technology evolves, so do the rules of image making. Photographers will have to adapt or be left behind.

Other Computer Applications

Software programs are now available to perform tasks such as calculating film developing time and labeling slides. In late 1989, Sinar introduced a 4 x 5" view camera controlled through a personal computer. The photographer sets up the scene, uses a focus measuring wand to measure the places that need to be in sharp focus, and selects the intended lens and film speed. With this information, the computer can calculate the camera's swing, tilt, scale of reproduction, and depth of field for the preselected f-stop and shutter speed combination. The photographer then uses the computer screen to set the camera's position in relation to the subject.

Stereoscopic Photography

The fusing of photography with Sir Charles Wheatstone's discovery of the stereoscopic effect—that is, the illusion of the third dimension on a flat field of view—touched off two waves of stereo mania in Europe (1854 to 1880) and the United States (1890 to 1920). Stereo cards became immensely popular because of the illusion of depth, space, and solidity that they were able to produce. The stereo phenomenon, like television of today, found its way into millions of homes, bringing entertainment, education, and propaganda in an aesthetically pleasing manner.

Producing the Stereo Effect Photographically

The three-dimensional effect is created by taking separate photographs of a subject from two different viewpoints. These viewpoints are 2-1/2 inches apart, which is the average distance between the pupils of the human eyes. The easiest way to do this is with a stereo camera. The typical stereo camera has two lenses, 2-1/2 inches apart, and an interlocking double shutter that simultaneously exposes the two images side by side on the film. A print from each image is properly mounted on a standard 3-1/2 x 7-1/2" stereo card. The right image is on the right side of the card, and the left image is on the

left side, with 2-1/2 inches between the centers of the images. The card is then placed in a stereo viewer, whose main purpose is to present the right image only to the right eye and the left image only to the left eye. The brain combines the two images, creating the visual sensation of the third dimension.

Stereo Cameras

The last big boom in stereo followed World War II and lasted until the late 1950s. Many cameras, viewers, and projectors were made during this time, and they constitute the majority of stereo equipment still used today. The most common cameras were manufactured by Kodak, Revere, Sawyer, Stereo Realist, and Wollensak. The Nimslo, which uses the lenticular screen (described below), was manufactured in the 1980s. At this writing, the 4-lensed Nishika and the 3-lensed Trilogy 3D 100 are the only new stereo cameras being made. Both, like the original Nimslo, are intended to produce specially processed lenticular prints. The Polaroid passport cameras, which make two exposures at the same time on a single piece of Polaroid film, also can be used to make stereo portraits.

Lenticular Screen Cameras Some stereo cameras produce three-dimensional effects by interlacing the images through the use of a lenticular screen. The lenticular screen is made up of a transparent pattern of tiny lens elements called lenticules. The lenticules recreate an image on the emulsion as a series of lines or points from which a completed image is formed. When viewed, the lenticules allow only the right eye to see the right lens image and the left eye to see the left lens image. This permits the human eye to blend the images, thus producing a three-dimensional effect. Stereo cameras such as the Nimslo, Nishika, and Trilogy use the lenticular system. Special processing of the prints is required to produce the stereo effect. The lenticular screen is used to make stereo postcards, posters, and magazine illustrations.

Stereo with a 35mm Camera

The simplest way to experiment with stereo photography is with a 35mm camera. Just make two exposures of a static (no movement) scene. After you make the first exposure, shift the camera to the left 2-1/2 inches and make the second exposure. This can be accomplished by making the first exposure with the camera up to the right eye and the second exposure with the camera up to the left eye. Binocular stereo attachments that consist of mirrors and prisms, which split a 35mm frame into a narrow vertical pair, are marketed for 35mm cameras.

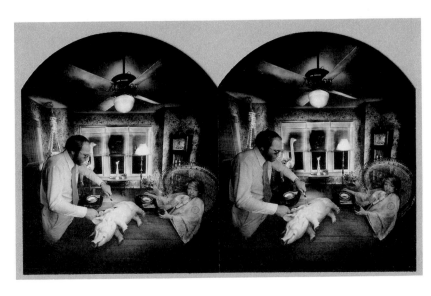

Figure 11.7 Meares designed and built a stereo camera using Polaroid Positive/Negative material. This permits instant evaluation and subsequent modification of the in-process image. The resultant three-dimensional photographs, when viewed with a stereoscope allow the viewer to enter the spatial world of Meares's archetypically derived dream images.

© Lorran Meares. "Thanksgiving with the Findell's," 1978. Gelatin silver prints (stereo pair). 3-1/2 x 7".

Make a print no larger than 3-1/2 x 3-1/2", of the right and left images, making certain that the density of both is the same. Mark the back of the right image with an R and the back of the left with an L to avoid confusing the two.

Draw a light pencil line down the center of a 3-1/2 x 7" board (the stereo card). Attach the right image to the right of this line and the left image to the left of the line. For viewing, put the card on a flat, evenly illuminated surface. Cut a piece of matte board to about 3-1/2 x 5" and place the 3-1/2-inch side on the centerline between the two images. Look down the 5-inch side. The board will act as a divider, keeping the right eye focused on the right image and the left eye focused on the left image. Inexpensive twin plastic lenses are available for easier viewing.

Additional Information

Book

Ferwerda, Jac. G. *The World of 3-D: A Practical Guide to Stereo Photography.* Distributed by Reel 3-D, P.O. Box 2368, Culver City, CA 90231.

Other Sources

American 3D Corporation, 15 Cactus Drive, Henderson, NV 89014 (the Nishika).

National Stereoscopic Association, P.O. Box 14801, Columbus, OH 43214.

Reel 3-D, P.O. Box 2368, Culver City, CA 90231 (new stereo equipment).

Stereo Photography Unlimited, 1005 Barkwood Court, Safety Harbor, FL 34695 (used stereo equipment).

Stroboscopic Photography

Photographs of moving subjects made by the use of repeated flashes or a pulsing light source are known as stroboscopic photographs. The first successful stroboscopic images, of bullets in flight, were achieved by Ernst Mach at the end of the 19th century. In the early 1930s, Dr. Harold Edgerton of the Massachusetts Institute of Technology (MIT) developed the modern electronic flash, ushering in the modern era of stroboscopy.

Stroboscopic Effects

There are two ways in which stroboscopic effects are generally used to make photographic images. The first method of stationary film stroboscopy takes place in a darkened room, where the shutter of the camera is opened for a very brief time. During this time, the successive flashes of light from a stroboscope stop and capture a subject in motion. The result shows the subject at different points during its course of travel on a single piece of film. Dr. Edgerton's widely known images are examples of this process. The limitations of this method include the number of exposures that can be made on a single piece of film before the event becomes chaotic and the actual length of time, determined by the speed of the subject's motion, that is available to record the path of the subject's travel.

The second method, moving film stroboscopy, permits a clear and detailed visual record of a subject's motion to be made over a longer period of time. This method is discussed in the following section.

Moving Film Stroboscopy

You need the following items to carry out moving film stroboscopy:

- A 35mm camera with a T (time) or B (bulb) setting that permits the film to be rewound with the shutter open. Some cameras automatically close the shutter when the film is rewound.
- A strobe that can be operated at a fractional power setting, such as 1/32 or

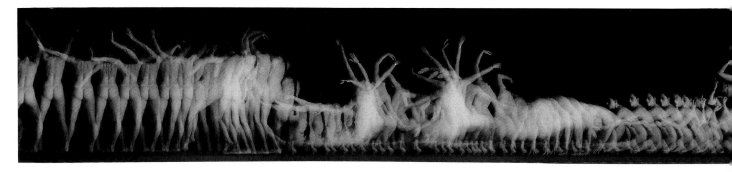

Figure 11.8 To overcome some of the limitations of using a strobe to stop action, Davidhazy has done extensive work with moving-film stroboscopy. These methods enable him to analyze motion in detail over an extended period of time while producing motion-analysis images suitable for publication.

© Andrew Davidhazy, Rochester Institute of Technology, "Stroboscopic Nude Study #2," 1987. 35mm transparency film. 1 x 9-1/4". Original in color.

1/64, and can be fired in quick succession. Flash units with a stroboscope mode designed for use with motor drives are ideal because of their rapid recycling time.

For those who want to purchase a true stroboscope, Edmund Scientific, 101 East Glouchester Pike, Barrington, NJ 08007-1380, and Radio Shack stores sell the least expensive stroboscopes. The physics department at a local school or college also might be able to lend you a stroboscope.

• Thirty-six exposures of black-and-white or color film.

Find a shooting area with a dark background (black is best) and enough room for the subject to carry out its intended path of motion. It must be possible to darken this area so that the stroboscope becomes the sole light source. Set up the stroboscope so it illuminates only the subject and not the background.

Load the camera with your film of choice and advance the film until the next to last frame appears on the film counter. To avoid exposing any of the film, it is best to do this in a darkroom or changing bag with the lens cap on, the aperture closed, and the shutter set to the highest speed. Make certain that the shutter is completely wound before going on to the next step. If the last wind leaves the shutter half-cocked, push in the rewind button and finish the cycle without forcing the camera's mechanism

Place the camera on a tripod. Set the camera's aperture to what it would be for a normal single-flash exposure based on the subject-to-flash distance or a flash meter. Focus on the subject. Push the rewind release button to enable the film advance sprockets to turn freely without tearing the film perforations. Set the shutter at the T or B setting. If you use B, lock the shutter in its open position with a locking cable release. Turn off or block out any light except the stroboscope or flash.

Turn on the strobe and have the subject begin its motion. Observe it a few times to get a good idea of its path of travel. When you are ready to make the exposure, open the shutter with the T or B setting and start winding the film at a steady and even pace as the subject performs, illuminated only by the strobe. If you are using a camera strobe, an assistant can hold and fire it off camera. The key factor in determining the outcome is the speed at which the film is rewound past the open shutter, based on the length of film in the camera. There are three basic factors to consider in deciding how fast to rewind the film:

1. The speed at which the subject travels
2. The frequency of the strobe illumination
3. The amount of separation desired between images

Additional Information

Davidhazy, Andrew. "Moving Film Stroboscopy." *Kodak Newsletter for Photo Educators,* Volume 21, No. 1 (1988): pp. 1–3.
Edgerton, Harold. *Electronic Flash/Strobe.* 3d ed. Cambridge, Mass.: MIT Press, 1986.

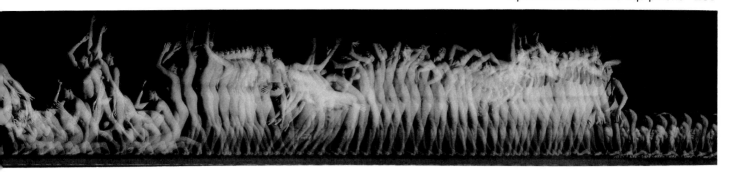

Edgerton, Harold, and James Killian, Jr. *Moments of Vision*. Cambridge, Mass.: MIT Press, 1979.

Jussim, Estelle. Edited by Guy Kayafas. *Stopping Time: The Photographs of Harold Edgerton*. New York: Abrams, 1987.

Scale Model Camera

The Photech Scale Model Camera was built to meet the needs of architects, designers, engineers, and others who work with tabletop models. It allows them to see how the model will look at full size. The Scale Model Camera is small and lightweight, and it has an inverted periscope snorkel design that enables the photographer to position it within the model rather than outside it. This greatly increases the number of vantage points from which images of the interior of the model can be made, while maintaining the correct perspective.

The camera comes equipped with an f-90 lens, giving it an almost infinite depth of field from about 2-1/2 inches to infinity. It has an optical viewfinder that allows you to preview the image without distortion. Exposures are made on Polaroid 3-1/4 x 4 -1/4" film by using a remote-control device. This ensures sharp pictures by eliminating camera shake, one of the biggest problems in scale model photography (see Figure 11.9).

For more information about the Photech Scale Model Camera, contact Charrette Corporation, 31 Olympia Avenue, Woburn, MA 01888.

Underwater Equipment and Protection

Until recently, if you wanted to make pictures in or around water, you had only two options: get a Nikonos 35mm underwater camera or find a cumbersome watertight housing for the equipment. Today many more options are available.

The Underwater Standard: Nikonos

Since the 1960s, the Nikonos has been the underwater camera by which all others are measured. The present model, Nikonos V, has interchangeable lenses, is submersible to a depth of 160 feet, can be operated manually or by automatic aperture priority, comes with through-the-lens (TTL) flash metering, and has a film speed range of ISO 25 to 1,600. It is the most professional and expensive of all the current underwater cameras. Nikon publishes *Nikonos Technique*, a publication devoted to underwater photography with the Nikonos. For more information, contact Nikon, Inc., 623 Stewart Avenue, Garden City, NY 11536.

Motormarine I and II

Sea & Sea of Japan offers underwater camera systems featuring the Motormarine I and II cameras. Theses cameras can go down to 150 feet and

Figure 11.9 Miniature tableaux allow DeFilipps Brush to use juxtaposition and extreme discrepancies of scale to explore visual conditioning. The counter-reality evokes the themes of anticipation, expectation, and recognition, which imply, but do not include, human presence. The Photech Scale Model Camera is an ideal tool, since it can be maneuvered within the constructed space itself. The alternative would be to use a camera to look into the space from above, which would not be suitable for the artist's purposes.

© Gloria DeFilipps Brush. "Untitled (#2155), " 1986. Gelatin silver print with colored pencils. 19-1/2 x 27-1/2" on 24 x 30" paper. Courtesy of MC Gallery, Minneapolis. Original in color.

offer a wide array of professional features, including interchangeable lenses, electronic flashes, and other accessories, many of which are compatible with the Nikonos. Sea & Sea products are distributed by GMI Photographic, Inc., P.O. Drawer U, Farmingdale, NY 11735.

Weatherproof versus Waterproof

The development of the weatherproof/waterproof lens shutter, or compact camera, has provided a number of alternatives to the Nikonos. These cameras are essentially automatic point-and-shoot machines to which weather/water protection has been added. They are designed for people with an active lifestyle who do not want to risk ruining their expensive camera gear in a canoe or on a ski slope. Many different models of waterproof and weatherproof cameras are available. There is even a disposable waterproof camera. It is important to distinguish between a completely submersible camera (waterproof) and one that only resists water, dirt, dust, and sand but cannot be submersed (weatherproof).

All the current models are lens shutter cameras and not SLRs. They have Galilean finders, which provide only an approximation of the exact image size. They are more limited than a Nikonos in terms of submersible depth, ISO range, and exposure control. In exchange for these limitations, the photographer gets a less expensive, lightweight, and durable camera capable of delivering good image quality in average lighting conditions.

Submersible Bags

Another recent development is the mechanically sealed, heavy-duty plastic bag, which enables you to keep your equipment dry and still operate the camera controls. High-quality bags such as Pioneer's EWA-Marine-housing have optical glass lenses for distortion-free images and built-in gloves for easy operation. They also are large enough to handle flash units and motor drives and are tested to a depth of 100 feet. These bags can be adapted to fit almost any camera, from a compact to a 6 x 7cm unit. Bags are even available for video camcorders and movie cameras. For further information about this product, contact Pioneer Marketing and Research, 216 Haddon Avenue, Suite 522, Westmont, NJ 08108.

For the general transporting of equipment in wet conditions, such as on a raft trip, try a product such as the Bagton. It is made out of yellow polyester that is resistant to UV light and is waterproof, tear-resistant, and supposedly unsinkable. Bagtons come in a number of different sizes, with a capacity ranging from 1 to 42 gallons. For more information, contact Ne, Inc., P.O. Box 1587, Cambridge, MA 02238-1587.

Hard Cases

To protect equipment when traveling or when doing fieldwork, you might consider purchasing a rugged, lightweight, shock-resistant, watertight case made of noncorrosive, light-reflecting material. Pelican equipment cases (Pelican Products, 2255 Jefferson Street, Torrance, CA 90501) are the least expensive. They are made from high-impact ABS structural resin and have an O-ring seal that is watertight to 10 feet. Satter's Tundra cases (Satter's, 4100 Dahlia Street, Denver, CO 80207) are structurally similar to those made by Pelican, but they are waterproof to a depth of 30 feet and cost a little more. The most expensive cases are made by Rimowa (H.P. Marketing, 16 Chapin Road, Pinebrook, NJ 07058) and are waterproof to 67 feet.

Hard Case Alternative

An inexpensive alternative to buying a hard case is using a large portable ice chest, such as those made by Coleman or Igloo. If watertight security is not important, an ice chest packed with foam offers excellent protection for photographic gear.

What to Do if Equipment Gets Wet

Should a piece of photographic equipment get wet, quick action is necessary to save it from ruin. If salt water is the culprit, flush the item with fresh water. Then open the equipment up as much as possible and completely dry it with a hair dryer set on low. A drying oven also can be effective and is easy to construct. Place the wet equipment in a plastic bag with a zip-type closure. Place the nozzle of a hairdryer inside the bag and zip the bag closed. Secure any open spaces with tape. Then make a small hole at the opposite end of the bag so the air and moisture can escape. Turn the hair dryer on low and let it run until the gear is totally dry. When the equipment is dry, take it to a camera repair shop as soon as possible.

Chapter *12*

An Introduction to Some Widely Used Alternative Processes

So far this book has dealt primarily with applications of traditional silver-based photography. But several alternative processes can be used to create a photographic image. Most of the processes discussed in this chapter are now considered to be commercially obsolete. They were considered technical breakthroughs, but were discarded in favor of new processes that are more convenient, faster, and easier to use. Some of these new processes come from other visual arts, such as drawing, painting, and printmaking. Other techniques, such as the use of a copy machine, come from commercial communications. These processes are often combined, blurring the boundary between the various visual arts (see Chapter 13).

The common factor among these diverse processes is that they do not produce an image like that in a straight photograph. The straight print is what most people expect a photograph to look like. It is the cherished frozen instant, removed from the flow of linear time, that has been preserved for contemplation and examination. The task of the straight photograph is to record and document the visible world. Since the 1960s, many photographers have questioned the virtues of the straight photograph, particularly its narrow range of working materials and the prescribed area in which the photographer is supposed to operate. The alternative processes seek to explore and extend the relationship between the photographer, the event being photographed, and the process of photography. In these alternative processes, the camera image becomes a point of departure for transforming the entire relationship. The resulting photographs challenge traditional ideas about the camera image, and as the facts become less important beauty and imagination become more important. The nature and scope of photography has been redefined by an alternative aesthetic that says a good photograph has nothing to do with objectivity.

This chapter provides an introduction to a number of processes that have been more widely used in recent years. It offers a technical starting point based on formulas and methods that have been proven successful. The processes discussed are contact-printing processes, not enlargement ones, and thus a negative equal to the final image size is required. See Chapter 4 for one way of making enlarged negatives and for information on making negatives directly from slides.

The discussion here is confined to coating paper stock with various emulsions, although it is possible to use these emulsions on almost any porous material, including fabric. For more information on coating other materials, see Additional Information at the end of the chapter. Be certain to follow all the safety rules outlined in Chapter 3. Regardless of which process you intend to use, it is advisable to read the chapter in its entirety before experi-

menting with any of the processes, as specific methods from one technique often can be applied to another.

Cyanotype Process

Cyanotype, Greek for "dark blue impression," is one of the easiest and least expensive ways of trying out an alternative nonsilver process. It was invented by Sir John Herschel in 1842 as a method for copying his intricate notes. Herschel did not trust the hand-copying procedures of his day and used the cyanotype as one would use a modern photocopy machine.

The first aesthetic application of the cyanotype is credited to Anna Atkin, who used it in the 1840s and 1850s to illustrate her book *Photographs of British Algae: Cyanotype Impressions*. The heyday of the process was in the 1880s, when architects and shipbuilders used precoated cyanotype paper to make fast, inexpensive copies of line drawings.

The major disadvantage of the process, which kept it from becoming more widely adopted, is its bright blue color. In *Naturalistic Photography*, Peter Henry Emerson says, "No one but a vandal would print a landscape in red or cyanotype." Yet the process remained popular for a time with both professional and amateur photographers as an inexpensive and speedy method for proofing negatives.

The chief attractions of the cyanotype are as follows:

- The process is simple and inexpensive, and it may be used on a variety of surfaces and materials.
- Its relatively long printing times enable the printmaker to observe the image during the printing process.
- The final image can last a long time, depending on the base material.
- The intense blue color can be altered with additional processing steps (see back cover).

How the Process Works

Herschel discovered that when light acts on certain ferric (iron) salts, they are reduced to a ferrous state. Many of these processes, including cyanotype, kallitype, Vandyke, platinum, and palladium, are sometimes referred to as iron-salt–sensitive processes or ferric processes, since they are all based on the reduction of iron.

In the cyanotype process, the light catalyzes the reduction of ferric ammonium citrate to a ferrous salt. The ferrous salt then acts as a reducer on the potassium ferric cyanide. This produces a precipitate of insoluble blue pigment, ferrous ferricyanide, which is also known as Prussian blue. The areas that are not exposed to light remain in a ferric state. During development, washing removes these unreduced salts, leaving behind the insoluble ferrous ferrocyanide. During drying, the ferrous ferrocyanide oxidizes to the distinctive deep blue.

It is possible to obtain different colors by changing the metallic salt applied to the ferrous image. Basically this is what happens in both kallitype and platinum printing. It is also possible to alter the final blue image through a process of toning.

Safety

In addition to the general safety guidelines provided in Chapter 3, be aware of these specific concerns when working with cyanotypes:

- Potassium ferricyanide should not be heated above 300°F (147°C) or allowed to come in contact with any concentrated acid, as poisonous hydrogen cyanide gas can be produced.
- Unused emulsion should be disposed of by absorbing it in kitty litter

placed inside a plastic bag. This bag should be sealed and placed in an outside trash container.

Printing

Cyanotype emulsion has a long exposure scale. Negatives with a complete range of tonality work well, as do contrasty negatives. A full range of tones can be produced on a smooth paper from a negative that would normally require a grade 0 paper in normal silver-based printing.

The cyanotype emulsion can be applied to any absorbent surface, including almost any paper, even colored stock (except those that have an alkaline buffer), fabric, bisque ware, and leather. The emulsion can be applied to other photographs or combined with other techniques, such as hand-coloring and toning.

Choosing a Paper

A high-quality, well-sized rag paper such as Strathmore Artist Drawing Paper works well as a starting point. Beautiful prints also have been made on unsized papers, such as Rives BFK.

After you have mastered the technique, you might try applying the emulsion to fabric or even chamois leather. The tighter the weave of the fabric, the deeper the blue tends to be.

Commercially made cyanotype paper is available at some art supply stores. It is also sold as sun paper in museum and science stores. The quality of these materials varies widely and should be tested before buying a large amount.

Making the Sensitizer

The cyanotype emulsion is made by preparing the sensitizer from two stock solutions that are combined in equal parts for use.

Cyanotype Formula

Stock Solution A

Water (68° F or 20° C)	250 milliliters
Ferric ammonium citrate (green)*	50 grams

*The green variety provides an emulsion that is about twice as light sensitive as the brown.

Stock Solution B

Water (68° F or 20° C)	250 milliliters
Potassium ferricyanide	35 grams

Mix the solutions separately. Store them in tightly closed opaque containers. The separate solutions have a shelf life of up to six weeks.

When you are ready to use them, combine equal amounts of stock solution A and stock solution B. Once combined, they have a useful life of about one day. The peak sensitivity of coated paper occurs within the first two hours after the emulsion has been applied. Coated paper may be stored and used, with reduced light sensitivity, for a period of about two weeks.

Applying the Emulsion

The emulsion can be applied under subdued tungsten light or in a darkened room. Avoid fluorescent lights because most of them produce UV light, which can affect the cyanotype emulsion, as well as all the other nonsilver processes discussed in this chapter. UV light raises the base fog level of the coated emulsion, reducing its overall sensitivity. This can reduce the contrast range and degrade both the highlight and shadow details.

Spread newspapers on all working surfaces to protect them from cyanotype stains. After making the sensitizer, coat the paper with it. Two ounces of working solution will coat about eight 8 x 10" prints.

There are two basic ways to coat paper. The first coating method is called *floating*. Put the emulsion in a tray and float the paper on the solution for 2 to 5 minutes. Occasionally tap the backside of the paper gently to dispel any air bubbles, taking care not to get any of the sensitizer on the nonemulsion side.

The second method involves using a polyfoam brush (the same type as you might use to paint the trim on your house). Tape or pin the paper to a smooth, nonporous surface. Dip the brush into the emulsion, squeeze out the excess, and brush evenly across the paper. The emulsion should be kept wet and not be overworked or reapplied during this process, or it will lose sensitivity.

Dry the paper in total darkness (a hair dryer, set on low, can be used to speed drying). The coated paper should appear yellow-green when it is dry.

Exposure

Cyanotypes are exposed by contact printing with a UV light source such as the sun, a sunlamp, or a carbon arc, mercury vapor, or fluorescent lamp. In a darkened room, put the negative on top of the sensitized paper (emulsion to emulsion) in a contact frame or under a heavy piece of glass. A contact-printing frame with a tensioned split back, which permits inspection without the risk of misaligning the paper and the negative, is a major convenience in all nonsilver printing.

Consistent sunlight is the best source of exposure. Sunlight exposure time may run from 5 to 20 minutes depending on the location, the time of day, the cloud conditions, and the season. Exposure times with sunlamps start at about 15 minutes. Keep the lamp about 24 inches from the print frame. Wear appropriate eye protection when working with any sunlamp.

The correct exposure time can be determined by making a test strip or through inspection. As the paper is exposed, it turns from yellow-green, to green, to dark green, to blue-green, and finally to blue-gray, at which time exposure should be complete.

It is necessary to overprint, as the highlight areas will lighten when the print is washed. Print until the highlights are considerably darker than desired. At this point, the shadow areas will begin to reverse. Check exposure by opening one side of the print frame back and carefully lifting the paper away from the negative, without disturbing the registration. If you are using glass, tape the paper and negative together on the support board on three sides, leaving the fourth free for inspection.

Processing

Process the print in subdued tungsten light by washing it in a tray of running water for 10 to 15 minutes at 68° F (20°C). Wash until the highlight areas are clear of stain (no yellow color should remain). Allow the print to dry in a darkened room. If intensifying or toning is planned, do it while the print is still wet. Washing in alkaline water (pH 8 or higher) will bleach the image. This can be corrected by increasing the exposure time.

Cyanotypes can fade slightly after processing, but they will return to their original color if left in the dark to reoxidize. The final look of a cyanotype cannot be determined until it has had a chance to dry completely and oxidize.

Oxidation Solution

To see the final tone immediately, place the print in an oxidation solution directly after it has been washed.

Cyanotype Oxidation Solution Formula

Water (68°F or 20°C)	200 milliliters
Hydrogen peroxide	20 milliliters
(regular 3% solution)	

Quickly and evenly immerse the print in the oxidation solution for a couple of seconds. Remove, rinse, and dry it.

Toning

You can alter the color of a cyanotype, with varying degrees of success, by using a number of chemical toners. Formulas that require the direct use of ammonia or ferrous sulfate are not recommended because the colors obtained from them fade easily. It is possible to produce only local changes in color by brushing the toner on selected areas of the print. You can make more than one color change on a print.

Deep Blue/Ultramarine Tones Prepare a 5 percent lead acetone solution. Heat the solution to at least 85° F (30° C) and immerse the print in it until the desired color is achieved. Wash the print for at least 10 minutes in running water at 68° F (20° C).

Red-Brown Tones The following formula produces a solid red tone, but the highlight areas turn yellow within about a week and will remain so.

Solution A	
Water (68° F or 20° C)	180 milliliters
Tannic acid*	6 grams

Solution B	
Water (68° F or 20 C)	180 milliliters
Sodium carbonate	6 grams

In a tray, immerse the print in solution A for 5 minutes. Then immerse the print in a separate tray of solution B for 5 minutes. Follow with a 10-minute wash in running water at 68° F (20° C).

Lilac to Purple-Brown Tones

Tannic acid*	70 grams
Water (68° F or 20° C)	1 liter
Pyrogallic acid*	2 drops

Mix the tannic acid and water. Heat the solution to 120° F (49° C) and add the pyrogallic acid. Rapidly and evenly immerse the print in the solution, or splotching may result. Allow the image to tone until it takes on a lilac color. Wash in running water at 68° F (20° C) for 15 minutes.

Deeper tones can be produced by putting the print in a solution of 15 grams of caustic potash and 1 liter of water. After toning in this solution, wash for 15 minutes.

Violet-Black Tones

Solution A	
Water (68° F or 20° C)	1 liter
Sodium carbonate (washing soda)	50 grams

Immerse the print in this solution until it turns yellow, then wash for 2 minutes.

Solution B	
Gallic acid*	8 grams
Pyrogallic acid*	0.5 grams
Water (68° F or 20° C)	1 liter

*Always add the acids to the water.

Take the yellow print from solution A and place it in solution B until the desired color appears. Follow with a 10-minute wash in running water. The gallic acid produces the violet tones. Increasing the pyrogallic acid results in a blacker tone.

Kallitype and Vandyke Brownprint Processes

Kallitype Characteristics

The kallitype was invented by Dr. W.W.J. Nichol in 1899. The process is based on Sir John Herschel's iron-silver reduction process called the chrysotype. This process is similar to platinum printing, except the kallitype image is made up of metallic silver instead of platinum.

The kallitype is a simple process consisting of silver nitrate and ferric salt. When the kallitype emulsion is exposed to light, some of the ferric salt is reduced to a ferrous state. The newly created ferrous salt reduces the silver nitrate to metallic silver. This metallic silver is not as stable as metallic platinum. Careful processing, which removes all the ferric salt and nonimage silver, greatly increases print stability.

The kallitype process was never commercially popular. This is attributed to the fact that the kallitype was introduced at the same time as gaslight papers, which are contact-printing, developing-out papers with a silver chloride emulsion that can be exposed by artificial light. Even more importantly, the kallitype had an initial reputation for impermanence. When Nichol first unveiled his process, he recommended the use of ammonia for a fix, which proved to be ineffective. When fixed in sodium thiosulfate (hypo), a kallitype can be as permanent as any other silver-based process.

The kallitype offers an excellent introduction to the more complex platinum printing. It is not as versatile as platinum, but it is a much less expensive way of achieving a platinum-like print quality. Like the platinum print, the kallitype works well with a continuous long-tone negative. There are several formulas for and variations of the kallitype process. The easiest one is known as Vandyke or brownprint. After mastering it, you will be prepared to move on to the more complex general kallitype process.

Figure 12.1 The kallitype offers an excellent starting place to gain experience before moving on to the more complex and expensive platinum and palladium processes. There are a number of kallitype variations, with the Vandyke brownprint being the simplest to master. Pirtle thought a gentle, uncomplicated subject was conducive for use with the Vandyke's warm tones. The dark brown image reveals subtlety and texture while displaying the subject's soft detail and contrast.

© Kenneth D. Pirtle. "Weed Pot," 1987. Vandyke brownprint. 7-1/2 x 10".

Vandyke Brownprint Characteristics

The Vandyke brownprint technique is named after the characteristic rich brown tones found in the paintings of 17th-century Flemish master Anthony Van Dyck (or Vandyke). A Vandyke image produced from a long tonal range negative will have complete detail, from full shadows to full highlights. Shorter tone negatives produce less deep shadows. The color can range from medium brown to dark black-brown. Image contrast can be slightly controlled during development with the addition of potassium dichromate to the developer water. The emulsion has a shelf life of a couple of months and improves with age. Ideally, the emulsion should be prepared and allowed to age two to three days before it is used.

Most acid-free rag papers, such as Crane's Kid Finish AS 8111, are a good starting point. Rives BFK will work, but it should be sized first for consistent results (see the section on gum bichromate later in this chapter). As with cyanotypes, the emulsion may be applied in subdued tungsten light by brushing or floating. No metal should come in contact with the silver nitrate, as it will cause a chemical reaction, so polyfoam brushes with all-wooden handles are suggested for coating. After the paper is coated, it should be dried in a darkened room. Paper may be heat- or fan-dried and should be printed on immediately, as the coated emulsion loses its sensitivity rapidly, producing flatter, grayer images. Be sure the coating is yellow before making any exposures. If it looks brown, it is no good.

The Vandyke process works very well on many fabrics because it contains no colloidal body, such as gelatin or gum arabic. The emulsion soaks into the fabric, leaving it unaltered (it does not stiffen up). Natural fibers, such as close-weave cotton, produce the deepest brown tones. Do not use permanent press materials because they repel the emulsion.

Vandyke Formula

Stock Solution A

Ferric ammonium citrate	90 grams
Distilled water (68°F or 20°C)	250 milliliters

Stock Solution B

Tartaric acid	15 grams
Distilled water (68°F or 20°C)	250 milliliters

Stock Solution C

Silver nitrate*	30 grams
Distilled water (68°F or 20°C)	1 liter

*Wear gloves when handling silver nitrate because it will stain anything it touches black.

Mix each stock solution separately. With constant stirring, combine stock solutions A and B, then slowly add stock solution C. Store in a tightly closed opaque container in a cool, dry location. Allow to ripen (age) 2 to 3 days before using. Shake the emulsion before each use, including between brush dips, to ensure even distribution of the silver nitrate. Tightly sealed and refrigerated solutions can last for years. Do not let the ferric ammonium citrate be heated above 300°F (147°C) or come in contact with any concentrated acid, as poisonous hydrogen cyanide gas can be produced.

Exposure　A Vandyke brownprint is contact printed, using a print frame or heavy piece of glass and a smooth support board, under sunlight or an artificial UV light source until highlight detail becomes visible. Summer sunlight exposures can be as brief as 30 seconds, while winter exposures can take an hour or more. The color of the emulsion will change from yellow to a dark reddish brown during normal exposure. The exposure time for the Vandyke emulsion is about half that for cyanotypes. A typical trial exposure in full sum-

mer sun might be about 2 minutes. A comparable exposure with photofloods at about 24 inches from the print frame could be about 15 minutes. Underexposed (thin) negatives can be exposed until the emulsion turns a tan-brown color. Overexposed (dense) negatives should be exposed until the emulsion turns silvery brown.

Development The Vandyke is developed in a darkened room in running water at 68°F (20°C) for a couple of minutes, or until the water runs clear. The contrast is basically determined by the negative, but it may be increased slightly by adding a 10 percent dichromate solution to the developer water. After the print has washed for 1 minute, transfer it to a tray containing 16 ounces (475 milliliters) of water and about 10 drops of the dichromate solution. Increasing the number of drops of dichromate solution produces more contrast. After the desired level of contrast is reached, transfer the print back into a tray of running water. This process may be repeated.

Fix To achieve the true Vandyke brown and ensure permanency, the image must be fixed in a 5 percent bath of plain thiosulfate for 5 minutes at 68°F (20°C). This fixing bath is prepared by dissolving 25 grams of sodium thiosulfate in 500 milliliters of water. Since it is a weak solution, it should be checked with a hypo check and replaced often.

When the image enters the fix, it will darken and turn brown, and the highlights should become brighter. Fix, with agitation, for 5 minutes. If the image is allowed to remain in the fix longer than 5 minutes, it can begin to bleach. Extending the time in the fix can correct for overexposed prints.

Washing and Drying Wash the image in running water at 68°F (20°C) for 5 minutes. Then place it in a hypo clearing bath for 2 to 3 minutes and give it a final wash of 30 minutes to ensure permanence. The image can be air- or heat-dried. Heat-drying will darken the brown tone.

A Basic Kallitype Process

The basic kallitype process is similar to the Vandyke, but it is more complex. The basic kallitype formula uses a mixture of ferric oxalate, oxalic acid, and silver nitrate as the sensitizer. When this emulsion is exposed to light, the ferric oxalate is changed to a ferrous state, which reduces the silver nitrate to metallic silver. During development, the ferrous oxalate is dissolved, leaving behind the metallic silver that forms the image. Although the kallitype is a more complex process than the Vandyke, it offers the advantages of better contrast and tone control of the image.

Kallitype Formula

Distilled water (100°F or 38°C)	16 ounces (473 milliliters)
Ferric oxalate	2-3/4 ounces (78 grams)
Oxalic acid*	80 grains (5.2 grams)
Silver nitrate*	1 ounce (31 grams)

*Both oxalic acid and silver nitrate are poisonous and will stain anything they come in contact with. Wear gloves when handling these chemicals.

Dissolve the ferric oxalate and oxalic acid in the water. Stirring constantly, add the silver nitrate. Pour the solution into an opaque bottle with a tightly sealed lid and allow it to ripen for at least 3 days before use.

After the emulsion has ripened, warm the container in a water bath at 100°F (38°C) to redissolve the crystalline silver oxalate precipitate. Apply the emulsion in a darkened room to paper or cloth at 100°F by floating or coating with a polyfoam brush. The emulsion can be heat-dried. Printing should be carried out immediately because the sensitized coating will begin to deteriorate within a day.

Development The image color is determined by the selection of developer. Contrast can be controlled through the use of a 10 percent potassium dichromate solution in any of the developers (see contrast control in the Vandyke section). With a normal contrast negative, add 2 drops of the 10 percent potassium dichromate solution to the developer. If the negative is flat (lacks contrast), add 6 to 10 or more drops to the developer. There is no need to add any dichromate with contrasty negatives. Prints are processed for 5 to 10 minutes in any of the developer formulas. Best results are usually obtained when the developer is warm.

Kallitype Black-Tone Developer Formula

Distilled water (100 F or 38° C)	500 milliliters
Borax	48 grams
Sodium potassium tartrate (Rochelle salt)	36 grams

Kallitype Brown-Tone Developer Formula

Distilled water (100° F or 38° C)	500 milliliters
Borax	24 grams
Sodium potassium tartrate	48 grams

Kallitype Sepia-Tone Developer Formula

Distilled water (100° F or 38° C)	500 milliliters
Sodium potassium tartrate	24 grams

Kallitype Clearing Solution Formula After development is complete, rinse the print in running water and clear it for 5 minutes using the clearing solution.

Water (68° F or 20° C)	1 liter
Potassium oxalate	120 grams

Kallitype Fix Formula After the clearing bath, fix the print for 5 minutes in the fix solution. Be sure to check and replace this solution often.

Water (68° F or 20° C)	1 liter
Sodium thiosulfate	50 grams
Household ammonia (plain)	12 milliliters

Washing and Drying Wash the print for several minutes, then treat it with a hypo clearing bath for 3 minutes. Give a final wash of 30 minutes to ensure permanence. Air-dry the print.

Combining Processes

The cyanotype and the kallitype processes contain chemicals that will attack one another when combined on the same surface. Unusual visual effects are possible, but do not expect the resulting image to be permanent. Changes can take place within a week. If you wish to preserve the effect, it is necessary to rephotograph the work on color film.

Platinum and Palladium Processes

William Willis patented the platinum printing process in 1873 and began to market it in 1879 under the name Platinotype. The paper was used by photographers such as P.H. Emerson and Frederick H. Evans. It also became extremely popular with the Pictorialists, the Linked Ring Society, and the Photo-Secessionists.

Figure 12.2 Arentz used a 12 x 20" banquet camera to make a direct contact print with a 50 percent mixture of platinum and palladium. It was applied by hand to a high-quality rag paper and exposed to a UV light source. This process delivers soft print quality with a very wide tonal range. Since platinum and palladium are more stable than silver, the resulting prints are considered to have a long life span.

© Dick Arentz. "Superstition Mountains, Arizona," 1987. Platinum-palladium print. 12 × 20".

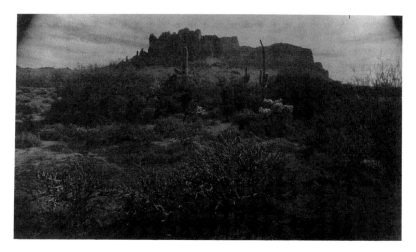

Platinum is a contact-printing process in which the image is first partially printed out (becomes visible) in UV light. After exposure, the full image is chemically developed out to completion. Like all printing-out processes (P.O.P.), it allows subtle highlight details to be retained without the deep shadow areas becoming buried. This is due to its self-masking ability. When a print is made using this process, the shadow areas are the first to appear on the paper, darkening the top layer of the print emulsion, which then acts as a mask. This mask holds back some of the light so the shadows do not get as dark as they would in a silver-based print that is developed out. Consequently, light is permitted to pass through the denser highlight areas of the negative without the shadows going black and losing detail. Thus a soft print with a long tonal scale and possessing luminous shadow detail can be delivered.

All sensitizing and developing can be done under subdued tungsten light. Contrast is controlled by varying the proportions of the sensitizer solutions. Platinum produces an image color from silvery gray to rosy brown. The print has a matte surface, so there is no reflected glare. Platinum is more stable than silver, so images can be as permanent as the paper upon which they are printed.

The major disadvantage of platinum is its extremely high cost. For this reason, platinum papers have not been widely available since 1937. At present, the Palladio Company is making a platinum-palladium paper in two contrast grades (see "Additional Information" at the end of this chapter). Palladium, which is somewhat less expensive, can be substituted for platinum and will deliver almost the same results, although it does not provide as much color variation. Palladium produces brown-tone prints. Platinum and palladium are often mixed in equal parts to produce a warmer tone than can be achieved with platinum alone.

Platinum Printing

Platinum is not light sensitive enough to permit enlarging, so a large or enlarged negative is needed for contact printing. Due to the slowness of the material, burning and dodging are not generally done during printing but are carried out when the enlarged negative is made (see Chapter 4).

The platinum process is similar to other ferric, iron-sensitive processes such as the kallitype, except that platinum salts are used in place of silver salts. The paper is sensitized with ferric oxalate and potassium chloroplatinite. When exposed to UV light, the ferric salts are reduced to the ferrous state in proportion to the density of the negative. When the print is developed in a potassium oxalate developer, the newly formed ferrous salts are dissolved, and they, in turn, reduce the platinum to the metallic state. The image is then cleared in a bath of dilute hydrochloric acid, which eliminates

the remaining ferric salts, leaving behind an image composed only of platinum.

Negatives Platinum delivers a classic straight-line response, meaning that the print will reveal the full range of tonal values, from dark shadows to very subtle highlights, that have been recorded on the negative. For this reason, negatives possessing a long and full density range with good separation and shadow detail make excellent candidates for printing. Platinum is one of the few emulsions capable of successfully rendering such a wide contrast range. Generally, a contrasty and dense negative that will print well on a grade 0 silver-based enlarging paper is a good starting place.

If the negatives being made are only for platinum printing, some printmakers increase the amount of exposure given to the film by as much as quartering the standard ISO rating. For instance, a 400 speed film would be exposed at ISO 100. T-Max films are an exception. Try T-Max 100 at ISO 75 and T-Max 400 at ISO 200. In addition, some people increase the developing time by 30 to 50 percent. D-23 is a favorite developer for negatives that will be used to print on platinum (see Chapter 5 for the formula). The main thing to remember is that thin negatives tend to look dull and flat. On the other hand, printing negatives made on high-contrast film (litho film) is not common because its lack of tonal range does not take full advantage of the subtleties of the platinum process. Obviously, experimentation is in order. If the negatives being made are for both platinum/palladium and silver printing, expose T-Max 400 at ISO 200 or T-Max 100 at ISO 50 and process in D-23.

Paper Fine-textured, 100 percent rag papers, such as Crane's Kid Finish AS 8111, are an excellent starting point. Papers with too rough a texture cause the fine details of platinum to be lost. Rives BFK and similar papers are very absorbent and soak up a lot of expensive emulsion. Such papers can be sized to reduce their rate of absorption (see the section on gum bichromate later in this chapter). A paper's chemical makeup can have a noticeable effect on the color and tonal range of the print. Paper manufacturers are continually making changes in their operations. Strathmore has switched from an acid to an alkaline paper-making process, which many people say is not good for platinum/palladium printing. They claim the chemicals used in the new paper interfere with the printing process and have given the paper a different absorbency. In order to know what will deliver the results you are after, test a variety of papers.

Chemicals The price of both platinum and palladium salts varies greatly, so be sure to check a number of sources before ordering. Sometimes ferric oxalate can be hard to find. It is deliquescent (dissolves by absorbing moisture from the air) and should be stored in a tightly sealed opaque bottle. If prints appear to be fogged, test the ferric oxalate by dissolving some in water and adding a 5 percent solution of potassium ferricyanide. If this mixture turns blue, the ferric oxalate has become ferrous. Discard it, as it will deliver poor results.

Platinum Emulsion Formula The emulsion is made up of three separate stock solutions, each stored in an opaque glass bottle with a medicine dropper. Do not interchange the droppers. Label the bottles and store them in a dark place. The platinum solution lasts indefinitely. The oxalates will keep for a couple of weeks or up to a few months if refrigerated. When the oxalate solutions go bad, the print highlights become uneven and start to fog. Follow all safety procedures as outlined in Chapter 3 when handling these chemicals.

Stock Solution 1

Distilled water (120° F or 49° C)	55 milliliters
Oxalic acid	1 gram
Ferric oxalate	15 grams

Stock Solution 2

Distilled water (120° F or 49° C)	55 milliliters
Oxalic acid	1 gram
Ferric oxalate	15 grams
Potassium chlorate	0.3 grams

Stock Solution 3

Distilled water (100° F or 38° C)	50 milliliters
Potassium chloroplatinite*	10 grams

*Do not use chloroplatin*ate*. If some of the platinum should precipitate out of the solution during storage, warm it in a water bath, prior to use, to redissolve the platinum.

All the solutions should be prepared 1 to 2 days beforehand and allowed to ripen. When you are ready to use the solutions, combine them to produce the desired contrast level (see the next section) in a clean glass bottle. Tighten the top and mix by shaking.

Contrast Control The contrast of the image is controlled by varying the proportions of solution 1 and solution 2. Following is a list of emulsion mixtures for contrast control with a normal negative.

Very Soft Prints

Solution 1	22 drops
Solution 2	0 drops
Solution 3	24 drops

Soft Prints

Solution 1	18 drops
Solution 2	4 drops
Solution 3	24 drops

Average-Contrast Prints

Solution 1	14 drops
Solution 2	8 drops
Solution 3	24 drops

Above-Average-Contrast Prints

Solution 1	10 drops
Solution 2	12 drops
Solution 3	24 drops

High-Contrast Prints

Solution 1	0 drops
Solution 2	22 drops
Solution 3	24 drops

Raising Contrast In addition to increasing the amount of solution 2 in the emulsion, you can raise the contrast of a print by doing one or more of the following:

- Use a hard, smooth-surface paper.
- Give the paper a second coat of emulsion after the first has dried.
- Add 5 to 25 drops of a 10 percent solution of potassium dichromate to the developer.
- Lower the temperature of the developer.
- After the first exposure is processed and dried, recoat the paper and expose it again with the same negative.

Lowering Contrast Print contrast may be lowered in the following ways:

- Use a soft, rough-surface paper.
- Reduce overall exposure time and process in a warm to hot developer.
- Add a few drops of clearing bath to the developer.

Applying the Emulsion You can apply the emulsion under subdued tungsten light. Practice coating on scrap paper. Use water to which food coloring has been added so that it is easier to see what is happening. Tape or pin the paper to a smooth, flat surface. Use a brush with no metal parts (about 2 inches wide) that has a thin row of bristles so a minimum amount of emulsion is used. If the brush has any metal, do not let the emulsion come in contact with it, as this will cause a chemical reaction that will contaminate the emulsion. Metal parts may be painted with rubber cement for protection.

Dip the brush into distilled water and squeeze it out. Doing this will reduce the amount of emulsion used. Using a clean dropper, put a line of emulsion along the top of the paper; with long, rapid, parallel strokes, brush the emulsion up and down and back and forth until the surface is dry. Coat an area larger than the negative so that the excess can be trimmed off to make test strips. Spread the emulsion as evenly as possible. Avoid puddles that may soak into the paper and produce uneven print density. Wash the brush immediately after use, as exposure to light will cause ferrous salts to form in any remaining emulsion. If the brush is not properly washed, these salts can contaminate future prints during the coating process.

Hang the paper with plastic clips or clothespins with no metal in a darkened room, or use a hair dryer on low heat to speed drying. Platinum emulsion is hygroscopic, which means that it absorbs moisture from the air. If too much moisture is absorbed into the paper, the highlight areas may be degraded and grainy. Heating the paper as it dries helps reduce the likelihood of this occurring. When dry, the unexposed paper should have a pale yellow color.

Do not handle the emulsion surface, as it is easily contaminated before printing is completed. Sensitize only the paper needed for immediate use. Expose and process as soon as possible.

Printing The emulsion is exposed by contact printing with UV light. Combine the negative and paper (emulsion to emulsion) in a printing frame or under glass with a smooth, firm support. A typical sunlight exposure can run 1 to 5 minutes depending on the season and the time of day. Many workers prefer a UV exposure unit with a fluorescent, pulsed xenon, or quartz light source. They produce more constant exposures that can be repeated more easily (see "Additional Information" at the end of this chapter). A home sunlamp also may be used. At a distance of about 24 inches from the printing frame, exposure times may run 15 to 30 minutes with a sunlamp. Since the platinum emulsion is expensive, making test strips that show key highlight and shadow areas is recommended.

The image will print out to a limited extent, appearing to be a lavender-gray against a yellowish ground. Correct exposure will have detail in the highlight areas, but this will be faint and is difficult to use as an accurate guide (another reason to make test strips). The correct exposure cannot be determined until the print has been processed and at least surface dried.

Exposure time also depends on the amount of potassium chlorate (solution 2) in the emulsion. An increase in potassium chlorate cuts the printing speed and results in higher contrast. An emulsion for very soft prints, having no solution 2, may need 25 percent less exposure than normal. An emulsion for high-contrast prints, having the maximum amount of solution 2, may need up to 75 percent more exposure than usual.

Platinum Developer Formula Due to the hygroscopic nature of platinum emulsion, the print should be processed immediately after exposure. Development can be carried out under subdued tungsten light in a saturated solution of potassium oxalate.

Water (120°F or 49°C) 48 ounces (1420 milliliters)

Potassium oxalate 1 pound (454 grams)

Store the developer in an opaque bottle and use at 68°F (20°C). Do not discard the developer. It lasts a long time without any replenishment and can actually improve with age as the platinum residuals build up. When a precipitate forms, decant the solution (gently pour off the solution without disturbing the sediment) into another container.

The developer acts very rapidly, so you must immerse the print, face up, with a quick, continuous motion. Hesitation may produce development lines or streaks, which can sometimes be removed by rubbing the print while it is in the developer. Development time is 1 to 2 minutes, with gentle agitation. Development is automatic, meaning that the chemical reaction will continue until it is complete and then it will stop. Consequently, increasing the development time beyond about 2 minutes will not affect the final image.

The color of a platinum print becomes warmer as the temperature of the developer rises. A warmer temperature also increases the printing speed of the paper, so less exposure is required. Make sure the developer temperature remains constant between the test strip and the final print to ensure consistent results. Warm developer reduces the overall print contrast. You can compensate for this to a certain degree by increasing the amount of solution 2 in the emulsion.

Platinum Clearing Bath Formula After development, in normal room light, clear the print in three successive baths of dilute (1:60) hydrochloric acid (1 part hydrochloric acid to 60 parts water). This bath removes any remaining ferric salts by changing them into soluble ferric chloride. If this is not done, the print will remain light sensitive and continue to darken. Some workers have found that citric acid, phosphoric acid, or Bostick & Sullivan's EDTA Clearing Agent (tetra-acetic acid tetrasodium) work well and are safer to use than hydrochloric acid.

Water (68°F or 20°C) 420 milliliters
Hydrochloric acid (37%) 7 milliliters

Always add acid to water. This solution may be reused and can last indefinitely.

Clear the print for 5 minutes in three separate trays of the clearing bath with occasional agitation. After a few prints have been cleared, dump the first bath, refill it with fresh solution, and move it to the end of the cleaning trays so it becomes the third bath. Move the second bath up to the first position and the third to the second. This ensures the complete removal of the iron salts from the print. The third bath should remain clear after the print has gone through. If it is not clear, give the print a fourth bath in fresh clearing solution.

Washing and Drying After clearing, wash the print for 30 minutes in running water at 68°F (20°C). Handle the print with care, as it is very delicate at this stage. Prints may be air-dried or dried with low heat from a hair dryer.

Spotting Dried prints may be spotted with black India ink diluted with water. This often matches the neutral to warm black tones of a platinum print. Burnt umber and lampblack watercolors work well when mixed to the proper shade.

Combination Printing

Platinum can be combined with palladium, gum, Kwik-Print, or cyanotype. When cyanotype is used with platinum, the cyanotype should be printed last, as the potassium oxalate developer will bleach the cyanotype image.

Figure 12.3 Working with alternative processes encourages the photographer to depart from known pathways. Goff used Rodinal (1:31) to make a negative with greater highlight density than normal without sacrificing image sharpness. He also altered the standard platinum-palladium emulsion formula to make his print. He omitted the potassium chlorate in stock solution 2 to extend the active shelf life of the ferric oxalate solution.

© Steve Goff. "Untitled," 1981. Platinum-palladium print. 5 x 7".

Palladium Printing

When comparing palladium with platinum, remember that they act very much alike. Even experts can have great difficulty seeing the difference between a platinum and a palladium print. Palladium is less expensive than platinum and produces a permanent brown-tone print that is warmer than the image achieved with platinum. The working procedures are the same as those used with platinum, except for the following:

- Palladium salts are not as sensitive as platinum salts to potassium chlorate, which controls the contrast. This can be corrected by doubling the amount of potassium chlorate in solution 2.
- Palladium is more soluble in hydrochloric acid, so the clearing bath can be diluted 1:200 (1 part hydrochloric acid to 200 parts water).
- The contrast of palladium cannot be increased by adding potassium dichromate to the developer because the image will bleach out during the clearing baths.
- Solution 3 of the emulsion sensitizer must be modified as described in the following formula.

Modified Palladium Emulsion Solution 3 Formula

Distilled water (100°F or 38°C)	2 ounces (60 milliliters)
Sodium chloropalladite	169 grains (9 grams)

If sodium chloropalladite is unavailable, use the following formula.

Modified Palladium Emulsion Solution 3A Formula

Distilled water (100°F or 38°C)	1 1/2 ounces (40 milliliters)
Palladium chloride	77 grains (5 grams)
Sodium chloride	54 grains (3.5 grams)

Gum Bichromate Process

The gum bichromate process operates on the principle that colloids (gelatinous substances) become insoluble when they are mixed with certain light-sensitive chemicals and exposed to UV light. This effect is called hardening or tanning. The most frequently used colloids in photography are albumen,

gelatin, and gum arabic. In the gum bichromate process, the support material is coated with a gum arabic that contains a pigment (watercolor or tempera) and with a light-sensitive chemical (ammonium or potassium dichromate) to produce a nonrealistic color image from a contact-size negative. Gum arabic, a water-soluble colloid, is hardened by exposure to UV light and thus made insoluble in direct proportion to the density of the negative. The areas that are not hardened remain water soluble and are washed away with the unneeded pigment during development. The hardened areas are left intact and bond the pigment to the support. A great deal of control over the final image can be exercised through the following: choice of paper, pigment, localized development, recoating the paper with the same color or a different color, or using the same or different negatives for additional exposures.

John Pouncy patented the first workable gum process in the late 1850s. The process was used by the Pictorialists from the 1890s to about 1920, often under the name Photo-Aquatint. Gum printing has experienced a revival since the late 1960s. Among the reasons for this are the following:

- It is inexpensive because it uses no metal salts.
- It permits extensive manipulation of the image.
- It is versatile, so it can be combined with other processes.
- It is permanent.

The disadvantages of gum printing stem from its versatility. It is a more difficult process to control than the nonsilver processes discussed earlier in this chapter. Multiple coats of emulsion and exposure are necessary to build up a deep, rich image. The support material (paper) must be sized, or the registration of the different exposures will not line up, thus producing blurry images. Any subtle or fine detail will be lost in the process. Gum also does not deliver a realistic color image balance.

This section offers a starting point for making gum prints on paper. There are countless formulas for gum printing, and the process can be used with almost any type of support material. Keep a record of your working methods and make adjustments. Feel free to modify the suggested working methods whenever necessary.

Paper

Start with a high-quality watercolor or etching paper that has a slight texture and the ability to withstand repeated soaking and drying. Some widely available papers include Arches Watercolor, Rives BFK, Strathmore 500 Series (two-or three-ply), Strathmore Artist Print, and Hot Pressed Strathmore Artist Watercolor. All paper should be presoaked and sized. Some papers, such as Strathmore 500, can be purchased presized. For exacting work, even these papers may have to be presoaked and resized.

Presoaking Presoak by placing the paper in hot water (100°F or 38°C) for 15 minutes and then hanging it up to dry. Without the presoak, the paper will shrink after the first time it is processed, thus making accurate registration of the next exposure impossible.

Sizing After the presoak, size the paper. There are two widely used methods of sizing. The quickest and easiest way is to use spray starch. Pin or tape the paper to a clean, smooth support board. At a distance of about 12 inches, start spraying the starch at the bottom of the paper in horizontal sweeps and work upward to the top of the paper. Do not overspray, as too much starch will prevent the emulsion from sticking to the paper. Use a soft, clean, damp sponge to wipe off any excess starch and to ensure an even coat. Apply a thin coat of starch between exposures to prevent the colors from bleeding into each other.

The gelatin method of sizing is more effective but also more time-consuming. Dissolve 28 grams of unflavored gelatin in 1 liter of cold water. Allow it to swell (sit) for about 10 minutes and then slowly heat the solution to 100°F (38°C) until it is completely dissolved. Pour the solution into a tray and soak each sheet of paper for 2 minutes. Lightly squeegee off the excess solution and hang the paper up to dry (low heat may be used).

Many workers give the paper a second coat of sizing after the first one has dried. In a well-ventilated area, harden the surface by floating the paper in a bath of 25 milliliters of 37 percent formaldehyde and 500 milliliters of water for 2 minutes and then drying it.

Emulsion

The emulsion is made of pigment, gum, sensitizer, and distilled water. Varying the amounts of these ingredients will result in noticeable changes in image characteristics. For this reason, experimentation is a must. A specific

Figure 12.4 This image began with an out-of-sync flash fired during a one-half-second exposure on Tri-X film. From this negative, a Kodalith positive (Dektol, 1:14) and a continuous-tone Kodalith negative (Dektol, 1:8) were produced. For gum bichromate printing, Rives BFK paper was prepared by sizing it in two baths of gelatin and water and then immersing it in a formaldehyde solution to harden the paper. The Kodaliths were printed eight times, using complementary color runs with each printing. This was done to build up a deeply saturated look that adds mystery and sensuality to the work.

© Alida Fish. "Untitled," 1983. Gum bichromate print. 20 x 24". Original in color.

Figure 12.5 In attempting to make visible the power and magic of this special place, Taylor first did the cyanotype exposure on Arches 140-pound watercolor paper. He did the second exposure with gum bichromate to add color, richness, and texture. The image was finished with layers of mixed media, such as acrylic, chalk pastel, watercolor, and colored pencil. The edges of the paper were hand-torn to enhance the primitive feel of the print.

© Brian Taylor. "The Great Pyramids," 1985. Cyanotype, gum bichromate, and mixed media print. 16 x 20". Original in color.

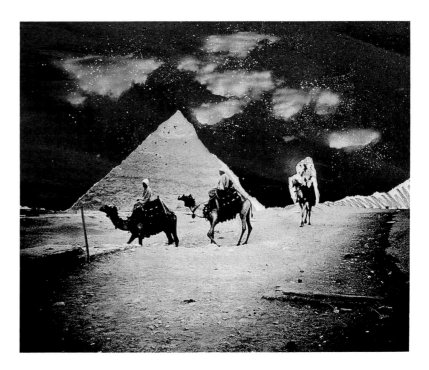

combination might deliver results that are pleasing to one image maker but unsatisfactory to another.

Pigments

The easiest way to add color to the emulsion is with good-quality tube-type watercolors such as Winsor-Newton and Grumbacher. Many workers find that the opaque gouache-style watercolors perform well. Tempera colors also may be used. The following is presented as a basic palette, which comes close to resembling the primary subtractive colors in color photography:

- Alizarin crimson (close to magenta)
- Monastral or thalo blue. Prussian blue is not recommended because it is chemically incompatible with cadmiums and vermilions.
- Cadmium yellow (pale). Hansa yellow is a less expensive synthetic that can be substituted for cadmium.

In addition to these three primary colors, there are earth colors such as burnt sienna (brownish brick red); raw sienna (more yellow than burnt sienna); burnt umber (dark red-brown); and raw umber (yellowish brown). These colors, in conjunction with lampblack, are useful in making a wide variety of tones.

Note that the chrome colors, such as chrome yellow, can be chemically incompatible with the sensitizer and with other organic pigments. Emerald green, which is poisonous, should not be mixed with other colors, as it is not chemically compatible.

Gum Solution

The gum solution may be prepared from a formula, but it is advisable to purchase it in small premixed amounts. This bypasses the difficult process of dissolving the gum and prevents the handling of mercury chloride, which is a toxic chemical used to stop the growth of bacteria. Lithographer's gum (14° Baumé) solution is available from graphic arts or printing suppliers. Be sure it comes with a preservative, such as 1 percent formaldehyde, as it does not keep well. To ensure its freshness, some practitioners buy it in small quantities and replace it often.

Sensitizer

The recommended sensitizer is ammonium dichromate (bichromate is the same thing) because it is more sensitive to light than potassium dichromate, thus making faster exposure times.

Ammonium Dichromate Sensitizer Formula

Distilled water (80° F or 27° C)	100 milliliters
Ammonium dichromate*	30 grams

*Wear gloves, as this may cause skin irritation.

Store sensitizer in an opaque bottle. If precipitate forms during storage, reheat and dissolve the solution.

Preparing the Emulsion

The amount of pigment should be varied depending on the desired effect and the type of paper being used. The following is provided as a general guideline, but experimentation is in order.

Gum Dichromate Emulsion Formula

Gum arabic solution	40 milliliters
Pigment (tube-type watercolors)	*
Ammonium dichromate sensitizer	40 milliliters

*Pigment amounts vary greatly depending on the desired effect. The following is only a starting point:

Alizarin crimson	3 grams
Monastral or thalo blue**	2 grams
Cadmium yellow	3 grams
Burnt sienna	3 grams
Burnt umber	3 grams

**Pure blues are difficult to achieve because the orange dichromate tends to shift the color balance to green.

Put the gum arabic and pigment in a clean baby food jar, secure the lid, and shake rapidly until the solution is completely mixed. Then add the dichromate and shake until the solution is uniform. Generally, the gum and dichromate are mixed in equal proportions, while the amount of pigment is varied. It is advisable to use the emulsion quickly, within one day or working session, as it does not keep well.

The Effects of Varying the Emulsion Ingredients

Varying the proportions of the gum, pigment, and sensitizer results in the following changes:

- *Increasing the gum* permits more pigment to be retained without staining. If there is too much gum, the emulsion will be too thick to be easily applied and may flake off during development.
- *Decreasing the gum* causes the emulsion to set up more slowly and also may cause staining.
- *Increasing the pigment* causes the emulsion to set up more rapidly and deepens the color in the shadow areas. This often requires forced development and may produce stains in the highlights. Too much pigment may cause the image to crumble off the paper during development.
- *Decreasing the pigment* allows the highlight areas to develop more readily but produces very low contrast, as there will be little shadow density.

- *Increasing the sensitizer* delivers less contrast, as it thins the emulsion; thus less pigment is deposited on the support surface.
- *Decreasing the sensitizer* results in a lack of light sensitivity, with only the shadow areas printing out.

Coating the Paper

The emulsion is not very sensitive to light while it is wet, so coating can be carried out under subdued tungsten light. The paper should be pinned or taped to a smooth, flat board. Generally, the lightest color is applied first, as it may not print well over the darker colors. Some workers like to print a dark color first to make registration easier when additional coats are applied.

Pour the emulsion in a small bowl or jar. Dip a spreading brush at least two inches wide (polyfoam brushes work fine) into the emulsion. Squeeze out the excess on the side of the bowl. Coat the paper with long, smooth, horizontal strokes and then with vertical ones. Have enough emulsion on the brush to make one complete stroke without having to redip. The strokes should overlap slightly. Perform this operation as rapidly as possible (10 to 15 seconds for an 8 x 10"). Do not let the emulsion puddle or flood the paper.

Immediately take a dry blending brush and, holding it vertically to the paper, paint in long, gentle strokes, using only the tip of the brush to smooth out the emulsion. This step also should be done as quickly as possible. The coating must be even and thin, or the gum may flake off the print later. Stop blending as soon as the emulsion becomes stiff or tacky. Many of the small brush strokes will smooth out as the paper dries.

Hang the paper to dry in a darkened room. A fan or hair dryer, set on low heat, can be used to speed drying. The paper should be exposed as soon as it is dry, as it will not keep for more than about a day. If it is sealed in a plastic bag and refrigerated, however, the paper can keep for up to two weeks. Try to avoid working in humid conditions, as the bichromate solution absorbs moisture from the air, making it less sensitive.

Exposure

Combine the negative and paper (emulsion to emulsion) in a contact-printing frame or under a clean piece of glass with a smooth support board. Expose this sandwich to UV light. Typical sunlight exposures can be 5 to 10 minutes. With photofloods, at a distance of 18 to 24 inches from the printing frame, exposures may be 20 to 60 minutes. Sunlamp exposures can range from 10 to 40 minutes. Different pigments require different exposures. Use a fan to lengthen the life of the light source and keep the negative and print from getting too hot. Excessive heat may produce a pigment stain in the print.

Development

Immediately after exposure, the print should be developed in subdued tungsten light. Slide the print, emulsion side down, into a tray of water at 70°F to 80°F (21°C to 27°C). Allow it to float without agitation. Change the water after about 5 minutes, when it has become cloudy. Transfer the print to a tray of fresh water or remove the print and change the water in the tray, then return the print to the tray. For the full range of tones, development should be complete in about 30 minutes. You can tell it is complete when the highlight areas are clear. If development seems to be going too slowly due to overexposure or the use of too much pigment, raise the temperature of the water to 100°F (38°C). If a print is underexposed, you can use additional layers of exposure to build up the image density. Overexposure or too much heat can harden the emulsion, making it impossible to wash off. The emulsion of an extremely underexposed image might float off the paper during development. If the emulsion flakes off, it was applied too thickly.

Forced Development

A soft brush and/or a directed stream of water (from a hose, graduate, or atomizer) can be used to manipulate the image. These forced development methods diminish subtle print detail but permit the use of more pigment in the emulsion, increasing the contrast and density of the image. The amount of pressure applied by the brush or stream of water determines the abrasive effect. The print may be removed from the tray of water, placed on a piece of Plexiglas for manipulation, and then returned to the tray to finish the development process. When development is complete, hang the print to dry.

Multiple Printing

After a single exposure, most gum images look flat and weak, lacking color saturation and a sense of visual depth. Multiple printing adds contrast to the shadow areas, can extend the overall tonal range, and can give the image an appearance of greater depth. In basic multiple printing, the dried image is recoated and re-exposed with the same negative in register. This can be repeated numerous times. Gum printing can be successfully combined with cyanotypes for heightened color and contrast or with posterization negatives.

A simple way to register the print is to mark all four corners of the negative on the paper with a soft lead pencil. Variations in multiple printing include printing negatives with different densities, using color-separation negatives, using entirely different negatives, printing out of registration, and changing the pigment. A lengthier, but more accurate, registration method is offered in the Kwik-Print section of this chapter.

Clearing

After all the printing operations are finished, a yellow or orange stain may be visible. This may be cleared in a 5 percent solution of potassium metabisulfite or sodium bisulfite. Immerse the print in the clearing bath for 2 to 5 minutes, wash it for 15 minutes, and dry it.

Kwik-Print Process

Kwik-Print was originally designed in the 1940s as a technique printers could use to make rapid color proofs from color-separation negatives. Over the years, the process has been modified, improved, and made more stable so that photographers and printmakers have been able to use it.

Kwik-Print is much like the gum bichromate process. A support (vinyl, polyester, paper, or fabric) is coated with Kwik-print color solution (pigment suspended in a bichromate light-sensitive medium) and allowed to dry. A negative is exposed through contact printing with UV light. The areas not blocked by the negative become hardened, in proportion to the density of the negative, and insoluble. The support material is washed in water, dissolving the unhardened pigment.

Kwik-Print is faster and simpler than gum printing. All operations can be carried out in subdued tungsten light. Kwik-Print's stability (the length of time the pigments remain stable before fading when stored in the dark) is said to compare with that of Cibachrome and Dye-Transfer. Kwik-Print is sold in kit form with all the basic materials needed to make a print. (See Color Plate VI.)

Kwik-Print Base Sheets

Kwik-Print is designed to be applied to vinyl or polyester Kwik-Print base sheets. These sheets are notched in the upper right corner for easy identification and are not light sensitive until they are coated. Since they are made out of nonabsorbent plastic, they will not shrink and do not require sizing. If the emulsion is damaged on one of the sheets, the pigment will not stick and scratches are difficult to spot. The sheets are available in four surfaces.

- *Hi-Con V* is 0.010-inch vinyl with a vellum matte surface identified with one notch in the upper right corner. It has the shortest tonal range but the widest exposure latitude, making it a good choice for beginners. It delivers the whitest highlights and is recommended for use with high-contrast negatives. This base is suggested for use when the image is built up through many coatings and when physical manipulation of the image is planned.
- *Wide Tone V* is 0.010-inch vinyl with a vellum matte surface and is identified by two notches in the upper right corner.
- *Wide Tone P* is 0.007-inch polyester with a smooth matte surface and a glossy backside. It is identified by three notches in the upper right corner.
- *Super White P* is 0.005-inch polyester with a smooth matte surface and a glossy backside. It has no notches.

Wide Tone V and P and Super White P are designed for continuous-tone and high-contrast negatives. They produce the most saturated colors over the widest tonal range. When used with color-separation negatives, all will produce a full color print.

Pigments

Kwik-Print pigments come in the four process colors commercial printers use to make four-color reproductions: lemon yellow, magenta, medium blue, and black. There are also ten other basic colors plus clear. They all have a shelf life of about one year. These colors may be mixed to form other colors. With the exception of opaque white, all the colors are translucent and can be made more transparent by mixing them with *clear* (1:1). These pigments are *not* designed to be diluted with water. Clear may be combined with gouache or watercolor pigments to create still more colors. Since the pigments are translucent, colors printed on top of one another combine to make a third color. For example, yellow printed over blue makes green. This is the additive color process.

One of the most common mistakes beginners make is the overuse of black. In many applications, black is not needed at all. When it is required, it is generally used sparingly to deepen shadow areas. An excess of black obscures color and detail, resulting in a dark, muddy print.

Negatives

A contact-size negative is needed because Kwik-Print is too slow for enlarging. A continuous-tone negative with moderate contrast will print well. High-contrast, halftone, and random-dot screens also will produce good results.

Preparing the Base Sheet

The Kwik-Print base sheets come in various shades of white and are not light sensitive. They have notches indicating the working side and surface type. When preparing the sheet, have the notch code in the upper right corner to indicate that the working side is facing in the correct position.

Tape the base sheet down at all four corners on a clean, hard, smooth surface. If you want to spread the emulsion out to the corners, sprinkle some water on a clean piece of glass and squeegee the base sheet into place. Remove all the water from the sheet and the glass before applying the emulsion. Excess water can cause streaking and allow previously applied dried color to come off the sheet.

Selecting Colors

Shake the bottle of Kwik-Print color emulsion well and pour a small amount onto the center of the sheet. A little puddle about 1 inch in diameter, or 40 to 60 drops, should cover an 8 x 10" sheet. The plastic canisters in which 35mm film comes make excellent mixing cups for preparing your own colors.

Registration

Generally, a dark color (except magenta) is applied first, as it provides the easiest guide for sight registering the negative when additional exposures are planned. For more accurate registration, tape a piece of heavy paper along one edge of the negative. Sandwich the negative and base sheet together. Use a standard hole punch to make a hole in two of the corner edges of the paper and the base sheet. Attach registration buttons, available at a graphic arts store, to the support board. Fit the negative and base sheet into the registration buttons. This will perfectly register the negative and paper each time it is recoated.

Coating

Using a clean Kwik-print wipe wrapped around a small block of wood, quickly spread the emulsion over the sheet. Using first horizontal and then vertical strokes, remove the excess emulsion by extending the strokes beyond the edge of the sheet. Change the cotton wipe and repeat the same movements, but add some slight pressure. Change the wipe again, continuing to make sweeping horizontal and vertical strokes to buff the base sheet dry. Use additional wipes if necessary to prevent streaking. The emulsion should be thin and even with no streaks (they will show in the final print). If streaks are visible, wash the sheet, dry it, and recoat it. The Kwik-Print base sheet becomes light sensitive as soon as the emulsion dries and should be exposed within 15 minutes.

Exposure

Place the negative and coated base sheet (emulsion to emulsion) in a print frame or under a heavy piece of glass with a firm, smooth support. Exposure is determined by the color of the pigment used, the intensity and quality of the UV light source, the density of the negative, the type of support, and the thickness of the emulsion. Exposure is best determined by a test strip. Times can run from 10 seconds to 10 minutes. Some workers intentionally underexpose the first dark color so that additional detail will be more visible when lighter colors are added through multiple exposures. Table 12.1 lists suggested starting times.

Development

Directly after exposure, immerse the base sheet in a tray of running water at 68°F (20°C). The unexposed color and its bichromate sensitizer should wash off within 2 minutes. After this time, you can gently rub the surface with a clean, wet wipe pad or sponge to help remove unwanted emulsion. If too much of the image washes off, increase the exposure time and make sure the exposure is being made with a proper UV light source. If image detail washes off unevenly, the emulsion was not applied evenly.

Clearing

If the highlight areas do not clear completely, immerse the base sheet in a solution containing 1/2 ounce (14.8 milliliters) of 28 percent aqua ammonia and 1 gallon (4 liters) of water. A solution of plain household ammonia can be substituted. Prepare 4 ounces (118 milliliters) of plain ammonia with 32 ounces (1 liter) of water. Agitate the sheet in the solution until the highlights clear. This clearing solution also may be applied to selected areas with a brush or spray bottle. After this clearing bath, wash the sheet for 2 to 5 minutes at 68°F (20°C). At this stage, handle the sheet with care, as the emulsion is very fragile and can be easily damaged.

If the highlights are still not clear after the ammonia bath, use Kwik-Print Brightener. This is a strong reducing agent and may remove some of the color from the emulsion. It is designed to be used straight, but try diluting it

Table 12.1 Starting Kwik-Print Exposure Times in Minutes for Different Color Pigments

Light Source*	Black	Blue	Red	Yellow
Sunlamp at 3 feet from the print frame	2 ½	¾	1 ¼	1 ½
Number 2 photoflood at 1 foot from the print frame	4	1	2	3

*When possible, use a fan to disperse heat during exposure, as the vinyl base sheet will buckle if subjected to too much heat. Excessive heat also may produce print staining.

1:1 with water. Pour enough brightener solution in a clean tray to cover the base sheet. Immerse the sheet smoothly in the solution and agitate for 15 seconds. Remove the sheet and carefully wash it for 5 minutes at 68°F (20°C).

Drying

The base sheets can be air-dried or dried with a soft cloth or with very low heat from a hair dryer. Too much heat can cause buckling and distortion.

Additional Layers

Since Kwik-Print colors are translucent, you must apply several layers to obtain rich, dense colors. This is done by recoating the dry base sheet with the desired color emulsion. Some printing possibilities include using the same negative with different colors and different exposures, recoating the same color, adding color only in specific areas, combining different negatives or different types of film, such as high-contrast or halftone, in conjunction with a continuous-tone negative.

Kwik-Print recommends making the first coat with any dark color except magenta. Magenta has a high pigment level and can be difficult to wash out. The manufacturer recommends not using yellow last, as it may dissolve previous coatings or produce a mottling effect.

Combining with Other Media

You can draw or paint on Kwik-Print when the printing is complete or as the layers of different-colored emulsion are added. Using a wax pigment, such as crayons, between coats can produce unusual effects. No new emulsion will affect the areas that have been crayoned. Additional colors can be applied after all the printing operations are finished.

Kwik-Print on Paper and Synthetic Fibers

Kwik-Print can be applied to artist's paper, thus enabling the image maker to expand on the plastic support material aesthetic. This permits variations in the surface texture as well as the ability to obtain more vivid and saturated colors with fewer coatings than on plastic support materials.
The disadvantages of paper include the following:

- It has to be preshrunk and sized in the same manner as paper used in gum printing (see Presoaking and Sizing in the gum printing section of this chapter).
- It requires a longer time to dry between coats.
- It is more fragile than the Kwik-Print base sheets.

Even with these added steps, Kwik-Print on paper is still faster and easier than gum printing. After the paper has been properly prepared, all the processing steps are the same as those outlined for use with the regular Kwik-Print plastic base sheets.

Kwik-Print also can be applied to synthetic fibers, such as filament nylon and acetate satin.

Source of Supply

Kwik-Print is not generally available through local photographic dealers. It is made by Direct Reproductions and is currently distributed by Light Impressions, P.O. Box 940, Rochester, NY 14603.

Electrostatic Processes: Copy Machines

Copy machines provide the image maker with another opportunity to experiment with technological advances originally designed for business use. They enable the photographer to combine electronic, manual, and mechanical processes in the creation of new images.

Black-and-White Copiers

Black-and-white copy machines are very accessible and less expensive to use than their color counterparts. They provide a good starting point for conducting experiments with copiers. You can apply many of the things you learn on these machines to work on a color copier. The quality of image reproduction varies widely depending on the type of system used. Generally, continuous-tone images lose a great amount of detail when copied. Some systems provide a special screen, which can be used to improve the copy delivered from a full-tone image. Graphic images tend to work well with most machines.

All the black-and-white copiers allow the image maker to alter the density of the print. Some accept a variety of paper stocks, including different colors. Many machines make enlargements and reductions at fixed percentages of the original. Others permit you to make more than one copy on the same piece of paper; thus multiple-exposure combinations are possible.

The black-and-white copiers rely on a number of different systems to form a completed copy print. The systems requiring a special chemically treated paper to create an image offer the least in terms of image permanence. The systems using an electrostatically charged toner that can form an image on any type of paper, including acid-free rag paper, provide the most stable copy print.

Color Copiers

Color copiers made by Canon, 3M, Sharp, and Xerox have become more widely available, and artists are now taking advantage of them to explore the new imaging functions they have to offer.

Xerox Copier The Xerox color copier is currently the most widely accessible machine. The Xerox system uses the subtractive colors (magenta, yellow, and cyan). Each color is separated from the original through an internal filtering unit. The image is then reproduced with toners (pigments) made up of thermoplastic powders that are electronically fused onto the paper, making a permanent image. One advantage of this system is that the toners do not require a specially treated paper and therefore can be fused onto a variety of artist's papers.

The lens of the Xerox machine, like those of the other copiers, acts like a simple camera without a bellows adjustment. It produces a very flat and limited field of focus that extends only about one-quarter to one-half inch above the copier glass.

The Xerox copier provides many printmaking options, including the following:

- Rapid and consistent duplication and production
- Ready conversion of three-dimensional objects into flat printouts

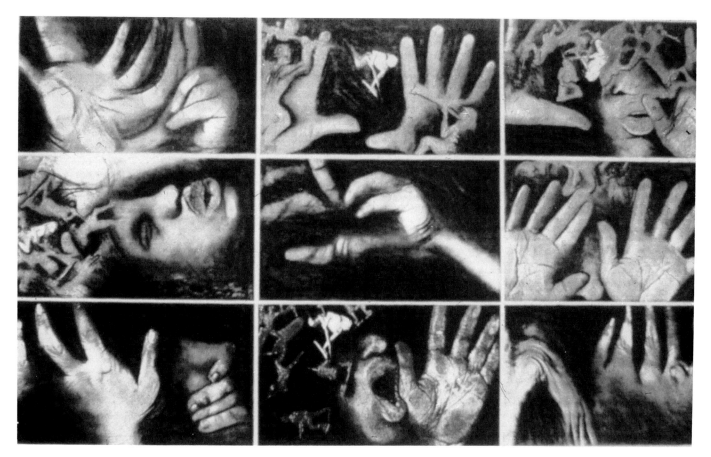

Figure 12.6 This work was made using a Canon laser scanning-digitizing copier. The machine's computer allows the work to be manipulated in a variety of ways. This copier can enlarge an original image up to 400 percent. It enlarges one section at a time. These sections can then be pasted together to produce a mural-size photocopy 55 x 68". After letting the copier carry out this function, Pinkel rephotographed the enlarged sections, and made a mural-size gelatin silver print.

© Sheila Pinkel. "Untitled," 1987. Gelatin silver print. 48 x 70". Original in color.

- Transformation of 35mm slides into hard copies
- Manipulation of colors and contrast, including single-color copying
- Image enlargements and reductions
- Printing on many different supports, such as archival artist's paper, acetate, and silicon transfer sheets (which can be ironed onto paper or fabric)

An added virtue is that the pigments used to form the image are stable and provide a long print life.

The rapid feedback of this process enables instant correction and further interaction of the printmaker with the materials and processes. Prints made on artist's paper can be hand-colored with pencils, dyes, inks, or watercolors. Individual prints can be connected with one another to form a larger mosaic of images.

Canon Color Laser Copier The Canon Color Laser Copier is the most technologically advanced copier. This piece of equipment has a scanner that reads the image to be copied and converts it into digital signals. These signals are transmitted to a laser printer capable of delivering color copies of up to 64 gradations per color. Like the Xerox copier, the Canon uses the subtractive color system, but in addition to magenta, yellow, and cyan, this copier also uses black. The black enables the machine to reproduce colors more accurately and to provide a greater sense of depth. (See Color Plate VII.)

This copier features an electronic pointer that can be used with the image editing unit. It also has many functions that image makers appreciate:

- A programmable color balance memory
- A sharpness control to accentuate or soften detail
- A bidirectional enlargement or reduction feature that permits a subject to be stretched or squeezed to fit a specific space

- A slanting control to set the horizontal and vertical copying ratios separately and position the original at a variety of angles
- A multipage enlarger that divides the image into as many as 16 sections that can be printed in sequence and assembled into a single piece
- A color conversion mode that lets you change the color of an original or a specified portion of the original
- An image composition key that lets you combine original color materials with black-and-white text
- An area designation that lets you frame, blank out, or segment the image
- Shifting modes that allow the image to be reduced and moved to any position on the page
- The ability to make a color copy from a negative as well as a slide

Additional Information

Books

Arnow, Jan. *Handbook of Alternative Photographic Processes.* New York: Van Nostrand Reinhold, 1982.

Blacklow, Laura. *New Dimensions in Photo Imaging.* Stoneham, Mass.: Focal Press, 1989.

Crawford, William. *The Keepers of Light: A History and Working Guide to Early Photographic Processes.* Dobbs Ferry, N.Y.: Morgan and Morgan, 1979.

Hirsch, Robert. *Exploring Color Photography.* Dubuque, Iowa: Wm. C. Brown Publishers, 1989.

Howell-Koehler, Nancy. *Photo Art Processes.* Worcester, Mass.: Davis Publications, 1980.

Nettles, Bea. *Breaking the Rules: A Photo Media Cookbook.*2d ed. Urbana, Ill.: Prairie Book Arts Center, 1987.

Reeve, Catharine, and Marilyn Sward. *The New Photography: A Guide to New Images, Processes, and Display Techniques for Photographers.* Englewood Cliffs, N.J.: Prentice-Hall, 1983.

Scopick, David. *The Gum Bichromate Book.* Rochester, N.Y.: Light Impressions, 1978.

Wade, Kent E. *Alternative Photographic Processes.* Dobbs Ferry, N.Y.: Morgan and Morgan, 1978.

Other Sources

Bostick & Sullivan, P.O. Box 2155, Van Nuys, CA 91404 (catalog of materials for platinum printing).

Chicago Albumen Works, Front Street, Housatonic, MA 01236 (a line of products including a gelatin chloride printing-out paper).

Photographers' Formulary, P.O. Box 5105, Missoula, MT 59806.

The Palladio Company, P.O. Box 28, Cambridge, MA 02140 (precoated platinum-palladium papers and UV exposure units).

Chapter *13*

Altering Photographic Concepts

Hand-Altered Work

The hand-altering of photographs began almost immediately after the daguerreotype process was made public in 1839 to compensate for the latter's inability to record color. George Bernard Shaw once commented, "A photographer imitating the work of a draftsman is like a man imitating the noises of a barnyard: he may do it very cleverly, but it is an unpardonable condescension all the same." Today hand-altering continues to play an important role in photography. Its purpose is not one of compensation or imitation but one of pushing the bounds and limits of the photographic medium. It enables photographers to bring into existence concepts, dreams, ideas, and methods that cannot be achieved by standard photographic processes, thus providing a way to unite materials, practice, and vision.

Hand-altered work allows image makers to prolong their interaction with the process. These techniques can expand the consciousness of the photographer and give rise to a heightened sense of reality. Hand-altered work delivers the message that all photography is a process of discovery and invention, not merely a fixed body of technical data. It comingles what is real, what might be real, and how we can tell the difference, reminding us that the invisible (the intangible) is as important as what we see (the concrete).

Hitting Resistance

When hand-altering work, do not be afraid to push and pull the materials until you meet resistance. Go to the limit, push against the wall of familiarity, but stop before resistance becomes destruction. When you hit resistance to new ideas and methods, it means you are entering uncharted waters. There are no guides, instructions, or maps to offer advice. You are on your own. This enables you to know how far you can stretch the medium and yourself. Keep a record of your experiments so the results can be duplicated and what you have learned can be passed on to others. Keep in mind what Picasso said: "The eyes of an artist are open to a superior reality."

There are far fewer rules and standards in hand-altered work than in conventional photographic methods. So how do you find satisfaction and success? Your mind will quit circling and say yes to what you have created. There is a dynamic interchange between the artist and the materials, which culminates in the moment of completion. This is when you know it is time to cease work. Your own character is now intertwined with the final piece. As the photograph is transformed, so is the photographer.

Doing the Opposite

Much of this book has been devoted to providing known pathways for the photographic image maker. As soon as you have gained control over the medium and tools and you are able to express what you desire, it is time to let

go and do the opposite. Too much knowledge can be as inhibiting as too little. Doing the opposite keeps us from being too sure and judgmental. Reaching into the unknown is how we grasp new possibilities.

Do not become complacent with what you already know. Education is a continuous battle of waking up and staying awake. It means giving in to possibility and allowing yourself to see that which is not yet visible.

The Insecurity of the New

When something entirely new is created, it brings with it a sense of insecurity. This is because the new is not identifiable with anything in the familiar world. This form of insecurity occurs when you are able to leave the beaten path and not yield to the comfort of habit or imitation. The new often produces much resentment because it entails throwing over the previous set of working conventions. Having blind faith in the ways of the past can lead to mediocrity. The new forces us to confront the past, discard its illusions, make corrections, and move forward.

Many times new images and working methods are not the final destination. Often the process of doing something for the first time helps us uncover what will ultimately bring new structure to our inner and outer vision. Hand-altering work allows the image maker to feel free to transform the ingredients of reality into previously unseen forms and structures. In "The Legend of the Sleepers," Danilo Kis sums up this idea: "Oh, who can divide dreams from reality, day from night, night from dawn, memory from illusion."

This chapter covers some aspects of hand-altered work by dividing it into the following working methods: cameraless images, camera-based photographs, darkroom-generated pictures, and postdarkroom work.

Additional Information

Grundberg, Andy, and Kathleen McCarthy Gauss. *Photography and Art: Interactions Since 1946.* New York: Abbeville Press, 1987.

Hughes, Robert. *The Shock of the New.* New York: Alfred A. Knopf, 1981.

Photograms

A photogram is a cameraless, lensless image made by placing two- or three-dimensional objects directly on top of light-sensitive material and then exposing it. Conceptually, the photogram is entirely different from traditional camera images based on outer reality in which the photographer starts with everything and eliminates or subtracts anything that is not wanted in the frame (a process of subtractive composition). When making a photogram, the image maker begins with nothing except a blank piece of paper, like a painter approaching an empty canvas, and adds the necessary ingredients to make the final piece (a process of additive composition).

The photogram plays with a viewer's expectations of what a photograph is supposed to look like. Although it appears on the surface to be a photograph, there is a sense of ambiguity and mystery, as the viewer attempts to figure out the reality of the image.

The light source used to make the exposure is often angled or moving rather than perpendicular to and stationary with the light-sensitive material. When the image is developed, no exposure effects will be visible where an opaque object was completely covering the light-sensitive emulsion. What is created is a silhouette of the object. When translucent or transparent objects are placed on the emulsion, or when partial shadowing occurs under opaque objects that are not in complete contact with the emulsion, a wide assortment of tones will be made. Any area left uncovered will get the maximum exposure and hence be black without any discernible detail.

The early pioneers in search of a practical photographic process were Johann Schuluze in 1725, Thomas Wedgwood and Humphry Davy in 1799,

Figure 13.1 This is an example of how Barrow uses the Polaroid SX-70 for note taking when working on an idea. The visual notes, including images made off a video monitor, are scattered across the photogram in an attempt to provide meaning that is simultaneously clearer and more ambiguous. When a satisfactory composition is achieved, the SX-70 prints are stapled in place. Color and text are added with spray lacquer paints.

© Thomas Barrow. "Sexual Ecology," 1986. Gelatin silver print with stapled Polaroid SX-70 prints and spray lacquer paints. 26 x 25". Courtesy of Andrew Smith Gallery, Santa Fe. Original in color.

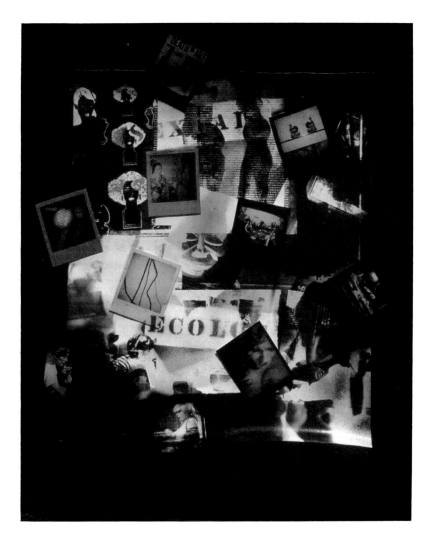

and Henry Fox Talbot from 1826 through the mid-1840s. All of them worked with cameraless images, establishing it as the earliest means of making light-sensitive pictures. The technique did not see much application until Christian Schad, a Dadaist painter, revived it in 1918 to create abstract images that he called Schadographs. Within a short time, Man Ray countered with his Rayographs. In Berlin during the 1920s, Laszlo Moholy-Nagy followed suit with what we now refer to as photograms. The contributions of these three image makers helped to perfect and reestablish the photogram in the 20th century.

What to Print On
Photograms can be made on any type of light-sensitive material. Black-and-white paper is a good place to begin experimentation. You can then move on to color paper and other materials such as cloth. Black-and-white paper is convenient and familiar, and it can be handled under normal safelight conditions. This makes it easier to arrange the objects in the composition.

Careful consideration must be given to the choice of objects used in making a photogram. The selection of materials is limitless. Go beyond the hackneyed approach of taking some coins and keys out of your pocket or purse.

Consider using natural objects such as feathers, flowers, grass, leaves, plants, rocks, and sand. Try putting raw eggs or oil in a zip-lock bag to make fluid compositions. Objects such as glass and stencils offer additional avenues to pursue. If you do not find what you need, make it yourself. Start simply, and as you master the working technique, increase the complexity of the arrangements. Ink applied on a thin piece of glass or acetate and then overlaid on the paper and exposed can widen your field of ideas. Also try combining natural, human-made, homemade, opaque, translucent, and transparent objects with ink to form a composition.

Exposure Methods

Although the easiest way to make an exposure is by using the enlarger or room light as a source, it also offers the least in terms of visual variety in the final print. To increase the range of visual effects, use another source of exposure, such as an electronic flash or a small desk light with a flexible neck. Using a fractional power setting on the flash or very low wattage bulbs (15 watts) will produce longer exposure times and thus provide more opportunity for manipulation. Fluorescent tubes will deliver a more diffused and softer image than a reflector bulb or flash. Using a light source at different angles to the paper will produce a wide range of results. Varying the intensity of the light or the distance of the light from the paper during exposure will help to create a wider range of tonality in the final print.

Another method is to use a penlight. Wrap opaque paper around the penlight to act as a crude aperture-control device, thus enabling you to have more precise control over the intensity and direction of the light. The penlight can be used like a drawing instrument to emphasize specific areas of exposure. It also may be attached to a string and swung above and around the paper to produce unusual exposure effects.

Rather than making a single exposure from one source, try a series of brief exposures that combine different angles and light sources. Also try moving as well as stationary exposures.

For repeatable results, without ruining the arrangement of objects, place a piece of glass on spacers above the printing surface. The glass should be slightly bigger than the paper being printed. Blocks of wood or 2 1/4-inch film take-up reels can be used for spacers. Arrange the objects on the glass rather than directly on the paper. Define the exact printing area beneath the glass by using tape or a china marker to indicate where the corners of the paper should be positioned. After the objects are composed on the glass, turn off the white light and slide the photographic paper under the glass, lining it up with the corner marks. Before making the exposure, remove the spacers and carefully lower the glass on top of the paper. Be careful not to disturb any of the arranged items. Now expose the paper. If the exposure is made with the glass still up on spacers, the final image will be softer and less sharp.

Basic Steps to Produce a Photogram

You can begin to create a photogram under white light conditions:

1. Put a piece of glass, a little larger than the paper being printed on, up on spacers.
2. Define the exact printing area under the glass by making marks with tape or a grease marker to indicate where the corners of the paper should be placed.
3. Use your collection of source materials to create a composition on the glass itself.

Now continue the process under safelight conditions:

4. Place the light-sensitive material under the glass, lining it up with the previously marked corner positions.
5. Carefully lower the glass from the spacers.

6. Expose the paper. (A working exposure range can be determined by making a test strip. Place a piece of unexposed paper under the glass. Hold or place the light source at the distance it will be used to make the exposure. Make a series of three- to five-second exposures, just as you would when making a regular print. Process the paper and select the desired time and density combination.)

7. Process following normal procedures.

Photogram Combinations

The color of the completed image can be changed through toning (see Chapter 10). After the print has dried, additional alterations are possible by drawing or painting on the image. Photograms can be produced on color negative and positive materials. They also can be combined with other photographic methods. For instance, try combining a camera-made image with a cameraless one. Try rephotographing the photogram and combining it with another cameraless image. Magazine pictures also can be combined with other cameraless materials. Remember, magazines are a print-through technique, and both sides of the page will be visible.

Experimentation with the choice of objects, sources of exposure, different types of light-sensitive materials, and postdarkroom techniques is necessary to discover the possibilities photograms have to offer.

Cliché-Verre

Cliché-verre, drawing on glass, is another cameraless method used to produce a photographic image. The technique was invented by three English artists and engravers, John and William Havell and J.T. Wilmore. They displayed prints from their process in March 1839, making it one of the earliest supplemental methods to be derived from the invention of photography. In the original process, an opaque varnish was applied to a piece of glass and allowed to dry. Then a needle was used to etch an image through the varnish. The etched piece of glass was used as a negative and contact printed onto light-sensitive paper to make a repeatable image.

In the early 1850s, Adalbert Cuvelier modified the process by etching on glass collodion plates that were intentionally fogged by light. Cuvelier introduced his method to Jean-Baptiste Corot, who used it as a means of produc-

Figure 13.2 Using one of the alternative cliché-verre methods, Feldstein substituted sheet film in place of a glass support. He developed 4 x 5" film in Dektol under white light until it was completely black. Then he made the image by scratching, etching, cutting, tearing, and sanding the film. When the work on the film was complete, he put it into an enlarger to make a large-scale print.

© Peter Feldstein. "#11-88," 1988. Gelatin silver print. 30 x 40".

ing fast and inexpensive editions of monochrome prints. Corot's success with cliché-verre caused many other artists of the French Barbizon School to follow suit. Thus the 1850s marked this process's high point in popularity.

There was only sporadic interest in cliché-verre during the first six decades of the 20th century. Experiments were carried out by Man Ray, Laszlo Moholy-Nagy, Francis Bruggiere, Henry Holmes Smith, and Frederick Sommer. In the United States, the process experienced a small revival during the late 1960s. Since then only a few image makers have used it, making it ripe for new exploration.

Making a Cliché-Verre

Obtain a piece of clear glass a little larger than the size of the final print (8 x 10" is a good minimum size; anything smaller makes it difficult to see what is being etched on the glass). Paint the glass with an opaque paint or varnish. Matte black spray paint also can be used. After the paint has dried, use a stylus (a sharp, pointed instrument such as an X-Acto knife, a heavy needle, a razor blade, or even a piece of rock or bone) to etch through the painted coating to the clear glass.

When the etching is finished, bring the glass into the darkroom. Under safelight conditions, lay it on top of a piece of unexposed black-and-white photographic paper. Make a print following normal working methods. As in photograms, try using different sources of light at a variety of angles to alter the look of the final image. The thickness of the glass will influence the clarity and sharpness of the final print. Thinner glass gives a sharper image. Generally, glass provides the smoothest and most concise line quality of any of the support materials.

Alternative Method 1: Color

Traditionally, cliché-verre was a black-and-white technique, but color paper may be used. By dialing in various color filter packs, you can produce a wide variety of color effects. Try using different filter packs in one print and varying the type of light used for making the exposure.

Alternative Method 2: Paint Substitutes

Other media besides paint and varnish can be used to opaque the glass. One method is to "smoke" the glass by holding it over the chimney of a lighted kerosene lamp. Frederick Sommer used a smoked-glass technique very effectively in the 1960s. Henry Holmes Smith poured various syrups on glass, then photographed them and made dye-transfer color prints from the camera images. Opaque and translucent inks can be applied instead of paint, and printer's inks may be rolled onto the support surface.

Alternative Method 3: Glass Substitutes

Sheet film that has been exposed to white light and developed to its maximum density can be used in place of the opaque glass support. Film has the advantage of not being breakable and can also be put in the enlarger, so cliché-verre prints can be produced in various sizes. Generally, etching sheet film will produce a rougher and more ragged line quality than that achieved from a piece of etched painted glass. Acetate also can be used in place of glass or film. It can be purchased already opaque, or it may be painted or inked.

Combining Methods

Here are some additional combinations to consider:

- Scratch directly into the emulsion of a camera-made negative and then make a print.
- Combine the cliché-verre with a camera-made negative.
- Use ink and scratching with a camera-made image.

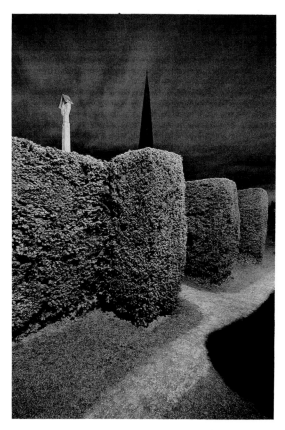

Figure 13.3 By taking advantage of camera vision, it is possible for the photographer to record a subject in a way not visible to the human eye. To make this extended time exposure (about 10 minutes at f-11), Kenna mounted his 35mm camera, equipped with a 17mm lens, on a tripod. The long exposure introduces a sense of passing time and directional movement not found in a conventional photograph. The print was toned with sepia and selenium to add to the mood of mystery and create visual contrast.

© Michael Kenna. "Painswick Graveyard, Gloucester-shire, England," 1987. Gelatin silver print. 6 x 9".

- Combine a cliché-verre with a photogram.
- Do not opaque the glass or acetate completely. Etch only the opaque portion and use the remaining clear area to incorporate a camera image or photogram.
- Collect images from newspapers and magazines. Under safelight conditions, position them directly on top of the light-sensitive material, cover it with glass, and make an exposure. Remember, they will be reversed, and both sides of the image will print. Try opaquing and etching part of the glass in concert with this method.
- Use a liquid emulsion such as Liquid Light to produce a cliché-verre on other porous materials such as fabric or clay.

Additional Information

Glassman, Elizabeth, and Marilyn F. Symmes. *Cliché-verre: Hand-Drawn, Light-Painted, A Survey of the Medium from 1839 to the Present.* Detroit: Detroit Institute of Arts, 1980.

Extended Camera Exposures

When the majority of people begin to undertake photography, they have the "1/125 second mentality." They believe it is the photographer's job to capture the subject by freezing it and removing it from the flow of time. By simply extending the amount of time the camera's shutter is open, however, an entirely new range of images can come into existence. This additional time also can provide an opportunity for the photographer to interact with the subject.

Equipment

You need a camera with a B (bulb) or T (time) setting to make extended time exposures. With the B setting, you hold the shutter in the open position for the entire exposure. With the T setting, you press the shutter release once to open the shutter and again at the end of the exposure to close it. The camera is usually attached to a sturdy tripod. The shutter can be fired by means of a cable release with a locking set screw, which permits hands-off exposures. This reduces the chances of blurred images due to camera movement. A sensitive hand-held exposure meter can be useful because some built-in camera meters do not read available darkness with accuracy.

For maximum steadiness, use a sturdy tripod and do not raise the center column any more than is necessary. A heavy weight can be hung from the center column as a ballast. Sandbagging the legs of the tripod also makes it less prone to movement. Close the shutter if the camera is shaken and resume the exposure after the disturbance has passed.

Acting as a Shutter

Hold a piece of black matte cardboard close to the front of the lens. When you are ready to end the exposure, place the cardboard in front of the lens and then close the shutter (using a cable release) to help reduce recording any camera jiggle on the film. This is important when using a single lens reflex (SLR) camera body whose mirror flips back down at the end of the exposure. This technique also can be used to permit changes in aperture and focus during the exposure. If the camera should be jarred during any of these procedures, allow it to settle down before removing the cardboard from in front of the lens and continuing the exposure.

Adjusting the Aperture

Varying the length of exposure time drastically affects the final outcome of the image. Opening the lens to a wide aperture diminishes the depth of field and delivers the shortest exposure time. Closing down the lens to a small aperture increases the depth of field and gives longer exposures. Closing down

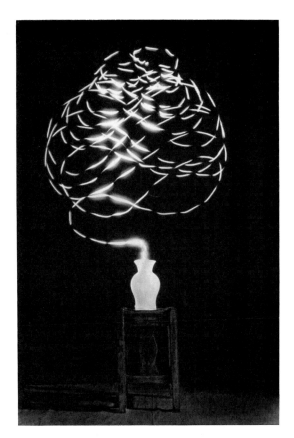

Figure 13.4 To make this light drawing, Lebe worked in a darkened room (the ambient light was below the film's sensitivity threshold) and wore dark clothing. The camera, mounted on a tripod, was set to B and left open as Lebe walked around using a small flashlight to make the exposure. When this was done, the subject was exposed with a quartz photolight. The resulting print was painted with watercolors. This series was made after the artist lost several people to the AIDS epidemic. What the photographer first thought were frivolous pictures came to express his experience of AIDS and death. The light became a life-affirming spirit, while the vase represented the body or a funeral urn.

© David Lebe. "Scribble, # 19," 1987. Gelatin silver print with watercolor. 20 x 16". Original in color.

the lens also allows for changes in focus and aperture. The extended exposure time permits you to work with additional sources of light, such as a strobe or flashlight, during the course of a single exposure.

Where to Start

Begin with a negative film having an ISO of about 100. Stop the lens down three f-stops from its maximum aperture. Bracket all the exposures (one f-stop under and up to three f-stops over in full f-stop increments). Keep a written record to compare with the results so more accurate exposures can be obtained with less bracketing in the future. Bracketing can always be useful, as the different lengths of time affect how the scene is recorded. Bracketing also is helpful in learning how to compensate for probable reciprocity failure, which is likely to accompany long exposures.

Reciprocity failure occurs with very brief or very long exposures. Each film has its own reciprocity failure characteristics, losing effective speed at different exposure levels and at different rates. A typical negative film of ISO 100 might need one-third f-stop more exposure if the indicated exposure is 1 second, one-half f-stop more time at 10 seconds, and one full f-stop at 100 seconds. This correction can be made by using either the lens aperture or shutter speed control. With color film, reciprocity failure also produces a shift in the color balance. For exact times and filter corrections of specific films, consult the manufacturer's reciprocity failure guide.

Most of the latest cameras rely on battery power to operate their shutters. Shooting a 36-exposure roll with minute-long times can drain a battery's power (button cells are more susceptible than AA alkalines or 6-volt lithium cells). Some of these electronic cameras offer a mechanical B setting. If you are not sure whether your camera has this feature, set the shutter to B, remove the batteries, depress the shutter release, and see if the shutter opens. If the camera does not have a mechanical B setting, take a fresh set of backup batteries, just in case the ones in the camera fail during the session.

Using Neutral Density Filters

When we contemplate long exposures, we tend to think of low-light situations, such as early evening, night, or inclement weather. One way to extend the amount of exposure time in any situation is to use a neutral density (ND) filter. An ND filter blocks equal amounts of all the visible wavelengths of white light. Such filters are available in various strengths, which will reduce the amount of light reaching the film by one, two, or four f-stops. ND filters may be used in tandem (one attached to the other) to reduce the intensity of the light even further.

Flash/Flashlight Techniques

A flash can be used to illuminate parts of a scene. Large areas can be "painted" with many flash exposures. With the camera on a tripod and the lens open, a person dressed in dark clothes can walk within the scene and fire the flash to illuminate specific items or to light a large space. A flash also can be combined with other techniques. For instance, you can focus on one area of a scene and illuminate it with a flash, then shift the focus to another area in the composition and use the flash to light it. Colored gels can be used to alter the color relationships within a scene.

A flashlight also may be used to illuminate the subject. Start with a subject in a darkened room. Put the camera on a tripod and set the aperture to f-8 or f-11. Use the B or T setting to open the shutter. Begin painting the subject with the flashlight, using a broad, sweeping motion. Do not point the light into the camera's lens. When you are done painting, close the shutter.

As you gain experience, you will be ready to tackle more complicated situations, such as working outside at night. When doing this, wear dark,

nonreflective clothes so you may walk around within the scene without being recorded on film. Since it is impossible to know exactly what the final effect will be, make a series of exposures varying the intensity of the light and the type of hand gestures used in applying it. Some gestures may be smooth and continuous; others may be short and choppy. Try dancing around, running, hopping, jumping, or waving with the light. You can have fun experimenting.

Postcamera Techniques

The traditional photographic concepts of time, space, and motion can be altered in the darkroom as well as in the camera.

Painting the Print with Light

You can re-expose the light-sensitive printing material with a controlled source of light after the initial print is exposed or while it is developing. This can be achieved with a small penlight. Wrap a piece of opaque paper around the penlight so it extends a few inches beyond the body of the light source. Secure it to the penlight body with tape. This paper blinder will act as an aperture to control the amount of light. Pinch the open end of the paper together to control the intensity and shape of the light source. Fiber optics also can be attached to the end of the penlight for tighter control over the light.

Working Procedure Correctly expose the image on black-and-white paper. Place a red filter beneath the enlarging lens. Since black-and-white paper is not sensitive to red light, the red filter enables you to turn on the enlarger and see the projected image without affecting the paper. Open the lens to its maximum aperture. Turn on the enlarger and project through the red filter. This allows you to see where to draw with the penlight. Begin drawing with the light. You can cover specific areas of the print with opaque materials to prevent re-exposure.

It is also possible to draw with the light as the image begins to appear in the developer. This can produce a grayer line quality or a partial Sabattier effect.

Moving the Fine Focus

If you move the fine-focus control on the enlarger during the exposure, the image will expand and/or contract. Start by giving the print two-thirds of its correct exposure. Then begin to move the fine-focus control and give the

Figure 13.5 Penlights, with aperture control devices in front of the lens, were used to draw with light on the photographic paper. To create print density in time and space, various negatives were placed in different enlargers. The paper, with the latent light-drawn image, was placed under each enlarger and moved around as an exposure was made. This work was produced because the artist's friend and model was dying, and she wanted to delight in her eternally but also to let her go.

© Rosalind-Kimball Moulton. "Light Drawing for Susie," 1987. Gelatin silver print. 11 x 28".

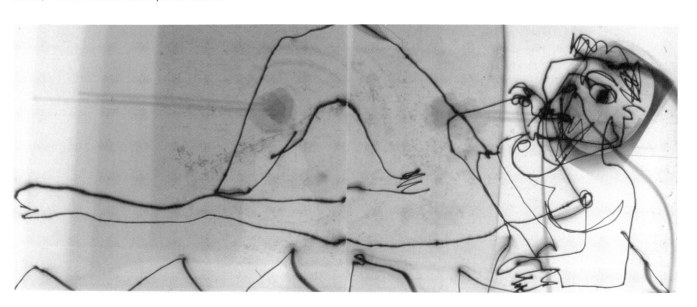

print the remaining one-third of its time. For example, if the normal exposure time is 12 seconds, give the print its first exposure of 8 seconds and the remaining 4 seconds while moving the fine focus. It may be necessary to stop down the lens and increase the overall exposure so there is more time available to manipulate the fine-focus control.

The final outcome is determined by the following:

- The ratio of the normal exposure to the moving exposure
- The speed at which the fine focus is moved
- How long the moving exposure is left at any one point
- Whether the fine focus is used to expand or contract the image
- When the moving exposure is made (Different effects will be produced depending on whether the fine focus is moved before, in the middle of, or at the end of the normal exposure.)

Multiple-Exposure Methods

Multiple exposures can be carried out in the camera or in the darkroom.

Multiple Exposures in the Camera

To make more than a single exposure in the camera on one piece of film, begin with a controlled situation having a dark background. You must use a camera that has a double-exposure capability (see the camera's manual for specific instructions on how to carry out this procedure). Use one source of illumination to light the subject. Put the camera on a tripod, focus, and then figure the exposure for each frame based on the total number of exposures planned for that frame. Generally, the individual exposures are determined by dividing the overall exposure time by the total number of exposures. For instance, if the overall exposure for the scene is f-8 at 1/60 second, the time for two exposures on one frame would be f-8 at 1/125 second each. This tends to work well if the illuminated subject(s) overlap. If there is no overlap and a dark background is used, the correct exposure would be f-8 at 1/60 second for each exposure. Be prepared to do some testing. To speed up the testing process, try using Polaroid materials (see Chapter 7).

Variations You can change the amount of time given to the separate exposures within each frame by altering the f-stop or shutter speed. This can produce images of varying intensities and degrees of motion within the composition. Changing the f-stop will introduce differences in the amount of depth of field from one exposure to the next. Altering the shutter speed can produce both blurred and sharp images in a single frame. Moving objects around within the composition can create a ghostly half presence in the picture. Altering the position of the camera can help you avoid building up the image on one place on the film. Start simply, bracket your exposures, and work your way into more complex situations.

Using a Masking Filter A masking filter, which exposes only half the frame at a time, can be used to make a single image from two separate halves. You can buy this filter or make it by cutting a semicircular piece of opaque material to fit into a series-type filter holder designed for the size of the lens being used.

The following is a basic guide for using a masking filter with an SLR camera.

1. Place the masking filter on the camera lens. Compose and normally expose half the frame.

2. Wind the shutter without advancing the film.

Figure 13.6 Northrup's in-camera multiple exposures were made with a homemade mask placed in front of the lens. The mask has "doors" that can be opened and closed for individual exposures. Colored flashes were used to create image luminosity and a color scheme. The fragmentation of the objects plays with a cubist sense of time and space.

© Michael Northrup. "Nude Descending a Staircase," 1988. Chromogenic color print. 16 × 20". Original in color.

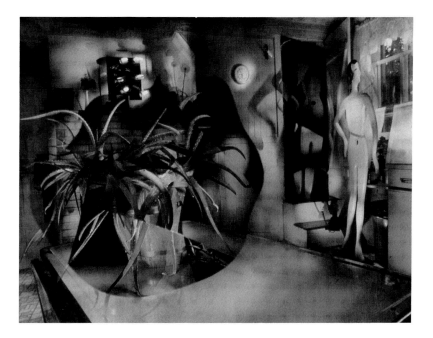

3. Rotate the masking filter so the first half of the image that was exposed is not masked off.
4. With the second half of the frame now in view, compose and expose the second half normally.
5. After this second exposure, advance the film to the next frame.

Generally, allow each image to cross the centerline of the frame (mask) and come about one-third of the way into the blocked area. This can help make the blend line less noticeable. The major problem with this technique is that it is often easy to see the line where the two images meet. Extra care in dodging and burning when making the print can make this less noticeable.

An intriguing variation is to make a mask that has a number of doors, each of which can be opened for individual exposure. These doors may be of different shapes and sizes. The composition can be rearranged and relighted for each exposure (see Figure 13.6).

Multiple Exposure in the Darkroom

There are a variety of ways to accomplish multiple exposure in the darkroom. The simplest method of altering the perception of time and space within a composition involves exposing a single negative more than once on a piece of light-sensitive material. There are many variations on this procedure.

- Enlarge or reduce the image each time a new exposure is made. Allow the exposures to overlap and intermingle to form new images within the image.
- Use different exposure times to create variety in image density.
- Move the fine-focus control during some of the exposures.
- Print only selected portions of the negative.
- Combine this with other techniques such as cliché-verre or photograms.
- Sandwich the negative with other negatives or with transparent materials.
- Combine the negative with a positive (slide) image.
- Print from more than one negative.

Combination Printing Combination printing occurs when two or more negatives are printed on a single piece of light-sensitive material to make the

final image. Some people believe that combination printing is a contemporary invention, but it was originally used with the wet collodion process in the mid-1850s to overcome the slowness of the film's emulsion and its inability to record certain parts of the spectrum. The technique was made popular in England by Oscar Rejlander and Henry Peach Robinson, reaching its peak in the 1880s. As technical improvements such as panchromatic emulsions and flexible roll film began to appear, combination printing was no longer necessary, and its practice rapidly declined. The process experienced a major rebirth in the 1960s with the images and teaching of Jerry Uelsmann. He used this technique in a surrealistic manner to juxtapose objects for which there was no correlation in the ordinary world (see Figure 13.7).

Combination printing can be carried out by switching negatives in a single enlarger or by moving the light-sensitive material from one enlarger and easel to another, each having been set up to project a different image. If more than one enlarger is available, most people find the second method easier to use.

Multi-Enlarger Combination Printing A simple combination print can be made by blending two images, each of which is set up for projection in a different enlarger and easel. This can be accomplished by following these guidelines.

1. Look through your contact sheets and find two images to combine. In the beginning, it is helpful to select images that have a clear horizontal or vertical dividing line. This will simplify the blending process.
2. Place each image in a different enlarger.
3. Size and focus the images. Allow them to overlap slightly.
4. Put a piece of plain white paper in the first easel. Use a marker to indicate the placement of the major objects and where the blending line will be.
5. Move this paper to the second easel and line up the second image and blending line with the indicated marks.
6. Make a test strip to determine the correct exposure for each enlarger.
7. Place the light-sensitive material in the first enlarger and make the exposure, using an opaque board to block the exposure around the blending line. Keep the board moving and allow some of the exposure to cross the blending line so there is no visible joining line.
8. Transfer the light-sensitive material to the second easel. Expose the second negative, using the opaque board in the same manner as in step 7 to block the first exposure.
9. Expect to carry out this procedure a number of times until you master moving the board to get a seamless blend. Patience and craftsmanship will be necessary to successfully create this illusion. "Fantasy abandoned by reason produces impossible monsters; united with her, she is the mother of the arts and the origin of their marvels" (Goya).

Opaque Printing Masks Printing masks can be used to block exposure to different areas of the light-sensitive material. The masks must be carefully cut to avoid making an outline around each area where the exposure was blocked.

A multiple opaque mask can be used with a single negative. In this case, a mask is made the same size as the final print. The mask is cut into various shapes corresponding to those in the image. One section of the mask is removed, and an exposure is made. This section is then replaced, and another is removed and exposed. The process is continued until all the sections have received exposure. The amount of exposure can be varied from section to section to create different density effects. Numbering the sections can help you keep track of what you have done.

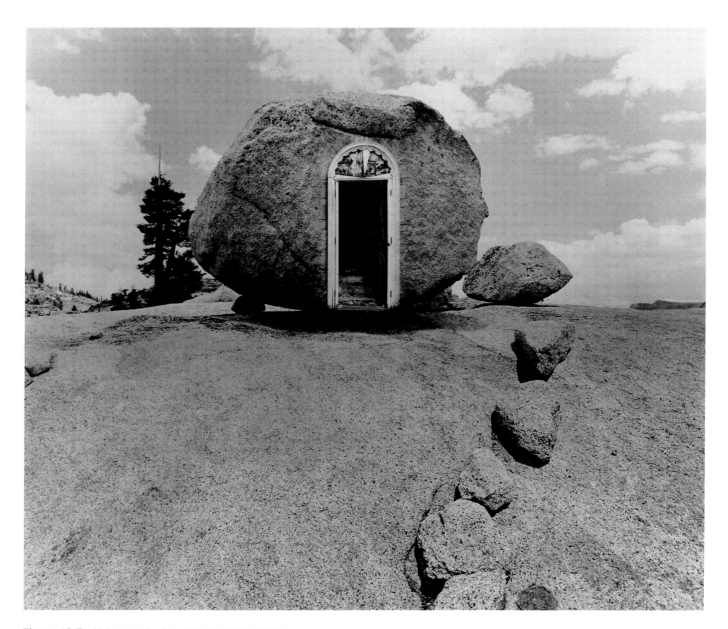

Figure 13.7 Uelsmann is the contemporary master of the multi-enlarger method of combination printing. Before entering the darkroom, he ponders his contact sheets, which make up his visual diary of things seen and experienced with the camera. This helps him to seek out fresh and innovative juxtapositions that expand the possibilities of the initial subject matter. He attempts to synthesize and reconstruct images to challenge the inherent believability of the photograph. All the information is there, yet the mystery remains. Uelsmann says that his greatest joy comes from amazing himself.

© Jerry N. Uelsmann. "Untitled," 1986. Gelatin silver print. 16 x 20". Courtesy of The Witkin Gallery, New York.

Fabrication: Making Things Happen for the Camera

The original impetus for photography was to fulfill the need for a practical method of capturing images from the visible world. Throughout photography's first 150 years, pictures were primarily of people and places. Many current image makers want to expand the range of photography to comment on internal realities.

One of the means photographers have used to express their inner concerns is *fabrication* (see front cover). In the photographic sense, fabrication is the creation of a new reality, one that cannot be found in the visible world. To accomplish this goal, the photographer constructs, devises, or invents an assemblage of materials. The techniques and methods used often explore and question the nature of photography and how it is used. This type of work forces the photographer and the viewer to become more aware of the artificiality of all photographic reality by posing the following questions: What makes up reality? What is a photograph? Why is appearance constantly taken

Figure 13.8 Brown constructs an environment that corresponds exactly to a small snapshot found someplace within the work. As one walks around the piece, the image begins to disintegrate spatially in a manner analogous to the way a photographed event dissolves in time. By repositioning himself or herself correctly, the viewer can again perceive the coherent image. The painted figures are intended to form and dissolve, suggesting the idea of emerging and fading memories. The interaction between the installation and the viewer presents the experience of watching an image come together, cohere, and fall apart again.

© Gillian Brown. "Untitled," 1986–87. Installation: oil painting on staircase, floor, walls, and doorway with gelatin silver print on table. 15 x 7 x 8'. Original in color.

for reality? Where and how does a photograph obtain its meaning? Do our representations correspond to reality? Could the world be different from the way we represent it?

In *Connections to the World: The Basic Concepts of Philosophy*, Arthur Danto states, "Philosophy is the effort to understand the relationships between subjects, representations and reality." The techniques photographers use to probe these questions and relationships include the following:

- Constructing environments to reflect ambitions, dreams, fantasies, and social commentaries
- Combining images and text by using typesetting, press type, and handwritten messages that appear on or around the photograph (see Figure 13.9)
- Creating three-dimensional photographic images by means such as painting emulsions on a variety of surfaces, cutting up images and hanging them from objects, sewing and stuffing cloth that has been treated with a photo-sensitive emulsion, or making freestanding floor screens based on classic Oriental models (see Figure 13.10)

Another aspect of fabrication involves departing from the traditional use of only a single image to convey a message. Cinematic seeing presents a series of images in which each frame modifies the sense of photographic time and space. The interaction between frames delivers additional information, thus enabling members of the audience to witness a different point of view or a new episode that enhances their understanding of the subject. This technique can be accomplished directly in the camera using previsualization methods or created from prints using postdarkroom procedures (see Figure 13.11). Some methods that have been used to explore cinematic image making follow.

- The sequence is a group of images designed to function as a group rather than individually. Typically, sequences tell a story, present numerous points of view, and provide information over an extended visual time period. Sequences can be made in the camera or put together using prints (see Figure 13.12).

- The grid, an evenly spaced grating framework of crossing parallel lines (like a tick-tack-toe board), has been used both at the moment of exposure and during printmaking to enclose and analyze an image. The grid breaks down an image into separate units while still containing it as a unified form (see Figure 13.13).
- A modified form of the grid involves using a specially constructed easel that has individually hinged doors that may be opened and closed. This permits a single image to be broken down into separate quadrants, each of which can receive different exposure times. The overall effect in a single image can be fractured by light to create separate units within the whole.
- The contact sheet sequence combines aspects of the in-camera sequence and the grid. A scene is visualized in its entirety, but photographed as individual segments. When these separate frames are laid out and contact printed, they create a single unified picture.
- Using joiners, the practice of photographing a scene in individual parts and then fitting these together to form one image, all the images may be printed at the same size or cut into different sizes or shapes and arranged and attached in place.

Composite Variations

The Collage

A photographic collage is produced when cut and torn pieces from one or more photographs are combined on a common support. A photographic collage may include images from magazines and newspapers; a combination of colored paper, wallpaper, and/or fabric; natural materials such as sand, grass, flowers, and leaves; and three-dimensional objects. No attempt is made to deny the fact that the image is an assemblage created from a variety of source materials. It is not rephotographed and is itself the final product (see Figure 13.14).

The Montage

A montage follows the same basic rules as those used in making a collage. The major difference is that the final collection of materials is rephotographed. This means that the end product is transformed back into a photographic print, additional copies of which may be produced. Sometimes the image maker attempts to hide the source of the various images and materials in an effort to present a new, seamless photographic rendition that will make people ask, "How can that be?" Great fun, innovation, and provocation are possible by juxtaposing people, places, and things that would otherwise not be seen together (see Figure 13.15).

Making a Collage or Montage

You will need the following materials to assemble a collage or montage.

- A large collection of source images and materials
- A support print, board, or other material for a base (This background material may be a piece of matte board or a photograph. Generally, photographs having open, uncluttered areas are a good starting point. The support should be large enough to allow plenty of room within which you can maneuver; 16 x 20" is usually a good size to begin with.)
- Sharp scissors
- A sharp X-Acto knife (a number 11 blade is good)
- Adhesive—glue or dry-mount tissue (if permanence is a concern, use an archival glue)
- Spotting colors and a fine sable brush (number 0)
- Fine-tip felt pens in various shades of gray and black
- A tacking iron and dry-mount press (if dry mounting is planned)

In 1971, when I was forty, I found an ad in the *Reader* for yoga classes. I gave up smoking, became a vegetarian and, from 1974 until 1983, I spent between three and six months of each year with the Hindu Swami, on Paradise Island. I learned that I had the right to remain healthy. Through yoga I was able to cleanse my soul.

Four months ago, my thirty-six year old daughter collapsed and died. The autopsy said pneumonia but I'm not sure. I have great guilt about her death. I wanted her to appreciate the change in my life, but I guess if it's your mother's, it's no good. Or maybe she thought, if I had so much strength at my age, she didn't have to try so hard to take care of herself.

I'd go berserk if I didn't know that there is a cosmic, electrical process of spark and burn and fizzle. We are all auras of light that glow and go out and are rekindled. I was the vessel for my daughter to get rid of her short, unhappy life. I'd like to put everything away from me and just sit at the Swami's feet and take in his wisdom. But I am my two grandchildren's legacy. In order to help them, I must be both spiritual and materialistic. I just try to keep that ball of light around me.

Figure 13.9 Kromer Shapiro has combined a photograph of her subject with written text supplied by the subject. The text is printed on acid-free paper that is glued to a board, and the photograph is attached to the paper The success of image-text combinations depends on being able to strike a balance between the two types of symbols. The danger is that instead of working together as a unit, one of the parts will overpower the other and make it seem weak and unnecessary. Each part of the image-text blend should complement and strengthen the other. Here the juxtaposition allows you to see the similarities and differences between how the woman presents herself visually and her inner concerns.

© Sherry Kromer Shapiro. "GMcC," 1986. Gelatin silver print attached to paper. 18 x 12".

Figure 13.10 "The Tell" is a collaborative, nonprofit site-specific public mural project consisting of more than 80,000 donated photographs of all type and sizes varying from 2 x 3" to 11 x 14". The project was conceived, designed, and executed by Jerry Burchfield and Mark Chamberlain in collaboration with hundreds of volunteers. "The Tell" celebrates the 150th anniversary of the invention of photography (the public unveiling of the daguerreotype) and uses photographs as contemporary artifacts to reflect upon our culture.

© Jerry Burchfield and Mark Chamberlain. "The Tell," 1989. All types of photographic processes. 30 x 600'. Photo courtesy of Jerry Burchfield. Original in color.

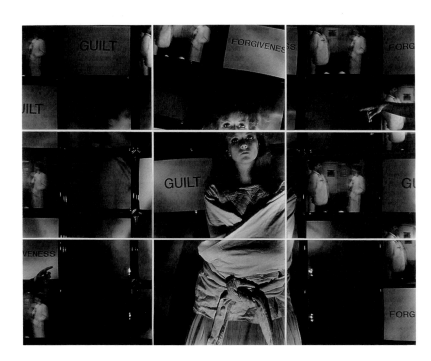

Figure 13.12 Metzker, not satisfied with the single image aesthetic, has experimented with multiple-image constructions. Here the stacked images use the interrelationship of the frames for content interpretation and visual contrast.

© Ray K. Metzker. "Untitled," 1969. Gelatin silver print. 8 x 10". Courtesy of Laurence Miller Gallery, New York.

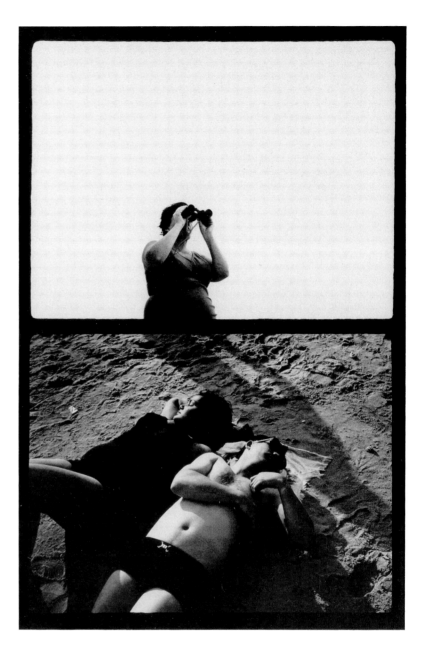

◄

Figure 13.11 Cinematic fabrications use a series of images in which each frame is capable of adding information that can modify the meaning of the entire piece. For this work, the background consists of a bank of video monitors connected to a computer. The images are from a videotape of the soap opera "General Hospital." Once the background images were arranged, the model was photographed on 4 x 5" tungsten film. This negative was divided into nine parts, each printed 20 x 24". The top middle image is from another negative shot during the same setup. The print shows the power of fabricated reality to raise important social and psychological issues that people face in the real world.

© Susan kae Grant. "Triangle," 1987. Chromogenic color print. 60 × 72". Original in color.

Following is a basic working guide for constructing your collage or montage.

1. Spread out all the source materials you are considering using. Do not be stingy.
2. Try a variety of arrangements and juxtapositions on the background support.
3. After you have made a preliminary selection, trim the source materials down to their approximate final size. If you are using dry mounting, tack the dry-mount tissue to the back of each selection so it will adhere properly after final trimming.
4. Trim materials to their final size. For the smoothest finish, use sharp scissors to make long, continuous, beveled cuts. Use the X-Acto knife only when cuts cannot be made with scissors. Cutting with a blade tends to produce a more jagged edge.

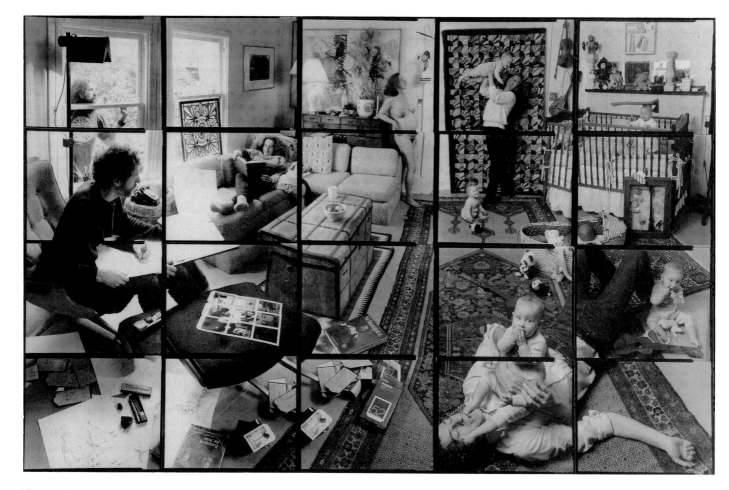

Figure 13.13 In an attempt to overcome his frustration with traditional portraiture's limited point of view, Levy constructed a photographic grid consisting of 20 individual images. Made with a 4 x 5" camera for precision of detail, these images scan the architecture and sense of time in the subject's living or working environment. They are printed together to form the illusion of glancing through a window at a snapshot of an event that may consist of fragmented views made months apart. The images explore and challenge our perceptive process by testing the limits of discontinuity in space and time that our brains will accept in reading an image. The self-reflective elements attest to the collaborative relationship between the photographer and the subject. The final print was made on variable-contrast paper so that each negative could be masked to give the correct contrast and exposure.

© Stu Levy. "Artist's Proof and Consequences or What It's Really Like," 1988. Gelatin silver print. 16 x 25".

5. Using the appropriate gray or black felt-tip pens, color the edges of the trimmed materials so they match each other and the support board. An edge that is too dark will be just as noticeable as one that is white.
6. Attach the trimmed, shaded pieces to the background support with glue or dry-mount tissue.
7. Add shadows with diluted spotting colors if desired.

Copying If you are making a montage, copy the assembled work outside in clear, direct sunlight. Place the work on a clean, flat surface. The sunlight should be striking it at a 30- to 45-degree angle. Photograph the work with a 35mm camera, ideally equipped with a macro lens to provide maximum flatness of field and sharpness. If you do not have access to a macro lens, you can use a 50mm lens instead. It will easily fill the frame of a 16 x 20" piece; even an 11 x 14" work should fill the frame. Stop the lens down to f-8 or f-11 to ensure good depth of field. For maximum detail and minimum grain, use a slow, fine-grain film such as Kodak Technical Pan Film for black-and-white or Kodak Ektar 25 for color. Determine the proper exposure by reading an 18 percent gray card in front of the work. Do not meter directly from the work, or you may get a faulty reading.

You also can copy the work indoors. Tack or tape the piece to a wall. Set up two lights at 45-degree angles to the work. Using a gray card, measure the light from each lamp, making sure each is casting even illumination across the work. Then place the gray card in front of the work and take a meter reading off it with both lights on. For the sharpest results, use a large-

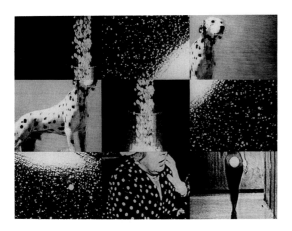

Figure 13.14 Broadcast television was selected as the imagery source of this work. The interaction of the images occurred when Baden made nine 8 x 10" prints and put them together to form a collage. This method allows the artist to comment on how photography can be used in our media culture.

© Karl Baden. "Untitled," 1985. Gelatin silver prints. 24 x 30".

format camera to copy the work. Collages also may be copied on a black-and-white or color electronic copy machine.

Processing Manipulation: Reticulation

Reticulation is the wrinkling of the film emulsion into a weblike pattern or texture. Normally this is viewed as a processing mistake caused by differences in the temperature of the film's developing solutions. In the past, reticulation was not an unusual occurrence. Modern films rarely suffer from this problem because of improvements in emulsion making, such as the use of improved hardeners. It can, however, be purposely induced for visual effect. Reticulation can literally dissolve the camera-based reality and replace it with a manipulated reality in which line, shape, and space are distorted and rearranged on the film's surface.

Reticulation can be accomplished through two basic methods. One way is to create extreme differences in temperature between the processing steps during film development. The other method is to induce it chemically after the film has been developed.

In the first method the film is developed at an elevated temperature (90° F or 32° C), then put in a very cold stop bath followed by a warm fixer. After this, the film is frozen before it is given a final hot wash. Even with these extremes, the hardener built into many contemporary films makes reticulation difficult if not impossible to accomplish.

With the second method, the film is reticulated by chemical means, and you have the advantage of working with normally processed film (even film that is a couple of years old can work). It also enables you to observe and interact directly with the process, stopping the reticulation when you see fit. This method works with most black-and-white films.

Simple Chemical Reticulation

Sodium carbonate can be used to produce simple reticulation. No two films seem to react to it in the same way. Even negatives on the same strip of film can respond differently, making this process highly unpredictable. Kodak's Tri-X is one film that works well with this technique. Use a medium- or large-format negative so that the film can be readily observed during the process.

Figure 13.15 The use of photomontage enables Taylor to express his thoughts, which do not exist to be photographed, in a concrete manner. The finished pieces are purely photographic. Color changes are achieved with selectively applied sepia toner, and drawn lines are added by scratching on the negative. There is no attempt to make a seamless montage. The edges of the prints are torn to allow the viewer to discover and explore the process used to produce the new reality.

© Brian Taylor. "When California Goes," 1985. Gelatin silver prints. 11x14". Original in color.

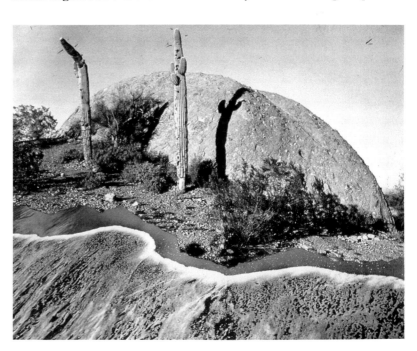

As mentioned earlier, previously processed film may be used. The older the film is, the harder its emulsion surface tends to be, thus increasing the time it takes for reticulation to take place and also limiting its effects. Best results are achieved with freshly processed film.

The following guidelines are provided for chemical reticulation.

1. Start with a completely processed and dried negative.
2. Prepare the reticulation solution by combining 30 grams of sodium carbonate with 500 milliliters of water at 140°F to 150°F (60°C to 65°C). This solution has a useful temperature range of 105°F to 160°F (40°C to 71°C). As the temperature goes down, the action of the solution becomes slower. If the temperature gets too high, it will ruin the film's plastic base. You can maintain the temperature with the use of a hot plate.
3. Place the film directly in the hot solution, which is held in a clear glass jar or a small tray. For easy handling, attach a paper clip through a sprocket hole to individual frames of 35mm film before placing them in a baby food jar filled with solution. Take care not to let the film come in contact with the walls of the jar, or uneven reticulation will result. Some workers prefer the tray process. Tape the film, emulsion side up, to a slightly larger piece of thin Plexiglas or glass and place in a tray. This technique makes observation and manipulation easier, and it provides a solid horizontal support. This method permits extending the time in the solution, which increases the effect and allows other visual distortion such as veiling effects to take place. Veiling is caused by the physical breakdown of the emulsion as it begins to dissolve and fold up. Be careful not to leave the film in the solution too long, or the emulsion will completely slide off its base. You can push the loose emulsion around with a brush or a very thin stream of water to create other effects.
4. When the film is placed in the solution, the protective gelatin layer will dissolve and rise to the surface. Allow the film to remain in the solution for 5 to 20 minutes, with occasional agitation. Reticulation may begin within 45 seconds. The first stages will produce a fine texture pattern. As time passes, the pattern should become larger and more exaggerated. The process may not take as long with 35mm film as with a 6 x 7cm format. This is because the pattern will be more evident when the 35mm film is enlarged to the same size as the 6 x 7cm film. If the process is allowed to go too far, the pattern will become more important than the original subject.
5. When you have obtained the desired result, remove the film from the solution. A pair of tweezers can be helpful when dealing with unattached pieces of film. Wash it in cool running water for 10 minutes, then hang it up to dry.

Water Reticulation

Some films that have not been fixed with an acid hardener can be reticulated in water. Put the freshly processed film, fixed only with a nonhardening fixer, in plain water at 150°F (65°C) and allow it to sit until the water cools to room temperature. This method will produce a much finer, softer pattern than that induced with sodium carbonate.

Masking

Specific areas of a negative can be masked with photographic Maskoid or rubber cement to prevent reticulation. Use a fine brush to apply the mask directly on the emulsion (dull) side of the film and let it dry. Then immerse the film in the reticulating solution. There may be some slight reticulation around the edges of the mask depending on the length of time the film is in the solution. After the film has been washed and dried, you can remove the mask with masking tape or with your finger. Film may be masked, partially reticulated, washed and dried, remasked, and further reticulated to create a variety of patterns within a single image.

Figure 13.16 Working from her collected negative files, Miller combined a variety of images into a single image. Portions of the assembled image are shown in relief, allowing the cast shadows to challenge our normal sense of figure-ground relationships. The assembled image was photographed and printed on black-and-white paper, then hand-colored with oil paints and colored pencils. The hand-coloring allowed the introduction of synthetic color schemes, making the outer reality match that of the imagination.

© Judy Miller. "Desert Couples," 1989. Gelatin silver print with oil paint and colored pencil. 32 x 39". Courtesy of The Afterimage Gallery, Dallas. Original in color.

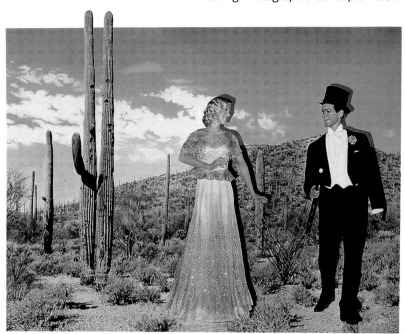

Hand-Coloring

Hand-coloring lets the image maker travel beyond the technical limitations of the photographic process to change the reality of a scene. The worker has more control over the final photograph, as synthetic color can be applied to alter the mood, eliminate the unnecessary, and add space and time that were not present at the moment of exposure. This technique can help bridge the gap between the inner/subjective and outer/objective realities by enabling the image maker to color the external world with his or her imagination.

Materials for Adding Color

A wide array of materials and processes can be used to apply color to a photograph. Some widely used coloring materials include acrylic paint, colored pencils, dyes (both fabric and food), enamel paint, marking pens, Marshall's Photo-Oil Colors, oil paint, photographic retouching colors, photographic toners (see Chapter 10), and watercolors.

Solvent-Based Materials These materials can be divided into four basic groups: lacquer based, oil based, water based, and miscellaneous.

- *Lacquer-based paint* is usually sprayed from a can or Airbrush (see the section on airbrushing later in this chapter).
- *Oil-based materials* are among the most common and easy-to-use coloring agents. Quality artist oil paints can be applied to almost any photographic surface. Before painting, a fine coat of turpentine is generally applied to the print surface with a cotton ball. Marshall Photo-Oils and Pencils are available in complete kits with directions for their application. Oil-based materials produce soft, subtle colors. Blending large areas of color is easy with oils. Since oils are slow drying, you can fix mistakes with cotton and turpentine.
- *Water-based materials,* such as acrylic paint, certain concentrated dye toners such as Edwal, photographic retouching colors, and watercolors, are considered additive coloring agents. They can be applied straight or mixed to form new colors on a palette. Overall coloring agents are considered to be toners and are covered in Chapter 10. Nonacrylic water-based coloring

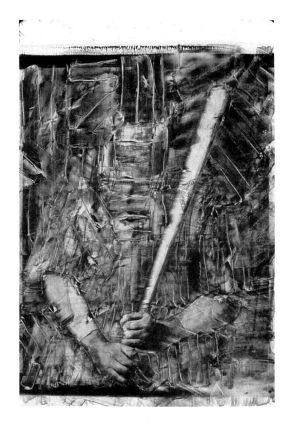

Figure 13.17 Farber uses photography to manipulate information from the real world in such a way that it makes the viewer question what is being seen. Layering is used to create visual ambiguity, tension, and enigmatic surfaces. In this work, the image of Babe Ruth was appropriated and rephotographed on 20 x 24" Polaroid material. The print was selectively masked and painted with a mixture of Rhoplex, gel, and acrylic paints. The masks were then removed, and these areas also were painted.

© Dennis Farber. "Baseball Abstract," 1988. Polaroid with acrylic paint. 20 x 24". Original in color.

agents such as watercolors affect the print surface in the same manner as conventional spotting. The color penetrates the surface and becomes a permanent part of the image. Mistakes cannot be erased as with oils but must be painted over. Consequently, more care, skill, and forethought are required.

You can create both intense and subtle color effects with water-based materials depending on how much water is used to dilute the coloring agent. Since these materials do not sit on the print surface, as do oil-based materials, colors tend to appear brighter, clearer, and more intense. When covering large areas, water-based materials must be applied rapidly and smoothly, or brush strokes will be evident in the final image. Dipping a brush in diluted Photo-Flo or lightly wetting the areas to be colored with a clean cotton ball and fresh water can reduce the likelihood of streaking.

Acrylics are somewhat different from other water-based materials. Acrylics reside on the surface of the print and so tend to appear brighter and more opaque. If these qualities are not problematic, it can be easier to work with acrylics than with watercolors because they are slower to dry. Thus, they can be removed while still wet using cotton and water.

- *Miscellaneous material* refers to unconventional materials, such as coffee or tea, which may be used to add color.

Combining Coloring Agents Coloring agents can be combined, as long as you keep in mind the old adage about oil and water not mixing . Remember that lacquer and oil do not adhere well to water-based materials and that water-based agents do not adhere well to lacquer and oil-based materials.

Permanence The permanence of all additive coloring agents depends on the following factors:

- The keeping properties of the specific coloring agents
- The type and condition of the surface being painted
- The levels of exposure to UV light
- Maintenance of proper display and storage conditions, including moderate temperatures and medium to low relative humidity

General Guidelines for Hand-Coloring
The following guidelines provide a starting point for applying additive colors to a photographic print.

1. Begin with a dry, processed, well-washed print. Many workers prefer a matte surface, but a glossy surface also can be used.
2. Gather together all the materials you will need, including the coloring agents and applicators. Colors can be applied with various sizes of good-quality brushes, Q-Tips, cotton balls, lintless cloth such as Photo-Wipes, or small sponges. A mixing palette, water or another solvent, and white paper on which you can test mixed colors are required. In addition, you need a good-quality light source for your work area.
3. Read all the manufacturer's instructions and follow all safety procedures as outlined in Chapter 3.
4. Start practicing the technique with throwaway prints.
5. The final results depend on a combination of application, print surface, type of coloring agent, temperature, and humidity.

As you become more familiar with the materials and procedures, begin to deviate from the given modes of application. Try hand-coloring on fabric and nonsilver emulsions or combining the procedure with toning and masking. Hand-coloring is a highly individualistic process, so be courageous and ex-

periment. Do not be afraid to make mistakes. The ability to make meaningful photographs often comes through a spiritual instinct that mastery of technique and hours of practice have liberated.

Airbrushing

The airbrush, invented in 1882, is a small spray gun capable of delivering a precise combination of fluid (ink, dye, or paint) and air to a specific surface location. It is a versatile tool for those interested in photographic retouching of a completed image.

Types of Airbrushes

There are three general types of airbrushes: dual-action internal mix, single-action internal mix, and single-action external mix. *Dual action* refers to the way the airbrush is triggered (push the trigger down for air and back for color). This procedure permits the operator to change the line width and alter the value of opaqueness of the fluid without having to stop and make adjustments. For all-around versatility, a dual-action airbrush is a good choice.

When the trigger is depressed on a single-action airbrush, a preset amount of fluid is sprayed. The only way to control the amount sprayed is by turning the needle adjustment screw when the airbrush is not in use. If uniformity of fluid application is critical, a single-action brush is a wise choice.

Internal mix means that the air and fluid are blended inside the head assembly. Internal mixing produces a very smooth and thoroughly atomized fine-dot spray offering the precision and detail usually required for smaller works such as photographs.

External mix means that the air and fluid are mixed outside the airbrush head or fluid assembly. It produces a coarser, larger-dot spray than does internal mixing. External mix brushes are generally used for spraying larger areas.

Head Assemblies

Airbrushes also can have different head assemblies (for internal mix) or fluid assemblies (for external mix) that can be changed depending on the type of line quality desired and the viscosity (thickness) of the fluid being sprayed. There are three basic head types: fine, medium, and heavy. Internal mix as-

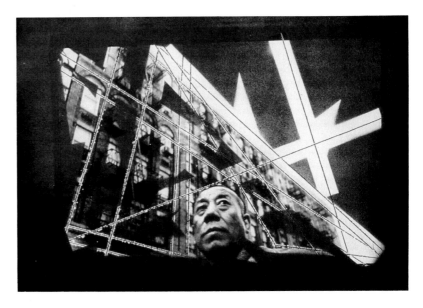

Figure 13.18 In this print, I introduced lines by scratching and cutting the negative from which the print was made. I then cut out masks of various shapes which were placed on the print. I used an airbrush to apply color, change tonality, and eliminate unwanted details in an attempt to blend the camera-recorded scene with my memory of the scene.

© Robert Hirsch. "Vanishing Point," 1986. Gelatin silver print with applied lacquer paint. 16 × 20". Original in color. Courtesy of The Afterimage Gallery, Dallas, Texas.

semblies always provide finer line quality than external fluid assemblies, even when they are equipped with a similar-size head.

A fine head, which has the smallest opening, is used for extra-fine detail work. An internal mix can deliver line quality from the thickness of a pencil line to about 1 inch. An external mix is capable of making a line only as small as about 1/8 inch wide. It is intended to be used with fluids having a low viscosity, such as dyes, inks, gouaches, very thin acrylics, and watercolors.

A medium head is intended for detail work and can produce a line from 1/16 inch for the internal mix or 1/4 inch for the external mix to 1-1/2 inches for both. A medium head will spray about twice the amount of fluid as the fine. It can handle more viscous materials, such as thinned acrylics, hobby-type enamels, and lacquers.

A heavy head has the biggest opening, delivering a spray line of 1/8 inch for the internal, 1/2 inch for the external, and 2 inches for both. Heavy heads spray about four times the amount of fluid as fine heads. They are designed for fluids having a high viscosity, such as acrylics, ceramic glazes, oil paints, and automotive paints.

Fluid Containers

Many airbrushes come equipped with a small cup, 1/16 to 1/8 ounce, for holding the paint. These are too small for larger jobs, so specially designed jars with capacities of 3/4 ounce to 2 ounces can be attached to the airbrush. These extend the spraying range without the user's having to stop to remix the paint or refill the cup.

Selecting the Right Equipment

You should select an airbrush based on its intended application. A dual-action, internal mix, fine-line unit with optional bottle containers is appropriate for most photographic uses. This combination provides the precision and versatility required for most operations involving the airbrushing of photographs.

Air Supply Sources and Accessories

The airbrush requires a steady, clean, and reliable source of dry, pressurized air. This can be obtained from canned air (propellant), such as Badger Propel, or from a compressor. Canned air, available at art supply stores, is convenient and initially less expensive, but it can run out unexpectedly at inopportune times. If airbrushing is going to be more than an occasional activity, you should consider investing in a compressor. Air compressors are available from airbrush manufacturers or at discount hardware and lumber stores. Get one with a regulator that permits adjustment of the air pressure in pounds per square inch (psi). A regulator offering a pressure range of 10 to 100 psi is excellent for airbrushing photographs. The regulator also allows additional control over the intensity of the spray and the pattern it produces.

The airbrush must have a flexible hose running from the source of air to the brush. A lightweight vinyl hose can be used with a canned propellant, but a heavy-duty braided hose should be used with a compressor. A ten-foot hose is recommended, as it provides greater flexibility of movement while spraying.

A filter/extractor can be attached to the compressor to remove moisture and impurities from the air delivered to the brush. This is especially useful in humid climates.

Your Work Area

A drafting table with an adjustable angle top provides an outstanding work surface. The table and the entire work area, including walls and floor, need to be protected from the airbrush spray fallout. Newspapers or drop cloths will do the job.

Prints can be pinned or taped at the corners to the work surface. They also may be attached with double-sided tape on the backside of the print.

Safety

Airbrushing should take place in a well-ventilated area. A work area with an exhaust fan is ideal. Since the spray is extremely fine, you should wear a double-cartridge respirator for protection. Bearded operators may not be completely protected because most respirators do not provide a tight fit over facial hair. Thin fabric masks do not offer adequate protection. Do not eat, drink, or smoke while airbrushing. Avoid putting your fingers in your mouth while working and wash your hands and fingernails thoroughly when you are done. Follow all other safety guidelines provided in Chapter 3.

Basic Airbrush Operation

Most airbrushes have the same basic operating procedures, but read the instruction book that comes with the airbrush for details.

1. Attach the air hose to the air supply (compressor or canned propellant), then connect the air hose to the airbrush.
2. If the air supply is regulated, set it to a beginning operating pressure of 30 psi. The normal working range is 15 to 50 psi.
3. Put the medium (such as paint) into the airbrush jar. The medium needs to be *thin*, about as thick as you would use if you were applying it with a brush. Screw on the jar top with the airbrush adapter and attach the entire unit to the brush.
4. If you are using a compressor, turn it on. Hold the airbrush perpendicular to the work surface. Press the trigger while easing it slightly backward to spray the desired amount of medium. For close-up work, reduce the amount of air pressure. Increasing the air pressure or the distance between the brush and the work will provide a wider spray pattern.
5. For best results, use a constant, steady motion. Start the motion before pressing the trigger. Then press the trigger, keeping the motion steady. Release the trigger when done, continuing to follow through with the motion. Uneven airbrush motion, known as arching, will result in an uneven application of the medium.
6. The most common problem beginners have is runs and sags, which result from holding the airbrush too close to the work surface, holding the brush still or moving it too slowly, or forgetting to release the trigger at the end of the stroke.

Mixing the Medium

A number of premixed, ready-to-use opaque airbrush colors are available from companies such as Badger and Paasche. These are convenient and easy to use but expensive. Mixing your own medium offers the greatest versatility and is the most cost-effective. A good sable brush, number 4 to 7, to mix the medium is desirable. Inexpensive brushes can lose their bristles and clog the airbrush. Most media must be thinned, or they will clog the airbrush. Mixing can be done in the spraying jar. The medium's consistency should tint the brush but not color it solidly. The medium should stick to the sides of the jar but should not thickly color its sides.

Here is a beginning guide to thinning various media:

- 1 part water to 1 part watercolor
- 1 part water to 1 part nonclogging ink
- 7 parts water to 1 part acrylic
- 1 part enamel thinner to 1 part enamel

Note that acrylics dry very rapidly, so spraying needs to be almost continuous, or clogging will result. If you have to stop for a short time, dip the head assembly in a jar of clean water to prevent clogging.

As soon as you have finished with one color, spray clean water or solvent, depending on the medium used, through the airbrush until all the color is out.

Practice

Before attempting to airbrush any completed work, practice operating the brush. Most airbrushes come with instructions containing basic exercises to get you acquainted with how the brush works. If the airbrush does not have these exercises, go to the library and get a book on basic airbrush technique. These exercises can be carried out on scrap paper or board. Once you have mastered these techniques, move on to practicing on unwanted prints. When you have built up your confidence, try your hand at a good print.

Masking

Masks made of paper, board, acetate, or commercial frisket material can be used to control the exact placement of the sprayed medium. Masks may be cut to any shape or pattern. Handmade masks are held in place with tape or a weight so the atomized medium does not get under the masked areas. Whenever you are using a mask, spray over the edge of it, not under it, to avoid underspray. Positive and reverse stencils can be used to repeat designs or letters.

Cleanup and Maintenance

When you have completed the work, clean the airbrush and paint jar thoroughly with water or solvent. The majority of airbrush problems are caused by failure to clean all the equipment properly. Follow the instruction guide for specific details on how to clean and maintain your airbrush.

Canned Spray Paint

Would you like to get a rough idea of what you can do with an airbrush? Experiment with different-colored canned spray paint. Follow all the general airbrush working and safety procedures. Canned spray paint provides a much wider field of spray and is not suggested for fine detail work. Canned spray paint and an airbrush can be combined. Just follow the guidelines provided in this section for combining media.

Since airbrushing is a postdarkroom activity, it can be used with any photographic printmaking method. To master airbrushing, you must be willing to perform the task repeatedly. Opportunity abounds with the airbrush. See what you can do.

Additional Information

Following are some of the major airbrush manufacturers:

Badger Air-Brush Company, 9128 West Belmont Avenue, Franklin Park, IL 60131 (equipment, paint, supplies, educational books, and videos).
Binks Manufacturing Company, 9201 West Belmont Avenue, Franklin Park, IL 60131 (airbrush equipment and supplies).
Paasche Airbrush Company, 7440 West Lawrence Avenue, Harwood Heights, IL 60656 (equipment, paint, supplies, and books).

Transfer Printing

Transfer printing is a process permitting a previously printed image to be transferred to another receiving surface. For most of us, the last time we thought about transfers was when we did a magazine rubbing in kindergarten. With image appropriation, the buzzword of the Postmodernistic 1980s, basic transfer techniques have experienced a revival. Transfers offer a fast, easy, and fun way to work with images from other sources such as magazines. Transfers are also called lifts.

Magazine Transfers

Magazine rubbing is a good introduction to the basic transfer printing process. The following is a step-by-step guide to the method.

1. Collect images from slick (clay-coated casein paper stock) magazines such as *Newsweek* or *Time*. Magazine covers may be used if they are not heavily varnished. Newspaper is not clay coated and does not deliver a good transfer.

2. Decide on the image and the support material to which it will be transferred. Almost any smooth, absorbent material can be used. Smooth paper provides the most consistent transfer. Textured paper delivers less detail. Cloth also can be used, with a fine, smooth, tightly woven material delivering the most detail.

3. Select a solvent. Two basic types of solvent are available—liquid and gel. The most commonly used liquid ones are acetone, lighter fluid, mineral spirits, rubber cement thinner, and turpentine. These evaporate rapidly, making it necessary to recoat the image several times during the transfer process. These solvents vary in their ability to dissolve inks. Finding one that works with a specific type of paper requires some experimentation.

Transparent gels are used for diluting oil-based silk-screen ink and are generally very effective in the transfer process. Gels penetrate the paper and readily loosen the print image. They evaporate more slowly than liquid solvents, so fewer applications are required. Oil-based transparent silk-screen bases are available at art and printer supply stores.

All these solvents contain volatile ingredients and can pose a potential health hazard. Read the warning labels with each product. Work only in a well-ventilated area and follow all general safety rules.

4. Tape together along one edge the receiving support material (face up) and the magazine image (face down). Place them on a hard, flat surface. Carefully fold back the magazine image from the support material and generously apply the solvent to the face of the image. Quickly lay the coated magazine image back in contact with the support base. Applying hard and even pressure to the magazine image, use a blunt-edged tool such as a butter knife, a clay burnishing tool, a metal or wooden spoon, or a soft lead pencil to transfer the dissolved ink to the support. Each tool will yield a different result. Try a combination of tools for a variety of effects. Periodically check the results by lifting one corner of the magazine image up and inspecting the receiving base. When the magazine image dries and will not transfer any more ink, add more solvent to the image. Repeat this process until the image has been transferred. Be patient. This procedure can take up to 15 minutes.

5. The transfer will be reversed (like a mirror image), so all lettering will be backwards. There also will be a shift in color, as the order in which the inks were applied in the printing process also is reversed. You can transfer more than one image to a single receiving surface, creating a collage of images.

Copy Machine Transfers

An original slide or print can be reproduced using an electrostatic copy machine, with the resulting copy image later being transferred onto another surface.

When working from black-and-white copies, acetone or lacquer thinner is a good solvent for transferring the image. To make the transfer, saturate a small part of the copy with solvent. Rapidly lay the copy image, face down, on the receiving surface and rub the back with a stiff piece of cloth such as raw canvas. Some copy machines make copies that transfer better than others. If the image does not transfer totally, try using a different copy machine.

To make transfers from color copies, follow the same procedure but use the transparent silk-screen base (as mentioned in relation to magazine transfers) as the solvent.

Transfer materials that go through the copy machine can produce an image that can be transferred to paper or fabric with a dry-mount press.

Transparent Contact Paper Transfers

Clay-coated magazine pictures can be transferred by using transparent contact paper with an adhesive backing. This is the type of contact paper often used inside kitchen cabinets. It is *not* photographic contact-printing paper.

Following are some basic guidelines for making transfers with transparent contact paper.

1. Select a clay-coated magazine picture.

2. Remove the backing from the transparent contact paper and stick it onto the front of the magazine image. Burnish the clear contact paper well with a blunt-edged tool. This will remove all bubbles and transfer the ink onto the adhesive layer of the contact paper.

3. Soak the adhered image and clear contact paper in hot water until the paper backing of the image dissolves enough to be removed with a small sponge or your finger. When this step is complete, only the ink transfer will remain on the contact paper.

4. Hang the image up to dry.

5. In order to protect the dry image and make it easier to handle, place a new piece of clear contact paper on the nonlaminated side of the dried image and burnish it.

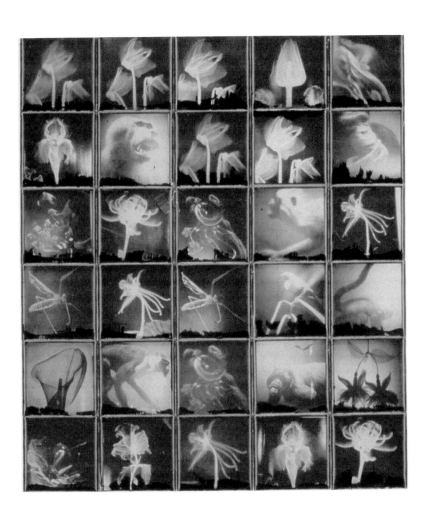

Figure 13.19 Transfer printing is an easy, fast, and fun method of working with found images. Hock made this piece from SX-70 images peeled apart during development. The backing was then adhered to a paper support. In this series, appropriated scientific images of primates and insects are juxtaposed. Visual contrast is created by combining cool- and warm-colored images within the composition.

© Rick McKee Hock. "Codex (Natural History) #17," 1986. Altered Polaroid SX-70 images on paper. 30 x 22". Courtesy of the Hallmark Collection, Inc., and Jayne H. Baum Gallery, New York. Original in color.

Aside from making a final piece with contact paper, you can use contact paper transfers for the following:

- Print them on light-sensitive material to get a negative image.
- Contact print them on a piece of film to make a negative from which prints can be made.
- Put them in a slide mount and project them.
- Use them in a copy machine that can make prints from slides.

Flexible Transfers

A clay-coated casein paper image may be transferred to an acrylic medium to deliver a flexible transparent transfer. To make a flexible transfer follow these steps:

1. Select an image that has been printed on a clay-coated paper.
2. Using a wide brush, coat the front side of the printed image with an acrylic gloss medium such as Aquatex, Hyplar, or Liquitex. Apply the acrylic medium in only one direction and allow it to dry. Then apply it again in another direction and allow it to dry. Continue repeating this process until you have at least eight layers of medium.
3. Soak the coated image in hot water until the magazine picture dissolves and can be peeled off, leaving only the printer's ink in the acrylic medium.
4. Hang the image up to dry. The acrylic medium will be white when it is wet, but it should become transparent after it dries.

The acrylic medium is flexible and can be shaped and stretched for many applications in which a regular transfer would not work. Warm the medium with a hair dryer before attempting to reform it, or it may break. Place it face down on a piece of glass and begin working it from the edges to form a new shape. The flexible transfer can be stretched around three-dimensional objects or be stitched, stuffed, and attached to other support bases.

Polaroid Transfers

Images formed on Polaroid instant print film can be transferred to another receiving surface, such as artist paper, 4 x 5" sheets of black-and-white or color film. These surfaces work well and provide an image large enough for viewing. To transfer an image from a piece of Polaroid print film to another surface, follow these steps:

1. Normally expose a sheet of 4 x 5" Polaroid film.
2. As soon as the film is pulled through the processing rollers, cut off the clipped end of the film packet with a pair of scissors.
3. Separate the positive and the negative images.
4. Immediately apply the negative image (face down) on the new receiving support material using a hard roller or squeegee. The quality and look of a transfer depends on the porosity of the receiving material. It may be lightly dampened with water, applied with a brush or cotton ball, to make it more receptive to the dyes. Be careful not to get it too wet. The negative image may be transferred to artist's paper, a photographic print, another Polaroid print, or even back to the positive from which it was originally removed.
5. Allow the negative to stay in place 60 to 90 seconds before removing it from the receiving base.

Additional Information

Howell-Koehler, Nancy. *Photo Art Processes*. Worcester, Mass.: Davis Publications, 1980.

Photography and Computers

Terry Gips

During the 1990s, photography will continue its transition from a chemistry-based medium to a digital or electronic medium. Although it is likely that some photographers will continue to use standard film and paper for personal and aesthetic reasons, electronic tools and materials will become commonplace among amateurs and professionals. Computers have already attained everyday status in some sectors of photojournalism, in advertising photography, and with many fine arts photographers.

Digital photography uses electronic instead of chemical means to record, store, process, and transmit visual images. Light is read electronically and translated into digital information. The new electronic cameras, loaded with small disks similar to those used in personal computers, are beginning to replace the familiar 35mm cameras (see Chapter 11). In the new darkroom, computers rather than developing tanks, enlargers, and chemicals are used to process images recorded on disk.

Although these changes appear revolutionary, the technological developments that have brought computers to the forefront in photography did not occur overnight. In fact, these changes continue the course established in the previous century when images were first recorded by the photographic machine known as the camera. The entire history of photography has been characterized by technological advances in cameras, lighting equipment, film, and so on. Cameras have had sophisticated electronics for years. Digital photography initially borrowed widely used electronic video technology and merged it with computer processing. Visual scanners were also used to "read" photographic prints directly into the computer. Today digital technology is emerging as the means to record images taken through the lens of a camera.

Computers and Image Making: A Brief History from 1960 to 1990

Until recently, computers have been known primarily for their ability to process numbers and words. Since about 1960, they have played a growing role in the processing of visual information (pictures). During the 1980s, *computer graphics* became a common catchphrase in almost every area of contemporary life. Computer graphics refers to the broad spectrum of visual images created and manipulated with a computer. These images range from business charts and graphs to highly technical illustrations for industry and science, from design drawings for architectural projects to expressive images by artists. They are made by many different kinds of computers and computer programs that vary greatly in complexity and ease of use. Some require extensive technical expertise with programming languages, while others en-

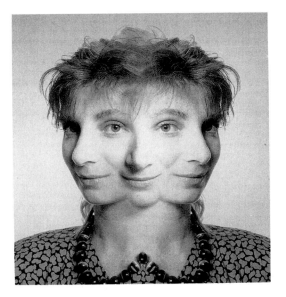

Figure 14.1 Using his own image-processing program, Holzman mirrored one image and then merged it with a front view of the model. The resulting image shows no edges or overlaps, which are difficult to avoid in a darkroom montage.

© Gerald J. Holzman. "Three Faces of Eve," 1988. Gelatin silver print. 8 x 10". Courtesy of AT&T Bell Laboratories, Murray Hill, New Jersey, and Gerald J. Holzman, *Beyond Photography: The Digital Darkroom* (Englewood Cliffs, N.J.: Prentice-Hall, 1988).

able users with little or no experience to draw directly on the computer as if with pencil and paper.

During the past 30 years, computer graphics technology has changed dramatically, making it possible to create increasingly complex and realistic pictures. In addition, computers have become more accessible; they are less expensive and much easier to use today than they were even 10 years ago. In the 1960s, most computer art was made by inspired computer scientists or by collaborating artists and scientists. In the 1970s, computers began to appear outside the confines of industrial and military research environments, thus providing easier access for artists. At the same time, less costly personal computers with a wide range of uses, including image making, were developed.

In the 1980s, costs declined significantly, making it possible for individuals to obtain fairly sophisticated machines for use in their homes, offices, and studios. Simultaneously, computers, including many with graphics capabilities, began to be widely used in schools. This produced a surge in the number and diversity of potential computer users and a parallel interest among manufacturers in developing equipment and software specifically designed for artists. With many obstacles removed, artists began using this new technology. The transition came so easily to some artists that they quickly adopted the computer as their primary medium. By the end of the 1980s, books, magazines, and exhibitions of computer art and digital photography had become commonplace, ensuring the new tool a prominent place in the future of image creation.

The Computer Dissolves Boundaries between Media

Artists can use computers in diverse ways, creating works that are described as paintings, drawings, prints, sculptures, films, and photographs, as well as others that are conceptual pieces and installations actively involving the viewer. One of the most important characteristics of the computer is that it can simulate many different picture-making tools. This lets us use the same computer to draw as with a pencil and T square, paint as with a brush, or make pictures that are photographic copies of reality. What is so amazing is that the artist can quickly switch back and forth among these techniques (as well as others) by simply pressing keys or choosing "tools" from the computer's lists of options.

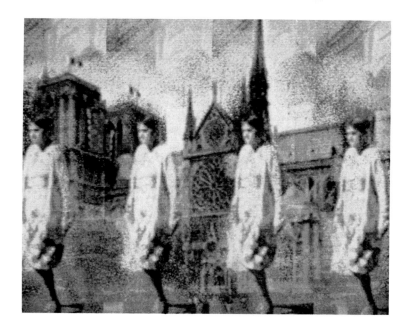

Figure 14.2 Black-and-white photographs served as the starting point for this image, which is one of a portfolio on the theme of architecture and memory. Using commercial software with millions of colors and settings to filter one image through another, Gips combined and enhanced several images with computer-painted elements.

© Terry Gips. "Retracing," 1989. Cibachrome print. 20 x 24". Original in color.

While some finished computer art is displayed only as a screen image that disappears when the monitor is turned off, other work attains independent, physical form. Much is printed or drawn on paper by computer-controlled devices. It is also possible to impress or cut materials to produce low-relief and three-dimensional forms.

Information Becomes Digital

Most image-making programs have sophisticated collaging capabilities allowing images and image fragments from different sources to be "pasted" together. Different media and image fragments can be fused in a single, seamless image, hiding the origins of the pieces and the methods of combining them. This melding of visual information also occurs in the latent or stored state, where all information uses the same digital code. It should be noted that sound can be represented by this same code (digital audiotapes are an example) and may reside on a common storage device with visual, verbal, and numerical data.

Mixing media and exploring the relationships among various modern technologies and the arts is not a new phenomenon. Such approaches have been central to much art since the beginning of this century, causing boundaries between media to soften and the overall definitions of art to shift. Traditional photography has been used by painters, printmakers, and sculptors in numerous ways, and photographers have incorporated the techniques and materials of these artists into their own work.

Electronic technologies are making the boundaries between photography and other media even more fluid. Computers serve as a common tool for a wide range of artists, facilitating innovations and crossovers and affecting the way art is made, stored, and disseminated, as well as the way it is defined and evaluated. Digital drawing, painting, and photography may be so intertwined that distinctions among them will be of little consequence.

Some Basic Questions

What Is Digital Photography?

Since the computer can blur the distinctions between media, it is important to define what is meant by the term *digital photography*. The word *digital* refers to information stored in a binary, or two-digit, code that controls pulses of electricity. A digital code is the basis of all computer operations and will be explained in the next section on basic concepts.

Digital photography refers to those images that are initially read, taken, or captured through the lens of a camera. It is possible to make photograph-like pictures on the computer without camera input by using complex mathematical algorithms, or program routines. Those images might be compared with photorealist paintings, but they are distinctly different from digital photographs. Although video that is processed by a computer and combined with computer-generated graphics has much in common with digital photography, this chapter focuses on still, single-frame images.

What Is the Difference between Image Processing and Digital Photography?

The term *image processing* is often casually thrown around when discussing digital photography. It specifically refers to the various mathematical manipulations that can be applied to any graphic image once it is encoded in digital form. Most image-processing programs designed for artists possess the capability of replicating what the photographer does manually in the darkroom or what the artist does in the studio. For instance, the size, contrast, and values of any picture can usually be modified electronically by pressing a key on the

keyboard or an icon (picture symbol) on the computer screen. But, just as the photographer in the chemical darkroom may choose to process images in a straight (unmanipulated) manner, so the photographer in the digital darkroom can use the computer to produce a realistic interpretation of the subject matter.

What Kind of Print Do We Get from the Computer?

One of the most confusing areas of digital photography is the finished product. You can say there is digital or electronic photography, images that are processed on the computer, but is there such a thing as a digital photographic print? And if there is, how is it made, and will you know one when you see it?

The issue of the finished product is complex. A computer processed image may take a variety of finished forms, many of which are still being developed and are currently beyond the reach of many users because of cost. These various technologies are discussed in detail later in this chapter, but in brief, there are four typical end products:

1. A picture displayed only as a computer screen image
2. A normal photographic print made from a negative or positive transparency that has been exposed in a box (the casual name for a variety of electronic devices) attached to and controlled by the computer
3. An image made by a printer that works like a typewriter using inked ribbons; an image produced by a printer that sprays liquid ink or a printer that melts pigment in a wax base and transfers it to paper; prints made using an electrostatic charge, such as a copier, to transfer the image
4. In addition, the digital image on the computer screen may be sent directly to four-color separation printing equipment for offset reproduction in books or magazines.

If the image is printed with inks on paper rather than with light-sensitive emulsions and dyes, is it still a photograph? There is no simple answer to this question. The facts reveal that the computer is affecting the overall arena of visual information in such profound ways that questions like this may no longer be relevant.

Will We Recognize a Digital Photograph When We See One?

Recognizing a digitally produced photograph in a magazine or hanging on the wall depends on the sophistication of the technology and the resolution of the equipment, as well as the experience of the viewer. With the low-resolution, economically priced equipment commonly used by individuals, the grid of square picture elements known as pixels (see the next section) is coarse and therefore visible. Expensive high-resolution systems, used widely by commercial design and production firms, have many more pixels per inch. When the pixels are very small, they are not visible without magnification. Most photography that has been digitally processed by sophisticated commercial equipment for high-quality printed materials such as books and magazines cannot be distinguished from its normally processed counterpart.

Basic Computer Concepts and Terminology

The first question you might ask is: How much do I need to know about computers to use them in photography? The answer is not easy unless it is exactly clear what you want to do with the computer. For the purposes of this chapter, it is assumed that you need only the basics of computer technology and terminology to make intelligent use of equipment, software, and related technical services. If you decide to write your own programs, the material

Figure 14.3 The digital image can take on many faces. This image intentionally exploits the patterning inherent in the bitmapped screen, which has been enlarged so each pixel becomes visible. The result is reminiscent of an impressionist painting but also reveals the current technology.

© Beverly and Jack Wilgus. "Fall," 1988. Raster/screen-displayed variable-size image. Original in color.

here will only touch the tip of the iceberg. You can spend years studying computing technology and theory, but most image makers use commercially available products, preferring to spend more time on the content of their work. Many user-friendly programs designed for the specific needs of artists have been on the market at a reasonable price since the late 1980s.

What Is a Computer?

A computer is a tool powered by electricity whose fundamental function is to manipulate numerical information stored in binary form (using two digits, 0 and 1). This information, which can be computed (added, subtracted, multiplied, and divided) like any other numerical information, is transmitted in electrical signals that are strings of off and on (0 and 1) pulses. Computers perform calculations based on information, commonly referred to as data, with extreme speed and accuracy. They also store, organize, manage, and retrieve some or all of it when commanded to by the user or by a program written for the user. It is important to understand that computers work by human input or direction and do not accomplish tasks on their own.

How the Computer Handles Visual Data

You might wonder how visual data, such as pictures, are handled if the computer works with numbers. Visual information, like other nonnumerical media such as words and sounds, are converted to binary code and stored as numerical information. This fusing of different kinds of information into one code or language is the key to the power of the computer.

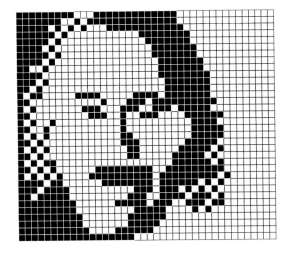

Figure 14.4 Digital pictures, pixels, and spatial resolution. This is a bitmapped image on a very low resolution screen in which each pixel is visible. Because there are so few units in the horizontal (x) and vertical (y) rows, the picture is very coarse and blocky. This spatial resolution would be improved if there were more pixels. This picture is also limited because each pixel is either white or black. A computer with more bitplanes would allow gray values or colors and thus would more closely resemble a continuous-tone photograph.

Cartesian Coordinate System: Pixels and Bitmaps Photographs are translated to the computer using what is called a Cartesian coordinate system. This means that an entire two-dimensional surface is divided into points that each have an x and a y value and that certain visual characteristics are matched to each separate point (see Figure 14.4). Each of these points is represented on the screen as a rectangular unit known as a pixel, short for picture element. Horizontal and vertical rows of these pixels form a grid, or bitmap. Any type of still picture can be bitmapped, or visualized, as a grid in which each unit has an xy value. The number of pixels in the vertical and horizontal rows determines the spatial resolution of the picture. This is similar to describing the quality of a printed image by the number of dots per

Figure 14.5 Bitplanes. Although some images can be successfully represented with just a few tones or colors, photographs typically contain the range of grays and hues visible to the human eye. To make photolike pictures, layers of bitmaps, or bitplanes, are used to provide numerous values for each pixel. This diagram shows four bitplanes.

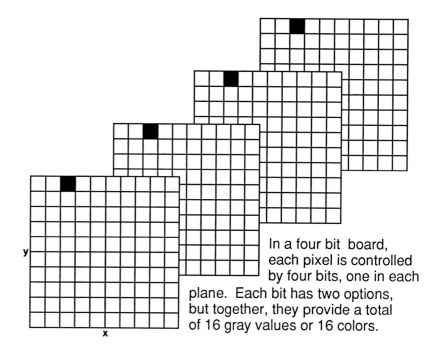

In a four bit board, each pixel is controlled by four bits, one in each plane. Each bit has two options, but together, they provide a total of 16 gray values or 16 colors.

Figure 14.6 Intensity resolution. The number of gray tones or colors available to each pixel is determined by the number of bitplanes. This diagram illustrates how many different ways the 0 and 1 settings can be combined for 1-, 2-, 3-, and 4-bit displays. The intensity resolution increases geometrically, as the number 2 is raised to higher powers. For example, 4 bits yield 16 (2 x 2 x 2 x 2) different values. Photographs need at least 64 shades of gray (6 bits) or 256 colors (8 bits) to look at all realistic. Good color is achieved on a 16-bit display with 32,768 colors (32,768 actually uses 2^{15} with the 16th bit reserved for other information). Some computers make 16,777,216 colors available using 24 bits.

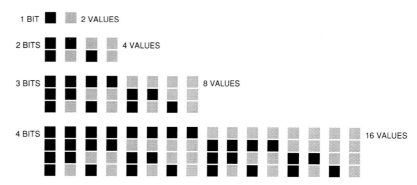

inch. The more pixels on the computer screen, the more detailed and realistic the image. On a small 10- to 12-inch screen, 400 to 600 pixels in each vertical and horizontal row are needed for the human eye to blend the separate pixels into a cohesive image that approaches photographic quality rather than appearing as a grid of square units.

Binary Digits and Bits Besides this two-dimensional resolution, a third range of information can be described. In the simplest bitmap, each pixel has only two options: off or on. You can obtain a greater range of values by electronically layering additional off/on possibilities (see Figure 14.5). Each additional layer is described as a bit (binary digit). An image is said to be 1, 2, or more bits deep or to have single or multiple bitmaps or bitplanes. For example, with a single bitplane, each pixel has only 1 bit, either 0 or 1, which might represent black (off) or white (on). Two bitplanes, or 2 bits per pixel, would provide 4 numerical possibilities, which could produce 4 colors or 4 grays; 3 bitplanes would produce 8; 4 would produce 16, and so on (see Figure 14.6).

With a single bit plane and only two options available, the kind of picture that could be made would be very limited. Therefore, most computers used for graphics have multiple bitplanes in their display hardware to increase the number of values. This stacking of off/on choices is described as intensity resolution or dynamic range. Systems with 16 colors (4 bitplanes) are very

common for low-end graphics workstations. To get an image that approaches a full color photograph 16 or more bits are required. With this configuration, more than 32,000 colors are available for each pixel and can be displayed simultaneously on the screen. If the same picture also has high spatial resolution, it will look like a traditional continuous-tone photograph.

Memory

The place for storing information in a computer, as in the human mind, is known as memory. The basic unit of memory for most microcomputers is a string of 8 bits, which is called a byte. When working with verbal information, each letter takes a byte of memory. Half a page of text requires about 1,024 bytes, known as a kilobyte. The prefix kilo, meaning 1,000, is used loosely here; 1,024 is actually 2 raised to the power of 10 (2 x 2 x 2 . . . ten times). In a similar way, a megabyte is 1,048,576 bytes, or 2 to the power of 20. A page of text might take a couple of thousand bytes, but bitmapped pictures need a great deal more memory. A continuous-tone picture in realistic color and moderate resolution would take from 50,000 to several hundred thousand bytes of memory.

Although the byte is the consistent unit of measure used throughout computer systems, there are several kinds of information storage, or memory. Two terms that are key to understanding the workings of computer memory are random access memory (RAM) and read only memory (ROM).

Random Access Memory RAM can be read or written in any order and is volatile, meaning it is changeable or erasable. RAM describes the various files accessed, saved, or deleted at the request of the user, and also refers to the portion of memory that is activated each time the computer is turned on. When selecting a computer system, the amount of this RAM is often a critical factor because it determines the complexity of the programs that can be run. Common RAM sizes in the first wave of personal computers were 64, 360, 512, and 640 kilobytes; more recent systems often have 1 to 4 or more megabytes.

Read Only Memory ROM is fixed memory and can be read but not changed or erased. ROM usually contains the basic instructions for operating the machine and other standard programs that are inscribed onto the memory chips by the manufacturer.

Both RAM and ROM are used in the main or internal memory, which is contained in the central processing unit (CPU). It is here that the electronic processing of information is carried out at the speeds for which the computer is so acclaimed.

Peripheral Memory Peripheral memory usually consists of RAM because it can be read, written, and erased and it is not an integral part of the CPU. It resides most commonly on hard or floppy disks and must be accessed by directing the computer to a specific location or file. For example, you may store programs on a hard disk built into or attached to the computer from which they may be conveniently loaded each time they are used. Programs and data files also may be put on a floppy disk and taken to another nearby computer or mailed across the country to another user. Similarly, a picture file, which is a collection of data stored as a unit that makes up one image, is written into peripheral memory until it is needed for display, revision, transmission, or disposal.

Frame Buffer A frame buffer is RAM specifically intended for temporarily storing bitmapped images until they are displayed on the monitor or sent to disk. This memory usually resides on a graphics card or board that is in-

serted into the CPU. This card, which is itself often called a frame buffer, contains chips and circuitry that determine the number of bits per pixel or bitplanes of information available. Thus graphics boards are often described as 8-bit, 16-bit, or 32-bit boards.

Software and Hardware Terminology

Although the specific graphics programs used for processing photographic images will be discussed in detail, it is useful to introduce a few general definitions of software terminology. *Software* refers to all the information involved in computing, including the directions to perform certain tasks and the data on which these tasks are performed. *Hardware* is the equipment or machinery—the actual physical components—that makes up the computer, such as the keyboard and the display screen.

A *program* is software organized as a set of instructions that direct the computer to perform a certain task or set of tasks. A program may be as simple as adding a series of numbers or as complex as calculating the pixel values required to change a photograph from positive to negative. Programs that take care of the day-to-day operations of a computer and manage other programs are called *operating systems.* Programs that are directed toward a certain kind of activity are called *application programs.* For instance, word processing programs are used to write text, while paint programs are used to create certain kinds of pictures.

A *language* is the form in which a program is written. Just as in verbal communication several different languages could be used to send the same message, various computer languages could be used to accomplish the same task. Different languages have different rules for organizing their components. In addition, there is a hierarchy of languages, with *machine language* at the bottom providing the instructions to the machine circuitry in binary code. Going up the ladder are *compilers* and *interpreters*, which translate the next group, called *high-level languages*, into machine language. Examples of high-level languages are FORTRAN, BASIC, Pascal, C, LISP, and Logo.

Graphics software is programmed in the aforementioned languages and then presented to the user in *very high level language* as picture symbols or words that belong to our everyday spoken language. The computer languages below this very high level are invisible to the user in most commercially distributed software, making these programs user-friendly to beginners and others who are not technically inclined.

A Typical Computer Graphics Workstation for Digital Photography

Basic Hardware Components

Workstations for digital photography range from very complex, costly, and powerful mainframe systems to very simple desktop or personal computers. Most individuals or small studios use low- to mid-level systems based on desk- top or personal computers. The basic equipment includes a CPU (also called the system unit), a monitor that displays anywhere from a few to millions of colors, and input and output devices (see Figure 14.7). The most common CPUs for microcomputers are the IBM PC, PS/2, and compatible family, the Apple Macintosh machines, and Commodore's Amigas.

Some workstations are described as turnkey systems, meaning that one company either designs all the hardware and essential software components or at least assembles and sells them as a single package. In systems such as the IBMs and their compatibles and the Macintosh, the CPU may be complemented by hardware and software components from many different companies.

Figure 14.7 A typical graphics workstation used by artists and photographers consists of a central processing unit (CPU); memory units, including disk drives where software and image files are stored; and various boards, including the graphics board, which determines resolution and palette. A monitor, also called a screen or cathode ray tube (CRT), a keyboard, and other input or drawing devices such as a mouse or pen and tablet also are basic components.

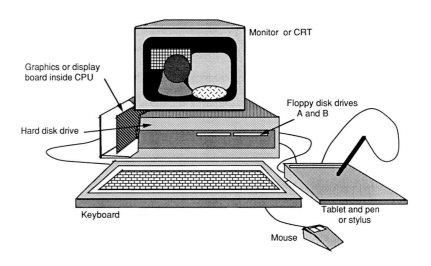

Graphics Cards and Frame Buffers

Graphics cards and frame buffers are key elements in an artist's workstation because they control the spatial resolution and the number of colors and gray levels available. They are thin boards, sometimes also called adapters, imprinted with circuits and RAM chips that fit inside the CPU.

Early in the 1980s, photographic and image-processing functions were given a great boost by the introduction of the powerful Revolution Number Nine graphics display card. Used in conjunction with a video capture card known as the PC-EYE from another company, computer pictures approached photographic quality in both color and black-and-white. Around the same time, many image makers had their first introduction to digital imaging with a very inexpensive product called Thunderscan used with the Apple Computer. This piece of equipment scanned (read electronically line by line) flat artwork so that it could be displayed and manipulated on the computer screen.

Many companies continued to improve this area of technology. In the middle of the decade, an offshoot of AT&T called Truevision began marketing the Targa boards. At the personal or desktop level, Targa boards have become a standard for photographic input and for drawing and painting on computers. They serve as both frame buffers and videodigitizers. Much software, including a wide range of drawing and painting programs, has been written for them. Although Targa boards and their more powerful AT Vista version were designed for the IBM PC and compatible systems, a comparable board for the Macintosh II known as the NUVista board also is available.

Input Devices

You can talk to a computer through a variety of input devices. A keyboard is essential to any workstation, although it is used less frequently in graphics applications than when working with words and numbers. Keyboards are needed for basic computer operations such as entering type into images and for various other simple functions in some graphics programs. It is possible for you to draw by moving the cursor (the dot, arrow, or plus sign that marks your location on the screen) with keyboard arrow keys, but this method is crude and difficult to control.

A mouse or a graphics tablet and pen are better input devices for working with visual images because they resemble the way in which we draw with our hand and a pencil. A mouse is a small oval or rectangular object that fits the hand and is slid or rolled around on the desk or table next to the computer. The movements of the mouse are immediately repeated in the movements of

the cursor on the screen. You can use it to draw lines and shapes and choose items from the menu. A tablet and pen are the preferred input devices for most artists because the pen works even more like an ordinary pen, pencil, or brush. The tablet serves as the page or sheet of paper, the space in or on which the artist draws. Instead of the marks being made on the tablet, they appear on the computer screen and correspond precisely with the speed, direction, and scale of your hand's movement.

Camera Input and Video Capture Devices

Anyone who wishes to electronically process (work with) camera images needs an input device that can transfer a camera image to the computer. This process is called digitizing because it is converting information from analog form (continuous tone) into digital form. Physical, three-dimensional subject matter, such as people, places, and objects, or a flat photographic print can provide a starting point. In the case of live subjects or still-life subjects, the current technology requires two pieces of equipment: either a still video camera (SVC) or a regular video camera to take the picture and record it and a digitizer to send it to the computer in the correct form (see Figure 14.8).

After the image is recorded, the video player is connected to a computer via a cable plugged into a digitizing device such as a Targa board. The digitizer can be inside the host computer as a special board or combined with a regular graphics board, or it may be a separate unit. The purpose of the digitizer is to convert the video signal into a digital signal. Both signals are electronic, but their forms are different. The digitizer converts the video signal into a digital signal that the computer can understand.

A regular video camera with a live, moving image also can be fed through a video digitizer to the computer screen. A simple software command grabs a single frame from the continuous video signal. Similarly, the continuous signal from a prerecorded videotape can be played on a normal videocassette recorder (VCR) through the computer's video digitizer.

Digital cameras are just beginning to enter the market but remain very expensive. They are similar to the SVC except that the electrical charges from the charge-coupled device (CCD) sensor are encoded directly as digital, rather than video, information on the disk in the camera. This disk is put directly into the floppy disk drive of the computer rather than into a

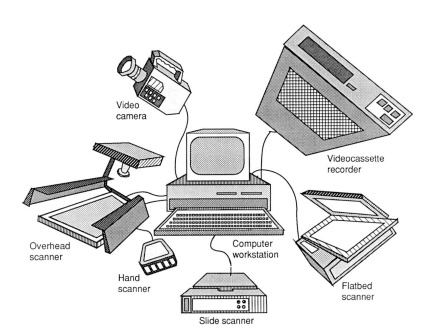

Figure 14.8 Photographic input devices. Computers themselves do not take pictures. Photographs must be input into the computer by sending signals from video cameras, video recorders, or still video cameras to a digitizing board in the computer or by sending signals from digital scanning devices.

video recorder/player. As soon as the cost of making the large, high-resolution CCD sensor comes down, digital SLR cameras may become the standard means for taking a digital picture.

When a photographic print is the subject matter, it can be rephotographed and put into the computer with one of the video cameras already described. Better results can usually be obtained with a high-quality scanner, a device that scans, or optically reads, flat art on paper. Scanners vary greatly in cost, size, and sophistication. Some are small, hand-held tools that the user moves back and forth over an image, reading and transmitting the visual data line by line into the computer. Others are more like copy machines and automatically trace across pictures fed into them. Like the sensors in still video and digital cameras, scanners use CCD cells. The CCD cells are sensitive to the varying levels of brightness in the source picture and are capable of transmitting this information in digital form.

Soft Copy Output Devices

Once an image has been processed by the computer, it can be stored as digital code on a hard disk or a floppy disk and then shown at another time. A hard disk is a rigid piece of hardware either inside or attached to the CPU that has room to store a large number of picture files or other information. A floppy disk is a small, flat disk that is inserted into the computer for recording files. Images stored on either type of disk may be displayed over and over again on the monitor of the original workstation or on any other compatible workstation. Copies can be sent via electronic networks or physically transported on disks. In addition, numerous identical copies can be made from the original file. When these are redisplayed, it is impossible to distinguish the copies from the original. Both the digitally stored images and the displayed versions, which are also called raster or frame buffer images, are described as soft copy output.

Some workstations provide the option of recording images on videotape. Then the output is redisplayed via a VCR and television monitor. This medium, also a kind of soft copy, is useful for disseminating images to a broad audience, since video and television are standard equipment in nearly every technologically advanced home.

Hard Copy Output Devices

Screen images can be converted to tangible images on paper, known as hard copy, via several types of printers. Although individual printers often require their own specific materials such as ribbons, inks, and papers, most machines come with several options, including matte and glossy papers and transparencies. Since printers increase dramatically in cost with the size of the output, most individuals and small studios are limited to 8-1/2 x 11" prints (longer if printing on a continuous role of paper). An individual can obtain larger and higher quality prints using a service bureau, a firm whose primary function is to serve one or more related needs of a large group of clients. Service bureaus cover the overhead of costly equipment and charge a fee for each service rendered.

Dot Matrix Printers A dot matrix printer functions by using impact similar to that of a ribbon typewriter. A single black ribbon is used to produce black-and-white prints. Cyan, yellow, magenta, and black ribbons are used together to make color prints. The quality of the image depends on the number of dots per inch and on the richness of the ribbon's ink. Generally, dot matrix printers are inexpensive devices that produce subdued, low-intensity prints. Although dot matrix output rarely approaches the quality of photographic or offset printing, some artists take advantage of its soft pastel colors for making delicate images.

Figure 14.9 Slayton input live video from a video camera to a Targa 16 board. A frame was frozen, and additional drawn elements were added with Lumena paint software. The finished image was output to a film recorder, where traditional film was exposed. The film was then enlarged in a conventional manner.

© Joel A. Slayton. "LJ71," 1988. Chromogenic color print. 50 × 60". Original in color.

Inkjet Printers Inkjet printers spray liquid ink at the paper from tiny nozzles and produce more saturated colors. Like four-ribbon dot matrix printers, inkjets use cyan, yellow, magenta, and black inks for full-color images.

Thermal Printers A thermal printer uses heat to melt plastic inks onto the surface of the paper, where they immediately cool and solidify. This type of printer can vary the number and size of the dots of color as well as the mix of colors, thus producing higher quality results than either inkjet or dot matrix printers. The drawback of a thermal printer is that it costs considerably more than either a dot matrix or inkjet printer.

Electrostatic Printers Electrostatic printers deposit dry toner (similar to a photocopy machine) on paper where the image has been traced with an electronic charge. Laser printers, the most popular type of electrostatic printer, deposit their charge with a laser beam scan. Most laser printers on the market today are black-and-white, but the technology can be applied to color. As the cost comes down, laser printers producing color will become more common. For text and black-and-white graphics, laser printers provide outstanding quality.

Plotters A plotter creates images by drawing continuous lines between points rather than applying color to each pixel as in a bitmapped picture. Plotter output is used for line-oriented drawings such as architectural plans. It is not intended for photographic images.

Drum Plotters Drum plotters are a different type of output device and are integrated into offset printing processes. A laser beam is projected onto film to produce high-contrast black-and-white or color separations, which are then used to make plates for standard offset printing. Drum plotters are complex and expensive machines that are widely used in the print industry but rarely in a small studio. The software needed to produce separations is becoming more readily available, thus reducing the need for drum plotters.

Film Recorders A film recorder, also known as a digital film printer, produces a hard copy that is literally photographic in that it relies on light-sensi-

Figure 14.10 Photographic output devices. Getting a photograph out of a computer requires a device that prints the image on paper with a pigmented medium (ink, wax, or toner) or a device that exposes traditional light-sensitive film, from which a photographic print is made. An image also can be output to a disk or tape, but this is described as soft copy because it is electronic and not visible until it is redisplayed on a screen.

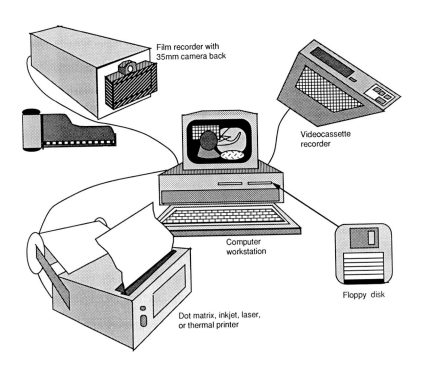

tive film and printing. Film recorders consist of systems of precisely integrated components, including black-and-white television tubes, color filters, lenses, camera backs, and electronic interfaces with the computer. The film recorder can use any normal film, with the camera's exposures being controlled by the computer. If traditional full-color and high-resolution photographic prints or offset print reproductions are desired, film recorders are the best output devices. Due to the high cost of this equipment, many people use film recorder service bureaus and then make prints from the transparencies in their own or commercial studios.

Software for the Digital Photography Workstation
There are several categories of computer graphics software commonly used by artists and designers. Within each category are dozens of commercially available programs that range widely in complexity and functional capability. While the first two listed below are most specifically designed for working with photographs, the current technology is moving toward integrated software that simulates the artist's studio by combining all of the frequently used tools from the various types of programs into one package.

Paint Programs Paint programs enable you to use the screen like a canvas or piece of paper, with each new mark filling in blank space or covering an earlier mark. The images, referred to as bitmapped and raster images, consist of a grid of pixels, each of which has a color or gray scale value. When any pixel is addressed (marked) by a particular painting tool of the program, it obtains a new value and what was there previously is erased. Photographic input and scanning produces a raster image and is usually done within a specialized paint program.

Image-Processing Programs Image-processing programs usually contain paint functions, but they have additional tools to do things such as shrink, enlarge, scale, flip horizontally and vertically, invert from positive to negative, and swap colors. Image-processing software designed to be used

with camera input also might be able to solarize images, enhance contrast, or blur or enhance sharpness.

Drawing Programs As in paint programs, the screen becomes the paper, or surface, on which you draw. Drawing programs differ from paint programs, however, in that thay are object-oriented. This means that shapes, lines, objects, and blocks of text are more like pieces of cut paper than marks on a surface. The computer stores or remembers each piece separately so that it can be moved and manipulated (scaled, colored, textured, etc.) independently of any other. When the pieces of the drawing are layed on top of one another, what is temporarily covered is not erased. This is because the data is not pixel-oriented, or bit-mapped, as in paint programs but describe lines that connect two points (known as vectors). Although drawing programs do not have photographic functions like paint programs, recent software packages enable you to import, or bring, a photograph into a drawn page.

CADD Programs CADD (computer-aided design and drafting) programs are specialized drawing programs designed for applications such as architectural and industrial design and engineering. These are linear, point-to-point or vector programs and are useful where the image consists primarily of lines and dimensioned units.

Three-Dimensional Modeling Programs Three-dimensional modeling programs also are object-oriented and use vector information with x, y, and z values. Software in this category can be an extension of CADD software, or it may be linked with paint, drawing, and image-processing software geared toward artists' needs for working with solid forms. Photographic images, which are bitmapped or raster images as defined under the previously mentioned paint programs, may be combined with modeling software as background and as texture maps. Texture mapping is the process of wrapping an image (a painted pattern or image or a photograph) around the surface of a three-dimensional object such as a cylinder or sphere.

Figure 14.11 Here initially unrelated images were joined into a single work. The color, scale, and backgrounds of the originals can be maintained or altered with computer processing tools. Picture components can be easily reassembled with editing tools provided in the software.

© Manual (Suzanne Bloom and Ed Hill). "Natural," 1988. Chromogenic color print. 30 × 40". Original in color.

Animation Programs Animation software attempts to achieve the same general effects as hand-drawn animation—a sequence of related images that, when displayed continuously, suggests moving objects. The artist creates key frames and then programs the computer to generate the in-between images. Photographic stills stored electronically can be incorporated into animation, and sophisticated programs can animate the photographic frame.

Page Layout and Desktop Publishing Programs Page layout and desktop publishing programs are primarily text-oriented programs typically used by graphic designers or others preparing material for printed reproduction. However, because such communications often incorporate images, these software programs are designed to import and manipulate pictures created in a variety of other programs. It is not unusual, for example, to find in one software package, tools that scan photographs, swap colors, create freehand drawings, print text in any one of dozens of common typefaces, arrange a page in accurately dimensioned columns, and create color separations.

Using a Typical Workstation

Capturing or Inputting Images

For photographers, the first step after getting an idea for a photograph is to find the subject matter as it exists naturally or to set up the objects, persons, or environment. The next step is to record the image with the camera. The same procedure applies when using the computer for electronic photography. The natural or set up image may be taken with a standard or still video camera and recorded for playback to the computer at a later time. In the case of a studio setting, a live signal from a regular video camera can be sent without recording to a nearby computer. The camera's cable is fed directly into the computer's digitizing board. If a scanner is used instead of a camera, a photographic print on paper is fed into the scanner, which then sends the digital reading to the computer (see Figure 14.8).

Processing the Image

Once the image has been put into the computer, a software function grabs a frame and displays it on the screen for processing. The amount of processing applied to the image can vary a great deal. You may make only slight changes such as darkening a background, removing freckles from a face, or cropping. You can also radically modify the picture by removing large sections of an image, seamlessly joining elements from two or more distinct images, or substituting new colors or tones.

Simple Manipulation and Image Editing Basic operations in most software programs are performed by choosing certain tools from a menu on the screen. A typical menu offers a series of options presented as picture symbols or words or as a combination of the two (see Figure 14.13). For instance, if you wanted to cut a cloud out of the sky, you would choose the cut or scissors tool. Then you would enclose the unwanted object inside a line or box and press the particular menu icons or words that will move it or delete it from the picture. If you wanted to change a red rose into a pink rose, you would use the fill, color swapping, or tinting tool. Modifications such as enlarging and reducing, as well as changing the proportion of images, also are standard menu choices in most software.

The ease with which such operations are performed varies from program to program, but learning one program usually makes learning a second or third relatively simple. Commercial software comes with a guidebook or documentation that explains how to use menus and tools, but well-designed

Figure 14.12 Porett used his own custom software to make this image. He is one of a number of artists who regard their computer expertise as an integral part of making art. While some consider their programs part of the finished piece, others like Porett produce work in which the content and aesthetic qualities are more important.

© Thomas Porett. "Untitled," 1986. Inkjet print. 13 x 13". Original in color.

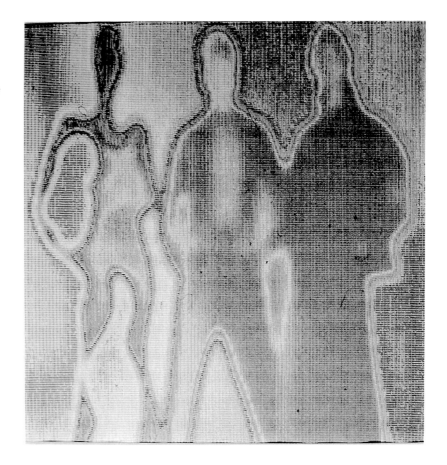

programs are quite self-explanatory and require the book mainly for problem solving. It is often possible to learn the basic functions of a program in a few hours, but using it for effective artwork can take a considerable amount of time. Although the computer may speed up the picture-making process, the artist must still bring ideas and technology together in the final work.

Digital Processing Many computer programs designed specifically for photographic work include simple menu choices that let you change the image from positive to negative, solarize it, increase or decrease contrast, and change the overall exposure or value range. You just move the cursor to the desired tool or function and then decide whether to apply that process to the whole picture or to part of it. When selecting a section, you make a window by using a special expandable rectangular cursor called a rubberband or by drawing a line around the desired area.

Drawing and Painting on the Photograph The majority of programs include standard drawing and painting tools for adding noncamera elements to the picture. For example, you may select a pencil, its color from a palette menu, and its width, then draw lines anywhere on the screen. Most programs have a series of brushes, and more sophisticated programs let you make choices such as pastel, oil, or watercolor. In addition, you can use shape tools to create circles, rectangles, and other polygons in outline and filled form. Any of these drawn elements can be placed in the photographic image. Generally, as new elements are laid down, those that are covered up are erased. If a transparency mode is available, the previous image may partially show through the new one.

Collaging and Montaging Images An image maker can obtain a collage effect by adding new elements as previously described or by combining two or more distinct images. Individual camera-derived and drawn images can be cut apart, rearranged, and recombined in a technique similar to making a collage in which one piece is pasted on top of another. Images also can be merged in a process that resembles film montage; degrees of transparency can be selected from the menu, allowing one picture to be displayed through another. Both of these techniques allow you to create a new picture with no visible seams, or you can do the cut-and-paste and layering more crudely to reveal the sources of the imagery segments.

Saving Images

As an image is changed through various processing operations, it can be saved again and again, producing a collection of different versions. Saving an image electronically requires a simple set of steps that includes naming the picture (you type a name on the keyboard) and choosing the location for the saved image (either a hard or floppy disk, or a tape when extensive memory is required). Selecting the storage location is done by specifying the drive, the part of the computer that reads from and writes information to the disk. Usually this is accomplished by typing in the letter of the drive or selecting a screen icon associated with a particular drive. Multiple copies can be saved in different locations to help prevent losing an image through accidental erasure.

Making the Finished Print

There are several ways to make a finished print. If a true photographic print is desired, there are two choices. One choice is to use a film recorder, which was described earlier in this chapter. Depending on what camera you attach to the recorder, 35mm or 4 x 5" film is loaded and the appropriate film speed settings are adjusted. A picture file is sent by special software to the film recorder, where its exposure through a sequence of color filters is controlled by the CPU.

As noted earlier, quality film recorders are costly, but service bureaus provide an alternative to owning one. To use a service bureau, send the picture file over the telephone lines using a device called a modem, or save the file on a floppy disk and deliver it to the bureau's studio, where it is loaded into the system. Once the film is exposed on the recorder, the bureau develops the film and returns the negatives or positive transparencies to you.

A second choice for making a finished print involves placing a conventional film-type camera in front of the computer monitor and taking a picture of the screen. The curvature of the screen can be reduced by using a telephoto lens, and reflections can be eliminated by darkening the room. Color daylight-type (5500K) film yields accurate results with meter readings taken directly from the screen. Bracketing exposures helps ensure the best results. The main drawback of this technique is that the scan lines of the monitor are visible as thin black lines in the print. People who want to reveal the source of the image, letting the computer's inherent qualities come through, find this method acceptable and even desirable.

Print and slide film can be used with either of these methods. Although positive transparencies are usually required when the work is to be color separated for printed reproduction, photographic prints can be made from film negatives or positives. Slide film creates more contrast and may require adjustments to the image as it is created on the screen (turning down the contrast). Many photographers prefer Cibachrome prints because their saturated colors resemble those on the computer screen and therefore use slide film in spite of the contrast problems.

Why Do Photographic Work with the Computer?

There are advantages and disadvantages to doing photographic work with the computer. Since digital technology is still evolving and the photographic community has extremely diverse needs, it would not make sense to advise everyone to use digital technology. In addition, chemistry-based film and printing is not likely to disappear completely even if the technical problems of digital technology are solved. Many photographers have found good reason to revive 19th-century processes such as gum bichromate and palladium printing, and many will no doubt continue to prefer chemical/darkroom processing. But a growing number of image makers have begun to experiment with the computer's wide range of options.

Commercial Uses

Digital technology is already affecting most of the photographic world indirectly and the commercial areas of the profession directly. At the upper end of the print industry, where expensive scanning equipment is commonly used, images are routinely processed and edited electronically. The computer enables easy and undetectable retouching, combining and montaging of multiple images, separations for four-color printing, integration into video for film presentation, and electronic transmission over wires and the air. For journalists, digital photography permits news photos to be rapidly sent anywhere over telephone lines. For advertisers, it allows greater control in composing ads. In addition, digital imaging is finding many uses in surveillance and law enforcement, in medical and scientific research, and in many areas of the communications industry.

Personal Uses

On a practical level, some photographers are finding the computer an interesting tool for breaking through the straight qualities of photography. It can be used to create mixed-media works in much the same way that drawing, painting, and collaging have been combined with photography over the years. Many are looking to the new technology as a way to perform more easily the tasks that photographers have traditionally done. For example, if it is more convenient to burn in an overexposed sky on the computer, many will choose this method.

Figure 14.13 Sample menu for drawing, painting, and image processing. Most programs used by photographers have menus with tools for inputting, or capturing, camera images, processing them, and also drawing or painting. By selecting tools from the menu and perhaps pressing a few keys, images may be scaled, rotated, reversed left to right, made into a negative, cropped, or enhanced with color and hand-drawn elements. The original and any number of copies and variations can be saved in memory for display or printing at a later time.

Artistic Uses

Beyond these technical tasks, which primarily affect the formal aspects of the print, some photographers are interested in using electronic technology because it allows them to address aesthetic and political issues related to the content, function, and meaning of visual images. Electronic processing reinforces some of the widely accepted qualities of photography, such as its reproducibility, and undermines others, such as its truthfulness (these and other issues were raised in Chapter 13).

On the Frontier

Most importantly, many artists are using computers because they are on the frontier of image making. As with any frontier, there are those who wish to explore the fringes of the known world. As photographers come in contact with electronic technologies, they will undoubtedly be involved in revising the definitions of photography. This active participation will affect not only the development of hardware and software but also the aesthetic and ethical standards that shape the field of photography (see Color Plate VIII).

Selecting a Workstation

There are two basic starting points for selecting a workstation: knowing what you want to do with your computer and how much money you can spend. Most image makers want to do nongraphic (word processing) as well as visual work on their computer. This rarely presents a problem, as most graphics workstations can do many different types of computing. The opposite of this is not necessarily true; a simple word processor may not have a graphics board or the memory capacity needed to perform graphics. If you already have a computer for word processing, you can investigate adding the hardware elements required for graphics, although this may be impossible or too costly.

Even if your primary interest is in photographic image making, you will probably want to be able to do other kinds of visual work on the computer. This should not present a problem, as most graphics workstations can support several types of software or one graphics program that combines various kinds of processes.

Factors to Be Compared

When comparing different hardware and software products, you should consider several factors. The most obvious is the probable cost, which can vary from about $2,000 for the simplest complete system, to $20,000 to $25,000 for a good medium-range workstation, to much more for commercial equipment. It is a good idea to come up with an approximation of what you are willing to spend for an entire system. Then look at the particular functions included in various software packages and decide which ones you need. The program you buy must do what you want it to do for an affordable price.

Once you have decided on the kind of software functions or applications you want, you need to determine the hardware required to run this program. Look at the minimum requirements and then assess the system's expandability and compatibility with other hardware and software. Very rarely will your needs remain constant. Even if you are good at resisting the market pressures to upgrade or improve your workstation, it is very difficult to foresee all you might want to do with a computer. Therefore, it is wise to invest in a flexible system. When deciding what components to purchase, consider using service bureaus for some parts of the process as a method of reducing the initial start-up cost.

Another factor to evaluate is the reputations of the manufacturers and vendors and the extent to which the products are used by persons with needs

similar to your own. If you know someone who is an expert on the overall computer marketplace, ask for advice about the products you are considering. Generally, it is not wise to obtain a product from a manufacturer or dealer who is likely to be out of business in the next few years.

Obtaining Experience and Information before Buying

There is no easy way to learn everything you might wish to know about computers before purchasing a system. One of the most effective first steps, however, is to find someone who already uses a computer for image making. Such a person will probably be able to answer your questions without using technical jargon, which can be confusing and intimidating.

It is best to see demonstrations of several different workstations or, better, to try out these workstations. The studios of computer graphics artists are a good place to test workstations, although most vendors usually have some demonstration equipment. Another good way to see a variety of workstations is to attend conferences or product expositions. Most large cities host one or more of these each year. Another source of information is printed materials. The difficulty here is deciding what to read. There is an enormous amount to look at, ranging from the promotional materials on various products to articles and books addressing the subject in both simple and highly complex technical ways.

Additional Information

Following is a highly selected sampling of available information.

Books

Breslow, Norman. *Basic Digital Photography.* Stoneham, Mass.: Focal Press, 1991.

Holzman, Gerard J. *Beyond Photography: The Digital Darkroom.* Englewood Cliffs, N.J.: Prentice-Hall, 1988.

Kerlow, Isaac Victor, and Judson Rosebush. *Computer Graphics for Artists and Designers.* New York: Van Nostrand Reinhold, 1986.

Ritchin, Fred. *In Our Own Image: The Coming Revolution in Photography.* Millertown, N.Y.: Aperture, 1990.

Truckenbrod, Joan. *Creative Computer Imaging.* Englewood Cliffs, N.J.: Prentice-Hall, 1988.

Magazines

AV Video, Montage Pub. Co., 1979–, 25550 Hawthorne Blvd. Suite 315, Torrance CA 90505.

Computer Graphics World, Computer Graphics World Pub. Co., Inc., 1714 Stockton, San Francisco, CA 94133.

Computer Pictures, Back Stage Publications, Inc., 165 W. 46th St., New York, NY 10036 (issued as section 2 magazine supplement of *Back Stage*).

Electronic Publishing and Printing, Chicago: Maclean Hunter Pub. Corp., 1986– . EP&P Circulation Dept., 300 Adams St., Chicago, IL 60606.

Macworld, San Francisco: PC World Communications, 1984–. Subscriber Services, P.O. Box 20300, Bergenfield, N.J. 07621.

Macworld Buyer's Guide, San Francisco: PC World Communication's, 1984– . Subscriber Services, P.O. Box 20300, Bergenfield, NJ 07621.

PC Magazine, New York: PC Communications Corp., PC Magazine, P.O. Box 2445, Boulder, CO 80322.

Organizations

National Computer Graphics Association (NCGA), 8401 Arlington Blvd., Suite 8401, Fairfax, VA 22301.

Small Computers in the Arts Network (SCAN), P.O. Box 1954, Philadelphia, PA 19105.

Society for Photographic Education, Campus Box 318, University of Colorado, CO 80309.

Special Interest Group-Graphics (SIGGRAPH) of the Association for Computing Machinery (ACM). 11 West 42nd Street, New York, NY 10036.

Hardware and Software Sources

Adobe Systems, Inc., 1585 Charleston Rd., Mountain View, CA 94039 (Macintosh software).

Apple Computer, Inc., 20525 Mariani Avenue, Cupertino, CA 95014 (Macintosh hardware and software).

AT&T Graphics Software Lab, 3520 Commerce Crossing, Indianapolis, IN 46240 (software for Truevision input hardware).

Commodore Electronics, Inc., 1200 Wilson Drive, West Chester, PA 19380 (Amiga products).

Hewlett-Packard Co., 1930 Pruneridge Avenue, Cupertino, CA 95014 (scanning hardware and output devices).

IBM, 900 King Street, Rye Brook, NY 10573 (IBM PC workstations).

Silicon Beach, P.O. Box 261430, San Diego, CA 92126 (Macintosh software).

Truevision, Inc., 7351 Shadeland Station, Suite 100, Indianapolis, IN 46220 (Targa, ATVista, and NUVista video input and image processing hardware and software).

Index